THE HEBRIDES

PAUL MURTON

BIRLINN

First published in 2017 by
Birlinn Limited
West Newington House
10 Newington Road
Edinburgh
EH9 1QS

www.birlinn.co.uk

ISBN: 978 1 78027 467 6

British Library Cataloguing-in-Publication Data
A catalogue record for this book is available
from the British Library

Designed and tyespet by Mark Blackadder

All photographs supplied by the author, except for the
following:
Title page Agenturfotografin/Shutterstock;
p. 10 Jaime Pharr;
p. 27 Dennis Hardley/Alamy Stock Photo;
p.28 Sue Burton Photography Ltd/Shutterstock;
p. 29 John Peter Photography/Alamy Stock Photo;
p.39 trotalo/Shutterstock;
p. 43 (top) John Copeland, Shutterstock;
p. 54 Heartland Arts/Alamy Stock Photo;
p. 61 Tom Richardson Scotland/Alamy Stock Photo;
p. 84 Lphoto/Alamy Stock Photo;
pp. 90–91 Christopher Drabble/Alamy Stock Photo;
p. 100 stocker1970/Shutterstock;
p. 102 iLongLoveKing/Shutterstock;
p. 105 Martin Gillespie/Shutterstock;
pp. 116–17 Joe Tree/Alamy Stock Photo;
p. 123 (top) Cephas Picture Libray/Alamy Stock Photo;
pp. 130–31 Nature Imagery/Alamy Stock Photo;
p. 135 SJ Images/Alamy Stock Photo;
p. 143 Colin Palmer Photography/Alamy Stock Photo;
p. 150 Ian Cowe/Alamy Stock Photo;
p. 163 Cath Evans/Alamy Stock Photo;
p. 214 Paul Williams/Alamy Stock Photo;
p. 217 Graham Uney/Alamy Stock Photo;
p. 222 corlaffra/Shutterstock;
p. 225 corlaffra/Shutterstock;
p. 226 Joe Gough/Shutterstock

Printed and bound by Livonia, Latvia

Title page: Fionnphort, Mull.

THE HEBRIDES

CONTENTS

MAP OF THE HEBRIDES

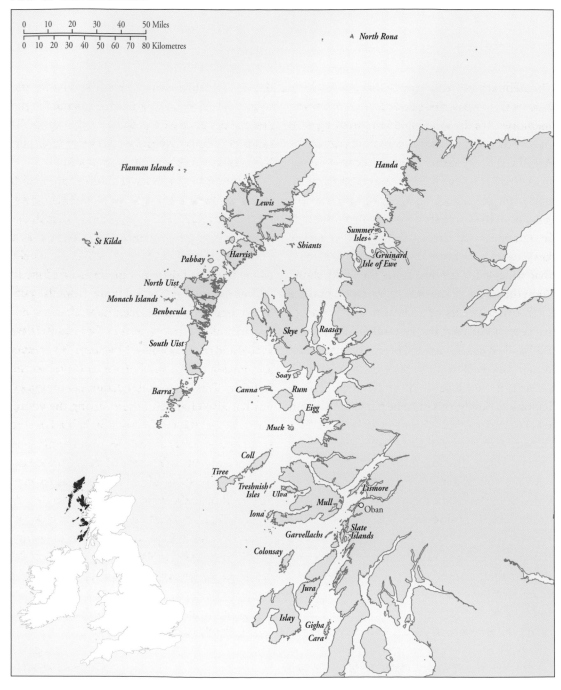

0 10 20 30 40 50 Miles

0 10 20 30 40 50 60 70 80 Kilometres

North Rona

Flannan Islands

Handa

Lewis

St Kilda

Summer Isles

Shiants

Harris

Pabbay

Gruinard
Isle of Ewe

North Uist

Monach Islands

Benbecula

Skye

Raasay

South Uist

Soay

Barra

Canna

Rum

Eigg

Muck

Coll

Tiree

Treshnish
Isles

Ulva

Lismore

Mull

Oban

Iona

Garvellachs

Slate
Islands

Colonsay

Jura

Islay

Gigha
Cara

INTRODUCTION

The Hebrides are in my blood – and my enduring love for them was sealed by one of my very earliest memories. It's the 1960s, and I'm travelling with my brother and parents to a remote part of the Argyll coast. My father pitches our tent on the *machair* – that uniquely Hebridean grass plain that bursts into colour every spring with wild flowers – just above the white shell sand of Kilmory beach in Knapdale. He then wanders off to gather kindling from the tangle of dwarf oaks and birches that struggle for survival along the rocky shore. Soon the sweet aroma of burning wood mingles with other smells of that summer evening: seaweed, sheep dung, bracken and the damp earth. Dad cooked us sausages and beans that night, and we ate our meal from tin plates, savouring each mouthful with a sense of gratitude and deep happiness. Surely, this must be paradise? The sun was setting in a blaze of crimson behind the Paps of Jura. A myriad of islands and rocky skerries seemed to drift, like ships at anchor, in a rainbow coloured sea. 'Listen!' whispered my mother, her voice full of excited expectation. 'The sound of utter peace!' Ever since then, the sight of distant islands on the western horizon has had an irresistible allure. I have sailed among the Hebrides, lived on them, walked and cycled over them, and in the past few years have had the extraordinary luck to earn a living by making documentaries about the people and places I have met on my travels.

The first island I got to know really well was Mull. After graduating from university, I lived there for a while with my girlfriend Nicky and future mother-in-law at Frachadil, towards Calgary and the north coast. I proposed to Nicky on the sands of Calgary Bay and was married in an outhouse on my mother-in-law's property.

I remember Mull as an island full of old-fashioned Hebridean character. Back then, there was no ferry on a Sunday, newspapers were always a day late, and I used to hear Gaelic in the streets of Tobermory, or in the post office at Dervaig, where the post mistress sometimes asked me to deliver the mail as I cycled home from the pub. Since then, there have been huge changes, not just on Mull, but among all the other islands I have visited and come to know. Nowadays, it's cheaper and easier than ever before to travel to the Hebrides. This has revitalised some communities, but has also changed others, luring the young away, so that the man or woman behind the bar pulling your pint is as likely to come from Poland or New Zealand, as from the islands. But then the social demographic of the Hebrides has always been in flux. In the days of the Clearances, whole communities – indeed the populations of whole islands – were evicted. However, the landscape remains a constant, and the beauty of the Hebrides is, for me, unparalleled. I hope this book gives a flavour of the places and the people that have inspired me to continue exploring these wonderful and endlessly fascinating islands.

Paul Murton
May 2017

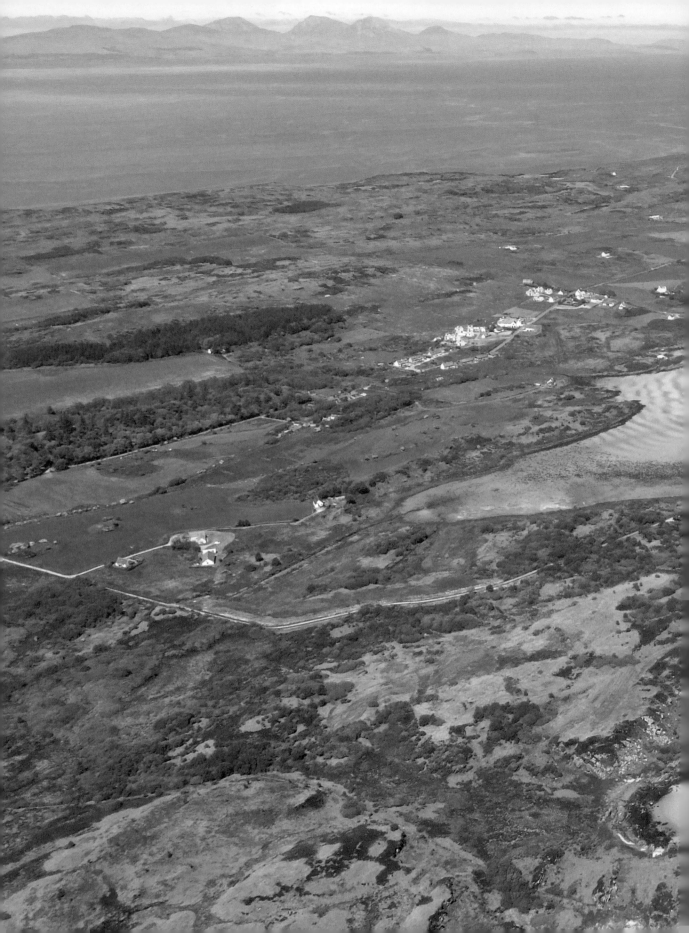

CHAPTER ONE GIGHA TO THE GARVELLACHS

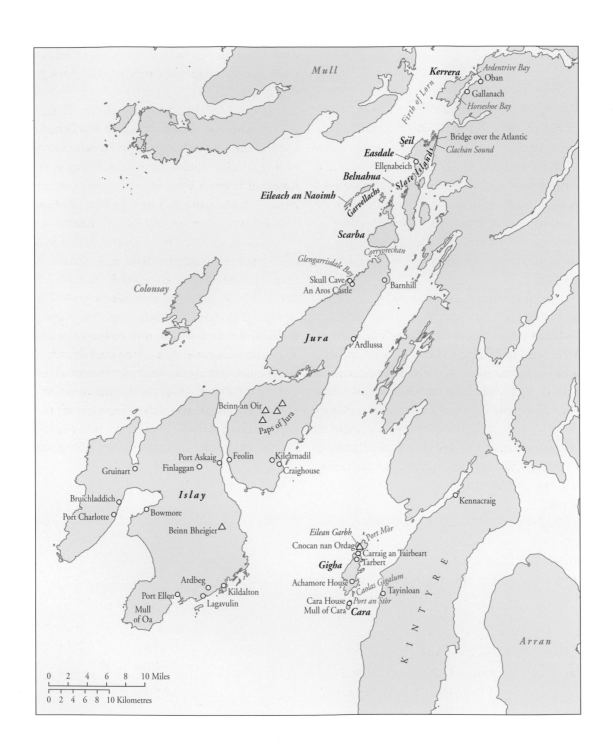

Mull

Firth of Lorn

Kerrera　　*Ardentrive Bay*
　　　　　　○ Oban
　　　○ Gallanach
　　　　Horseshoe Bay

Seil
　　　　　　—○ Bridge over the Atlantic
Easdale　　　*Clachan Sound*
　　　○ Ellenabeich
Belnahua　　*Slate Islands*
Eileach an Naoimh
　　　Garvellachs

Scarba
　　Corryvreckan

Glengarrisdale Bay
Skull Cave ○
An Aros Castle ○　　　　○ Barnhill

Colonsay

Jura
　　　　　　○ Ardlussa

Beinn an Oir △　△
　　　　△
　　Paps of Jura

　　　　　　Feolin ○
Port Askaig ○　　　○ Kilearnadil
Finlaggan ○　　　　○ Craighouse

Gruinart ○

Islay

Bruichladdich ○
Port Charlotte ○　○ Bowmore
　　　Beinn Bheigier △

Kennacraig ○

Eilean Garbh　*Port Mòr*
Cnocan nan Ordag △
　　　　○ Carraig an Tairbeart
Gigha　　　○ Tarbert
Achamore House ○
　　　　Caolas Gigalum
　　　○ Tayinloan

Ardbeg ○
　　　　○ Kildalton
Port Ellen ○
　　○ Lagavulin
Mull
of Oa

Cara House ○　*Port an Stòr*
Mull of Cara **Cara**

K I N T Y R E

Arran

0　2　4　6　8　　10 Miles
0　2　4　6　8　　10 Kilometres

GIGHA

The name is said to date back to the days of the Vikings, derived from *Gud Øy* – meaning 'God's Island' or 'Good Island'. Gigha is a small island lying approximately 5 kilometres west of the Kintyre Peninsula. Orientated north to south, it measures about 9.5 kilometres long by 2 kilometres wide. A small RoRo ferry makes the 20-minute crossing several times a day from the village of Tayinloan on Kintyre. The population of Gigha is 110. The principal settlement on the island is Ardminish.

A couple of years ago I had the good fortune to accompany my cameraman pal and ace aviator Richard Cook on a microlight flight from Flanders Moss, west of Stirling, to Jura – a round trip that took us over the island of Gigha. Suspended in an open cockpit beneath the microlight's fabric wing, I had a fabulous, if somewhat precarious, view of the low-lying island below me. From a height of over 2,000 metres, it looked like a tropical paradise, with green pastures and sandy bays set in an azure sea. No wonder people still refer to it as God's Island.

The size of Gigha makes it a perfect place to explore by pushbike, which my wife Nicky and I did one hot July weekend, following the route of an earlier visitor, the Welsh-born naturalist Thomas Pennant who landed in 1773 while on his Hebridean voyage. Pennant was on a mission to report and inform. He thought that the British public knew more about foreign lands than they did about their own, which is probably still true today. To remedy this, he embarked on an expedition to the Hebrides and published a best-selling book about his adventures. Arriving on Gigha two and a half centuries ago, Pennant experienced what it was like to be in a foreign land, where Gaelic was the language of the people, and where the MacNeil laird ruled with an almost feudal authority. MacNeil's ancestors were the Thanes of Gigha, who took over from the MacDonald Lords of the Isles, a chapter of the island's bloody history which includes clan battles, Viking invasions and an attack by the legendary 16th-century pirate Alan Maclean (Allan-na-Sop), who killed the MacNeil laird and many of Gigha's inhabitants.

Wandering the island churchyard, Pennant discovered reminders of those more turbulent times: 'In the ruins of the church,' he wrote, 'I found some tombs with two-handed swords.' The church in question is Kilchatten. Nicky and I explored this picturesque ruin and came across several ancient grave slabs of the kind described by Pennant. Moving on, we climbed the small hill Cnocan nan Ordag, whose Gaelic name commemorates a clan battle when the victors cut off the losers' thumbs and piled them up to make a cairn. Despite the grisly associations, the Hill of the

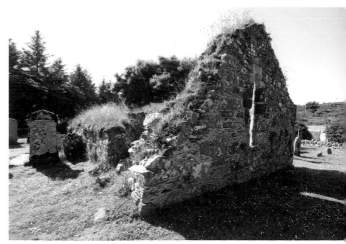

Chapter opening: Gigha from the air.

Above. Kilchatten Chapel, Gigha.

One of the grave slabs at Kilchatten described by the 18th-century traveller Thomas Pennant.

Thumbs turned out to be a very fine place to have a picnic and enjoy the views.

Near Tarbert, where the island narrows between two opposing bays, is Gigha's most prominent ancient landmark, the Carraig an Tairbeart, a standing stone known locally as the Giant's Tooth. Legend tells of how a giant, suffering the agonies of toothache, pulled out the offending tooth and hurled it away to land on Gigha. Other stories tell of how the stone was used as a place of execution. Criminals were once tried on nearby Court Hill and the guilty hanged from the cleft in the stone. On a happier note, local tradition also considers it to be good luck for young lovers to hold hands through the same cleft in the stone before they marry. Somewhat belatedly, Nicky

and I did this. I can honestly say that our luck hasn't got any worse since then – so there must be something to it! Also near here is the strange and enigmatic Well of the Winds, as mentioned by the Hebridean traveller Martin Martin 300 years ago. Here a female guardian would take payment to use the well to change the direction of the wind.

Beyond the Carraig an Tairbeart, we followed the road to the north end and took the track down towards Eilean Garbh – the Rough Island – which is connected by a narrow neck of land that forms a beautiful double beach. There wasn't a breath of wind. Sails of distant yachts hung limply in the shimmering heat haze, which cast a translucent veil over the distant Paps of Jura. At Port Mòr, we

braved the cold and swam in the turquoise, glassy sea. Unfortunately, we discovered that we were not alone. A herd of cows, including a rather intimidating black bull, was watching us intently. They kept their distance at first, but eventually curiosity got the better of them and they sauntered lazily across the white shell sand to check us out. We were soon surrounded by several bovine heavyweights with slavering mouths. When they started muzzling into our bags and licking our toes, I knew it was time to go.

One of the other things which Thomas Pennant observed about Gigha, and which our sunny weekend seemed to confirm, was the weather. Like us, he found it to be 'extremely fine'. When Nicky and I were enjoying splashing about in Gigha's inviting waters, it was hard to imagine that we were on the same latitude as the icebound coast of Labrador in Canada. This tropical feeling was enhanced by a visit to the extraordinarily lush gardens and grounds of Achamore House, which is situated in sheltering woods towards the south of the island. Wandering through this Arcadian paradise, I was impressed by the thought that this latitude-defying display was created by a man who believed that a good night's sleep was more than just a dream.

Achamore House, along with the entire island, was bought in 1944 by the Anglo-American Sir James Horlick, who had inherited a fortune from the malted night-time drink that bore his family's name: Horlicks. One of the driving reasons behind his purchase of Gigha was the climate, which is greatly influenced by the warming effect of the Gulf Stream, creating a perfect environment for his extensive collection of exotic plants.

Horlick also used his considerable business experience to develop the island's economy and

The Carraig an Tairbeart (the 'Giant's Tooth'), Gigha's most prominent ancient landmark.

agriculture. He loved Gigha; and many visitors, including royalty, came to marvel at what he had created. The Queen Mother was a regular guest, and enjoyed the produce from the two-acre walled garden, which was famous for the quality of its fruit and vegetables.

In the years following Sir James Horlick's death in 1972, the island fell into the hands of a series of absentee landlords. They didn't have the same commitment, and Gigha went into decline. These hard times changed after a quiet revolution heralded a new era. Disillusioned with their land-lords, local people formed the Isle of Gigha Heritage Trust and bought the island for the community when it was put up for sale in 2002. Since then, the place has flourished. Perhaps more impressively, local control has reversed the age-old problem of population decline and has attracted new businesses and families to the island.

CARA

The derivation is obscure – perhaps from the Old Norse *Karis Øy* meaning 'Kari's Island'. Cara is a small uninhabited island lying about a kilometre south of Gigha. It is 1.5 kilometres long by half a kilometre wide of mostly rough ground covered with bracken and heather. It rises gently to the south to a height of 50 metres, before plunging into the sea at the Mull of Cara, which Thomas Pennant described as 'a hill formed exactly like a loaf of bread', when he sailed past in 1773. I have seen this hill from several angles, and it looks nothing like a loaf, from which I conclude that 18th-century bread must have been very different from today's loaves. Apparently, this cliff was hit by lightning during a great storm in 1756, a fact which might explain its present appearance. Part of the rock face collapsed causing a huge wave which engulfed the island, damaging several houses. Cara has been uninhabited since the 1940s but its long and fascinating history stretches back to the great days of the MacDonald Lords of the Isles and beyond. The Lords of the Isles – Righ nan Eilean in Gaelic – were the descendants of the 12th-century warrior hero Somerled. These MacDonald chiefs were once so powerful they were looked upon as kings of the Hebrides. Today, the tiny deserted island of Cara is the only territory still in the hands of the once mighty MacDonald clan.

To get to Cara, I took a boat from the old steamer pier at the south end of Gigha and sailed down the Caolas Gigalum. My skipper told me that this was where the Viking king Håkon had anchored his battle fleet of a hundred ships before his disastrous defeat by the Scottish king Alexander III at Largs in 1263. The Lord of the Isles at the time was Angus Mor MacDonald, the grandson of Somerled. He had initially fought for King Håkon, but changed sides when the Norse king was defeated.

'The MacDonalds were allowed to keep their lands – but they were never as powerful again,' explained the skipper Angus Maxwell MacDonald. It was only after chatting further that I realised that Angus was more than just my skipper. He owns Cara and is a direct descendant of the MacDonald Lord of the Isles. 'The present Lord of the Isles is Prince Charles,' Angus pointed out when I asked him what it was like to have such distinguished ancestors. 'Well, I suppose you could still call yourself "The Lord of the Isle",' I suggested as we prepared to land on the sands of Cara's Port an Stòr.

'When you step ashore, remember to raise your hat,' said Angus.

'Why's that?' I asked

'It's a tradition. It's to appease the Broonie,' he answered enigmatically.

Although the great MacDonald empire has shrunk to just one island, it is remarkable that they managed to keep any territory at all in the Hebrides. Perhaps the secret of their survival was their involvement in the lucrative but risky trade of smuggling, which in these parts was probably conducted from Cara House – the only dwelling left on the island. Built in the early 17th century, this rather bleak, slate-roofed building was once the nerve centre of an illegal trade. To give an idea of the scale of smuggling that was going on, a government revenue cutter, *The Prince of Wales*, was sent to Gigha in 1786, landing a party of men on the island. Following a tip-off, the customs officers discovered 18 barrels of brandy hidden along the shore. When questioned, the MacDonald laird apparently had no idea how the barrels had got there . . .

Cara House is also home to the legendary Cara Broonie, or Brownie, the spiritual 'familiar' of the MacDonalds. Angus MacDonald explained that, according to another legend, the Broonie is said to be the ghost of a MacDonald ancestor who was murdered centuries ago by a Campbell. Apparently he still haunts an attic room in Cara House.

In folklore, Broonies traditionally helped out with a range of chores around the home and were considered good luck – if you treated them right and left them a wee treat from time to time to keep them sweet. But if they were unrewarded or unacknowledged, you could expect their anger and revenge. This no doubt explains the tradition of politely raising one's hat when making a landfall.

The Cara Broonie seems to have been kept onside and even lent a helping hand with the MacDonald smuggling operation. Stories tell of barrels apparently being moved by unseen hands. I wondered what the Broonie's reward was back then. Being a spirit, perhaps he was paid in kind – a glass of brandy left beside the fire?

When I announced to Angus that I was going to walk to the south end of the island to visit a rock called the Broonie's Chair, he looked at me seriously. 'Do you know the rules?'

'I've been told that if you sit in the Broonie's chair, he may grant you a wish,' I said.

'Only if you don't speak while making it, and if your wish is something the Broonie will approve of.'

'How will I know that?'

'You'll know if you've got it wrong,' he said ominously. 'But whatever you do, DON'T sit in the Broonie's Chair if there's the least suspicion

On the Broonie's Chair, Cara, waiting for my wish to be granted.

that Campbell blood courses through your veins. If you do, then you will surely die.'

With this dire warning ringing in my ears, I slogged through acres of waist-high bracken to the south of Cara. There, just below the summit of the sea cliff, was the rocky ledge known as the Broonie's Chair. Hoping that I didn't have any unknown Campbell ancestors, I scrambled up and sat in the throne-like natural seat, made a secret, silent wish, and admired the views south to the Mull of Kintyre and the coast of Northern Ireland.

That was some years ago, and I'm still here, so must be Campbell free!

ISLAY

The derivation is not known. In old Irish records, the island is referred to as *Ile* and in Old Norse as *Íl*. It has also been suggested that the name comes from the Old Norse *Jle-óy*. Jle, or Yula, was a Viking princess who is said to be buried under a standing stone near Port Ellen. In Gaelic, Islay is also known as Banrìgh nan Eilean – the Queen of the Isles.

Islay is the largest of the islands that make up the Inner Hebrides and the fifth largest of all Scottish islands, lying 25 kilometres from the mainland of Kintyre. Ferries connect Islay to the mainland at the Kennacraig terminal on West Loch Tarbert. The crossing takes between two-and-a-half hours, depending whether embarkation is for Port Ellen or Port Askaig. The island has a population of around 3,500 and measures 40 kilometres from north to south, and 20 kilometres from east to west at its widest. Islay is surprisingly agricultural, especially towards the west. The eastern half is rougher and hilly. The highest point is Beinn Bheigier at 491 metres, and on a clear day gives

great views across the whole island, which was once the heart of a vast Gaelic empire with close links to Ireland and Norway.

Islay has been inhabited for thousands of years. A flint arrowhead found in the 1990s provides some of the earliest evidence of human habitation anywhere in Scotland, dating the first known people on the island to 10,800 BC, which is not long after the glaciers of the last Ice Age receded. A succession of peoples and cultures have been and gone since then. Standing stones dot the landscape, the remains of Iron Age duns sit on many of Islay's hills; Irish saints sailed across the seas in leather boats, and the Vikings came out of the north, first to conquer and then to settle. The legendary grave near Port Charlotte of Godred Crovan, founder of the mighty Crovan dynasty of the Isle of Man, who died in 1095, is witness to the centrality of Islay in the Norse–Gaelic world of the Hebrides and Irish Sea.

On a cold and decidedly wintry day in early May, I made my way south to Kildalton, where I was keen to see a famous Celtic cross, which has rightly been described as the finest of its type in Scotland. Remarkably, the cross still stands where monks of the Celtic Church erected it over 1,200 years ago. Made of intricately carved bluestone and standing at over two-and-a-half metres high, it says as much about the status and power of the culture that made it as the religion it proclaims. In the ruined chapel beside the High Cross I also saw a range of magnificent carved medieval grave slabs.

When it comes to monuments, the islanders of old had a lot to be proud of; but despite erecting impressive crosses, they still fell prey to all the afflictions of the day. Yet even then, their faith was rock solid – quite literally. When the people

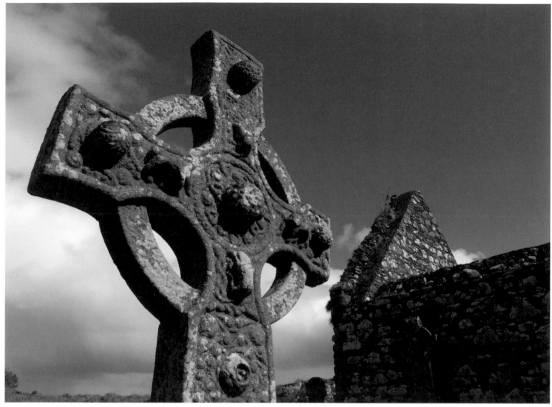

The Kildalton Cross, Islay, regarded by many as the finest Celtic cross of its kind in Scotland.

of Islay succumbed to the horrors of toothache, they sought out a tooth-shaped stone with special powers. In a field not far from the road leading out of Port Charlotte, I found the Tooth Stone. For centuries, this was where the afflicted came in fear and desperation – armed with iron nails and a hammer. The idea was to hammer a nail into the rock, working so hard that the toothache would magically disappear – as if the Tooth Stone had somehow become a proxy for the pain of the actual tooth. These were desperate measures indeed!

I left the Tooth Stone as dark clouds swept in, bringing unwelcome and unexpected snow, and made my way to one of the most intriguing and ancient locations in all the Hebrides: Finlaggan, where two small islands nestle in a diamond-shaped loch overlooked by several standing stones. This place has been a site of spiritual and cultural significance since the earliest times.

I first came to Finlaggan some years ago in the company of the archaeologist David Caldwell whose pioneering work brought attention to its enduring importance. I was immediately struck by the primeval feeling of the place and turned to ask David if there was any reason why ancient people had singled out Finlaggan as special. The Paps of Jura were our backdrop, and the loch's

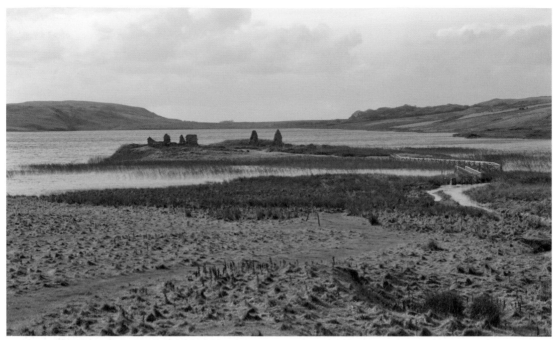

Finlaggan, Islay: the nerve centre of the Lordship of the Isles during medieval times.

dark triangle of water below us added to the illusion, which grew stronger as David spoke about the beliefs of the ancient Celtic peoples whose culture was once centred here. Among the deities they worshipped was a goddess. Then the penny dropped and the vision crystallised. The Paps behind us were the breasts of the goddess. The landscape falling away from us appeared as the belly and legs of a giant sleeping woman – the loch with its double island, the centre of her sexuality. When I articulated this idea to David, he nodded and with a half smile said, 'I know. It's always felt like that to me too. But from a historical, archaeological perspective, there's absolutely no evidence for it.'

'But as a hunch, wouldn't you agree?'

'Well, there's no denying your eyes, is there?'

David's work at Finlaggan spanned over a decade. During that time, he rediscovered its importance to the half-Norse, half-Gaelic warrior Somerled and his descendants, the MacDonald Lords of the Isles. Nearly 800 years ago, Somerled destroyed Viking control over the Hebrides and established a kingdom of his own centred on Islay. Finlaggan was the political heart of this empire – the focal point for the government and administration of the Lordship which made its own laws, fought its own wars, and on one occasion even signed a treaty with the King of England in an alliance against the King of Scots.

The whole MacDonald Finlaggan complex, which occupies the site of a much earlier Celtic monastery, was probably never permanently settled, but was used on those special occasions in the political calendar of the Lordship when the great and the good came to set up court on the

two islands in the loch. This first of these is Eilean Mor, which today is reached by a wooden walkway. The ruins here are centuries old. They include the Great Hall, the Lord's Residence, a chapel, a burial ground and up to 25 other buildings associated with the administration of the MacDonald Lordship. Here the Lord of the Isles was installed with great ceremony and feasting. It is also where the lord met with his councillors to discuss the great issues of the day and to make legal judgements to settle disputes. The small, circular, man-made island Eilean Na Comhairle, which was connected to Eilean Mor by a now-submerged causeway, is where the 14 councillors met and had their parliament in a castle that was dismantled centuries ago. Archaeologist have discovered that this castle was actually built on the foundations of an Iron Age broch. Stone Age artefacts have also been discovered, suggesting that Eilean Na Comhairle was occupied for at least 5,000 years. When I borrowed a rowing boat to reach the island, I was surprised to discover that the overgrown ruins were still occupied – not by Mac-Donalds but by a nesting duck! Startled, it shot out of the undergrowth, scared me witless and almost knocked me back into the water in fright.

I had recovered my composure by the time I reached Gruinart in the north of Islay, with its beautiful machair lands. (This type of low-lying, sandy, grassy ground near a shore is typical of the Highlands and Islands.) The weather had improved considerably too, and I was dazzled by the brilliance of the day. Outlined against the Caribbean-blue sea was the ruin of an ancient chapel, surrounded by acres of daisies blooming in the close-cropped grass. Here I met the Gaelic singer and Islay native Iseabail Mactaggart. She wanted to show me the ruins and to talk about a song which has long been part of her repertoire: 'Blàr Tràigh Ghruineart', which commemorates a terrible and bloody battle that took place in August 1598. The song is amongst the oldest of its kind to have survived into modern times, and laments the death of chief Lachlan Mor Maclean, who was killed and left behind as his clansmen rushed to escape the vengeful onslaught of the MacDonalds of Islay. Lachlan Mor was trying to secure Islay for himself and had recently arrived with a fleet of war galleys and an army of invading Macleans, who far outnumbered the defending MacDonalds. Despite their superior numbers, the Macleans were beaten. Those who couldn't make it back to their ships sought the sanctuary of the church, which the MacDonalds then surrounded and burnt to the ground, incinerating all within its walls. Listening to Iseabail's grim account, it was hard to imagine that anything so dark could ever have happened in such a beautiful place.

The ruined chapel looks out across the shallow waters of Loch Gruinart. When the tide goes out it leaves a vast expanse of exposed sand, making this an ideal place to find an expensive delicacy: the oyster. The numerous middens of oyster shells uncovered by archaeologists suggest that oysters were once a staple food for our ancient ancestors; and in the 18th century, oysters continued to be eaten by rich and poor alike. Sadly, by the 20th century, overfishing and disease saw oyster numbers dwindle. By the 1950s the native Scottish oyster was almost extinct.

Down on the shore, I met farmer and oysterman Craig Archibald who runs a family business that has brought oysters back to Loch Gruinart. He grows them in cages on the tidal sandbanks and produces both Pacific oysters and the smaller, sweeter, more delicately flavoured native oysters,

Ostrea edulis, which take at least three years before they are large enough to sell at market. Historically, oysters have probably always been a 'love 'em or hate 'em' food. In the 18th century, Jonathan Swift wrote: 'He was a bold man who first ate an oyster.' But Louis XIV loved them for breakfast, and Napoleon liked to down a dozen before going into battle. Now, I have always counted myself among the hate 'em number, but I felt it ungracious to decline Craig's offer to try one 'in their natural setting', as he put it. To help me overcome my obvious reluctance, he suggested the addition of a nip of Islay malt to wash it down. Craig opened the shell with a knife and poured the dram over the exposed and still living flesh. The dying oyster reacted to the alcohol. 'Not a bad way to go when you think about it. Stunned by Bruichladdich

eighteen-year-old!' he said. I was still apprehensive. Following Craig's instructions, I put the whole oyster in my mouth. It was too big to swallow, and I couldn't bring myself to kill it by biting into it, so I spat it out! I felt embarrassed, rude and ungrateful, so agreed to try again to enjoy the elusive delights of oysters. After some more encouragement from Craig, I managed to bite as I swallowed and downed my first oyster – along with a considerable amount of fine malt, it has to be said.

Wherever you go on Islay, it's impossible to avoid what the island is world famous for: whisky, which has been produced here from at least the time of the Celtic monks over a thousand years ago. For devotees of the spirit, Islay is whisky heaven, with distilleries in just about every village.

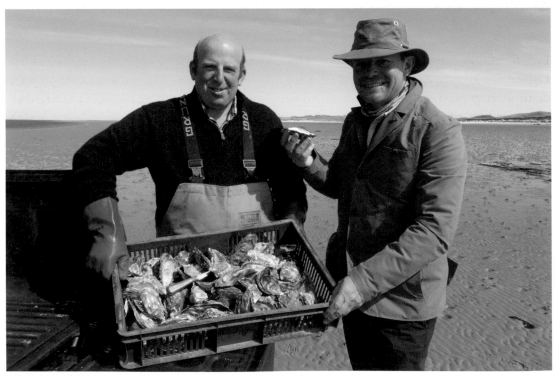

With Craig Archibald, oysterman of Loch Gruinart.

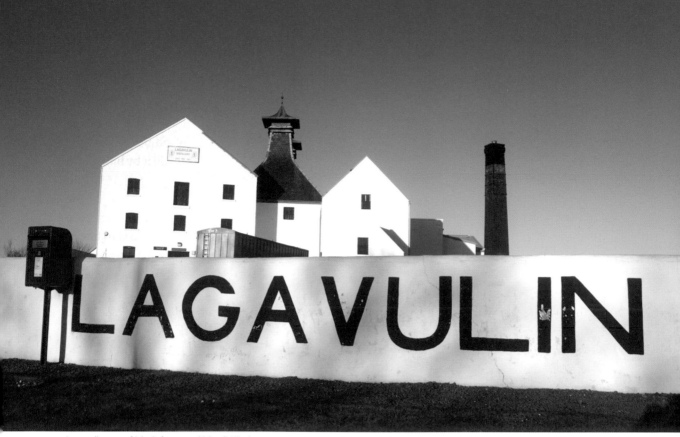

Lagavulin, one of Islay's famous whisky distilleries.

Even the signposts here point to favourite tipples: Lagavulin, Bowmore, Ardbeg, the list of imbibing destinations goes on and on. But there was a time when whisky distilling was carried out very secretively and the island's fondness for whisky attracted considerable disapproval. A Church of Scotland minister in 1794 wrote that: 'The quantity of whisky made here is very great and the evil that follows drinking to excess of this liquor is very visible in this island.'

To curb the evils of alcohol, the government attempted to control the trade. This had the inevitable effect of driving it underground. The resourceful islanders took to the hills with portable copper stills. At secret locations, usually beside a burn, they lit peat fires and began the magical process of transforming water and fermented barley into *uisge beatha* – the 'water of life' – which

was then smuggled away. But the work was sometimes dangerous – not just because the perpetrators faced arrest by government excise men. Occasionally, there were miscalculations and the science of distillation produced an unexpected explosion instead of valuable liquor. Eventually the government realised it was losing the 'war on spirits' and a new law was passed making it legal to produce whisky in return for a licence fee. After the Excise Act was passed in 1883, Islay's talent for producing *uisge beatha* was able to flourish openly, making use of the island's natural abundance of water, peat for drying and heating, and barley – the three essentials for Islay malt.

Any visitor to Islay will be struck by the architecture of the three principal villages: Port Ellen, Bowmore and Port Charlotte. With their neat whitewashed Georgian houses and street plans,

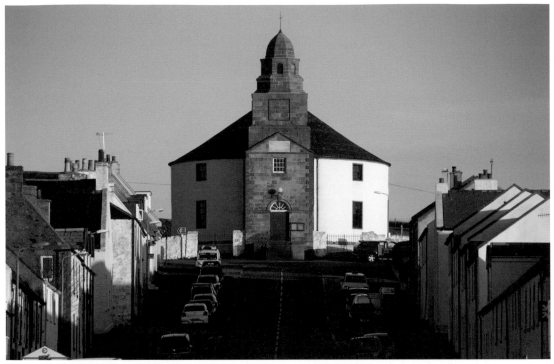

Bowmore, Islay's capital and one of three principal villages built by the Campbells of Shawfield.

they seem picture-postcard perfect – almost model villages. In fact, their history was just that, and reveals the improving hand of the island's former owners, the Shawfield Campbell family and their ambitious designs for the whole island.

The Campbells bought Islay in 1726. Unlike many other landlords who invested in sheep, the Campbells invested in people, developing linen manufacture, mining, fishing and distilling. From their dynastic home at Islay House, they also directed their resources at the island's infrastructure, building schools, roads, prisons and churches. When Daniel Campbell returned from a Grand Tour of Europe he was inspired by the geometric street layouts he'd seen in the great cities of Europe. At Bowmore, which he founded in 1767, he wanted to create a hilltop village with a church at the top,

and with streets double the normal width to allow the light to get into houses on both sides. Campbell's design was highly innovative and resulted in one of Scotland's first planned new towns. Today, Bowmore's famous round church dominates the surrounding streets. It was designed, the locals will tell you, so that the 'devil could find no corners to lurk in'.

In the early 1800s, Walter Frederick Campbell went bigger and better than his forbear by building more planned villages. Touchingly he named Port Charlotte after his mother and Port Ellen after his wife. His plans were ambitious but, tragically, he was overtaken by circumstance. The population of Islay increased dramatically. At its height there were more the 15,000 people on the island, four times more than today. Feeding so many put

strains on the whole economy, and things got worse in the aftermath of the Napoleonic Wars. Cattle and crop prices plummeted, forcing the island into debt. Walter Frederick Campbell tried to hold on to the ideal of an ordered society, but in the 1840s the potato blight in Ireland reached Islay. The consequences for the whole island were famine and misery. In 1847 Campbell went spectacularly bust to the tune of nearly £900,000, equivalent to around £750 million today. On the morning that he was sequestrated, there was a terrible thunderstorm. Local people interpreted this as the wrath of God coming down on the head of the Campbell laird, who fled with the family silver to Normandy, where he died a few years later.

For me, the most poignant memorial to the Campbell legacy can be found along the shore near Port Ellen. The square lighthouse there was built by Walter Frederick Campbell. A poem inscribed on a wall plaque gives a touching insight into the character of the island's last great improver. It's dedicated to the memory of his young wife Ellen, who died in childbirth:

Behold where shines this friendly ray and
 hail its guardian tower.
Tis but faint emblem of her light my fond
 and faithful guide.
Whose sweet example meekin bright led
 through this worlds eventful tide my
 happy course aright.
And still my guiding star she lives in realms
 of bliss above.

Just as Ellen once guided William Frederick through life, so the light named after her continues to guide ships safely into harbour.

Leaving Port Ellen, I took a boat to explore the dramatic coastline of the remote and exotically named Mull of Oa, which forms the south-western extremity of Islay. This is a place of storms and rugged cliffs and has a bleak history of shipwreck and maritime disaster. The worst of these occurred during the First World War. In 1918 the American troop ship *Tuscania*, carrying 2,000 American soldiers destined for the Western Front, was torpedoed off Islay by a German submarine. The *Tuscania* sank with the loss of 230 lives. Many bodies

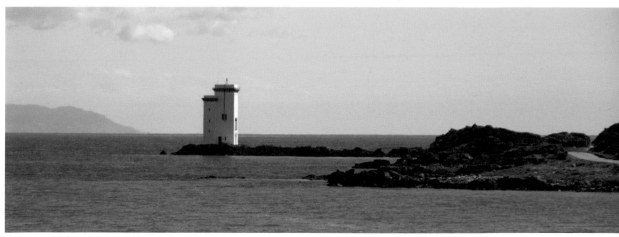

The square lighthouse at Port Ellen, Islay, named after Walter Campbell's young wife.

were washed ashore around the coast of the Mull of Oa. Eight months later, another troop ship, the *Otranto,* collided with the Royal Navy destroyer HMS *Kashmir*. Over 400 lives were lost in this disaster. To commemorate these appalling tragedies, the American Red Cross erected a monument on the Mull of Oa in 1920. It stands high on the 131-metre cliffs overlooking the unforgiving seas where so many lost their lives. But despite their grim association with catastrophe, the cliffs of the Oa peninsula have an undeniable grandeur. The Soldier's Rock is an impressive stack and stands guard near a dramatic sea cave, which has partially collapsed, forming a broad-roofed arch,

permeated with veins of glistening green copper ore. At the back of the cave, which is only accessible by boat, the roof is now open to the sky. Here I watched early swallows perform aerobatics beside two crystal-clear waterfalls, tumbling down the cave's walls and into the sea.

If the weather is clear and your legs are in reasonable fettle, I'd urge any visitor who loves a good view to scale the modest heights of Beinn Bheigier. In terms of those vital height tables, the hill isn't a Munro, a Corbett, a Graham or even a Donald. But at 491 metres, Beinn Bheigier is Islay's greatest eminence and well worth the effort of reaching the summit cairn, which takes just under

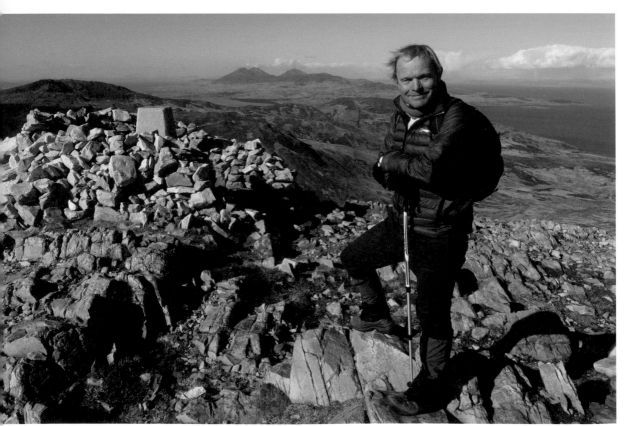

At the summit of Beinn Bheigier.

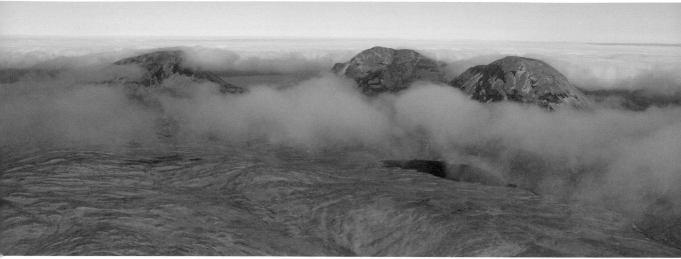

The Paps of Jura from the air.

two hours after a walk of about 4 kilometres. From the old trig point I enjoyed views of Jura and its famous Paps to the north, Kintyre and Gigha to the east and south and, on the far horizon, the coast of Ireland.

JURA

Most scholars agree that the derivation comes from Old Norse – perhaps *Dyr-óy*, or 'Deer Island' on account of the great herds of these wild creatures that inhabit the island; or again from *Jur-óy*. This translates as 'Udder Island', which makes sense if Jura's famous mountains are seen in a certain light.

Jura is one of the wildest, most rugged and least populated islands in the Inner Hebrides. It stretches 43 kilometres from the south-west to the Gulf of Corryvreckan in the north-east, and is about 11 kilometres wide. To get there, most people have to first visit Islay and then catch a small ferry from Port Askaig across the kilometre-wide Sound of Islay to Feolin. Much of the interior of Jura is trackless wilderness dominated by the three quartzite summits of the imposing Paps of Jura, which rise to over 780 metres. The village of Craighouse is the only settlement of any size, and just one solitary, winding, single-track road links the isolated communities of the east coast. Life isn't easy here, which is perhaps why the size of the population is small, hovering at around the 200 mark. As an island destination, Jura is still off the beaten track for most people. It's a demanding place where visitors have to put in more than the usual effort to appreciate its stark beauty. But the rewards are more than just compensation. For those with the right attitude and sensibility, Jura is a place that invigorates the soul. When I was a small child, the sight of the distant Paps at sunset, seen from the remote coast of Knapdale, beckoned with a magical allure. They still do.

One of the earliest travellers to visit Jura was Thomas Pennant, the Welsh-born naturalist and

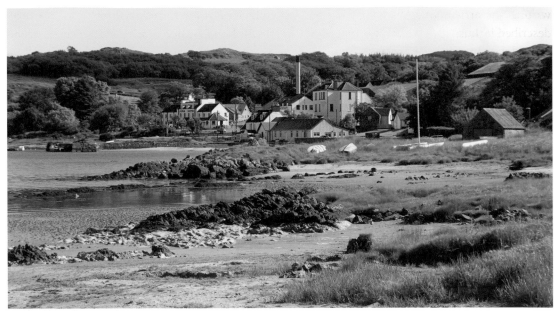

Craighouse, Jura's main township.

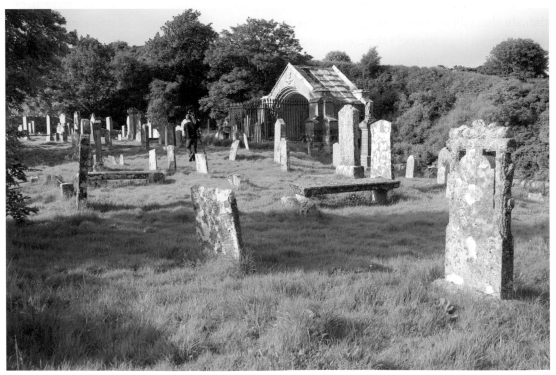

The ruined chapel of Kilearnadil, named after an uncle of St Columba.

writer, who arrived one August day in 1772 and described it thus: 'Jura is the most rugged of the Hebrides, composed chiefly of vast mountains, naked and without the possibility of cultivation. Four hills, aspire above the rest – two of them known to seamen as the Paps, useful in navigation.' Unless Jura has grown another breast since Pennant's time, his description is misleading, for there are three Paps.

Pennant made his landfall on Jura at Craighouse harbour, when the population was about 800. Although the distillery which now overshadows the village wasn't there in his day, he noted with concern that much whisky was consumed by the locals. In fact, they loved whisky so much, they risked starvation for the benefits of a dram, diverting grain for bread to make the spirit they adored. The concerned and moralising Pennant thought that whisky was a luxury the islanders could ill afford. But who could blame them seeking a little cheer from the water of life? Their lives were unimaginably hard, as Pennant himself noted. He was appalled by the poverty he encountered. On the morning of his arrival, he watched a ragged group of women and children scavenging on the shore for shellfish, where 'they collect their daily, wretched fare of limpets and periwinkles'. Despite having such an obviously poor and unappetising diet, the natives of Jura had a reputation for exceptional longevity and Pennant was impressed by their health and vigour: 'The inhabitants LIVE TO A GREAT AGE and are liable to few distempers. Men of 90 work and there is now living a woman of 80 who can run down sheep.' Maybe the whisky helped!

Just along the road from Craighouse is the ruined chapel of Kilearnadil, named after St Earnadail who was an uncle of St Columba and who is said to have preached here 1,500 years ago. In the burial ground nearby is evidence that seems to support the claims of longevity enjoyed (or perhaps endured) by the Jura folk of old. Among the memorials, I came across the fallen headstone of Gillouir MacCrain, of whom the early Hebridean traveller Martin Martin wrote in 1703: 'He lived to have kept one hundred and eighty Christmasses in his own house. He died about fifty years ago, and there are several of his acquaintances living to this day, from whom I had this account.'

It seems unlikely that anyone could have lived for so long, but back in the 17th-century it was possible to celebrate two Christmases every year – one for the old Gregorian Calendar and another for the Julian calendar. This meant that old Gillouir MacCrain was probably only 90 when he died, which is still pretty good going for someone sustained by a diet of whisky and limpets.

By far the grandest memorial to the dead at Kilearnadil is the 19th-century Campbell mausoleum. The Campbells succeeded the MacDonald Lords of the Isles as the owners of Jura, after Clan Donald sold the island to them in 1607. The early Campbell grave slabs inside the mausoleum date back to that time. In the early part of the 20th century the Campbell lairds began selling off their land, dividing it into seven sporting estates. By 1938 everything had gone and the 300-year-old Campbell connection with the island was over.

Ardlussa is the only one of the island's estates that is occupied all year round. It's about 3 kilometres north of Craighouse, and takes a good half-hour to reach by car along the painfully narrow road that skirts Jura's eastern shore. Here I met the Fletcher family and their four young daughters. Andy Fletcher, who inherited the estate, was born on the mainland and is deter-

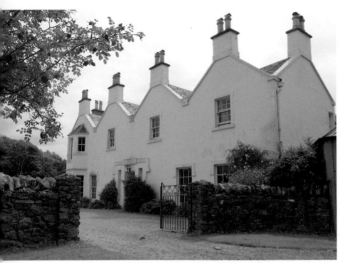

Ardlussa, centre of Jura's nascent gin industry.

mined to make a success of Ardlussa, its farm and the shooting rights that go with the land, which covers most of the northern quarter of Jura. The estate was bought by Andy's great-grandfather – a banker – as a holiday retreat in the 19th century. Sport still plays a big part in the life of Ardlussa, and Andy derives a large amount of his income from paying guests who come to fish the rivers and stalk the great herds of red deer that roam the heather-clad hills. But it's not easy to make the estate pay its way. 'To be honest, it's a black hole,' Andy told me. 'I trained as a landscape gardener. Nothing prepared me for the shock of running this place!'

He had taken me for a tour of the estate on his Argocat all-terrain vehicle, which bumped noisily across a bleak stretch of moorland where black peat oozed from the wounded ground. 'We are investing heavily in renewables. I've sunk a huge sum into a biomass project using wood from our spruce plantations,' he said as we watched a bank of low cloud roll down the mountains. 'I hope we

succeed. I'd be happy if we kept the place going for at least twenty years. At least I could say I'd given it my best shot. But my siblings hate the idea of losing Ardlussa. Granny let me off the hook, though. She told me to sell the place if it ever got too much.'

It seemed a heavy burden to carry. But perhaps the biggest threat to Andy's plans to hold onto Ardlussa might come from his own children. They were currently attending the primary school of Jura but, when they reach senior school age, they will have to travel to Islay – a daily journey of two hours each way, by car and ferry. As we bumped back down the hill towards the house, I wondered how the Fletchers would manage as a family. It didn't seem realistic for the children to spend four hours a day travelling to school in all weathers – summer and winter. More optimistically, Andy's wife Claire, a former music journalist with a sense of adventure, has teamed up with two other local women and is now producing an island gin at Ardlussa of exceptional quality. With luck it will be just the spirit to keep them all going.

Leaving Ardlussa, I walked further across the Fletchers' estate. It was hard going because the country was unbelievably rough. When Thomas Pennant came here almost 300 years ago, he was shocked at the poor living conditions of the people he met. As a good reporter, he sketched their houses and the shielings: those rough shelters on the moors, which were occupied during the summertime by women and children. They tended the cows and goats, keeping them away from growing crops nearer home and making cheese for the winter months. Pennant's description of these temporary dwellings was less than bucolic: the shielings 'formed a grotesque group ... so low that entrance is forbidden without creeping

through a little opening that has no other door than a faggot of birch branches.'

More generally, Pennant noticed that, despite the miserable housing conditions – or perhaps because of them – there was an abundance of children. He wrote that: 'The women are very prolific, and very often bear twins.' Perhaps that was the effect of the whisky again!

In the bar of the hotel in Craighouse, I met a man who was drawn to Jura because of the island's wild and untamed reputation. Neil Cameron said that the environment demands a simpler lifestyle: one which is naturally geared to living in harmony with his surroundings. To demonstrate what he meant, he took me to his croft house. Neil has lived on Jura for 16 years and tries his best to work with nature, rather than against it. As we paced his acre of lovingly cultivated land, I was impressed by the transformation he'd wrought, from barren hillside to fertile garden, orchard and wild wood plantation. Neil had dug lazy beds in the traditional way, making strips of raised earth for planting. Fertilised with seaweed and dead bracken, they supported an astonishing array of fruit and vegetables, including globe artichoke. Neil claimed to be self-sufficient in fruit and vegetables, and I quite believed him; and I wasn't surprised that he once trained as a horticulturalist.

With Neil's dog Tess running around our feet, we carried some ancient, rusty iron implements out to a nearby peat bank. Using a huge spade-like tool with a serrated edge, Neil first removed the turf to expose the dark peat beneath. For centuries this provided islanders with their only means of heating. Traditionally, it was cut during the summer months, when Jura's peat banks were worked by whole families: men digging and cutting, the women and children carrying and

The road on the east coast of Jura.

Peat cutting with Neil Cameron.

stacking it to dry in the heather. It was a huge communal effort; but today it's a fading memory. 'There are only four of us cutting peats on the whole island this year,' Neil told me.

Watching Neil at work with his *tairsgear*, the old peat-cutting tool, I was keen to have a shot myself. The peat was soft and dark, and the *tairsgear* slid smoothly, like slicing through a chocolate

brownie. It was rhythmic, almost meditative work. 'It not only soothes the soul,' said Neil. 'It's great for the bank balance. In just a week I can cut enough fuel to keep me going for the winter. And it doesn't cost me a penny. What could be more satisfying than that?'

So far, my travels had been confined to the eastern side of the island, where Jura's inhabitants live. With only 89 houses on the whole island, it appears pretty deserted, but that's really crowded compared to the western side – known locally as the 'Empty Quarter' – a truly desolate tract of uninhabited land. There are no roads through this desert of bog, heather, midges and sheep ticks. To get there, I took a fast RIB (rigid inflatable boat) around the north end of the island, passing through the Gulf of Corryvreckan, the narrow stretch of water that separates Jura from its uninhabited neighbouring isle, Scarba. The Corryvreckan is one of most notorious stretches of water in the world. I was justifiably nervous as we approached, and my skipper Nicol wasn't exactly reassuring. 'It says on the chart that this stretch of water is unnavigable,' he said. 'You get standing waves sometimes between 15 and 17 metres high, with giant whirlpools up to 50 metres across.'

'Not somewhere to fall in,' I said weakly.

'No! They put in some test dummies with monitors, a few years back, to see what would happen. The dummies went down nearly 200 metres, and popped up over 6 kilometres away.'

So why were we heading for such a lethal stretch of water? The Corryvreckan only becomes really dangerous when the tide and the weather are perfectly aligned. That's when the ebb tide rushes through the narrow channel and pushes against a westerly gale, forming a great standing wave. The huge whirlpool Nicol spoke about is created when the tidal surge hits a 300-metre submerged pinnacle, a feature that showed up clearly on the RIB's sonar screen. The danger to us today was minimal – at least as long as the RIB's engines continued to power us along. We were making our passage when the tide was slack and the weather calm. Even so, the water all around us was boiling and streaked white with angry currents, an appearance which apparently gave the Corryvreckan its name: *Bhreacain*, from the Gaelic meaning 'speckled' because of the foaming waters. Alternatively, the name might also come from the legendary Breackan, a Norwegian prince mentioned by early travel writers. The story goes that Breackan fell in love with a local princess, whose father consented to the marriage on the condition that Breackan showed his courage by anchoring in the whirlpool for three days and three nights. Breackan accepted the challenge and returned to Norway, where he had three strong ropes made: one of hemp, one of wool and one with magical powers, made of faithful virgins' hair. He returned to Jura and confidently anchored in the Corryvreckan whirlpool. On the first day the rope of hemp broke, but still the others held. On the second day the woollen rope parted, leaving just the rope of virgins' hair to keep him safe; on the third day all went well until the evening when it too broke under the strain. Tragically, Breackan was drowned in the tumultuous, swirling current because, it seems, one of the maidens had been unfaithful.

Poor Prince Breackan wasn't the only victim of the whirlpool. The novelist George Orwell, author of *Animal Farm* and *Nineteen Eighty-Four*, almost suffered a similar fate. In 1947, Orwell rented the cottage of Barnhill at the north end of

the island. He wanted peace and quiet to allow him to conjure up the nightmare dystopian world of Big Brother. Taking a break from writing, he organised a picnic boating trip to Scarba and put to sea in a small dinghy with his niece and nephew and his three-year-old son. Halfway across, the engine failed. The tide then swept the party onto a rocky skerry where the boat upturned, trapping Orwell and his son underneath. Miraculously, a wave caught them and threw the boat back onto the shore, and all were able to scramble to safety. They were eventually rescued by a passing fishing boat.

Having made it safely through the infamous Corryvreckan, Nicol and I continued down the west of Jura. It is unremittingly bleak, but awe-inspiring. Although no one lives here today, there were a few isolated communities up until the early part of the 20th century. But the history of human occupation goes back much further. The coast boasts spectacular examples of raised beaches, formed after the last Ice Age when sea levels fell. At intervals along this elevated shoreline are enormous dry caves. Eight thousand years ago they provided shelter and basic accommodation for the first human migrants to the Hebrides.

Nicol skilfully navigated into Glengarrisdale Bay, where I rowed ashore to explore an old house which a hundred years ago was the last working croft on the west coast of Jura. Despite being unoccupied, it was in remarkably good condition – and thanks to the Mountain Bothy Association, now provides shelter for walkers, stalkers, kayakers and assorted urban refugees who want to experience the delights of a more basic way of life. Inside, the furnishings were admittedly a bit spartan, but I could imagine that with a fire going and a nice mug of hot tea – or perhaps something a little

The bothy at Glengarrisdale Bay, Jura.

stronger – the bothy would be an attractive and cheery place to stay.

After signing the visitors' book, I stepped outside again and went in search of the remains of An Aros Castle, which I'd been told once stood close to the present-day bothy. But there wasn't much to see: just a few stones in the matted grass to indicate the site of a former Maclean stronghold that once bore witness to a bloody clan massacre. In 1647 a ferocious battle was fought here between the clans Maclean and Campbell. Many Macleans lost their lives. According to local legend, the skull of a Maclean warrior was kept in a nearby cave, which is still marked on the OS map as Macleans' Skull Cave. In the 1930s a photograph was taken of local worthy Angus McKechnie holding this grisly relic of clan warfare; but mysteriously, and disappointingly, the skull disappeared and hasn't been seen since 1976.

Continuing along Jura's wild and rugged west coast, I was impressed by the barren and forbidding flanks of the Paps, rising to 785 metres above the southern end of the island. In the dying light

On the Paps of Jura.

of day, I resolved to climb the highest, Beinn an Oir (Mountain of Gold). From any angle, the breast-like outline of each of the Paps makes it easy to understand why they got their name. Some scholars have speculated that these are reminders of a pre-Christian Celtic goddess, linked to fertility and the land. To reach the summit of Beinn an Oir involved a ghastly lung-busting slog over peat-bog and heather, followed by a purgatory of steep-angled scree slopes. Pennant, who made the first recorded ascent in 1773, found the going just as fatiguing: 'It was a task of much labour and difficulty, being composed of vast stones … the whole mountain forms a vast cairn.'

Of course, many people had climbed Beinn an Oir long before Pennant put pen to paper and, as I drew closer to the summit, I could see the evidence of these early mountaineers. All around were cairns, both great and small. Pennant described seeing them 250 years ago. But they are much older and may well date back to pagan times, when worshippers of the mother goddess came on a pilgrimage to the heights, each dropping a stone and uttering a prayer as they passed. Unfortunately, after two-and-a-half hours and 7 kilometres of hard slog, my efforts were not rewarded with a magnificent view. Clouds had descended, capping the summit slopes. Thinking of the ancients who came before me, I added a stone to a cairn and wished for better weather – and a view.

THE SLATE ISLANDS
AND THE OBAN ARCHIPELAGO

Lying in the Firth of Lorn, running south from the ferry town of Oban, is a chain of islands that are so near to each other that in places it's possible to throw a stone from one to the other. Known as the Slate Islands, Seil, Easdale and Belnahua were famous in centuries past for the quality roofing material that was quarried there. These waters also contain a number of other, no less fascinating, islands.

KERRERA

From the Old Norse *Kjarbar-øy*, meaning 'Kjarbar's Island' – although who this gentleman was, no one today seems to know. Kerrera lies across Oban Bay from the town of Oban. Ferries to Mull pass the northern end of the island, while those heading down to Colonsay sail the length of its eastern shore as they pass through the Sound of Kerrera and into the Firth of Lorn. The island measures 7 kilometres long by 2.5 wide and provides good grazing for the farms there. In the mid 19th century, over 180 people lived on Kerrera. Today the population is around 30. Traditionally, Kerrera is MacDougall territory. The clan came into possession of it through the 13th-century warrior chief Somerled, whose son Dougall inherited the island, along with most of Argyll and the southern Hebrides, including Mull, Coll and Tiree. The ruined Gylen Castle, built in the 16th century by the MacDougalls, was destroyed by a Covenanting army in 1647 when many MacDougall defenders were burnt alive or killed as they fled.

My trip to Kerrera began with a short, 200-metre ferry trip across the Sound from the mainland at Gallanach. The ferry runs regularly on request. To attract it, all you have to do is turn a panel on a signal board to black, and the ferryman heads over – if he's watching.

The weather was glorious. The only other passenger was a woman with long purple hair and piercings. Her name was Angel and she came from Glasgow, and had used public transport to get here. 'I'm a volunteer at the parrot sanctuary,' she said through a cloud of cigarette smoke.

We gazed for a moment across the water to the few houses we could see on the far shore. 'Kerrera is a beautiful place,' Angel said. 'It's beautiful and special. I don't know about history, but the island is full of crystal. It's a crystal island and transmits beautiful vibrations.'

I liked Angel's vision, but wasn't convinced about the vibrations, although dreams and the supernatural have played a part in Kerrera's history. Eight hundred years ago the Scottish King Alexander II sailed into Horseshoe Bay with a fleet of warships, determined to drive the Vikings from the west coast. But his hopes were dashed after he had a dream in which three saints – Olaf, Magnus and Columba – warned him that if he continued with his enterprise, something terrible would happen. Alexander ignored the warning and landed on Kerrera, just as he'd planned. But, he immediately fell ill and, within a few hours, was stone cold dead. The fate of the hapless monarch is remembered in the Gaelic name of a field above the bay, Dal Righ – the King's Field.

There was an incredibly battered 4x4 waiting at the jetty to take Angel to the parrot sanctuary. I was offered a lift and jumped in beside the driver Ian, whose wife Yvonne founded and runs the sanctuary. Once there, I met Yvonne, whose energy, dedication and fundraising skills have

Barnabuck House, Kerrera.

Having had my ear chewed off – almost literally – by one of Yvonne's noisiest and most verbally abusive parrots, I left her avian sanctuary and headed north along an unmade track that passes for a road on Kerrera. There was no traffic at all, and no signs of life either; but 200 years ago, before the mainland town of Oban became a ferry and transport hub, Kerrera was a busy place. Travellers arriving from the islands, or heading west to Mull, used the old pier at Barr-nam-boc, where ferries came and went. The large, white 18th-century Barnabuck House was once an inn and the focal point for this busy port, which boasted a brewery and whisky still amongst its shore-based activities. In addition to the human traffic, cattle from Grass Point on Mull were landed close by, and then driven through the island to swim across Oban Bay to the mainland. At the height of the droving era, thousands of beef cattle passed through Kerrera on their way to markets in the rapidly industrialising south. Droving was big business, but it was hard to imagine a scene of such activity today as I followed the old drove road north to Ardentrive, where, every autumn, great herds of cattle made their slow progress, urged onwards by the shouts of men and the barking of dogs.

helped rescue over a hundred birds, ranging from budgies to green-winged macaws. She told me that it all started a decade ago with one blue and gold macaw called Max. She looked after him for a weekend, but when the owner came back it attacked him, so Max stayed on Kerrera. From then on the sanctuary grew quickly. Most of Yvonne's parrot patients talk in some way or another. One of the Amazons only spoke Punjabi because he came over from India. Others had regional Scottish accents – one called Shuggie boasted a vocabulary of over 400 words. 'The thing is,' said Yvonne, 'he was taught by a brickie so he's a bit foul-mouthed at times.'

I didn't see any cattle on my route. But I did spot several feral goats, the descendants of the domesticated variety kept long ago by crofters for their meat and milk. The shaggy-looking animals I saw grazing on the hillside were relics of a way of life that has died out entirely in the Highlands and Islands. When the people were forced to leave, their goats went wild. Curiously, these goats with their Rasta locks played an important and surprising role in the defence of the nation during the Second World War. One moonless night the German submarine *U33* surfaced in the Firth of

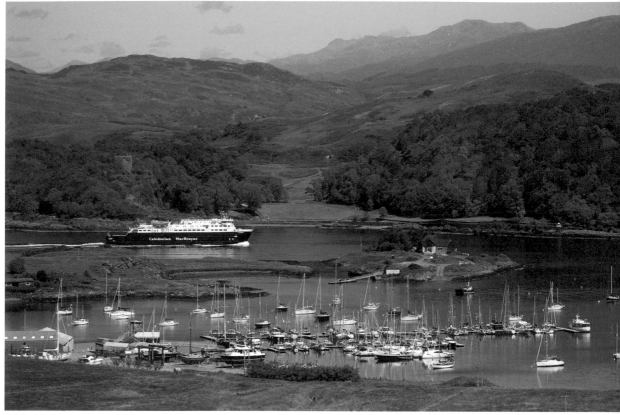

Yachts at Ardentrive Bay, Kerrera.

Lorn. A landing party came ashore on Kerrera's west coast, looking for fresh water, but they were disturbed when they heard noises. Thinking they were about to be caught by a British patrol, the Germans fled. It was only when they were clear of the island that they saw the source of the noises: feral goats. Perhaps even more surprising is the source of this story. It was told to me by my guide around Ardentrive, Neil Owen. According to Neil, he'd heard the account from none other than the German captain of *U33*, who many years later had retired to a house overlooking the Firth of Lorn.

Ardentrive, at the north end of Kerrera, looks east across Oban Bay. It's a busy place with a large yacht marina, boatyard and ancillary services occupying the site of a former RAF shore base for a squadron of huge flying boats whose role was to patrol the north Atlantic during the Second World War. Scattered here and there along the shore were a few brick huts that date from those dark days – old storerooms and workshops that are now put to more peaceful uses. Neil told me that the story of RAF Oban and the role of the flying boats aren't well understood – but the brave men who flew on dangerous sorties from Kerrera made a huge contribution to the victory in the Battle of the Atlantic. It was a plane from Kerrera's base that spotted and helped to sink the German battleship

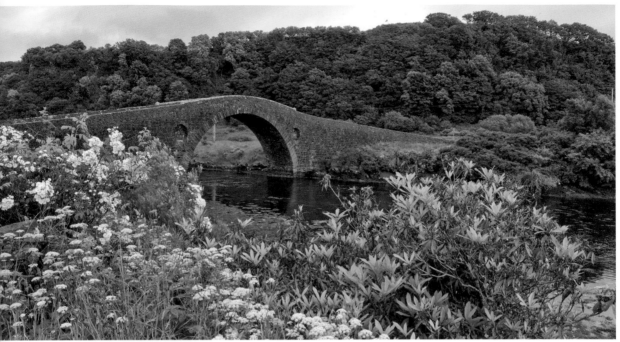

The ocean-spanning Bridge over the Atlantic, Seil.

Bismarck, which posed such a huge threat to Britain's supply convoys. Neil reminded me of the strategic importance of the North Atlantic at that time: 'As Churchill pointed out, if we had lost the Battle of the Atlantic we would have lost the war.'

SEIL

No one is really sure of the derivation of Seil, but by all accounts it is an ancient name, predating the Norse and perhaps even the Gaels, and may refer to a stream or flowing water. This would make sense, given the tidal channel called Clachan Sound, which separates Seil from the mainland.

I reached Seil Island by way of the famous and iconic Bridge over the Atlantic. Built by the engineer Thomas Telford in 1797, its elegant single arch spans an arm of the Atlantic that separates Seil from the mainland. However, this is an extremely narrow stretch of that mighty ocean; so its name is more of a joke than a reality, because at this point Seil is no more than a stone's throw from the mainland – quite literally. Although the bridge is perhaps one of the smallest 'ocean-spanning' examples in the world, it changed the lives of people living on Seil, making a vital connection that in part explains why the population of around 660 has remained pretty stable in numbers for the last century or so.

I first became acquainted with the Bridge over the Atlantic as a child, when an aunt returned from Seil with a souvenir tea towel decorated with the image of the bridge and a record called *Islands of Beauty*, which she had bought at the Highland Arts Exhibition in the island's largest village, Ellenabeich. Both the tea towel and the song were the

work of the self-taught artist and polymath C. John Taylor, who lived at Ellenabeich until his death in 1998. During his lifetime, he became an unlikely ambassador for his island home, and his depiction of the Bridge over the Atlantic was so popular that he sold nearly a million copies.

On the Seil side of the Sound of Clachan I passed the old inn called Tigh na Truish, or the House of Trousers. If you believe the story, it got its name after the failed Jacobite uprising of 1745. Travellers heading across to the mainland took a break and swapped the plaid for trews or trousers, before marching forth over the bridge and entering less traditional society where their attire might have offended or even got them arrested. Presumably they retrieved their Highland dress when they returned, though I suspect there were occasions when travellers picked up the wrong plaid – or even the wrong trousers.

Outside C. John Taylor's original gallery and studio, now the Highland Arts Exhibition, the first of the tour buses arrived. Thirty mostly elderly German tourists made their way to the entrance, leaning into the wind and the rain that was beginning to fall heavily. Looking south through the gathering gloom was evidence of Seil Island's industrial past – a flooded quarry. To find out more about the industrial heritage of these islands, I took the small foot-passenger ferry a few hundred metres across the slate-darkened waters to Easdale Island.

EASDALE

From the Gaelic *eas* for 'waterfall', and the Old Norse *dal* meaning 'valley' or 'dale'. I suspect the name refers principally to Easdale village on the opposite shore, where waterfalls are more likely than on this tiny, hollowed-out island, which is less that a kilometre square.

Arriving on Easdale.

29

Leaving the ferry, which I'd boarded at Ellena-beich on Seil, I passed a glorious collection of colourful barrows and improvised trolleys parked around the old red phone box. These are used by islanders to carry life's essentials from the ferry to their homes. Most of the properties are old, single-storey quarrymen's cottages, built in neat rows. Many of them are now holiday homes, but quite a few of their owners have long-standing connections with Easdale Island.

Island resident Iain MacDougall can trace his ancestors back 200 years on Easdale. Leaving the shelter of the house his great-grandfather once rented, we braved the rain and wandered through a surreal landscape of slate. It was everywhere: it made up the walls, it was on the roofs, on the beaches and in large piles all over the island. For over two centuries, millions of tonnes were extracted by an industry that literally dug the heart out of the place, feeding the demand for roofing material in the newly industrialised towns and cities of Britain.

Ian explained how it all began. The original slate-quarrying technique used seawater and the tides. At low tide, an oak wedge was hammered into a crack in the exposed rock. When the tide came in, the oak swelled and the crack widened, shattering the slate. As technology developed, the quarries got deeper, aided by steam pumps, explosives and a system of dams and sluices. Eventually quarrying took place at depths of 75 metres below sea level, in vast pits separated from the incoming tide by a narrow wall of rock. Then the inevitable happened. On 22 November 1881 a violent storm, accompanied by an exceptionally high tide, caused the sea to break through, flooding all Easdale's quarries.

'It was a disaster – a fatal blow for the whole community,' said Iain as we peered through the rain at two of the flooded quarries. 'Hundreds of families across the Slate Islands lost their only means of support and severe poverty ensued.'

The population of Easdale struggled to survive in the years following the catastrophic flood. By 1965 the island had only four residents, and the population showed every sign of dwindling to nothing at all. But since then numbers have steadily increased. There are now about 60 people living on this tiny rock, many with young families. And every year, the flooded quarries are put to festive use when the island holds the world's only international slate skimming competition. Frankly, I can't think of a better location for such an esoteric sport.

BELNAHUA AND EILEACH AN NAOIMH

Both names are from the Gaelic. Beul na h-Uamha means the 'Mouth of the Cave' and Eileach an Naoimh the 'Rocky Place of the Saints', or 'Holy Rocks'.

Heading south, I hitched a ride on board the *VIC 32*, one of the last seagoing steam puffers still sailing the west coast. These stumpy little cargo boats were once an integral part of the history of the islands, bringing in supplies and leaving laden with slate. Through the short stories of Neil Munro, puffers achieved an almost mythical status with the fictional *Vital Spark* and her wily skipper Para Handy.

The *VIC 32* no longer operates as a cargo boat, but as a rather exclusive yacht for hire. For the last 40 years, she's been owned by a well-spoken steam enthusiast called Nick, who runs his little ship as a holiday cruise business. Puffers were originally designed for the inland waterway of

On board the restored puffer *VIC 32*.

the Forth and Clyde Canal and were initially built far from the sea at a yard in Kirkintilloch. However, they were soon discovered to be far more versatile and seaworthy than their design suggested. Because they are flat-bottomed, they could be easily beached at low tide. This allowed them to supply remote islands that had no pier. Horses and carts would come down to the shore to offload the cargo, an occasion that sometimes involved whole communities. Our helmsman, Alan MacFadyen, told me he worked on commercial puffers in the 1980s. He had the benefit of a hydraulic crane, but, in his father's day, everything had to be shovelled by hand.

It was blissful up in the wheelhouse and surprisingly silent. The steam engine was almost noiseless, just a faint pulse like a gently beating heart. The only sounds came from the wash of the ship's bow wave and the cry of following gulls.

'This is a very leisurely pace. It's so relaxing, it's almost therapeutic,' I said.

'We don't have a lot of choice,' replied Alan. 'Maximum speed is only four knots.'

'And if we have the wind and tide against us, we sometimes go backwards,' added Nick, grinning.

On the port bow, we were passing the now uninhabited slate island of Belnahua. So much slate was extracted that the island came to look like the top of a half-submerged volcano, with the

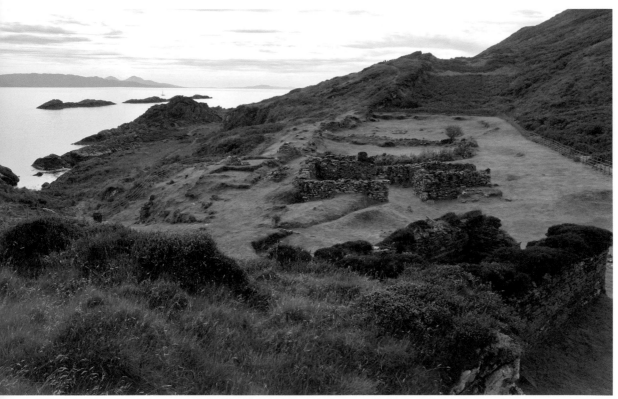

The ruins of St Brendan's monastery on Eileach an Naoimh.

hole of the quarry forming an enormous crater in the middle. Life for the 200 people who lived and worked there before it was abandoned must have been desperate. They were paid poorly and forced to rent their homes and buy all their supplies from their feudal superior, the Campbell Marquis of Breadalbane, who kept the workforce in a state of permanent debt and poverty. Effectively, the people of Belnahua were slaves. This miserable and desperate way of life came to an end with the First World War when most of the able-bodied men left to fight the Germans. The few remaining islanders were later evacuated, and Belnahua has been uninhabited ever since. The ruined slate workers' cottages, the church and rusting machin-

ery remain as a stark testament to a vanished way of life.

Eileach an Naoimh was in view now. The biggest of the small archipelago known as the Garvellachs, the uninhabited 'Isles of the Sea', Eileach an Naoimh is only 2 kilometres long and a few hundred metres wide, yet has a unique place in the history of Scottish Christianity. Nearly 1,600 years ago, the Irish missionary St Brendan the Navigator founded a monastery on this unlikely rock in the ocean, 21 years before St Columba landed on Iona. Incredibly, the ruins of his religious settlement have survived.

In the centre of this green and fertile island I came across the oldest religious building in Scot-

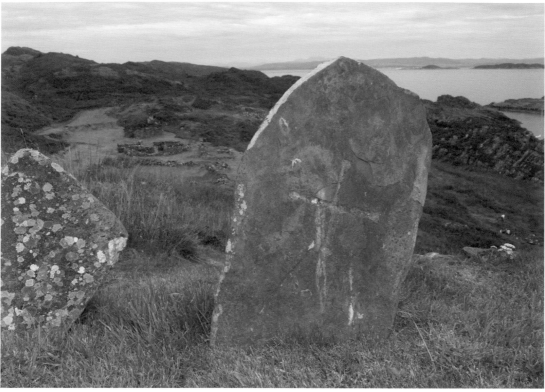

The grave of Eithne, St Columba's mother, Eileach an Naoimh.

land: a wonderfully preserved example of a type of building that's intimately associated with the Irish missionaries who brought Christianity to Scotland. Known as 'beehive cells' because they resemble old-fashioned beehives, these were the conical dwellings built by Celtic monks who sought out lonely islands like Eilcach an Naoimh, to pray and contemplate the wonders of creation. Far from the distractions of the human world, they felt close to God.

When St Brendan came here he was on a quest for the mythical 'isle of the blessed'. With seven disciples, Brendan embarked on a seven-year voyage in a boat made of leather. Sailing from Ireland, he explored the west coast of Scotland and north to the Faroes and Iceland. Walking through the ruins, I was looking for another relic from the distant past – and one that connects Eileach an Naoimh to the Slate Islands: a gravestone made of slate which reputedly marks one of the oldest Christian burials in Scotland. I found it on an elevated piece of ground overlooking the fallen stones of the monastery. A simple upright slate headstone with the sign of the cross etched into one face marked the legendary last resting place of an Irish princess. Her name was Eithne, the mother of St Columba. And what a beautiful and peaceful last resting place she had. Surrounded by the sea and within sight of the mainland, perhaps this was indeed the Isle of the Blessed.

CHAPTER TWO THE FIRTH OF LORN AND MULL

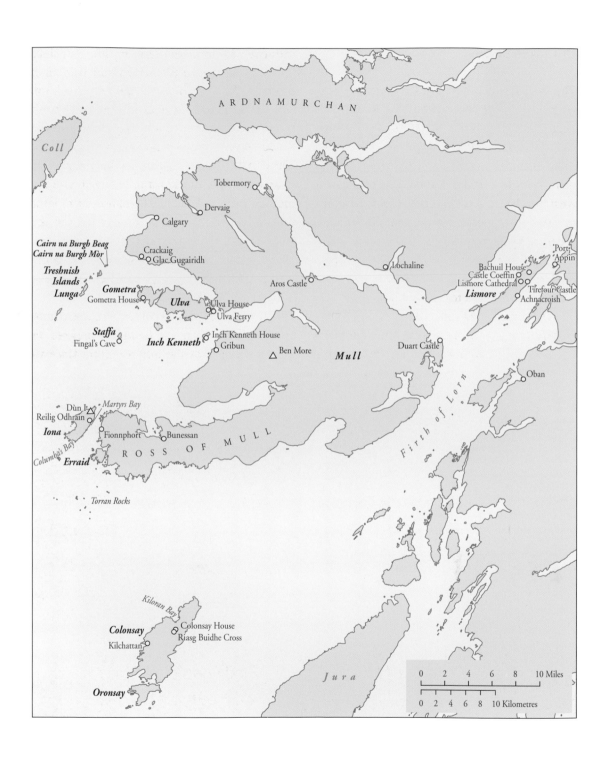

ARDNAMURCHAN

Coll

Tobermory ○

Dervaig ○

Calgary ○

Cairn na Burgh Beag
Cairn na Burgh Mòr

Treshnish
Islands
Lunga

Crackaig ○
Glac Gugairidh ○

Lochaline ○

Bachuil House ○
Castle Coeffin ○
Lismore Cathedral ○

Port
Appin ○

Tirefour Castle ○
Achnacroish ○

Lismore

Aros Castle ○

Gometra
Gometra House ○

Ulva
Ulva House ○
Ulva Ferry ○

Staffa
Fingal's Cave ○

Inch Kenneth

Inch Kenneth House ○
Gribun ○

△ Ben More

Mull

Duart Castle ○

Oban ○

Firth of Lorn

Dùn Ì △
Reilig Odhrain ○

Martyrs Bay

Fionnphort ○ Bunessan ○

Iona

Columba's Bay

Erraid

R O S S O F M U L L

Torran Rocks

Kiloran Bay

Colonsay

Colonsay House ○
Riasg Buidhe Cross ○

Kilchattan ○

Jura

Oronsay

0	2	4	6	8	10 Miles

0	2	4	6	8	10 Kilometres

THE FIRTH OF LORN AND MULL

MULL AND ERRAID

The Isle of Mull – An t-Eilean Muileach in the language of the Gaels – means 'the Island of the High Places'. The second largest island of the Inner Hebrides after Skye, it is bigger and wilder than most visitors expect. It's about 40 kilometres from north to south, and 41 kilometres from east to west but, because the interior is mostly mountainous and the 300-mile coastline deeply indented by numerous lochs and inlets, it takes a long time to get anywhere by the mostly single-track roads. Just over 2,600 people live on Mull, which is connected to the mainland by ferries from Oban and Lochaline.

Of all the islands of the west, Mull is probably the one closest to my heart. I have known it intimately for more than half my life, ever since my future mother-in-law moved from Edinburgh to Frachadil Farm near Calgary. From a knoll behind her house were magnificent views north to Ardmamurchan, Muck, Eigg, Rum and the distant Skye Cuillin. I proposed to my girlfriend Nicky on the sands of Calgary Bay and was married in an outhouse on the farm. We lived with my mother-in-law at Frachadil for almost six months while I looked for work. That was back in the recession of the 1980s, and Mull was a different place. There was no ferry on a Sunday, newspapers were always a day late and I used to hear Gaelic in the streets of Tobermory.

For many people who make the CalMac ferry crossing from Oban, the first place they see on Mull is the spectacular and romantic Maclean

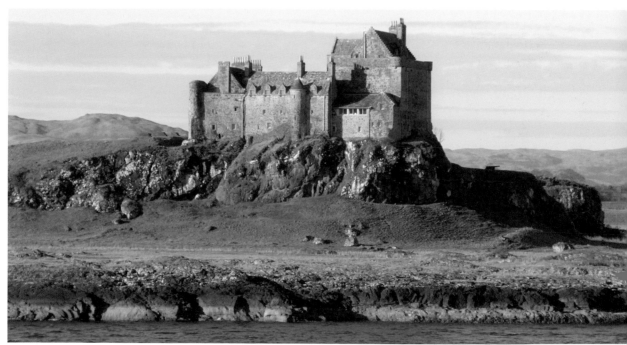

Chapter opening: Fishing boats at Salen, Mull.

Above: Duart Castle, Mull. There has been a castle on this site for almost 800 years.

stronghold of Duart Castle. It stands guard over the anciently strategic Sound of Mull, where the waters race over ridges in the seabed, creating swirling tidal overfalls. There has been a fortification here for nearly eight centuries. Although the current building looks every bit the archetypal clan chief's castle, it was actually rebuilt in the early 20th century – complete with electricity and plumbing – on the site of an earlier ruin.

When the kilted chief of Clan Maclean greeted me at the entrance to his ancestral abode, I introduced myself rather pretentiously as Paul MacGregor Murton – just to boost my Highland credentials. I don't think Sir Lachlan, who is the 28th chief, was terribly impressed. 'Ah, MacGregors! That's what my father called those squalls of wind and spindrift you see in bad weather.'

'Why MacGregors?' I asked.

'Because they come from nowhere, full of bluff and bluster, then disappear!'

Sir Lachlan took me on a tour of Duart. He seemed proud to live in the castle, though he freely admitted that its historic charms can wear a bit thin in winter, which is when he decamps to the mainland to wait for spring and better weather. The story of how Sir Lachlan's ancestors secured both the island of Mull and Duart Castle as their family seat sums up the story of the warlike clan Maclean – known throughout history for its impulsiveness. According to legend, an earlier Lachlan – the fifth clan chief – kidnapped and married the daughter of the MacDonald Lord of the Isles, the most powerful man in the Hebrides. This mighty chief was forced to acknowledge the marriage of his daughter with a dowry, which he did by giving Lachlan Maclean the island of Mull. The present Sir Lachlan pointed out the great keep, which is the oldest part of the castle, built by his

ancestor in the 14th century. 'A hundred years ago, the keep and the whole castle was a ghastly ruin, walls tumbling down, cattle coming in and out, until my grandfather Sir Fitzroy bought and restored it. The restoration was finished just before the First World War, and Duart once again became the seat of the Maclean chiefs – two centuries after they had been forced to give it up.'

Sir Lachlan showed me Sir Fitzroy's imposing portrait hanging in the Great Hall.

'None of this would have happened without Sir Fitzroy. But he was a lucky man. He was in the Crimean War, and part of the Light Brigade, which made their infamous charge: one of the six hundred who rode into the valley of death,' he said, quoting Tennyson's famous poem. 'But miraculously he survived.'

'How?' I asked.

'He actually had dysentery that day and was unfit to fight. So as a result of a *lucky* tummy bug, he missed the slaughter and lived to be a hundred and one.'

For centuries, Clan Maclean were swords for hire, mercenaries fighting other people's battles for financial reward. The warrior tradition made them a force to be reckoned with in conflicts with other clans, until they came up against the Campbells. In about 1520, another Lachlan Maclean (the 15th chief) married the sister of the Campbell Earl of Argyll. However, when Catherine Campbell failed to produce an heir, Lachlan decided to get rid of her, and left her to drown on a tidal reef, known to this day as Lady's Rock. After a night of high winds and rain, there was no sign of Catherine Campbell. Assuming that nature had done his bidding, Lachlan reported her death to her brother, the Campbell earl. The earl then invited Lachlan to a banquet at his castle at Inverary. Arriving

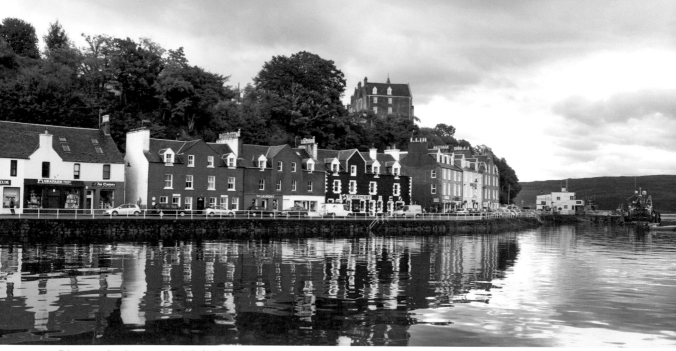

Tobermory, the picturesque capital of Mull.

there, the murderous Maclean chief was aghast to see his wife sitting beside her brother. She had been saved when a passing fishing boat had seen her clinging desperately to the wave-washed rock. Nothing was said about the incident, and Lachlan was allowed to go home. However, he was murdered a couple of years later in Edinburgh, stabbed to death by a Campbell assassin.

Campbell revenge continued down the centuries. When Maclean of Duart backed the losing Royalist side in the civil wars of the 1640s, the clan went bankrupt and were forced to sell their lands to the Campbell Earl of Argyll. But Duart Castle remained the Maclean stronghold until their support for the first failed Jacobite uprising led to their remaining lands being forfeited. It was only 200 years later when Sir Fitzroy Maclean bought it that Duart returned to Maclean hands.

Standing on the battlements, looking at the islands and mountains to the north, I asked Sir Lachlan what it was like to know that his own story was so deeply connected to this place and

to the generations of Macleans who went before him. He thought for a while and then said that it all came down to a sense of belonging. 'I always say to Macleans who come here from around the world, looking for their ancestors: you might not know exactly which part of Mull your family came from, which now lost and forgotten croft, but the mountains haven't changed for thousands of years. Your ancestors would recognise the landscape that you can see today. This was their country. This is your home too.'

Tobermory, which in Gaelic means 'Mary's Well', is the biggest settlement on Mull and has long been a favourite destination for tourists and visitors. The colourfully painted shops and houses along the waterfront have drawn comparisons in the past with more exotic locations. Some early 19th-century travellers even likened this Hebridean town to an Italian fishing village. But for me, it is always bound up with Spanish gold. In 1588, England and Spain were at war. The Spanish Armada, which was sent to attack the English, was defeated by the weather as much as the Royal

Navy. Freak storms sent its fleeing ships off course; and in a bizarre twist of fate, one of them ended up in Tobermory Bay. The *San Juan de Sicilia* was looking for somewhere to repair storm damage and to resupply with food and fresh water. On board were 300 crack troops from Spain's finest regiments. When the Maclean chief at Duart Castle heard about this, he saw an opportunity. He gave the Spanish every assistance – in return for a favour. He asked them to join him in a campaign against his old enemies, the MacDonalds. Together, Maclean clansmen and Spanish soldiers went on a bloody killing spree in the Small Isles – Muck, Eigg and Canna. When Elizabeth I realised that an enemy warship was on active service in the Hebrides, she acted swiftly, fearing that Spain might use Scotland as a base from which to attack England.

By November 1588 the *San Juan* was ready to sail again, having been repaired and restocked by the Macleans. But she would never reach Spain. One night just before she was due to leave, there was a huge explosion on board and the great Spanish ship sank instantly. The suspicion was that Elizabeth had sent a spy to blow it up. Ever since, there have been rumours of Spanish treasure lying at the bottom of Tobermory Bay. There have been countless dives to try and find the gold, but whilst some debris from the wreck has been recovered, nothing of any real value has ever been found. Most historians believe that the story of Spanish gold is a myth, but the legend still exerts a powerful hold on the imagination – so much so that Tobermory's emblem depicts the galleon on signs welcoming visitors to the town.

Another galley features in Mull's history, this time in the waters beneath Aros Castle, a few miles south of Tobermory. It was here that James VI kidnapped the Highland chiefs after a long, alcoholic feast on board the *Moon*. The end result was the Statutes of Iona of 1609, a seminal moment in the king's attempt to bring the unruly Highlanders under control.

The north-west of Mull was my old stomping ground when I lived on the island. Heading out of Tobermory, past the lochs and down to the pretty village of Dervaig with its unusual church tower, which always reminds me of a pencil without any lead, the road eventually passes Frachadil, and skirts along the machair of Calgary Bay. This part of the country seems to speak to me in a different register. The light, the views, the shape of the land and the whole atmosphere of the place strike an unfathomably deep chord every time I return. The feeling is almost euphoric. It's where I feel spiritually at home – an odd thing for an outsider to say and perhaps even perverse considering the sad history of this corner of Mull.

In the early 19th century, over 10,000 people lived on Mull. Today, the number hovers around 2,500, and a visitor doesn't have to stray far to see the telltale signs of the Clearances in which 19th-century landowners evicted the inhabitants of many parts of the Highlands in favour of the more profitable sheep. The landscape is full of ruined townships and tumbled walls where generations of *Mullachs* (the Gaelic word for people from Mull) lived and worked. The old weed-choked path from Calgary to Caliach Point winds along the cliffs and raised beaches, passing several of these old settlements and shielings. The right of way is mostly used by sheep these days, but at one time it thronged with human traffic as whole families made their way down to Calgary Bay and the large stone pier that was built there to enable the people to embark on emigrant ships for North America.

The village of Dervaig, Mull, with its unusually shaped church tower.

Few wanted to leave. Tragically, at Crackaig, a mile to the south, a man hanged himself from the ash tree that still grows beside his ruined house, rather than leave the home he loved. The twin ruined townships of Crackaig and Glac Gugairidh, with their illicit whisky cave at the bottom of the cliffs, remain one of the most poignant testaments to the Clearances on Mull.

The Canadian city of Calgary was named after the settlement on the bay from where the emigrants left – not because *Mullachs* settled there, but because a Colonel MacLeod of the Canadian Mounted Police had enjoyed a pleasant holiday staying with the laird at Calgary House. It's strange how the misery of others can be missed by those having a good time.

The single-track road that winds around the coast south of Calgary Bay has a spectacular out-look, with sweeping views towards the islands of Ulva, Gometra, Staffa and distant Iona. Passing the extraordinary and almost Mediterranean garden of Lip na Cloiche, about 3 kilometres north of Ulva

Ferry, the road crosses a bridge over a small river, which tumbles over a series of waterfalls through stunted oak trees, before plunging dramatically over a cliff, 30 metres into the sea below. This is the Eas Fors waterfall – a waterfall three times over. Its name derives from *eas*, the Gaelic for 'waterfall', and *foss*, the Old Norse for 'waterfall', a tautology that makes this spectacular feature the only water-fall, waterfall, waterfall in the country. Near here too are the tumbled ruins of Dun nan Gall, the best preserved broch on the island.

Dominating the southern half of Mull is the mighty bulk of Ben More (966 metres) and the peaks that surround it. Ben More is the eroded heart of an ancient volcano. Fifty million years ago, it rose to nearly 5,000 metres, spewing lava and ash across the landscape for hundreds of square kilometres. The characteristic stepped land-scape of much of Mull is due to the weathering of successive basalt lava flows, giving it a some-times forbidding appearance, as Dr Johnson noted when he visited Mull in 1773: 'It is natural in travers-

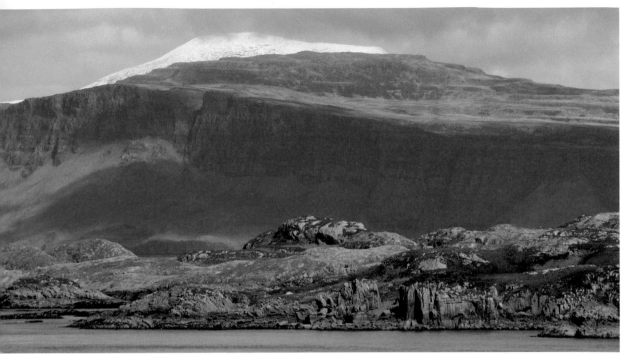

Ben More, which dominates the landscape of southern Mull. Sixty million years ago it rose to the spectacular height of 5,000 metres.

ing this gloom of desolation to enquire whether something may not be done to give nature a more cheerful face.'

Where the man of letters saw gloom, others saw sublime grandeur. Ben More has always given me a cheery face whenever I've scaled its heights. My preferred route to the top of this most southerly of Hebridean Munros includes the rocky peak of A'Chioch, which is reached before an airy scramble along a narrow connecting ridge leads to Ben More. From the wide summit, superb views take in a great sweep of islands lying far below in the Sea of the Hebrides.

But just as the beauties of nature are part of its attraction, human tragedy is woven into the landscape. Below Ben More, close to the road that winds tortuously through the great cliffs and boul-

ders at its foot, lies the tiny community of Gribun. Some 200 years ago a small house stood where a gigantic boulder now rests. According to local legend, it was a dark and stormy night when a young bride and groom left their wedding feast and retired to the cottage that had been built specially for them by their neighbours. As they began to consummate their marriage, a massive rock weighing at least a hundred tons was dislodged by torrential rain that had been falling all day. It careered down the mountainside with a furious roar, smashing into the cottage and killing the couple where they lay in each other's arms. To this day, their mortal remains lie beneath the great boulder that crushed their home, their hopes and their lives.

The southern peninsula of Mull is known as

the Ross. It thrusts west into the turbulent waters of the Atlantic and is very different from the rest of the island. With big skies, the Ross is no longer dominated by the old volcanoes of Ben More. Instead of basalt, the rock is mostly granite, which glows pink against the sand in sheltered coves and bays along the coast. Some of this beautiful stone was quarried in the 19th century for landmark structures in London, including the Albert Memorial, Blackfriars Bridge and the Holborn Viaduct.

On my way to the road end at Fionnphort, I came across a memorial at a crossroads outside the village of Bunessan. It's dedicated to the memory of the Gaelic poet Mary MacDonald, who was born there in 1789. Mary spent her life on Mull, but her words and legacy have travelled the world. Mary wrote the original Gaelic hymn which in the 20th century became 'Morning Has Broken', made famous by a galaxy of international stars including Cat Stevens, Demis Roussos and even Roger Whittaker.

At the village of Fionnphort, which is also the location for the Iona ferry terminal, I climbed aboard an old Danish sailing boat. The *Birthe Marie* was once a fishing boat, until she was converted to carry passengers on day trips to the islands. Mark Jardine, the skipper, explained that where the cabins are now was once the fish hold, which was designed to be flooded to keep the catch fresh for market. Mark has lived locally for over 30 years. Like many islanders today, he isn't a native. Originally from Glasgow, he studied at Glasgow School of Art before his love of the sea and for the island of Iona, where he'd spent family holidays as a boy, brought him west. Today, he was taking me to the beautiful and inspirational island of Erraid, following a course through a cluster of dangerous reefs and skerries known collectively as the Torran

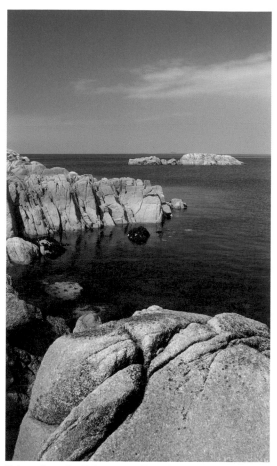

Pink granite on the Mull coast near Fionnphort.

Skipper Mark Jardine of the *Birthe Marie*, on the trip to Erraid.

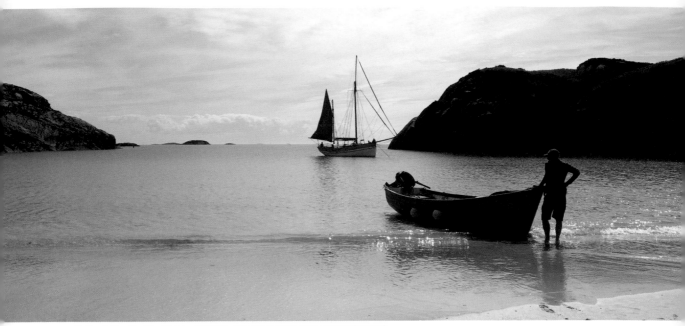

Balfour's Bay, Erraid, which inspired Robert Louis Stevenson to write *Kidnapped*.

Rocks. Many lie just beneath the surface, and only betray their malign presence with a sudden burst of spray as an Atlantic roller breaks over them.

The Torran Rocks took such a toll on shipping that a lighthouse was built on one of them – Dubh Artach, or the Black Rock, which lies 24 miles southwest of the Ross of Mull. It took over five years to build and was designed by Thomas Stevenson, the father of the novelist Robert Louis Stevenson, who came to know this part of the west coast well. Keeping the distant sentinel of Dubh Artach to our starboard, Mark anchored in Balfour's Bay on Erraid, a tidal island of less than 200 hectares that lies off the south coast of the Ross of Mull. The very name Balfour's Bay gives a clue to this little island's literary importance, for it was on Erraid's tropical-looking white shell sands that Robert Louis Stevenson found inspiration for his novel *Kidnapped,* imagining the book's hero David

Balfour, struggling ashore after being shipwrecked on the Torran Rocks.

In the 1860s Erraid was developed as a base for the construction of the Dubh Artach lighthouse, and later as onshore living accommodation for the families of the lighthouse keepers. Today the old buildings are home to members of the Findhorn Foundation, who offer a diet of organic food and meditation to those in need of peace and spiritual restoration.

INCH KENNETH

From the Gaelic meaning 'Kenneth's Island' this small island was named after a follower of St Columba from Iona. There is no public ferry service to the privately owned Inch Kenneth, which hugs the west coast of Mull, covering an

Inch Kenneth House, home of Hitler's 'English rose', Unity Mitford.

area of just of 55 hectares. To get there I hired a boat from nearby Ulva Ferry and was dropped by dinghy on the seaweed-strewn sands of this green island, which is one of the most ancient and mysterious that I've ever visited: a tiny sheltered crescent of fertile land nestling beneath the stark and forbidding cliffs of Ben More. Inch Kenneth is one of the most historically important islands in Scotland. Along with Iona, it has a significant number of important burials in the graveyard of the ancient ruined chapel. As well as high-ranking members of Clan Maclean, kings of Scotland and Norway are interred here.

Facing east and clearly visible from Mull is the only residence on the island: Inch Kenneth House, a gaunt white-painted, four-storey building which is much altered since the literary tourists Johnson and Boswell were guests of Sir Allan Maclean back in 1773. Even then, Inch Kenneth was remote and

lonely. As Dr Johnson noted, 'Its only inhabitants were Sir Allan Maclean and two young ladies, his daughters, with their servants.'

In recent times, the island's most famous owners were the Mitfords, who bought the island in the politically turbulent 1930s. Famously, the Mitford children were ideologically divided between communism on one side and fascism on the other. During the war, Inch Kenneth became a refuge for the most notorious member of the family, the hapless Unity Valkyrie Mitford, who took her love of fascism and Adolf Hitler to extremes. I was lucky enough to be given a tour of Inch Kenneth House in the company of its caretaker, the Argyllshire-born writer Lorn Macintyre. I was surprised at first to see the place in such a poor condition. It was a mass of ongoing repairs to rectify years of damage caused by a leaking roof. Plaster had been stripped from the walls to

reveal red brickwork beneath; there were holes in the floors and ceilings, and there was a damp, bone-numbing chill in the air as we settled in a large room filled with period furniture, overlooking the cliffs of Gribun. 'Unity Mitford would have recognised the wallpaper and the curtains. They've not been changed,' said the caretaker. I shuddered involuntarily. It was cold for the time of year.

Lorn spoke about Unity Mitford, describing her as a stalker who had succeeded in getting close to Hitler. She knew that the Führer had a favourite cafe in Munich, so she staked it out, day after day, until she was noticed and invited to join Hitler's table. Hitler soon fell under her spell because she was young, beautiful and aristocratic. He thought of her as his 'English rose' – a perfect specimen of English womanhood. She became a member of his entourage and was invited to party rallies, becoming the English voice of the Nazi Party. At the Hesselberg midsummer meeting in June 1935 she addressed the assembled Nazis. Backed by swastika banners she gave a virulently anti-Semitic speech. 'She would do anything for her beloved Führer. He could do no wrong,' said Lorn. 'She loved being at his side but, when Britain declared war on Germany in 1939, her world fell apart. In despair, she put a pistol to her head and shot herself. Why? Because she couldn't bear the thought of her two favourite countries being at war.'

Miraculously, Unity survived her suicide attempt. Hitler sent her home to Britain, where she arrived a broken woman. She spent her last years on Inch Kenneth, where her condition and the remoteness of the island made her an exile from the world. Isolated and alone, she lived in a fantasy world, conducting imaginary services in the ruined chapel, and staring out to sea, perhaps

in the hope of attracting the attention of a passing U-boat. The end came in 1948. She contracted meningitis and was taken to hospital on the mainland, where she died with the bullet still in her brain. She was just 33.

ULVA AND GOMETRA

The name Ulva is of Norse origin and means 'Wolf Island'. The derivation of Gometra is obscure. Some believe it comes from the Norse *Goðr Maðr Ey*, which means 'Good Man's Isle'. The twin islands of Ulva and Gometra are joined by a causeway, which carries the inter-island Land Rover track. Together they are separated from the west coast of Mull by a narrow channel of the sea known locally as the Brew (from the Gaelic Am Brù).

ULVA

Ulva is the bigger of the twins (with Gometra being about a quarter of its size) and is about 7 kilometres from east to west, by 3.5 kilometres north to south. To get to the island from Mull involves a short ferry ride in an open boat from Ulva Ferry. The service is run on a 'when required' basis. To call the ferry, passengers simply lift a wooden flap to reveal a red painted board which summons the ferryman from the opposite shore.

When I lived on Mull, I took this ferry several times to explore Ulva, which is both strikingly beautiful and full of melancholy. On my first trip, I walked through the wooded grounds and policies of Ulva House and took a rough track around the south coast. Lying just offshore were dozens of rocks and skerries, scattered across the sparkling sea. Beyond them, Colonsay and Staffa basked in

The ferry landing-stage at Ulva.

Ulva had a population of almost 700 before the Clearances. This abandoned house has since been restored.

the spring sunshine. But there was no one else on the whole coast to appreciate the glorious view. The road I was travelling on was quite empty, like much of the rest of the island: an emptiness made more acute by the ruins I was walking past. These were not just the usual sad huddle of stones, but included some quite substantial buildings. There was an old mill and a two-storey house, I remember, both roofless and choked with brambles. Perhaps it was the solitude of this remote coast that caused me to imagine that I was walking down a road of ghosts – or the road as it might have been a hundred and fifty years ago. Dogs barked, children played and women sang, while men looked up from their work to greet the passing stranger. A fantasy, yes; but Ulva was once a populous and prosperous island. Nearly 700 people once lived here, on what was then the homeland of the ancient and distinguished Clan MacQuarrie. Their boats harvested the rocky coast for fish, and their labour produced enough crops for export. There was even a school of bagpiping on Ulva. However, by the time Dr Johnson and

his companion James Boswell came to visit the clan chief in 1773, the fortunes of the MacQuarries were in decline. Johnson wrote: 'M'Quarrie's house was mean; but we were agreeably surprised with the appearance of the master whom we found to be intelligent, polite and much a man of the world. He told us that his family had possessed Ulva for nine hundred years; but I was distressed to hear that it would soon be sold for the payment of his debts.'

Sometime after Johnson's visit, the old clan chief was indeed forced to sell Ulva. Most of the ancient race of MacQuarries were ruthlessly cleared from their homes by subsequent owners. Today there are just seven full-time residents on the entire island – none of them MacQuarries. Despite the loss their ancestral lands, the MacQuarries' influence on world affairs has been enormous. Historically, the most significant was undoubtedly Lachlan Macquarie. He was born on Ulva in 1761 – a poor relative of the last MacQuarrie chief. Like many impoverished Gaels, Lachlan found an opportunity for advancement in the British army.

Rising quickly through the ranks, he was appointed governor of New South Wales and the notorious prison colony there. His enlightened and progressive approach to governorship helped Australia become established as a country – and not just a dumping ground for convicts.

Macquarie's success earned him the fortune he once desired as a young man. By the age of 45, he was able to retire and buy his uncle's estate on Mull. But Lachlan's homecoming wasn't easy. The government he'd served all his life refused to award him the pension he thought he was entitled to. On a trip to London to plead his case, he fell ill and died. According to his wishes, Lachlan Macquarie was buried on Mull, close to the island of his birth. His mausoleum lies within sight of Ulva. Mounted on an exterior wall, an inscription proclaims him as 'The father of Australia', and with so many places in Australia – from Macquarie Street in Sydney to the Macquarie River – named after him, perhaps that's no exaggeration.

GOMETRA

My first experience of Gometra was back in the 1980s when I spent a night of high anxiety in a yacht anchored in the waters of Gometra harbour. At least, that is what is said on the sea chart; but the harbour was in fact no more than a shallow inlet on a wild and uninhabited coast. It was also very exposed to the gale-force wind that was blowing from the south and screaming through the rigging. Everyone on board was anxious. Our anchor was dragging and we feared that we might be blown ashore. For greater security we dropped a second anchor, and nervously watched the shoreline for any sign that we might still be drifting. To make extra sure, we kept the motor running

all night and set watches on deck through the wee small hours, fearful that we might be driven onto the rocks while we slept – not that any of us did, with the noise of the engine and the wind competing to keep us awake.

The history of human settlement on Gometra goes back thousands of years, and there is evidence of at least three duns or Iron Age forts, and an ancient burial ground near the old centre of population at the south of the island. This is where Gometra House still stands, once the centre of the community. As late as the 1930s, nearly 40 souls lived in the neighbouring cottages, sending their children to the old schoolhouse down by the shore. By the 1980s the population had dwindled to just a single household and then the island became uninhabited; but a new owner has since restored Gometra House and its neighbouring cottages, which are home to at least two further families and their children. The permanent residents are involved in farming, breeding blackface sheep. Other members of this new community live on the island part-time.

STAFFA

Staffa is another Hebridean island with a Norse name, which comes from *Staffi-øy* meaning 'Stave Island' on account of the stave-like basalt pillars that are its predominant feature. Uninhabited, it measures about a kilometre north to south by half a kilometre east to west.

Lying eight miles off the west coast of Mull, Staffa is a contender for being the most famous Scottish island, on account of its remarkable and spectacular cave, known the world over as Fingal's Cave. It is usually reached by boat from Ulva Ferry

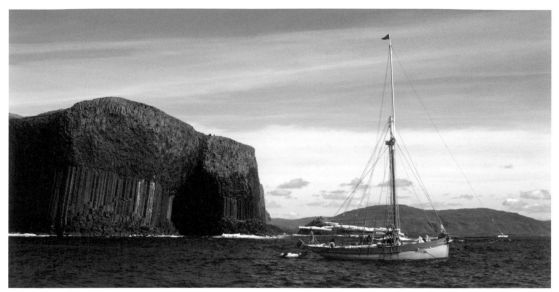

The isle of Staffa, with its extraordinary basalt pillars.

or Fionnphort, but going ashore is only possible when the sea is relatively calm. The first time I visited Staffa, I was making a documentary film with a student friend of mine. We were aboard an old sailing boat, which had been hired by a group of folk musicians to reach the less accessible venues on their island tour. When we got close to Staffa, the piper Duncan MacGillivray invited me to take a small boat inside the mighty Fingal's Cave so that he could play the pipes. He said he thought that the acoustics would be 'a thing of wonder' – as indeed they were. I remember the sound of the swell as it surged and sucked around our dinghy, forcing us along the sea channel that forms the watery floor of the cave; the cry of startled gulls; and the disorientating, droning echo of the pipes – each note reverberating with an impossible sustain until it was absorbed by the next.

Any trip to Fingal's Cave is bound to be exciting. Even on a calm day, the swell and the tides make for a bumpy crossing. But why has this small,

uninhabited lump of rock become such a must-see attraction? The answer takes us back to the 18th century and the rise of the artistic movement known as Romanticism.

In 1762, James Macpherson published what he claimed were fragments of ancient Gaelic poetry. He maintained that they had been composed centuries earlier by the blind bard Ossian, who celebrated the deeds of Fingal: a bold hero who lived in the Celtic twilight of a pre-Christian world. The publication of this northern epic created huge excitement across Europe. The deeds of Fingal and his band of warriors, full of chivalry and primitive nobility, struck a chord. Here were authentic heroes who acted from impulse and raw emotion. The deeds of Fingal were enough to impress even Napoleon Bonaparte, who is said to have carried a copy of the poem with him into battle.

In 1772 the explorer James Banks of the Royal Society was forced to shelter from a storm off the west coast of Mull and 'discovered' the island of

Staffa and its unique and marvellous cave. Despite being a scientist, Banks was influenced by the romantic cult that had grown up around Ossian's poems and named the great cave Fingal's Cave, no doubt because of its truly heroic proportions. It measures 75 metres long. The roof rises 20 metres above the sea and is supported by hundreds of angular basalt columns. It's like being inside the nave of a surreal Gothic cathedral.

For some early visitors, Staffa expressed the essence of Romanticism: wild, remote, spectacular and full of heroic associations. When an early lady tourist, Sarah Murray, saw Fingal's Cave in 1796, she could hardly contain herself: 'The atmosphere of the Deity filled my soul. I was lost in wonder, gratitude and praise. Never shall I forget the sublime, heaven-like sensations with which Fingal's Cave inspired me. I was in Ecstasy!'

Just about everyone who considered themselves to be someone made the difficult journey to this improbable rock in the Atlantic. Wordsworth and Keats came, as did Sir Walter Scott and the French fantasy writer Jules Verne. The artist William Turner captured the romantic essence of Staffa in oil paint and Robert Louis Stevenson made the journey; the young Queen Victoria thrilled at the sound of the national anthem played in Fingal's Cave. But perhaps most famously, the 20-year-old composer Felix Mendelssohn wrote his celebrated *Hebrides Overture* after a stormy visit in 1829. Despite suffering seasickness, he was so inspired by his elemental encounter that the opening notes formed spontaneously in his imagination as he gazed upon the spectacle that is Fingal's Cave.

The interior of Fingal's Cave, Staffa. Famous visitors have included William Wordsworth, Sir Walter Scott, Queen Victoria and Jules Verne.

THE TRESHNISH ISLANDS

This group is named collectively after the area of Mull which lies opposite them: Treshnish. The main island is called Lunga, a name which comes from the Gaelic *long,* meaning 'ship', and the Norse *øy* for 'island'. The other large island, commonly called the Dutchman's Cap, has to me always resembled a gigantic submarine. Its Gaelic name Bac Mór means the 'Big Bank'.

Uninhabited, the Treshnish Islands lie 3 kilometres south-east of Treshnish Point on Mull and continue in a chain in the same direction for about 8 kilometres. The largest of the islands, Lunga, is 2.5 kilometres long and only a few hundred metres wide, yet despite its remoteness and diminutive size people lived on it for generations until the island was abandoned in 1857. To get there, I joined skipper Iain Morrison, who regularly takes tourists out on his boat from Ulva Ferry. Iain is Mull born and bred, and is one of the few people who still speaks Mull Gaelic. 'Are there enough folk left speaking the language on the island to have a conversation?' I asked.

'There's not much chat, right enough. We're down to a handful these days, and to be honest I rarely use it at all, except maybe to speak to my son on the VHF radio. It's an excellent way to have a private conversation on a busy boat!'

As we drew closer to Lunga, Iain told me that the people who once lived there combined fishing with crofting. But he said that there was no peat on the island. This meant that the islanders had to import their fuel from Tiree or the Ross of Mull, 17 kilometres away. It would have required a huge effort to row a year's supply of peat across such a stretch of water, to bring it ashore, and then carry it up to the village.

On Lunga.

There has never been a jetty on Lunga. Today, tourists are landed by means of an ingenious mobile floating jetty, which Iain keeps moored offshore and then tows into position when needed. It was quite a struggle for some of the more elderly visitors. Once they'd landed they had to negotiate a boulder field of a beach before they could regain their balance on more stable ground. Most of the passengers had come to see, and to photograph, the puffins which nest in great numbers along the grassy clifftops. The birds seemed quite unperturbed by the human invasion, allowing the visitors to get within inches of them. 'People are good for puffins,' explained Iain. 'We keep the predators – the Bonxies [Great Skuas] and the like – at bay. And of course, the puffins are good for us. Getting close to these comical birds is a great way to de-stress. It's what I call puffin therapy.'

North of Lunga, the twin islands of Cairn na Burgh Mòr and Cairn na Burgh Beag, with their ruined fortifications, bear the dubious distinction of reputedly being the last place in Britain to hold out for James VII and II, forced to abdicate after the Glorious Revolution of 1688. Even more spurious is the claim that the great library of Iona – one of the greatest libraries in Europe – was moved there in order to preserve it from Viking raiders.

IONA

Known for centuries as I Chaluim Chille, which in Gaelic means the 'Island of Colm's Monastery', Iona is traditionally considered to be the cradle of Scottish Christianity. The derivation of Iona is from the much more ancient name *Ioua*, which may mean 'Place of the Yew' in old Gaelic. The island has a population of less than 200, and they and the many visitors are served by regular ferries from Fionnphort on Mull.

For me, Iona is a priceless jewel. There is nowhere else like it in the Hebrides and, despite the thousands who make the short crossing from Fionnphort, the island is bathed in a unique and peaceful atmosphere. The late Lord MacLeod, the founder of the Iona Community and the man credited with restoring and rebuilding Iona's ancient Abbey, once described Iona to me as a place 'where the veil is thin'. Although I am a spiritual sceptic and avowed agnostic, I intuitively understood what the venerable clergyman meant. There is something about the quality of light and the feeling of tranquillity that seduces the senses into believing that there may indeed be another reality 'behind the veil' of what can be immediately perceived.

I have been to Iona dozens of times, and I'm always surprised by how easy and quickly it is to find the space to be alone to enjoy the beautiful beaches, amazing variety of landscape and spectacular views. My own family connections go back several generations, ever since my children's great-grandmother decamped from Edinburgh every summer with her children. It was a complicated operation. Everything that was required for a long holiday was packed in cases and sent ahead.

Although getting to Iona is much easier than it was in the past, most modern visitors still follow in the footsteps of early pilgrims. For nearly a thousand years – until the Protestant Reformation of the 16th century – people came to pray at this Christian place of worship, which was founded by St Columba in 563. Born a prince, he devoted himself to God and set out from Ireland in a leather-covered boat, or *churaich*, with 12 followers,

landing on the stony beach known as Columba's Bay. Out of sight of his native Ireland, he established a monastery where the abbey now stands, and launched missions to convert the heathen Picts to Christianity. The religious community flourished until a murderous raid by Vikings marked the beginning of a succession of attacks that eventually forced the monks to flee to the safety of Dunkeld on the mainland. The beach at Martyrs' Bay, just a couple of hundred metres south of the ferry slipway, is so named because in 806 the Vikings returned, destroyed the monastery, and butchered 68 monks on the sand. However, the surviving monks managed to save their most precious possession, an exquisitely illuminated Bible containing four gospels, which they had lovingly created in the scriptorium of Iona. When the monks fled, they took their holy book with them to the monestary at Kells in Ireland. The Book of Kells, as it has come to be known, is perhaps Iona's greatest gift to the world.

When today's visitors arrive on Iona, they invariable follow a route to the Abbey which in

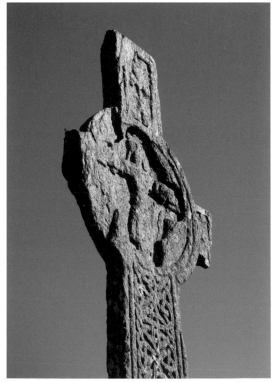

Top: One of Iona's magnificent beaches.

Above: Maclean's Cross, which marks the way to the Abbey burial ground, Reilig Odhrain.

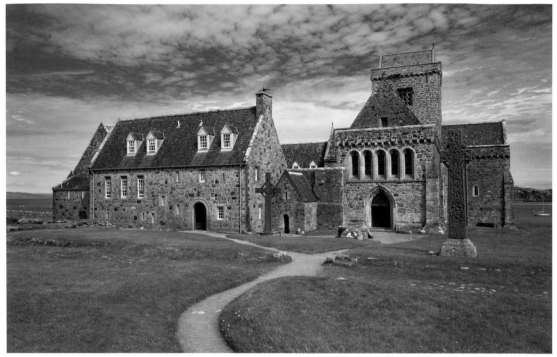

Iona Abbey, founded by St Columba almost 1,500 years ago.

ancient times was known as the Way of the Dead, because it also led to the burial ground, Reilig Odhrain, where the mortal remains of royalty from Scotland and Scandinavia still lie with the bones of the Lords of the Isles, Highland chiefs and ordinary islanders. The 6th-century St Oran was perhaps the first man to be buried in the graveyard that takes his name. According to one legend, St Columba was keen to know more about the afterlife and asked for volunteers to take part in a dangerous experiment. None were forthcoming, so Columba chose Oran, who was then buried alive. Some days later, Columba ordered the monks to dig him up again. Miraculously Oran was still alive. 'Tell me,' commanded Columba, 'what is the afterlife like? Did you meet God and His angels?' Oran apparently couldn't or wouldn't answer his spiritual superior. In a fit of rage, Columba felled him with a spade and had Oran reburied. Hardly a Christian act, but then things were a bit different back then. Whatever the truth of this story, the graveyard became the burial place of the Kings of Scots until Macbeth.

The beautiful and elegant 15th-century Maclean's Cross is the first landmark on the way to Reilig Odhrain. It stands beside a bend in the road, not far from the substantial ruins of the nunnery. This was built by order of the Lord of the Isles in the early 13th century, at around the time that the abbey was rebuilt as a Benedictine monastery; but after the Reformation, both fell into ruin. If anything this made Iona more attractive to early tourists and visitors. Dr Johnson was among the first to make this point: 'That man is little to be

envied whose piety would not grow warmer among the ruins of Iona.'

In the 1920s and '30s the Reverend George MacLeod was inspired to rebuild the abbey and to revive Iona's reputation as a world spiritual centre. Having survived the horrors of the First World War and experienced the poverty and social injustice of the Great Depression, George MacLeod mobilised students, ministers and unemployed workers to restore the ruins to their former ecclesiastical glory.

The restoration work took decades to complete. The abbey and its great stone crosses now attract thousands of visitors every year. Personally, I am drawn less to old churches and ruins than to landscape. Whenever I visit Iona, I make a pilgrimage of my own to the summit of Dùn I, which is the highest point on the island at 101 metres. It is an easy walk of about 15 minutes. Close to the summit is the Well of Eternal Youth, a rock pool whose waters are said to have the power to keep bathers young and beautiful. Sadly, in my case it doesn't seem to have had the desired effect; but any disappointment is more than compensated for by the views, which are to die for when it's clear: the Paps of Jura to the south, Tiree to the west, Skye and Rum to the north, and the wild and spectacular cliffs of Ben More on Mull to the east. In all, this is the best reward for the least effort of any hill I know in Scotland.

LISMORE

The name comes from the Gaelic Lios Mòr, meaning literally 'the Great Garden'. Despite that name, the island is relatively small, being roughly 15 kilometres long by 2 kilometres wide, with a population of around 190. Two ferries connect it to the mainland: a vehicular ferry from Oban and a foot-passenger service from Port Appin.

For centuries, some islands have been consid-

Lismore, 'the Great Garden'.

ered as sacred: places where mystics and holy men have sought refuge to live a contemplative life. In Scotland, we have more than our fair share of them and can boast more 'holy isles' than any other European country. I took the ferry to Lismore from Oban with my bicycle, following a route once taken by the dead. It's said that in pre-Christian times, when a king died his body was rowed over to Lismore, where his remains were buried in sacred ground. These were kings of the western Picts, the ancient people of the Highlands who flourished during the Dark Ages before the arrival of the saints. Cycling from the ferry slipway at Achnacroish, I was relieved to discover that Lismore is not a hilly island. With quiet single-track roads, I thought it would be ideal to explore by bike.

'The great garden' – or more correctly, 'the big enclosure' – which gave Lismore its name may refer to either a long-lost walled garden or, more likely, the sort of enclosure associated with an early monastery. In fact, a monastery was founded on the island by the 6th-century St Moluag, a contemporary of St Columba and one of the missionary heroes of the Celtic Church. He made Lismore a significant Christian centre in what was then the kingdom of Dál Riata. There is nothing left of the monastery today, but the little 18th-century church with the grand name of Lismore Cathedral consists of the remains of a 13th-century cathedral dedicated to St Moluag. Inside the current building I came across a stained-glass window depicting St Moluag and St Columba. To me, both men looked very pious – almost meek and mild. But the legends about them tell a different story. The Celtic saints were a tough, almost warlike bunch.

St Columba and St Moluag apparently were rivals to found the monastery on Lismore and decided to settle their differences with a boat race to the island. When they set off, St Columba – a man of legendary feats – was soon in the lead. But Moluag was not to be beaten. Just before Columba crossed the finish line, Moluag picked up an axe at his feet, chopped off his own finger, and hurled the bloody digit onto the shore, saying, 'My flesh and blood have first possession of this island, and I claim it in the name of the Lord.' St Columba is said to have taken the huff. He cursed the island, and St Moluag, hoping that his stay would be miserable. Hardly very Christian!

St Moluag may not be as well known as his rival Columba, but he played a vital role in converting Scotland to Christianity. He died in 592 after founding 120 monasteries, and it's believed that his remains were returned to Lismore, where they became holy relics. These were lost during the Reformation; however, another relic from Moluag's time is still in existence. His staff, or *bachuil* as it's called in Gaelic, is in the care of the hereditary Livingstone Barons of Bachuil.

Just up the road from the cathedral is Bachuil House, where I cycled to meet the kilted figure of the current Baron, Niall Livingstone, who is also the Livingstone clan chief. Niall told me excitedly that his title goes back 1,500 years and that every generation of his family have had the onerous responsibility for looking after the original crozier of St Moluag. Taking me into the drawing room, Niall opened a fireproof display case and took out the 6th-century relic. I have to say that there wasn't a lot left of the saint's staff – just the upper quarter with the curved hook – but it was amazing to think that, 1,500 years ago, St Moluag had held this same blackthorn staff in his hands.

'It has wonderful healing powers,' said Niall

The parish church, Lismore, which incorporates parts of the medieval cathedral.

enthusiastically. 'And it's enough just to touch it. It has been used to help women in labour, to bless the sick, to cure madness; and there have been three miracles that I'm aware of in my lifetime.'

'It must be a worry having such an ancient and valuable relic in the house,' I observed.

'Indeed it is. We are neurotic about fire, obviously, and keep it in a fireproof safe. But so far, it's survived. Touch wood!'

Leaving Niall, who asked me to return for refreshments later in the day, I continued on my cycle tour, catching glimpses of the ruined Iron Age broch known as Tirefour Castle. On a high point on the road I stopped to admire the views, which included Ben Nevis, and the Glencoe hills to the north, Ben Cruachan and the hills of Mull to the south, and Morvern to the west.

The peace and tranquillity of Lismore might have attracted St Moluag and his monks, but the island's strategic position in the Firth of Lorn also

brought some unwelcome visitors. On the west side of Lismore are the ruins of Castle Coeffin, which is a relic from a very bloody period in the island's history. Its crumbling walls, which from a distance look like a broken tooth, are all that's left of a castle built by the clan MacDougall on top of an earlier Viking fortress.

The Vikings came first to raid and plunder the riches of St Moluag's monastery, and later to settle, but things didn't always go their way. During one early raid, the islanders fled – all except one very brave woman: Eilidh Mor. She was enraged when the Vikings tried to steal her favourite cow. In a fury, she hurled herself at them and beat three of them to death and then rolled an enormous boulder onto the beach, killing the Viking chief. The Vikings fled in terror, leaving Eilidh to keep her favourite cow.

On my way back to Bachuil House I fell off my bike and knocked myself out. Coming round,

I realised that I had split open my head. Cycling in a daze, I wobbled back down the road to find help. Niall Livingstone was aghast at the sight of my bloody face. He phoned the doctor on the mainland and made an emergency appointment, and then rushed over to the fireproof display cabinet. Removing St Moluag's sacred *bachuil*, Niall held the ancient blackthorn relic above my head in blessing. He then sprinkled my wound with holy water and asked me to touch the saint's crozier. 'You've got nothing to lose,' he said in answer to my sceptical look. 'St Moluag has never failed me yet.' I still needed stitches!

COLONSAY AND ORONSAY

The name Colonsay comes from the Old Norse for Columba, or 'Colm's Island'. Similarly, Oronsay means 'Oran's Island'. The fact that both Columba and Oran are saints gives a clue to the islands' significance to ecclesiastical history. These twin islands lie at the entrance to the Firth of Lorn, with nothing between them and America but 3,000 miles of open Atlantic Ocean. Colonsay is the larger of the two, with a population of around 120. Together with Oronsay it forms an island pairing roughly 16 kilometres long and 3 kilometres wide – small enough to make this destination an ideal place to explore on a bike. It can be reached by ferry from Oban and even by a short flight from there to its little airport. Despite its charms, Colonsay is often overlooked, but the island has much to offer the visitor.

My first stop after the ferry pier at the main centre of population, Scalasaig, was Colonsay House, which today is the home of the Strathcona family – the descendants of Lord Strathcona, who bought the entire island in 1904. Lord Strathcona was an entrepreneur, philanthropist, politician, empire builder and remarkable Victorian. Born plain Donald Smith in the town of Forres, his beginnings were humble, but he rose through the Hudson's Bay Company to become the governor and principal shareholder. He later went on to become the president of the Bank of Montreal and a founder of the Canadian Pacific Railway. As a leading Canadian politician, he turned his attention to furthering the interests of the British Empire, along with his own, of course. By the time he bought Colonsay and Colonsay House, he was fabulously wealthy, with homes in North America, England and Scotland.

Lord Strathcona fell in love with his island and lavished a fortune on creating a fabulous garden in the grounds of Colonsay House, which in its heyday employed 18 gardeners. Since then, the garden has gone wild, but in a good way: it's full of exotic, overgrown plants. There's even a tree fern in the woods. When I came to visit this untamed fantasy garden I wasn't paying much attention to the flora. I was looking for an extraordinary and obscure relic from the distant past – the Riasg Buidhe Cross.

Standing at just over a metre high, this stone cross was moved from the now abandoned village of Riasg Buidhe where it once stood beside a long-vanished chapel. Dating from sometime between the 5th and 7th centuries, it has a human face carved into one side. Some think that it depicts a monk or a saint. Others see the face of Christ – though frankly I hope it's not! Whoever or whatever it represents, there's a strong pagan feel to the whole thing. The reverse side is less ornately decorated and displays the outline of what appears to be a large penis. At least that's what some archaeologists

maintain, and they are more learned than I am on such matters. Some experts have speculated that the Riasg Buidhe Cross was once a pagan totem that was transformed into a Christian object by later stonemasons who added the Christian symbols. Like elsewhere in the Hebrides, Colonsay is a place where different cultural influences have been absorbed over the centuries and where the lines between Christian and pagan traditions became blurred. The cross is not the only example of this. At the beautiful Kiloran Bay archaeologists found evidence that invading Norsemen were influenced by the people they came to conquer. In 1892 a Viking boat-burial was uncovered in a sand dune. Inside the ship were the remains of a Viking warrior and his horse, along with a number of weapons including a sword and spear. There were also trading scales, weights and measures, and coins, which dated the burial after the year 850.

Archaeologists also found two slabs, each roughly carved with a Christian cross. This implied that Christian symbols and beliefs were having

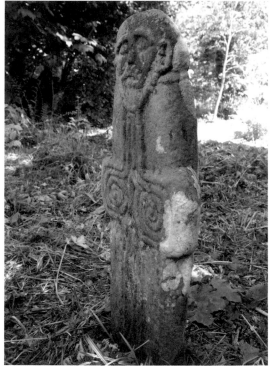

Top: Colonsay House, built by the Strathcona family, who bought the island in 1904.

Above: The stone cross, originally from Riasg Buidhe, which may have pagan origins.

an influence on the pagan Viking colony. It would also suggest that the Viking warrior may have thought that Christianity was worth a two-way bet. He kept his sword and horse for Valhalla, but just in case he was destined for the Pearly Gates, he carried two Christian crosses. On the dunes above Kiloran Bay, I met local historian Kevin Byrne, who showed me where the Viking ship was discovered. Although there is nothing to see today, the site is where Kevin believes the Viking Jarl Ghillie was interred. He was the great-grandfather of Somerled, the progenitor of all the MacDonalds. Kevin would love archaeologists to re-examine the burial site and to compare modern MacDonald DNA with the DNA of the Viking warrior, if it still exists. 'It would be wonderful if they could trace the Macdonald ancestry all the way back here to that early date.'

It's reckoned that Colonsay has been inhabited for at least 5,000 years. With such a long history, death naturally features prominently – and it's not surprising that there are a lot of memorials to the dead on the island. At the little graveyard of Kilchattan on the west coast, I couldn't fail to notice and to be moved by the simple headstones marking the graves of men who died at sea during two world wars. The huge convoys of merchant ships that crossed the Atlantic during the Second World War were easy targets for packs of German U-boats. Over 3,500 ships were sunk in what became known as the Battle of the Atlantic, costing the lives of 8,500 Allied sailors. At Kilchattan, there are the graves of several of these men. Perhaps the most poignant shipwreck story concerns the cruise liner *Arandora Star*. She was transporting 1,200 Italian and German internees and prisoners of war to Canada when a U-boat torpedoed her in July 1940. More than 800 men were killed. Many

of their bodies were washed up on Colonsay, where they were laid to rest, far from home.

Cycling back across the island, I dumped my bike and walked over a short stretch of moorland to visit the deserted village of Riasg Buidhe, which in Gaelic means 'yellow marsh'. It was from here that the curious Riasg Buidhe Cross was moved to the gardens of Colonsay House. Up until the end of the First World War it was a thriving fishing community, and photographs taken in 1909 reveal what life was like for the residents before the village was abandoned. Now the stark, melancholic ruins make a great location for a photography safari. From Riasg Buidhe it's a short bike ride to the southern end of Colonsay, which is separated from its sister isle of Oronsay by a narrow stretch of water which dries out at low tide. It then becomes the Strand, acres of smooth shell sand connecting the two islands, making it possible to cross to Oronsay on foot. But you have to be quick if you don't want to be cut off. Rather than risk getting my feet wet, I hitched a lift with Duncan McDougall in his Land Rover.

'You need to check the tide tables and keep to the marked route – the straight and narrow – when making the crossing. It's very easy for a vehicle to get stuck in the soft sand. If you do, maybe the farmer, or maybe me, will pull you out with a tractor – if we see you. If not, there's no stopping the tide. I've seen many four by fours completely covered by the sea in my time.' Duncan pointed to a rough cairn with a marker on it about halfway across. 'That's the sanctuary cross. They say that, in the old days, any man on the run from Colonsay who reached the cross could claim asylum on Oronsay – provided he stayed on the island for a year and a day.'

Duncan is a Colonsay man. For the last ten

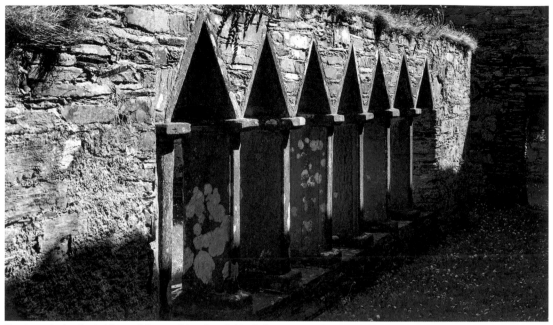

The atmospheric ruined cloisters of Oronsay Priory, founded by St Oran, a companion of St Columba.

years he and his wife Margaret have worked for Oronsay's American owners. We reached the Oronsay side of the Strand and drove ashore, past an old stone jetty and along an unmade road to the old farmhouse where the American owners stay when they come to visit. Duncan told me that there are just five full-time residents on Oronsay now, but in the summer the population swells to about ten when RSPB volunteers arrive to work on the important bird reserve and to study the population of Britain's only native black bees. 'It gets quite crowded then,' Duncan explained half-seriously. 'We are a small island – just two square miles – with no facilities, and entirely dependent on tidal access across the Strand to Colonsay.'

At the farmhouse, I had tea in the fabulous guest annex: an old outbuilding converted by the American owners to look like a medieval great hall, complete with hanging tapestries. I was told that some of the masonry in the farm originally came from the adjacent 14th-century Augustine priory, which was abandoned after the Reformation. Earlier in the 6th century, St Oran, a companion of St Columba, founded a monastery of the Celtic Church on the same spot. Despite the rain and the mist that had blown in off the Atlantic, the priory ruins were wonderfully atmospheric. I wandered through the cloisters and up to the altar in the roofless church, where a fine, high-arched window faced east. Before the Reformation, this group of ecclesiastic buildings was a centre of learning, culture and worship, second only to Iona in importance. It's a long time since prayers were said here. They were replaced long ago by the sound of wingbeats from low-flying geese and the rasping call of the corncrake, which rings out every spring from the long grass close to the crumbling walls.

COLL

GUNNA

TIREE

SKERRYVORE

MUCK

EIGG

RUM

CANNA

SANDAY

CHAPTER THREE SKERRYVORE TO CANNA

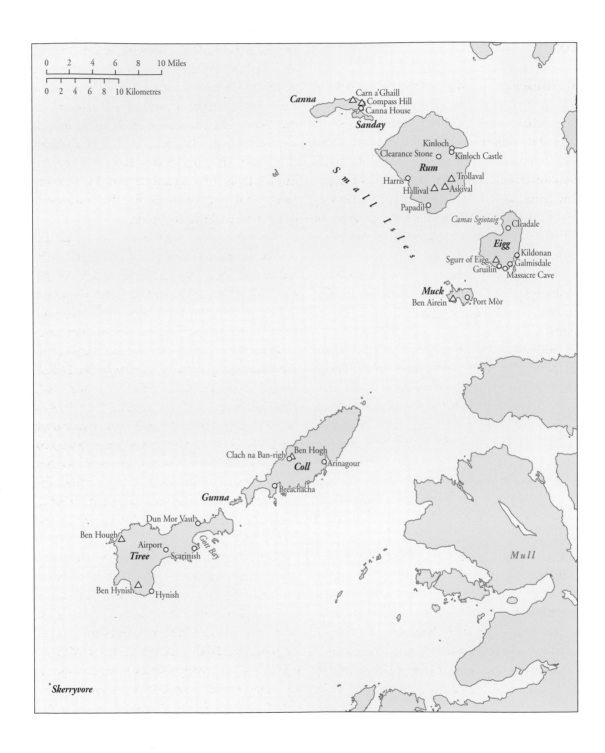

0 2 4 6 8 10 Miles

0 2 4 6 8 10 Kilometres

Canna

Carn a'Ghaill
Compass Hill
Canna House

Sanday

Small Isles

Kinloch
Clearance Stone
Kinloch Castle

Rum

Trollaval
Harris
Hallival Askival
Papadil

Camas Sgiotaig Cleadale

Eigg

Kildonan
Sgurr of Eigg Galmisdale
Gruilin
Massacre Cave

Muck

Ben Airein Port Mòr

Clach na Ban-righ Ben Hogh
Coll
Arinagour

Gunna
Breachacha

Dun Mor Vaul

Ben Hough
Airport
Gott Bay
Tiree Scarinish

Ben Hynish Hynish

Mull

Skerryvore

COLL

The name apparently derives from the Gaelic word *coll* – a 'hazel tree' – though today these are very few and far between. Coll lies some 12.5 kilometres west of the nearest point on the west coast of Mull and is connected to the mainland by a 2-hour-40-minute ferry crossing from Oban. Coll is a rugged low-lying island. It is roughly 20 kilometres long and 5 kilometres wide, and has a population of about 160 people. Arinagour is the principal village on the island, which was the inspiration behind the fictional island of Struay, the setting for Mairi Hedderwick's delightful Katie Morag stories. The author herself lived on the island for a number of years.

Some years ago I was lucky enough to make the perfect landfall on Coll. I was helping a friend sail his old yacht from Tobermory, around stormy Ardnamurchan Point to the waters west of Mull. It was an exhilarating trip, with magnificent skies, brilliant shafts of sunlight and big breaking seas. Late in the afternoon, as the wind dropped to almost nothing, we found ourselves off the coast of Coll, drifting amongst the largest shoal of basking sharks I've ever seen. There must have been about 20 of them, lazily cruising just below the surface. To get a better view I stood on the bow, with my camera poised to photograph one of these leviathans of the deep. I realised that the nearest shark was almost as long as the boat: about 10 metres from nose to tail. Its huge dorsal fin flopped characteristically to one side as the tide slowly carried us together. I could clearly see its enormous, gaping, cave-like mouth. Basking sharks are plankton eaters and can filter up to 2,000 tons of seawater every hour. It's strange to think that these creatures, which belong to the second-largest fish

species in the world (the whale shark is the largest), are sustained by the smallest organisms in the sea. As I lifted my camera to frame a shot, my shadow passed along the back of the beast and over its eye. That's when it reacted. With a slow turn of its massive body, the great fish disappeared into the depths. Only my shadow had made contact, but it was as if I'd actually touched it with my hand – an almost primeval feeling that sent a shiver of excitement down my spine.

An early traveller to Coll and Tiree thought that the two islands were perfectly matched. Visiting in the 1690s, Martin Martin noted that the good folk of Tiree ate barley bread while the people of Coll ate oats. Curiously, this dietary balance also extended to sowing oats of another kind. Coll's surplus of boys neatly matched Tiree's over-abundance of girls. No one on these two islands needed to travel very far to find their other half. Things have changed considerably since the 17th century when 'boy-meets-girl' was an easy boat ride away. For a start, there's no longer a surplus of eager bachelors on Coll, and its population has declined from a high point of over 1,400 in the 19th century to around 260. I'm also told that to find a partner these days you have to travel a lot further than Tiree.

Thankfully, I wasn't looking for a date as I strolled along the main street, which is lined with a terrace of pretty, whitewashed, single-storey cottages. The name of the village, Arinagour, derives from Gaelic and translates as 'the place of the goats'. But I didn't see any livestock. With my mind fixed on buying a snack to sustain me on my island ramble, I popped into a nearby shop called Tesco, which on Coll is the acronym for The

Chapter opening: the island of Coll.

The picturesque main street of Arinagour, 'the place of the goats'.

Ethical Sales Company. Having got everything I needed for my picnic, including organic lemonade, I set off to explore the island, following in the footsteps of Dr Johnson and James Boswell, who were blown ashore here during their famous tour of the Western Isles in the autumn of 1773. The literary gents from London and Edinburgh were storm-stayed on the island for three days but, being the inquisitive souls they were, they made the best of a bad job by visiting the locals, who in the vernacular Gaelic of the island are known as *Collachs*. Two hundred and fifty years ago, there were fewer amenities on Coll than there are now. There was no Tesco. In fact, there were no shops at all, and money was almost unheard of. Everything was either produced on the island or acquired by exchanging island products for items

that the *Collachs* couldn't produce themselves.

Despite the material poverty he met with, Dr Johnson was impressed by the character and intellect of the islanders, especially the 77-year-old Rev. Maclean, who lived in a damp, smoky hovel that passed as the island manse. Here Maclean and Johnson locked philosophical horns, arguing for several hours about the merits of Newton and Leibnitz. While not admitting defeat, Johnson later confided that he liked firmness in an old man, and was pleased to see 'Mr M'Lean so orthodox'. It's amusing to think that the great Dr Johnson, so comfortable in the coffee houses of London, could meet his intellectual match on a Hebridean island.

Taking the road south, I made my way to the tiny settlement of Breachacha – 'the speckled field' – where two castles have been home to Macleans

Nicholas Maclean-Bristol, current resident of old Breachacha Castle.

for centuries. Dominating the skyline is the 'new' castle, built by Hector Maclean in 1750. Here Maclean entertained Boswell and Johnson during their enforced stay. For their pleasure, he laid on an evening of pipe music, played by the last hereditary piper to the chiefs of Coll. This may have been the last straw for Johnson, who grew increasingly desperate to leave the new castle, which he dismissed snobbishly as being a 'mere tradesman's box'. Behind the now-dilapidated new castle is the old Breachacha Castle, the ancient seat of the Macleans of Coll. When Johnson and Boswell were guests of Hector Maclean, it was in a ruinous state, but has since been lovingly restored by the present owner, Nicholas Maclean-Bristol, whose thirteen times great-grandfather built it in the 14th century. Nicholas bought the ruin in the 1960s for £500.00,

determined to restore the fortunes of the Macleans of Coll, from whom he is a proud descendant.

Nicholas, who wasn't born on the island, nurtured an ambition to reclaim the home of his ancestors from the age of nine, growing up in England during the war. 'I looked like a Maclean and behaved like a Maclean,' he told me excitedly. 'I read all the histories of Clan Maclean and was determined to live on Coll.' The front door of the ancestral pile is tiny. When Nicholas opened it to greet me, all I could see of him were his legs. The lintel was so low that I was forced almost to crawl on hands and knees to enter the presence of the owner. 'It's to keep the wind out,' explained Nicholas cheerily.

'And to force me to bow to my feudal superior,' I added.

Nicholas and his wife Lavinia treated me to lunch in the great hall, overlooked by portraits of earlier Maclean incarnations. They all had an imposing military bearing. 'I'm terrifically proud to be from a military family,' said Nicholas. 'We Macleans have always been warriors and in the regular army since the sixteen hundreds. And every generation, we've produced three sons to answer the call to arms. As for me, I was in the KOSB [King's Own Scottish Borderers] and I count myself lucky. I had proper little wars to fight in Aden and Borneo. My eldest son, poor sod, got Northern Ireland and bloody Irish terrorists!'

Before Nicholas retired from the army, he set up Project Trust – a UK-wide charity that is based on Coll. The trust selects young men and women from a range of backgrounds for overseas voluntary work. Nicholas explained that the impetus behind the scheme came from Britain's declining role as a world power. In the 1950s, when the Empire was pulling back east of Suez, there was a crisis of purpose for the armed forces. This is when Nicholas conceived the idea to somehow recycle the skills of Empire, by training young people to help in developing countries. Nicholas thought that Coll was the ideal location for his purposes – he had the accommodation he needed in the refurbished but, admittedly, leaky castle, and the island and its people were in many respects like a developing country. If youngsters could integrate here and make themselves useful in an alien society far from the comforts of home, they could integrate in Africa or Indonesia. Today, Project Trust has exceeded his wildest expectations. It not only sends out hundreds of volunteers every year to over 20 countries worldwide, it is also the island's biggest employer with 27 people working full time and more in the summer. In addition, the island benefits from housing the volunteers who come to Coll for the selection process, so all in all the contribution of Project Trust is enormous.

There is another benefit that is more cultural. Twenty years ago, the island population was half what it is now. Today incomers account for by far the bulk of the population. Consequently, there is a higher percentage of people under 20 years old on the island than anywhere else in the Hebrides. Nicholas tells me that having a wide age demographic is good for any community.

Not all Macleans have been as altruistic as Nicholas. When Coll's population rose to 1,440 souls in the mid 19th century, the MacLean laird failed to manage the land to support them. The situation reached a crisis when potato blight from Ireland caused a famine, leading the laird to clear nearly half of Coll's people from their island home and transport them to Australia and Canada. Further emigrations by young people decimated the population, until Coll was almost uninhabited, with no longer enough younger people living on the island to keep a viable community and to work the land.

Over two centuries later and with the success of Project Trust secure, Nicholas has handed on responsibility for its day-to-day running to others who share his passion for Coll. Now he deploys his energy and intellectual vigour in pursuing his great passion in life – the history of Clan Maclean. Up on the castle battlements we look across the 'speckled field' of Breachacha, home to the Macleans of Coll. Traditionally, their great rivals were the Macleans of Duart on the isle of Mull, who once ruled over the neighbouring island of Tiree. Typically, there is a long history of violence between these two related clans, including a battle

that gave the name to the burn running close to Nicholas's castle. Struthan nan Ceann, the 'Burn of the Heads', is so called because of the number of decapitated Duart Maclean heads that filled the stream after the battle. Nicholas still has time for farming and runs a few sheep on his land – but not as many as he used to. Gazing at his distant flock through a smirr of rain, he tells me that he has been farming since the 1960s. 'Lachlan Maclean my old shepherd taught me everything I know,' he says wistfully. 'We still keep sheep, but we don't have a dog any longer. It's just too much to train up a pup again.'

I am puzzled. 'How do you round up the flock?' I ask.

Nicholas grins. 'Lavinia! She rounds them up! I've always thought it important to have a wife at least ten years younger than oneself. They can take over when you begin to flag.'

Back in the village of Arinagour, I pop into the post office and meet Cathy Maclean. She has just retired as the island postmistress after many years of dedicated service. Cathy proudly tells me that she is a rarity on Coll. There are just six original *Collachs* left on the island and she is one of them. She was born in the 1930s, when the world and Coll were different places. Back then, the family home had a thatched roof and a beaten earth floor. Gaelic was the language of the island. Not any more. 'It's all English now,' she says with regret. 'In the old days there was a real sense of community. You were in and out of each other's houses and lending a helping hand when needed. Now people talk about community, but it's just an empty word.' Throughout Cathy's childhood, people continued to leave Coll. Her two brothers emigrated to Canada. Girls in her class moved to Glasgow, where some became nurses and others

worked in shops and hotels. I'm not sure if Cathy thinks that the modern, regular ferry service is a good thing or not. Does she blame better connections for the changes she's seen on the island? Perhaps in part: 'Folk rush off the island at the drop of a hat. The ferry is used like a bus these days. It was only used for special occasions when I was a wee girl – like the time I went to Oban. I was ten years old and it was the first time I had ever left the island.'

Many islanders I've met are extremely well travelled and know parts of the world most of us can only dream of visiting. Cathy did admit to having been on holiday to Aberdeen once. Though to this day, she hasn't visited the neighbouring island of Tiree. 'Och! Why would I want to? I've got everything I need here,' she protests.

Continuing my stravaiging, I set off to the west side of the island with the aim of climbing Coll's only mountain – Ben Hogh – another place visited by Johnson and Boswell back in 1773. Unsurprisingly for the 64-year-old compiler of the famous English dictionary, Dr Johnson never made it to the summit, preferring instead to read a book halfway up this modest protuberance, which rises to the less than dizzy height of 106 metres above the sea. The reason for Johnson and Boswell's unlikely expedition over bog, heather and hill was an extraordinary rock on the summit, which their host, Hector Maclean, had urged them to visit. Called Clach na Ban-righ, or the 'Queen's Stone', it's perfectly poised on three small boulders – as if carefully placed there by a giant. So perhaps it's no surprise that local legend does in fact mention a giant – and a gigantic domestic row with Mrs Giant. Instead of dinner plates, this oversized pair hurled boulders at each other, and the huge stone on top of Ben Hogh is said to be one of them. In

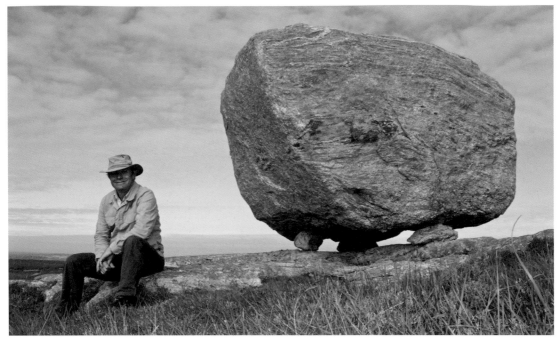

Following in the footsteps of Boswell and Johnson at Clach na Ban-righ (the Queen's Stone), on Ben Hogh.

1773, neither Johnson nor Boswell could explain how the boulder got here. Science was yet to discover ice ages and the power of long-since melted glaciers to carry rocks great distances on their icy backs. Clach na Ban-righ is in fact a fascinating example of a glacial erratic. The views from the summit of Ben Hogh easily repay the effort of the short climb from the road. Away to the south I could see Tiree; to the east the Treshnish Islands and Mull; while the view to the north was dominated by the great bulk of Rum. Below, fringing the west coast, were a host of beautiful white sandy beaches and turquoise water.

Heading downhill, I joined Angus Smith, who was keen to show me his flock of traditional Hebridean sheep. Angus called to his flock in Gaelic: 'Trott! Trott!' and rattled a bucket of feed to encourage them. They appeared suddenly over the crest of a hill. And down they came in a breaking wave of wool and bleating. They were so eager for Angus's offerings that they leaped like springbok. These diminutive sheep are an ancient breed whose ancestors were among the domesticated animals brought by the first farmers when they settled the Hebrides. Angus told me that on the island of Barra they are called 'Blessed Sheep' in Gaelic, on account of the shadows that their double horns cast on the ground, which apparently look like the shadow of the Cross. Angus was clearly proud of his flock. 'My grandfather was a shepherd here. I now live on his old croft,' he explained, leaning on his crook and watching the sheep as they began to graze on the knolls around us. Despite the rural demeanour and the crofter's Gaelic lilt in his voice, Angus is actually a retired policeman with a media background. The

Angus Smith's traditional Hebridean sheep.

Hebridean image he projects isn't an act. It comes from a deep affinity with the land of his ancestors and nostalgia for a way of life that is fast disappearing. He wants to hang on to what's left if he can. Breeding Hebridean sheep is his way of keeping the traditions of the past alive.

Before we parted company Angus told me about the wartime wreck of the *Nevada II*, which ran aground on the north end of Coll in 1942. Unlike the famous ss *Politician*, which was wrecked with a cargo of whisky off the coast of Eriskay at about the same time, the *Kansas* was stuffed full of money – newly printed banknotes bound for West Africa. Seeing a once-in-a-lifetime opportunity to get rich, one of the men responsible for salvaging the wreck began to make regular deposits of bank notes at the British Linen Bank in Oban. 'Can you believe it?' said Angus. 'He waited for

twenty years, before trying to convert his salvage takings into usable currency. But the police were waiting for him. They pounced and he was arrested, tried and sentenced to ten months in jail.'

GUNNA

The name sounds Scandinavian and probably derives from Old Norse, meaning 'Gunni's Island'. His identity has been lost in the mists of time. Although there isn't much to uninhabited Gunna, which lies in the narrow sound between Coll and Tiree, the island sits in full view of passengers sailing close by on CalMac ferries on routes heading to Barra or to Coll. The island is small – just under 2 kilometres long by 500 metres wide, and very

low-lying. The highest point is a mere 35 metres above sea level. Despite this, when the sun shines it looks like a tropical island, with crystal-clear, turquoise water lapping its rocky shoreline, which is interspersed with beautiful sandy bays and inlets. On a good day, this makes Gunna an ideal island to explore with a sea kayak.

The history of the island is interesting. It was once the property of the nuns of Iona and was part of the medieval parish of Coll. According to a description of Gunna written in the 1600s, 'in the midst of it is a ruinous Chepall'. There is nothing left of this ancient structure today, although excavations have revealed what appear to be its foundations at Port na Cille on the south-east coast. According to tradition, the chapel and its burial ground were associated with the Macleans of Coll. Apart from monks or nuns who may have spent time on Gunna, the island doesn't seem to have been permanently inhabited. Despite this, the remains of extensive lazy beds are evidence of cultivation in the past. The ruins of turf-walled shielings suggest that people from Coll occupied Gunna on a seasonal basis. Every spring, cattle continue to be swum across the shallow kyle from Coll to graze the rich grass growing on the machair, which in winter is enjoyed by migrating barnacle geese.

TIREE

The name probably derives from the Gaelic Tir Iodh, meaning the 'Land of Corn', on account of the island's reputation in medieval times for being the breadbasket of the Hebrides, producing barley for export to other islands. The Tiree ferry leaves from Oban and takes a good 3 hours 50 minutes to reach the island, partly because it stops first at Coll for 15 minutes. Tiree is 18 kilometres long and covers an area of 7,834 hectares. It is flatter than the neighbouring Coll, much less rugged and more fertile. The current population of nearly 700 is three times that of its neighbour. Despite their proximity, there is a degree of rivalry, which has its roots in history. For centuries, Tiree was ruled by the Macleans of Duart on Mull, while Coll had an independent Maclean chief of its own. Even today there is a mutual suspicion amongst some islanders. Many Tiree folk I've met consider themselves to be closer to Hebridean traditions than *Collachs,* who are often rather unfairly dismissed as 'incomers'.

For many years Tiree was a mystery to me. From the west coast of Mull where my mother-in-in-law lived, I could clearly see its highest hill, Ben Hynish, but most of the rest of Tiree was hidden below the horizon or was no more than a thin dark line separating the sea from the sky and merging with its twin, Coll, which seemed similarly submerged. From the cliffs of Caliach Point on Mull I often watched the CalMac ferries sail west to Tiree and I longed to go with them. The opportunity arose when my brother-in-law Robbie said he'd also like to visit. Together we cycled two rickety old bicycles 12 miles to Tobermory to catch the ferry, which in the 1980s still called at Mull on its way west. I managed to clamber to the top of Ben Hynish where, buffeted by the wind, I gazed in wonder at the view below. Fourteen miles to the south and west, in the midst of a halo of white breaking waves, I could distinctly make out the elegant shape of Skerryvore lighthouse.

I didn't return to Tiree until 2014. Approaching the terminal at Scarinish, the ferry negotiated a flotilla of windsurfers slicing through the choppy

Much of Tiree is low-lying.

waters of Gott Bay. The island is among the windiest places in Britain. In fact, there seem to be few days when a gale isn't blowing, a godsend for windsurfing enthusiasts who love Tiree and its amazing beaches for the sporting opportunities it offers.

Another Gaelic name for Tiree is Tir-so-Thuinn or the 'land beneath the waves' and, from my own experience of viewing the island from the coast of Mull, it's easy to see why. Most of the island is low-lying and disappears below the horizon, except for the two points of higher ground which appear from some angles to be two separate islands: Ben Hough to the north is just 119 metres; the less than mighty Ben Hynish, which I'd climbed on my first visit, is the highest hill at 141 metres and instantly recognisable by the golf-ball-like radar installation on its summit. For a Hebridean island, Tiree's climate is benign. It is one of the

sunniest and driest places in the whole of Scotland and has attracted human settlement since the last ice age ended 10,000 years ago. Stone circles and standing stones are evidence of the first people to make their homes here, among them a woman whose remains have puzzled archaeologists. Carbon dating has established that she lived 9,000 years ago in Mesolithic times. Surprisingly, her deformed skeleton provides the earliest evidence for rickets – a disease associated with vitamin D deficiency. However, an average Mesolithic islander would have eaten a vitamin D-rich diet of fish and spent a lot of time out of doors – a lifestyle that would not have made her susceptible to rickets. Further analysis of the deformed skeleton has led some to suspect that she was deliberately abused and kept in the dark. But why? The way she was buried also seems to mark her out as

One of Tiree's amazing beaches.

a low-class member of society who was possibly ostracised from the rest of the community: someone to be feared. A witch perhaps?

We can have no idea what beliefs and superstitions Mesolithic people held or what the Iron Age inhabitants of Tiree thought about the afterlife, although in the magnificent Dun Mor Vaul they left one of the finest brochs in the Hebrides, but we do know more about the Celtic monks who settled on Tiree in the 6th century. They established at least one monastery, but 300 years later their community was destroyed when Magnus, the young king of Norway, swept the island with fire and sword. According to the Viking bard Björn Cripplehand: 'The glad wolf Magnus reddened tooth and claw with many mortal wounds in Tiree.' King Magnus was just one of many warriors to leave his mark on Tiree over the centuries. The island's most recent battle scars date from the Second World War, when Tiree was converted into a huge air base – rather like a giant, unsinkable aircraft carrier in the Atlantic – from where the RAF flew sorties to protect vulnerable

shipping convoys bringing vital supplies to Britain from America. Today, old Nissen huts, ruined gun emplacements and derelict military buildings dot the landscape as reminders of the wartime past.

The island's transformation from crofting community to air base began when the government declared it to be a Restricted Area. The local community was then swamped by hundreds of labourers, who were brought in from Ireland and several Scottish jails to build the runways, roads and associated infrastructure. When RAF Tiree opened in 1941, its 4,000 personnel outnumbered the islanders three to one. There was a cosmopolitan mix of aircrews, with Canadians, Australians, Polish and British squadrons. The crews also took the important meteorological readings that helped to create the D-Day weather forecast, which greenlit the Allied invasion of occupied France in 1944. The work of the aircrews was extremely hazardous. Aircraft frequently iced up in cold weather. High winds, driving rain and enormous seas added to the danger. By the end of the war, 12 planes had been lost, including two that collided in the skies above the island. Although the RAF left decades ago, the runway has survived. Instead of bombers, commercial aircraft now land and take off, providing a daily passenger service to Glasgow, which is just a 40-minute flight away.

At a tearoom near the airport, I met up with Mabel MacArthur. Mabel's first language is Gaelic. In fact, she is a Gaelic playwright and was born on Tiree, but the family moved to Glasgow when she was seven. During the war, she was evacuated to live with her island relatives. 'RAF drivers used to give us a lift to school if they saw one of us walking on the road when they were passing,' she told me. 'The lorries were so big they had to lift us up into the cab.' Mabel said that before the war

there was no electricity or running water on the island. Even worse, Tiree was a dry island, where alcohol was strictly prohibited. 'But that all changed with the NAAFI. There was a bar for service personnel. So suddenly Tiree had a pub! Not only that, there was a cinema, where most islanders had their first experience of the movies. There was also a theatre for shows and concerts.' Islanders were encouraged to use the NAAFI and its facilities, and it became a place to socialise and mingle, allowing island lassies to meet dashing young men in their flying machines. Quite a few girls were swept off their feet, marrying and leaving Tiree for good.

Mabel took me to visit her old school. Despite the war, her days there were happy ones and, by all accounts her teacher, Miss Nesbit, was a good and enthusiastic educator. To help the war effort, she encouraged the children to grow vegetables in the garden. But the playground and the classroom are empty of children now. The school closed years ago and is now a private house. Mabel sighed and said that she had seen the island population decline from well over 1,000 to just 600 in a few decades. 'Before the war, nearly everyone was involved in crofting or fishing. That way of life is almost finished now,' she said with sad resignation. 'We need employment opportunities to keep the young here and to give Tiree a future.'

Island life has never been easy. Tiree's sunny climate and good soils may once have been good for growing oats and barley and given employment to a large population of crofters, but life here was a relentless battle against the elements. Tiree is one of the stormiest places, not just in Britain, but in the whole of Europe. To protect themselves from the ferocity of Atlantic storms, islanders developed a unique architecture. Single-storey

Mabel MacArthur, who remembers the air base on Tiree during the Second World War.

A typical Tiree but-and-ben house, built to withstand fierce Atlantic storms. This one is now abandoned to the elements.

but-and-ben croft houses have walls 6 feet thick and deeply-inset little windows, which give them all the characteristics of an underground bunker, braced for the onslaught. Because of the weather, it's also said that you can tell a Tiree man just by the way he stands: never upright, but always leaning into the wind, even when he's indoors at the bar!

SKERRYVORE

The name comes from the Gaelic meaning the 'Big Skerry', or the 'Big Reef'. Storms made the coast of Tiree notorious. For centuries ships ran the gauntlet of the treacherous seas west of the island, until February 1844 when the light was first lit on Britain's tallest lighthouse, Skerryvore, which lies 19 kilometres further out into the wild Atlantic. Ever since, Skerryvore Lighthouse has warned sailors of the dangers lurking beneath the waves. To discover more about this extraordinary structure, I headed to the south end of Tiree and the small village of Hynish, founded by the pioneering lighthouse engineer Alan Stevenson. Today, the village is cared for by the Hebridean Trust. I met Monica Smith who is part of the team dedicated to maintaining this unique part of the island's heritage. Monica told me that, before building work on the lighthouse could begin, Stevenson needed to establish a self-sufficient community

at Hynish: a base for operations, with a barracks for workers, a pier, a dry dock, keepers' cottages, offices, outbuildings, a small farm and a walled garden to provide the community with fresh food. Only after the village was completed could work begin on the lighthouse.

Construction was seasonal, beginning in the summer of 1837 and taking nearly seven years to complete. Every summer, workers were taken out to sea to the tidal reef of Skerryvore, where they were accommodated in a temporary wooden barracks raised on stilts above the waves. During the first winter, the entire structure was washed away in a storm. Even in summer, the hostile environment threatened operations. During another storm, the workers were forced to evacuate the barracks and seek shelter inside the partially built lighthouse. I was amazed to learn that Skerryvore was effectively built twice. Before taking the dressed stone out to sea, each course was assembled on land to ensure that the interlocking

Skerryvore Lighthouse.

masonry fitted together correctly – a truly monumental effort. Monica told me that, after the lighthouse became operational, Hynish continued as a shore station, housing the keepers' families. There is a round tower in the village that overlooks the sea. From this watchtower, signals were made to the keepers on distant Skerryvore, which is just visible on a clear day on the horizon. There are stories about keepers whose wives were expecting a baby. The keeper would watch out for a coloured flag to indicate if he had a son or a daughter – pink for a girl, blue for a boy! Skerryvore was manned by keepers until it was automated in 1994. Today, a powerful electric light both warns passing shipping and acts as a beacon to the memory of the workers who achieved the almost impossible feat of building Britain's tallest lighthouse on the wave-washed reef of Skerryvore.

THE SMALL ISLES

As a child I was always intrigued and amazed by the crazy-sounding names of Muck, Eigg, Rum, Sanday and Canna. Collectively known as the Small Isles, they lie between Ardnamurchan and Skye. Although grouped together, each island is very different and distinct from its neighbours.

MUCK

The name derives from Gaelic, either Eilean nam Muc – the 'Island of Pigs' – or, perhaps more romantically, Eilean nam muc-mhara – 'Whale Island'. Personally, I've not seen any pigs on Muck, but I have seen whales and dolphins nearby. Muck is the smallest, most fertile and southerly of the Small Isles. It is roughly 3.5 kilometres long by half

a kilometre wide at its narrowest. It has a population of around 40 people. Ben Airein is the highest hill, rising to just 137 metres above sea level. Ferries leave for Muck and for other Small Isles from the mainland port of Mallaig.

There is evidence that people have lived on Muck since the Stone Age. Bronze Age artefacts have been found, and the remains of a fortified dun, Caistel nan Duin Bhan at the entrance to Port Mòr probably dates from the Iron Age. The island has many associations with the early Celtic church. A local legend tells of a visit by St Columba in the 6th century. He was apparently so impressed by the virtuous folk of Muck that he blessed them, promising that their faith in God would save them and their descendants from drowning. A useful blessing indeed for an island people. Muck was also home to Viking invaders and the clan Maclean, before the island eventually fell into private hands, after which it was owned and run, like much of Scotland, by a landlord or laird.

When Dr Johnson visited the Hebrides in 1773 he dined with the original Maclean Lord and Lady Muck. It seems that Lord Muck was uncomfortable with his title and tried to change the name of the island to Monk Island. But it didn't catch on. The fortunes of the community on Muck fluctuated over the centuries. Some lairds were benevolent landlords. The Maclean laird whom Johnson met seems to have been one of them. According to the good doctor: 'The Laird having all his people under his immediate view, seems to be very attentive to their happiness. The devastation of the small-pox, when it visits places where it comes seldom, is well known. He has disarmed it of its terrour at Muack, by inoculating eighty of his people. The expence was two shillings and sixpence a head.' This must be the earliest recorded account of a

Lawrence MacEwan, the current Laird of Muck.

mass vaccination programme in Scotland.

Muck was considered to be a valuable and profitable island. Its fertile soils produced good harvests. Cattle thrived, and a lucrative income was derived from the sale of potash that was produced by the process of kelp burning. The population peaked in 1821, when Muck supported 320 souls. But when kelp prices crashed, the laird went bankrupt, and tenants fell behind with their rent. Harsh times followed, culminating in a series of emigrations and evictions. In 1828, 150 islanders left for Cape Breton in Canada on the emigrant ship *St Lawrence*.

Muck was bought in 1896 by the MacEwan family. Today they still own the island, running it as a single farm. I met up with the current laird Lawrence MacEwan, who had taken a break from tending his cows. For obvious reasons, he preferred not to be called Lord Muck, but admitted to being teased mercilessly when he was at boarding school, where he was known as Big Muck, while his younger brother was known as Little Muck. Being the laird means that you can decide who can live on the island. The MacEwans own all of Muck – and the homes of its residents. Lawrence has seen people come and go, but he has lived on Muck all his life and it's where he hopes to die. But he isn't remotely sentimental. 'It's not about scenery. It's about community. This is my home,' he said as I climbed aboard his beloved red Massey Ferguson tractor for a quick tour of his domain. I clung to the mudguard while Lawrence steered past the school, the shop with its honesty box, the tearoom and his daughter Ruth. She was driving a quad bike, with her offspring: one child strapped on her back and the other wedged in front, gripping the handlebars.

Opportunities to live on the island don't come up very often, and the laird interviews all would-be Muckers. The idea of 'community' guides all his decisions – and his choice of who can share the island with him. Standing beside him on the summit of the little hill, Ben Airein, we took in the spectacular Hebridean view. 'What's it like owning an island?' I asked. Lawrence considered for a moment. 'I don't get up in the morning and think "How wonderful, I own this." You see, I am here for just a short while, and during that time, it's my job to look after it. And I certainly don't take being the laird seriously. Muck belongs to everyone who lives here, I think.'

EIGG

The name comes from the Gaelic word *eag*, which means a 'notch' and refers to the island's profile. The gigantic mass of volcanic rock that forms the

At anchor near Eigg.

Sgurr of Eigg – the island's most prominent feature – ends in a vertical 150-metre cliff, which from a distance looks like a notch in the skyline. Eigg lies to the north of Muck, but is a much bigger island. From north to south it measures over 9 kilometres, and 6 kilometres east to west, covering an area of 3,049 hectares. The population today is just under 100. Most live around the south of the island at Galmisdale, near where the ferry from Mallaig comes in, or to the north-west at the old crofting township of Cleadale.

When I came to Eigg as a student in the 1980s, the island pier was too small to handle the CalMac ferry from Mallaig. To get ashore, passengers were forced to make an awkward descent from the ferry into a small wooden boat that came bobbing alongside. This could be a tricky manoeuvre in rough weather, especially if there was a lot of luggage to deal with – or as I once observed, boxes

of live chickens bound for Eigg were part of the cargo. Things are much easier today. A new pier and a roll-on roll-off ferry allows people, vehicles and even hens to reach Eigg with ease.

Like other islands in the Small Isles, Eigg has been inhabited since the earliest times, with evidence of human activity going back 8,000 years. Stone Age axe heads have been discovered; and dotted across the island are standing stones and cairns that mark Neolithic and Bronze Age graves. During the Iron Age, the population built hill forts or duns for protection, including one on top of the Sgurr. According to local legend, the arrival of Christianity in the 6th century didn't go as smoothly as elsewhere in what was then the land of the Picts. When St Donan, who was a missionary of the Celtic Church and a contemporary of St Columba, established a monastery on Eigg, he incurred the wrath of a powerful local

woman – perhaps the warrior queen of Eigg who is said to have lived on an artificial island in Loch nam Ban Mora, the 'Loch of the Mighty Women'. The loch is reputedly also the home of one of the most famous Hebridean kelpies – mythical water-horses on whom one rides at one's peril. Recent archaeological evidence discovered at the ancient Christian centre of Kildonan suggests that St Donan may well have built his religious community on a site that was already sacred to the early islanders and their queen. Perhaps this is why she reacted so badly when the holy men moved in and explains why her vengeance was so bloody and limitless. Acting either alone or with the help of Viking raiders, she had Donan killed. The story goes that he was celebrating the sacrament when intruders broke in. He begged to be allowed to finish the mass. When it was over, he led his community to the refectory, where he and his 52 followers were beheaded – a barbaric act that constitutes the worst single incidence of religious violence in the history of the Celtic Church.

Unfortunately, despite its beauty, Eigg has acquired something of a reputation for death, destruction and the slaughter of innocents. Leaving the road about a kilometre from the ferry pier, I cut across a field and followed a faint path heading towards the south coast of the island. I then clambered down a steep bank to gain access to the shore and to the dark and sinister opening in the cliff face know in Gaelic as Uamh Fraing – or the 'Cave of Francis' – an innocent-enough name, but one that masks a ghastly history. Today, it's more commonly called the Massacre Cave – and it's not for the squeamish. The entrance is low and narrow, and it was quite a struggle getting inside. I was forced down on my hands and knees through some unpleasant-smelling mud before I

found enough room to stand up. By the light of my head torch, I could see that the cave was large, stretching up to 79 metres into the darkness. In the dank air I shuddered at the thought of what horrors had happened here.

In the 16th century, the island of Eigg was the home of the MacDonalds, who were locked in a bitter vendetta with the MacLeods of Skye. In 1577, the MacLeods invaded Eigg and, when the islanders saw their approaching war galleys, they fled their homes and hid in Uamh Fraing. It's reckoned that there were up to 400 of them in the cave – men, women and children. But they were discovered. What happened next was one of the worst clan massacres in history. The MacLeods lit a fire at the entrance to the cave and suffocated everyone inside. The entire population of the island perished and for centuries the bones of the victims lay where they died. Perversely, they became an early and ghoulish tourist attraction, and some remains were even taken away as grisly souvenirs. When the Victorian geologist Hugh Miller visited, he was appalled and moved by what he found: 'At almost every step we come across heaps of human bones. The hapless islanders died in families, each little group separated by a few feet from the others.' Thankfully, a few years after Miller's visit the local minister respectfully gathered up the bones and transferred them to the island church for burial.

Eigg was eventually resettled and by the 19th century there was a population of 500. But as so often happened in the history of the Highlands and Islands, the desire for agricultural improvement meant that sheep were valued more highly than people. Throughout the Hebrides, it's almost impossible to escape the legacy of the Clearances as they were called, and Eigg is no exception.

The ruins of Gruilin, Eigg. The village's inhabitants were cleared in 1853.

Walking further west along the unmade road that skirts the south coast, I arrived at the ruined village of Gruilin – a place where history speaks from the soil. When the village was cleared by the laird in 1853, many of its people emigrated to Canada. With them went a language, a culture and a way of life.

Eigg never really recovered from the devastating effects of depopulation. By the time of the Second World War, just 47 people lived on the island, and the fortunes of the whole community were at a low ebb. Throughout the latter part of the 20th century, a succession of owners came and went, while the island and its dwindling population suffered from years of neglect. For the increasingly disgruntled islanders, the final straw came in the 1990s when Eigg was sold to a mysterious

German artist who called himself Maruma. He flew in by helicopter with big promises and grand plans: his 'Concept', as he called it. But during the two years that he owned the island, the new laird – like so many before him – did absolutely nothing. But his failure inspired the community to do something for themselves. They launched a public appeal to buy the island and managed to raise over £1.75 million from 10,000 members of the public. In 1997, the people of Eigg finally won their battle and took control of their destiny, which now looks much brighter. Today, the island boasts an innovative renewable power grid – the first of its kind in the world – and a booming population with plenty of children to fill the school.

The anniversary of the historic community buyout is marked every summer with a big ceilidh

– a kind of island Independence Day bash – with musicians and guests from all over Scotland and beyond. Fortunately, my visit coincided with the island's 16th anniversary. The celebrations were held in the village hall, which was bursting at the seams with revellers who had travelled from as far afield as the USA. Unfortunately, the presence of so many partygoers provoked a feeding frenzy of Eigg's ferocious midges, which descended in a great cloud. But bite as they might, they could not spoil the fun.

The following morning, I decided to clear my head with some exercise and took a stroll on the beach at Camas Sgiotaig, where the sands are said to sing, which they did. Every step I took was accompanied by a peculiar squeaking – rather like the sound boots make if you have ever gone for a walk in very cold snow. Apparently it's something to do with the original rock material and the size and shape of the sand grains. The views towards the mighty peaks of Rum from the Singing Sands were breathtaking. It was an almost painfully beautiful day of blue skies, sun and sparkling seas. But I couldn't linger. I had an appointment with a mountain – the Sgurr of Eigg, which rose dramatically behind me. The Sgurr is a geological curiosity. It is the largest piece of exposed pitchstone in Britain. It was formed millions of years ago when molten lava filled a river bed and solidified. The softer surrounding rocks were gradually eroded away, leaving the harder pitchstone in the river bed, standing proud of the landscape. The Sgurr looks impregnable at first, but is easily breached with a straightforward walk that takes about two hours. A path skirts around the north face to a

The Sgurr of Eigg, the island's most noticeable geological feature.

gully. An easy scramble up this leads to the wide ridge and the summit trig point.

Climbing the Sgurr, I was walking in the footsteps of my favourite early traveller, Sarah Murray, the indefatigable lady adventurer who visited Eigg in 1802. In her *Companion and Useful Guide to the Beauties of Scotland*, she writes: 'The first clear morning after my arrival in Eigg, I mounted a pony and began my journey to the Sgurr, accompanied by my friends on foot.' The elderly servant who led Sarah Murray's pony was a survivor of the Battle of Culloden. Sitting on the summit, the party picnicked, took in the stupendous view and listened with rapt attention to his tales of the Jacobite Rising of 1745.

RUM

The derivation of this name is obscure, but is most likely to be Norse, in line with many of the place names found there: *Röm Øy* means 'Wide Island' in the language of the Vikings. Rum is by far the biggest of the Small Isles. Diamond-shaped, it measures 14 kilometres from north to south and 13 kilometres from west to east. It's a wild and rugged wilderness of rough moorland and high mountains rising steeply to 812 metres above sea level. The peaks are the remains of a once mighty volcanic caldera which spewed out ash and lava 50 million years ago.

The CalMac ferry *Lochnevis* made steady progress towards the majestic grandeur of Rum's signature skyline, dominated by the Viking-named peaks of Askival, Trollaval and Hallival. The weather was glorious and I had been invited up to the bridge by the ship's captain, Kenny Macleod. As we sailed along the barren coast, there was little sign that the island was inhabited. However, in 1801, there were nine townships on the island, which had a population of 450. The entire Gaelic-speaking population were forcibly evicted between 1826 and 1827 by their landlord Dr Lachlan Maclean to make way for 8,000 sheep. When sheep prices collapsed, Maclean went bankrupt, and the island was sold as a sporting estate for the enjoyment of wealthy English aristocrats who

The Isle of Rum seen from Skye.

Kinloch Castle, Rum, built by the eccentric millionaire George Bullough.

came to shoot and fish. When the Victorian geologist Hugh Miller visited in 1844 he was not impressed: 'In the entire prospect, not a man, nor a man's dwelling could the eye command. The landscape was one without figures. I do not much like extermination carried out so thoroughly.' Today, the only permanent settlement on Rum is in the village of Kinloch, with a population of about 20 people, many of whom work for Scottish Natural Heritage, which owns and runs the island as a National Nature Reserve.

Bizarrely, on this vast and almost empty island, visitors are greeted by a somewhat incongruous sight: the vast baronial pile that is Kinloch Castle. It didn't exist until 1897, when multi-millionaire industrialist George Bullough had it built as the centrepiece of his island kingdom, which he thought was going to last for generations. The Bullough family had made their fortune from the textile industry in Lancashire. And like many wealthy 19th-century industrialists, he considered

a sporting estate in Scotland de rigueur. Bullough, reputedly one of the richest men in the world, had inherited Rum from his father, and wanted to build his dream castle on the island. No expense was spared. It cost about £250,000 at the time, the equivalent of a cool £15 million in today's money. Kinloch Castle is built of beautiful red sandstone, which was specially quarried and shipped from Ayrshire, and it took a team of 300 men just over three years to turn George's fantasy design into a reality. An enormous staff, including 40 gardeners, attended to the needs of the Bulloughs, keeping them in the height of luxury on their Hebridean island, where they spent just four or five weeks every year.

Abby Dudgeon from Scottish Natural Heritage guided me around the sumptuous interior, where the finest craftsmanship, the best furniture and fittings that money could buy, from solid oak panelling to silk wall hangings, to the Steinway concert Grand provided the owners with life's

comforts. Kinloch Castle was one of the first houses in Scotland to have hydro-electric power, and it also boasted the first internal telephone system in the country. The Edwardian plumbing is another marvel. An extraordinary shower-cum-jacuzzi takes pride of place, soothing the bather with jets of water. All these luxuries and innovations made life more elegant and sophisticated for George Bullough and his wife, the society beauty Lady Monica, whose influence on Kinloch Castle can clearly be seen in much of the decor.

Up on the first floor, I was impressed by Lady Monica's boudoir, its soft furnishings and pastel shades, but surprised to find no sign of George in the bedroom. Abby told me that George had rooms on the other side of the castle. In effect there was a gender divide running through Kinloch. He had his half of the castle and she hers. They often entertained their own guests separately. 'Not all Lady Monica's guests were women,' Abby began to explain coyly. 'She had a bit of a reputation and there were rumours of affairs.' Discretion seems to have been a byword at the castle. Servants were excluded from the ballroom. If the Bulloughs and their guests needed anything, there was a hatch through which written orders were passed to the butler, who sat patiently waiting on the other side.

Crossing the island, I came to a monument to the less fortunate inhabitants who had been forced to emigrate. Known locally as the Clearances Stone, it's a poignant reminder of the troubled history of this island and is said to have been rolled into place by the people of Rum as they were being evicted and sent to Canada. The stone was a final gesture – a display of grief and defiance by a people who had no desire to leave the land of their ancestors. Continuing south-west, I passed through the eroded magma chamber of Rum's ancient volcano.

Poking through the heather were the cracked remains of lava flows, which looked as if they had only just recently cooled. The rough track I followed eventually took me to a place called Harris on the bleak south-west coast. Here I was astonished to see the extent to which the land had been worked by islanders in the past. Outlines of their lazy beds, raised strips of cultivated soil, were everywhere, like giant worm casts of effort in the landscape. Further on, past the forlorn, weed-choked ruins of a cleared village, a bizarre sight greeted me. On a green sward overlooking the sea stood a Greek temple. This was the ostentatious mausoleum built by the Bulloughs, designed to make a statement about their status. George Bullough is interred there, along with his father. Lady Monica, who lived to be 98, chose finally to lie with her husband in death. She died in 1967. And with the passing of her daughter in 1990, the Bullough line died out.

I spent the night in an island B&B. Despite well sealed windows, Rum's notorious midges managed to seek me out indoors. To get to sleep, I was forced to wear a midge net for protection. In the morning, the shower tray was thick with their corpses. I shared the breakfast table with two middle-aged ladies who were on an island walking holiday. They were both excited to have seen a sea eagle – part of the population that was reintroduced to Rum in the 1970s.

Leaving the ladies, I set off to climb Hallival and Askival. Just before Corrie Dubh, a large otter crossed my path and scrambled down to the bottom of a deep ravine where it swam in the river – all sleek and wet. It took two hours to reach the summit of Hallival (702 metres). The weather was deteriorating and it began to rain. Mist swirled around the tops as I clambered gingerly along a

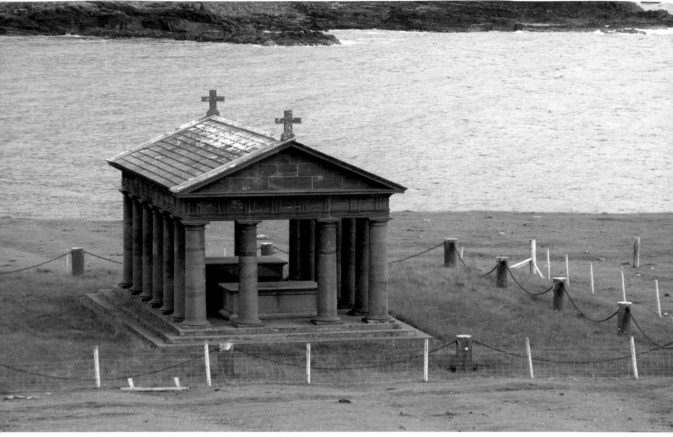

The Bullough mausoleum, Rum, built in the style of a Greek temple.

narrow, steep and exposed ridge of grass and rock. Here I found the skulls and bones of a couple of Manx shearwaters. I then heard the eerie call of these nesting seabirds coming from burrows in the green turf. Legend has it that when the Vikings heard this sound among the cloud-wreathed summits, they thought it was made by underground trolls and named the mountain after them: Trollaval or Troll Fell. In the remote south of the island, the name Papadil reminds us of an age before the Norse arrived – of the early Irish monks and of Beccan the Solitary, the 7th-century monk whose home this is said to have been and whose poetry still survives.

CANNA AND SANDAY

No one can be certain of the origin of the name. It could come from Old Irish *Cana*, meaning 'Dog Island', from Gaelic *Cana* meaning 'Porpoise Island', or perhaps from Old Norse *Kne Øy* or 'Knee Island' on account of its shape. Canna is the most northerly of the Small Isles and is owned by the National Trust for Scotland. It actually comprises

two islands. Smaller Sanday is separated from the main island by a narrow tidal channel, which is crossed by a small bridge. Together, the islands measure about 8 kilometres from east to west, and 2.5 kilometres from north to south. Canna is fairly flat with fertile basalt soils. The high points are Compass Hill (143 metres) at the eastern end and Carn a'Ghaill (210 metres) just to the west of it. The population has fluctuated wildly in recent years. In 2001 it was down to just six. Ten years later it had increased to 18 – not because of a baby boom, but because the NTS had tried to 'grow the population' with a campaign encouraging people and families to move to the island.

There is a regular CalMac ferry service to Canna from Mallaig, but I chose instead to make the crossing from Elgol on Skye. It was a beautiful June day, with the Black Cuillin providing a dramatic backdrop and the savage coast of Rum, reminding me of the perils of the sea. Wedged into a cleft in the cliff was the wreck of a French fishing vessel that had run aground in a gale a couple of years previously. 'There were fourteen men on board,' my skipper explained. 'They were all lifted off by helicopter. Apparently, the captain had fallen asleep at the wheel!'

'It's an odd sight,' I said. 'It looks as if the fishing boat was put there by some giant.'

'It won't last long in that position. The storms will smash it to pieces. In a few years' time there will be hardly anything left to see.'

Canna was probably inhabited for the first time shortly after the great ice sheets of the last glacial period finally melted about 10–11,000 years ago. The earliest evidence of human occupation dates back 7,000 years to the Neolithic period. An Coroghon is the probable site of an Iron Age dun or fort, perched on top of a basalt rock stack near the harbour where my boat came in. Rubha Sgorr nam Ban-Naomha in a difficult and isolated site is said to have been an early Christian nunnery. In medieval times, An Coroghon was turned into a prison, whose only access was by way of an improbably narrow and dangerous path. According to local legend this is where Donald, the 13th chief of Clanranald, imprisoned his wife to keep her away from the clutches of her lover, his enemy, a MacLeod from Skye. Judging by the steepness of An Coroghon, I imagine it would have been an almost impossible task for MacLeod to steal the lady away.

For many centuries, Canna belonged to Mac-Donald of Clanranald. During the 18th-century Jacobite risings, the clan's support for the exiled Stuart dynasty meant that many Canna men left to fight for the 'king across the water'. During the failed rising of 1745, records show that over 30 men left the island and never returned – victims of Bonnie Prince Charlie's ambition and the Hanoverian government's brutal reprisals. In the 19th century, Clanranald sold Canna to owners who were intent on clearing the island of its inhabitants. Evictions continued until a succession of new owners restored Canna's fortunes, first with the arrival of the shipping magnate Robert Thom and his descendants, and then latterly when the Gaelic folklorist John Lorne Campbell bought the island. After he moved into Canna House with his wife, the American ethnographer and musician Margaret Fay Shaw, the couple devoted their lives to the language and culture of the people they lived amongst. They collected songs and folk tales, and recorded the spoken word of a culture that was on the cusp of irrevocable change. John Lorne Campbell died in 1996, having gifted Canna and Canna House, with its priceless collection of Gaelic

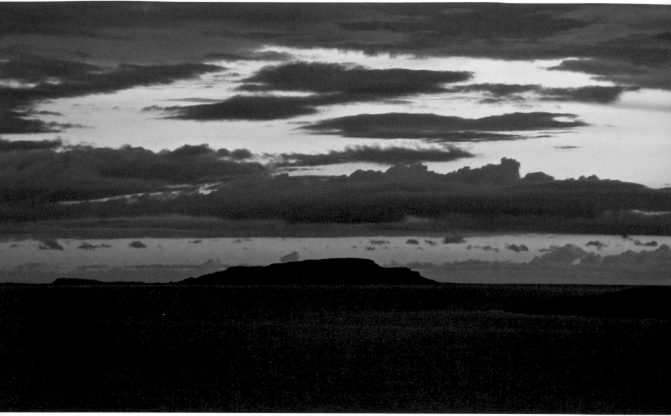

Canna from Elgol, Skye.

literature and folklore, to the National Trust for Scotland in 1981.

At Canna House, I met Magdalena Sagarzazu, who hails from the Basque region of Spain. She first came to Canna on holiday as an 11-year-old, staying with the Campbells, who were friends of her own parents. Magdalena fell in love with the island, and 45 years later was still there, having worked as the Canna House archivist for many years. In the cluttered library where John Lorne Campbell once worked, Magdalena showed me the equipment he used in the field to collect the songs, stories and daily life of the Hebrides. They

looked extraordinary, Heath Robinson contraptions, but were at the cutting edge of technology in the 1930s. Recordings were made on wax cylinders or onto wire spools, the forerunners of reel-to-reel tape machines. I was amazed to learn that such fragile recordings have survived and are now available in digital format and online.

John Lorne Campbell and Margaret Fay Shaw were pioneers in the field of ethnology, she with her camera and he with his microphone, recording and preserving the sights and sounds of a disappearing way of life. In their quest for authenticity, they not only recorded in the Hebrides, they also

Canna House, home of the eminent Gaelic scholar John Lorne Campbell.

followed in the wake of the emigrants who had left, generations earlier, for Canada, and Nova Scotia in particular. When Campbell died in his 90s, Magda came to stay with Margaret to be her companion and help, until Margaret's death in 2004 at the age of 101. Magda showed me into Margaret's study, which is kept just as it was when she was alive, full of mementos of a busy life. 'Margaret was a classically trained pianist and studied in Paris under Nadia Boulanger before she discovered the Hebrides,' Magda said. 'You know,' she continued, 'she was ageless when she played the piano. Her whole face radiated youthful energy.'

It is no accident that the couple chose to live and work on Canna. The island is geographically and culturally at the centre of the old Gaelic world. Steeped in legend and folklore, it was ideally placed to study and record the culture of the Hebrides, a labour of love that turned out to be very timely. Within a generation, the oral tradition, and the way of life that supported it, would largely die out in the islands. The songs and stories in the archives of Canna House are not just a testament to the couple who assembled them, they are a hugely important cultural resource.

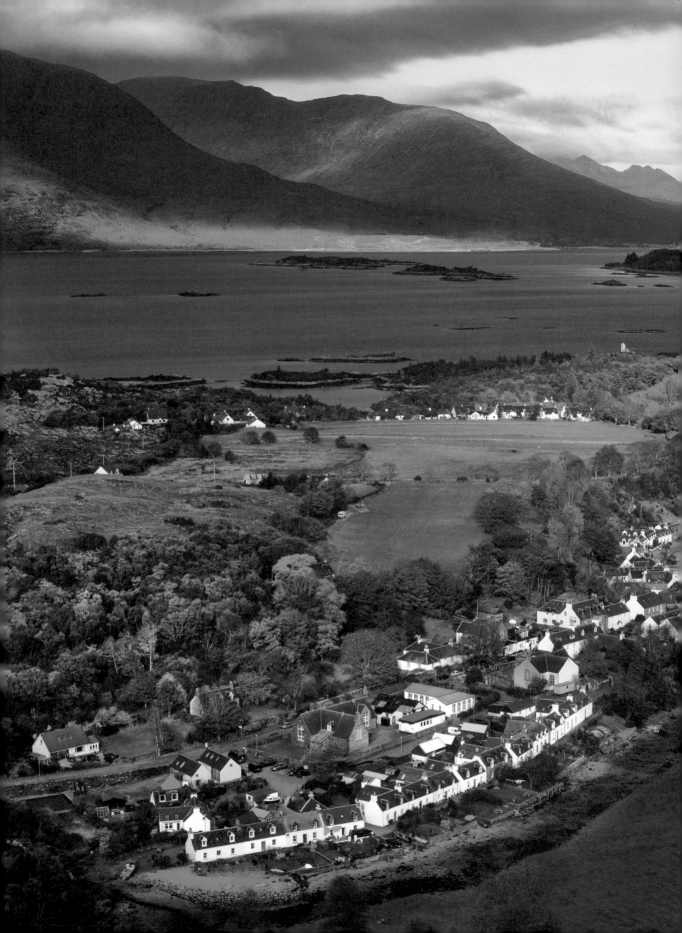

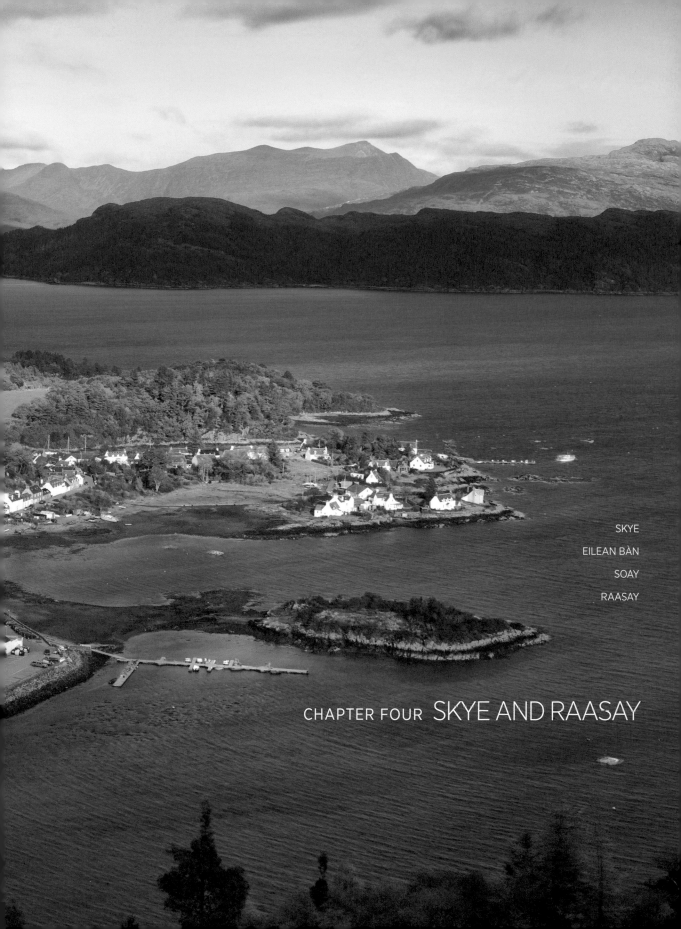

SKYE

EILEAN BÀN

SOAY

RAASAY

CHAPTER FOUR SKYE AND RAASAY

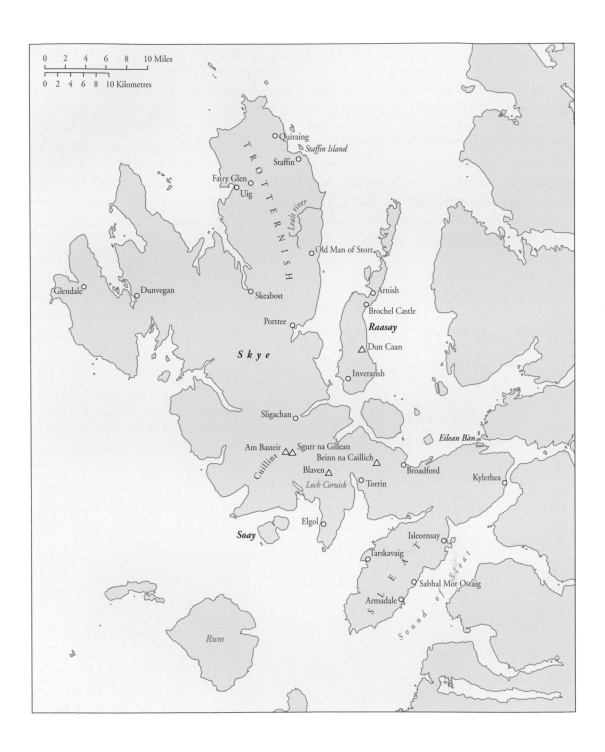

0 2 4 6 8 10 Miles

0 2 4 6 8 10 Kilometres

Quiraing

Staffin Island

Staffin

T
R
O
T
T
E
R
N
I
S
H

Fairy Glen
Uig

Lealt river

Old Man of Storr

Glendale Dunvegan

Skeabost

Arnish

Brochel Castle

Raasay

Portree

S k y e

Dun Caan

Inverarish

Sligachan

Eilean Bàn

Am Basteir Sgurr na Gillean

Beinn na Caillich

Cuillins

Blaven

Broadford

Kylerhea

Loch Coruisk Torrin

Soay

Elgol

Isleornsay

Tarskavaig

S
L
E
A
T

Sabhal Mòr Ostaig

Armadale

Sound of Sleat

Rum

SKYE

In Gaelic, the island is called An t-Eilean Sgitheanach, which is often said to mean 'the Winged Island', on account of its many peninsulas radiating like wings into the surrounding sea. It was referred to as *Skíð* in the Norse sagas, or *Skyöy*, 'the Misty Island'. The poetic Gaelic name for Skye, Eilean a'Cheo, also means 'the Misty Isle'.

The Isle of Skye is the second largest island in Scotland, after the long island of Harris and Lewis, and unlike most Hebridean islands has an increasing population (just over 10,000). From north to south Skye is about 100 kilometres long but, as the writer W.H. Murray noted, 'its breadth is beyond the ingenuity of man to state', because of its convoluted and irregular coastline, indented with many lochs and bays. Geologically, much of Skye claims volcanic origins. Dominating the south-west are the Cuillin mountains, which boast 14 Munros (mountains over 3,000 feet). These summits form the horseshoe crater of a huge, extinct volcano, which 60 million years ago rose 5,000 metres above the sea. Erosion by ancient glaciers and aeons of wind and rain have reshaped this once mighty volcano into a spectacular range of rocky peaks and improbable spires. Known collectively as the Black Cuillin, they provide arguably the best rock climbing in the whole of the British Isles. The north of the island towards the Trotternish peninsula is composed of a 300-metre-thick layer of basalt rock, which flowed as

Chapter opening: Isleornsay, Skye.

Above: The Red Cuillin, Skye, once part of the great Skye volcano.

lava from the Cuillin volcano, overlying much older sandstone. The sandstone collapsed millions of years ago and the resulting rock fissures have weathered into the surreal and fantastical shapes that can be seen at the Quiraing and the Old Man of Storr.

There is some dispute as to whether or not Skye is an island any longer. Since 1995, it has been connected to the mainland by a road bridge. However, because there are at least two ferries operating to the island, I think there's justification in keeping Skye's island status. The smallest of the ferries taking vehicles 'over the sea to Skye' plies the waters of Kyle Rhea. It sails from a slipway just north of Glenelg on the mainland to a landing stage on the opposite Skye shore. At Kyle Rhea there's an unmanned cafe housed in the little lighthouse above the slipway. Dropping a coin in the honesty box, I sipped a coffee that I'd made for myself, and waited for the ferry to arrive. Called the *Glenachulish*, she is the only turntable ferry still operating in Britain. She looked an ungainly craft when she hove into view, pushing against the strong current that flows through the kyle. There were once many similar little ships in Scotland. Their swinging decks enabled traffic to drive aboard from simple jetties, which larger vessels couldn't access. When the *Glenachulish* came alongside, the skipper Donnie MacDonald, aided by his dog Mac and a young student, swung the turntable deck into position, spanning the gap between the vessel and the slipway, like a bridge. Simple but effective. After a handful of cars had driven off, I followed the embarking traffic as it drove carefully onto the deck. It didn't take many vehicles before the *Glenachulish* was fully loaded. Then the turntable was pushed with some effort and locked back into position.

The kyle that separates Skye from the mainland is very narrow, only about 520 metres, but the current passing through is ferocious and strong. This means that Donnie has to use the technique known by mariners as ferry gliding – steering well upstream and side-slipping with the tide to reach the jetty on the opposite shore. I was amazed to learn from Donnie that in the old days, despite the tidal race, cattle from Skye were swum across the kyle on their way to markets in the south. 'They waited until slack tide, but even then the water boils and looks ugly,' Donnie said. 'But I suppose they thought there was safety in numbers.'

Two hundred years ago, the numbers of cattle crossing the kyle in autumn droving season would have been in their thousands. Driven by dogs, horses and men, enormous herds clattered onto the Skye shore like an unstoppable force and then plunged into the swiftly flowing waters of the kyle, where they were escorted by boats towards the mainland. Occasionally a beast or two was lost to the tide, but by far the majority reached safety. Halfway across, we gave way to a sailing yacht. Mac the dog began to bark. 'He's just making sure the seals keep their distance,' said Donnie, as the whiskery nose of a seal slipped beneath the surface. I was impressed to learn that the ferry, which runs every day from Easter to October, is a community venture. It was built in 1968 and originally served at the Ballachulish crossing of the narrows of Loch Leven before the Ballachulish Bridge was built. A Skyeman then bought the ferry and ran it as a private business until he retired in 2005. Then, because it was still a vital link for local people, the community formed a company to buy and run the ferry, which carries 34,000 passengers and cars every year. The company receives no

The turntable ferry at Kylerhea, the only one of its kind still operating in Britain.

subsidy and no grants, so all the costs of covering the ferry operation and the associated salaries have to come out of the revenue they make from fares.

From the ferry slip at Kylerhea, I took the road north over a steep pass, heading towards the village of Broadford, a linear development overlooking the islands of the Inner Sound. At the post office, I bought a Gaelic phrasebook, but was disappointed that no one I met seemed confident in the native language of the island. The only exception was a young woman who was studying at the Gaelic college, Sabhal Mòr Ostaig. She came from the Home Counties, but her grandparents were Skye folk and she had been inspired by their history to learn the language of her ancestors. 'Did they speak to you in Gaelic?' I asked.

'No, not at all. They thought there was no point in me learning a language that no one spoke, except themselves. But for them, Gaelic was their world. The world of their childhood and their romance. I wanted to learn to speak Gaelic so that I could share that world with them.'

Rising majestically above Broadford village is Beinn na Caillich – the 'Hill of the Old Woman'. The first recorded ascent of this rounded, scree-strewn mountain was made in 1772 by the geographer and early travel writer Thomas Pennant, who was struck by the mountain peaks he could see from the summit: 'the prospect to the west was that of desolation itself; a savage series of rude mountains, discoloured, black and red, as if by the rage of fire. The serrated tops of Blaven affect with astonishment: and beyond them, the clustered height of Quillin.' Although the name Beinn na Caillich is Gaelic, the legend behind the huge

cairn that adorns the summit connects this part of Skye with its Norse heritage. The 'old woman' in question was once a beautiful Viking princess. In later life she asked to be buried on top of Beinn na Caillich and close to the winds blowing from her Norwegian homeland. When she died, her body was carried to the top of the mountain, and a cairn built around it. Not wishing to disturb the repose of a Viking princess, I turned my back on Beinn na Caillich and the wonderful view it promised and set off instead towards the Sleat peninsula – where a lighthouse marks the southernmost point of the island.

Isleornsay, or Eilean Iarmain, is a picturesque village of mainly white houses on the shores of the Sound of Sleat. Although the name suggests an island, the village isn't surrounded on all sides by the sea. Instead, it takes its name from a wooded, tidal island opposite called Ornsay, which helps to create a sheltered harbour for the village. Most of the older buildings date from the 18th century when Isleornsay was a busy herring fishing port and an important link in the steamer network connecting Skye to the cities of the south. The growth of railways sent Isleornsay into decline. However, an unlikely scheme was devised to revive the fortunes of the village and the whole island of Skye with a Hebridean rail network. This Victorian vision of modernity imagined a railway line leading from the steamer pier at Isleornsay to Portree in the north and to Uig in the north-west, with a branch line to Dunvegan, the ancient seat of Clan MacLeod. In total, the Hebridean Light Railway, as it was called, would have stretched for over 75 miles, and its meticulously detailed plans, dated 1898, are still held in the National Archives at Kew. Its budget was £500,000, a bargain when you think about it, but lack of funding meant that the Hebridean Light Railway never happened.

If the Victorians' vision of the future was full of steam, steel and burning coal, then the white modern buildings of Sabhal Mòr Ostaig, a few miles south of Isleornsay, offer a different take on things to come. This further education college, which is part of the University of the Highlands and Islands, is the only higher institute of education to offer courses through the medium of the Gaelic language, which for so long was reviled and branded as a handicap to social advancement in the monoglot English-speaking British state. Founded in the 1970s by activists who campaigned to raise the profile of the Gaelic language, Sabhal Mòr Ostaig is a significant achievement and boasts students from home and overseas, who come to the college to study a range of courses relevant to modern life, from accounting, ecotourism, hospitality management, mechanical engineering, social services, music, film and television. With modern skills and armed with Gaelic, it's hoped that graduates will help to keep the ancient language of the Highlands and Islands alive for generations to come.

Since the 16th century, Sleat has been part of the territory of Clan Donald, whose chiefs were at one time the most powerful rulers in the Hebrides. At Armadale, near where CalMac ferries come and go to Mallaig on the mainland, is Armadale Castle – or what's left of it. From the 1650s onwards, MacDonald chiefs began staying at Armadale, building a succession of ever grander mansions and country houses on the site until they abandoned the present 19th-century building in the 1920s. The castle and much of the old MacDonald lands now belong to the Clan Donald Lands Trust, founded and supported by the global community of MacDonalds, the most numerous

of all Scottish clans, boasting a family of over 20 million worldwide. At the castle today, there is a heritage centre, museum, library and genealogy centre to help modern MacDonalds unravel their ancestry and ancient Skye connections.

I took the single-track road over to Tarskavaig on the north coast of Sleat, where I had a rendezvous with a female member of a rival clan: Shona Mcleod from Sutherland. Unusually, Shona is a drystane dyker, a builder of stone walls, and is one of the few women in Scotland qualified to undertake this traditional craft. When I met her in the half-ruined croft house she was rebuilding for a client, she was clad from head to foot in a fine mesh – a net to keep the dreaded midges at bay. It wasn't long before I too had to use similar protection; so the memory of our encounter is somewhat blurred by a partial loss of vision due to seeing the world through a cloud of midges. Shona told me that many of the drystone dykes we see today, crossing miles of empty hill and moor, were the work of crofters in the past who were sometimes forced to build a section of wall in lieu of rent; and during the era of the Clearances and the potato famine, tenants were often given tasks to do in return for food. Building walls and estate boundaries is often what they did, binding their fingers with strips of torn cloth for protection because they were too poor to afford gloves. It must have been desperate work. Midges may be the terror today, but at Dunscaith on the west side of Sleat the legendary warrior Queen Sgathach is said to have taught the Irish hero Cu Chulainn his fighting skills.

I followed the route of a disused railway line for a few kilometres over the moors. Although the Highland Light Railway remained an unrealised plan, steam trains did in fact puff their way across this part of Skye. In 1908, a five-mile stretch of track was built to link the steamer pier at Broadford with several quarries in the neighbouring hills where marble has been extracted since the 18th century. Skye marble is a beautiful and highly prized green serpentine stone and was used to adorn the interiors of many fine churches and secular buildings around the world. The quarries that were linked by the old railway line I was walking along closed a hundred years ago – but plenty of evidence remains of the workshops and the track that carried the products to market. Marble is still extracted on Skye from giant quarries near the settlement of Torrin – but today it's put to a much more mundane use. Instead of being fashioned into high value products – such as an altar for a cathedral – the stone is crushed into powder and used as agricultural lime. This seems a terrible waste of such a beautiful resource. However, Skye marble is still considered by local folk to bring good luck; so picking up a small piece I found lying in one of the old quarries, I popped it into my pocket and continued on my way.

Ahead of me towered the mighty bulk of Blaven, an impressive and intimidating outlier of the main Cuillin range. Blaven is a mountain that inspires poetry – indeed, the great 20th-century Gaelic poet Sorley MacLean, who knew Skye and its peaks intimately from having roamed them in his youth, made many references to the Cuillin mountains and to Blaven in his work: 'And even if I came in sight of Paradise, what price its moon without Blaven?' Sorley MacLean wasn't the only wordsmith to climb Blaven. The first recorded ascent was made in the 19th century by the poet Algernon Swinburne and John Nichol, a professor of English at Glasgow University. They spent the summer of 1857 on Skye, mostly in an alcoholic

Blaven, the Skye mountain which inspired Gaelic poet Sorley MacLean.

stupor, but found the energy to climb Blaven, which they mistakenly thought to be the highest peak on the island. Unlike Sorley MacLean, there's no record of Swinburne having immortalised his experience of Blaven in verse. Perhaps the view from the summit was enough to take the words right out of his mouth.

Instead of replicating Swinburne and Nichol's drink-sodden achievement, I decided not to climb Blaven on this occasion, but to explore underground: descending into a nether world of darkness, bones and ancient myth. My guide to the underworld was archaeologist Steven Birch, who for the past decade had been studying a limestone cave system opposite the towering summit of Blaven. Called Uamh An Ard Achadh (Cave of the High Field), the network of subterranean passages

has revealed much that brings the lives of our pre-historic ancestors into sharper focus. We accessed the cave system by ladder, climbing down a shaft to emerge into a limestone passage that had been formed by the erosion of an underground stream. After crawling almost bent double through the dank darkness, we reached a dry chamber, which Steve called the Bone Cave. Originally, a series of now blocked-off stone stairways linked the cave to a ritual site above ground; but it was here in the tomb-like dark, 15 metres below the surface, that Steve and his team made their most significant finds, which are regarded as amongst the rarest and most intriguing artefacts ever to appear in the Scottish archaeological record. 'It was like a treasure trove,' Steve remembered. 'There were stone tools, pottery, bone needles, covering a time span

On the way to the Bone Cave with Steve Birch, who found the fragment of an ancient lyre whilst excavating the site.

of 5,000 years of human history – from the Stone Age to the Iron Age builders of the brochs.'

'Why did you think this was a sacred site?' I asked.

'From other cave sites around the world, and especially in Ireland, we think that there was ritualistic activity going on underground. For centuries, caves were seen as other-worldly places – a transitional environment between the upper world of the living, and the underworld of the dead. This is where you could communicate with the ancestors, or perhaps make offerings to the gods who dwelt beneath the earth.'

Steve went on to explain that the cave was probably only used ceremonially at certain times of the year, coinciding with festivals we now call Beltane and Hallowe'en.

Steve put his hand in his pocket and pulled out a fragment of carved bone. 'This,' he said with slow emphasis, 'is the bridge of a stringed instrument – an early lyre. It's been dated from between four and five hundred years before the Christian Era and is considered to be the earliest evidence of a stringed musical instrument in the whole of western Europe.' It was extraordinary to think what sounds the original lyre would have made, and what music our ancestors once played.

Emerging from Uamh An Ard Achaidh and back into the light, I headed west along a road that skirts the foothills of Blaven, to a place that sounds more mythical than real: the evocatively named Elgol – not a location in *The Lord of the Rings*, but a real place of fishing boats and working crofts, where the view into the heart of the Cuillin is

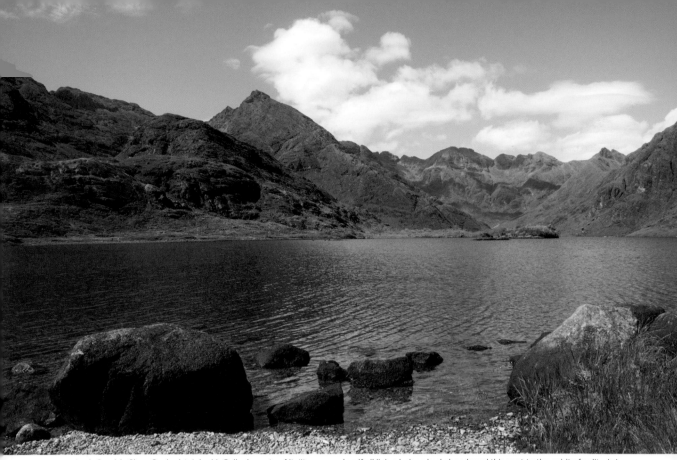

Loch Coruisk, Skye. Geologist John McCulloch wrote of it: 'It appeared as if all living beings had abandoned this spot to the spirit of solitude.'

billed as one of the best vistas in the world. It has inspired artists, musicians and storytellers for centuries. Sir Walter Scott came, as did Tennyson and Turner, to name just a few of the greats who have gazed in awe at nature in all its naked and unrestrained grandeur. Following in their wake, I took a little boat from Elgol pier on a quest to find the quint-essence of romantic inspiration – the utterly desolate landscape of Loch Coruisk: a body of fresh water lying at the centre of a gigantic amphitheatre formed by the rocky peaks of the Cuillin mountains, which tower threateningly more than 3,000 feet above its dark surface. Sixty million years ago this was the heart of a gigantic volcano. The dramatic nature of this location was first brought to public attention by John McCulloch, a geologist and friend of Sir Walter Scott. McCulloch was quite a cynical man. Usually, he

relished the opportunity to rubbish any landscape eulogised by guidebooks or previous visitors but, when it came to Loch Coruisk, even he was enthralled by what he claimed to have 'discovered': 'I felt transported as if by some magician into the wilds of an Arabian tale. Not an atom of vegetation was anywhere discernable. It appeared as if all living beings had abandoned this spot to the spirit of solitude. I held my breath to listen for a sound, but everything was hushed.'

The mountains of the Black Cuillin have provided adrenaline-fuelled sport since 1836, when Sgurr na Gillean became the first peak to fall to the ambitions of a party of keen climbers. However, in mountaineering terms, the Cuillin was developed relatively late. The Alps had already been opened up and, in England, the Lake District was providing a climbers' paradise. The reason for

Skye's mountains being initially overlooked was due to their relative remoteness. Before the railway to Kyle of Lochalsh was built, the Cuillin mountains were less accessible to southern-based gentleman climbers than the peaks of the Mont Blanc massif. After the railway opened to traffic however, climbers discovered the grandeur of Skye's mighty Cuillin. These challenging summits could be enjoyed like an Alps in miniature. And because they were small enough to conquer in a day, this enabled pioneering climbers to enjoy the comforts of the Sligachan Hotel in the evening. One of these pioneers was an Englishman called Norman Collie, who came to Skye on a fishing holiday in 1886. The salmon weren't biting that year, so he turned to climbing instead. Am Basteir was his first peak, and he never turned back, going on to climb extensively in the Alps, America, as well as in Skye,

which he loved with a passion. Collie, who later became a celebrated research chemist, didn't climb alone. He had a guide, a Skye man called John Mackenzie, who was working as a ghillie at the Sligachan Hotel. The two became firm friends and together pioneered many now classic rock climbs on the Cuillin. Collie went on to make many first ascents in the Himalayas and the Canadian Rockies, but John Mackenzie never left Skye. When he died his friend Collie, who was now well into his 70s, made a solo ascent in his honour of their first peak, Am Basteir. As I negotiated the final narrow ridge of their route to the summit, I metaphorically took my hat off to those two admirable climbing friends.

Portree is a pretty harbour town about halfway up the east coast and is the capital of Skye, with a population of about 2,500. In Gaelic Port Rìgh

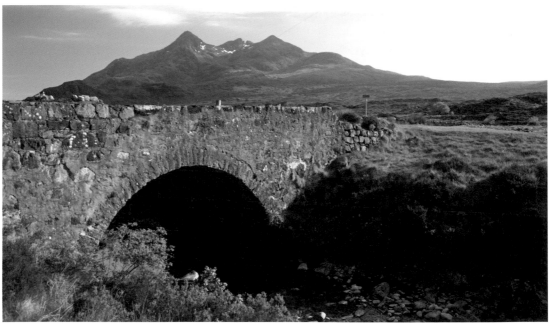

Sgurr na Gillean, one of Skye's Black Cuillin.

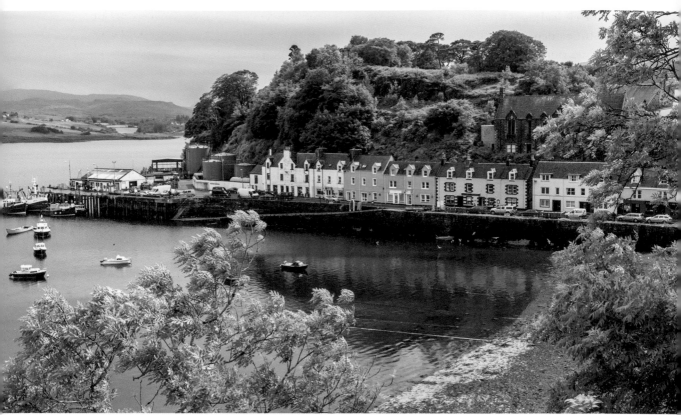

Portree, the main town of Skye, where Bonnie Prince Charlie bade farewell to Flora MacDonald.

means the 'Port of the King'. In this case, the king in question was the Stuart James V. He came here in 1540 with a large fleet of warships, but he wasn't on a royal visit to meet and greet the locals. For a long time, warlike island clans had been a thorn in the side of the king. So when James came to Skye, he was on a mission to ensure that the powerful MacLeods and MacDonalds acknowledged his authority as King of Scotland. And just in case of any misunderstanding, James had the might of his navy to back him up. Like the clans he wanted to cow, King James was more than willing to use strong-arm tactics to ensure he got his way. The warrior reputation of the Skye clans was based on an ancient military tradition which venerated physical prowess and fighting skills above all else. To impose his will, the king had to show that he was even more powerful.

The town of Portree that stands on the shore today is just a couple of hundred years old and was designed by the MacDonald lord as a herring fishing port. The little hill to the south of the harbour is known as the Lump and was the location in former years of grisly public executions. Today, the Lump is crowned by magnificent pine trees and an early 19th-century castellated folly. Known as the Apothecary's Tower, it was built by a respected local worthy who had trained as a

doctor. He had plans to transform The Lump into pleasure gardens, with the tower as a centrepiece set to become a museum. I'm not sure if these plans bore fruit, but the flat area close by is the location for Portree's biggest annual event – the spectacular Skye Highland Games.

Portree is where Charles Edward Stuart, the Bonnie Prince of the Jacobite uprising, said his final farewell to his saviour Flora MacDonald, who had famously carried him by boat 'over the sea to Skye'. This wasn't the last sad parting of the 1700s. As the century neared its close increasing numbers of Skye folk began to flee poverty and overpopulation. Boarding ships anchored in the bay, they sailed to North America. James Boswell, who visited Skye in 1773 with Dr Johnson, wrote: 'Last year when the ship sailed from Portree for America the people on shore were almost distracted when they saw their relations go off. This year not a tear is shed. The people on the shore seemed to think they would soon follow.' And follow they did – but not always voluntarily, as the lady traveller Sarah Murray found out just thirty years later. Sarah Murray was an extraordinary woman. A wealthy resident of Chelsea, this refined lady loved Scotland with a passion. And nothing – not the bad hotels, the non-existent roads, not the midges or even the dreadful weather – dampened her enthusiasm for the landscape and the people, who made a great impression on her. She described them as honest and brave despite their poverty. When she came to Skye in 1802, she was charmed by their manners and saw the human dignity beneath their rags:

It was a very fine day, and we found several very old men and women sitting upon stones near their huts beside a rattling burn, with their grandchildren playing about them – watching and attending them with filial anxiety and affection. It was a pleasant sight. I entered one of the poorest huts, and there found a female, who seemed out of her place in society, for she could certainly have been born in a superior station in which I found her.

Sarah Murray knew that she was witnessing the end of an era. Tenants on Skye were being forced from the land they loved, and Sarah saw for herself the 'melancholy departure of many of the emigrants'. She was quick to apportion blame: greedy landlords screwing – and that's her word – their tenants for money. 'In a very few years,' she wrote, 'the Hebrides will be deserted, and the honest, brave race of West Highlanders will be totally extinct – as well as their language.' She made that prediction long before the worst of the evictions – the infamous Highland Clearances – emptied so many islands and glens of people.

A generation later, another woman wrote passionately about the cruel treatment of the people at the hands of their landlords. Unlike Sarah Murray, she was a poor native of Skye. Her name was Mairi Macpherson.

Mairi was born at the north end of Skye in 1821. She married and moved to Inverness, where she had several children. When her husband died prematurely, Mairi had to work to feed her family, but her life changed dramatically when she was falsely accused and imprisoned for stealing a scarf. This had a huge psychological and emotional effect. To express her anger at the injustice she had experienced at the hands of society, she turned to Gaelic poetry and song, articulating the greater injustice experienced by her own folk on Skye

and across the Highlands, as more and more communities were cleared off their land and sent into exile. Her talent for speaking truth unto power enabled Mairi to become a mouthpiece for land reform, which was then regarded as a dangerous revolutionary movement by the authorities. But after decades of forced evictions, the people began to resist. Violence erupted on Skye. Troops were mobilised to protect the rights of the landlords. But public opinion, led by the newspapers and influenced by the voice of Mairi Mhor, became sympathetic to the plight of the crofters. After years of struggle, ordinary people eventually won the legal right to make a decent living from the lands of their ancestors, without the constant fear of eviction hanging over their heads.

Leaving Portree, I headed towards the Trotternish Ridge, which runs north for about 24 kilometres, forming a veritable geological circus: a floorshow of weird rock formations, a cabaret of the fantastic and the surreal. The entire ridge is an ancient volcanic wilderness composed of lava beds that flowed across the landscape 60 million years ago. Since then, time and the elements have worn the basalt rock into strange and awe-inspiring rock formations, creating a unique landscape which has been used as a dramatic backdrop in several epic films, from the *Alien* prequel *Prometheus* and *Star Wars* to the 2015 version of *Macbeth*. Perhaps the most famous and widely photographed of the rock formations is the spectacular Old Man of Storr. Easily seen from Portree, he looks like a finger of rock rising at a preposterous angle from the base of the basalt cliffs of the Trotternish Ridge, which rise to over 700 metres above the sea. On account of the Old Man's movie fame, he's become a major attraction for fans and tourists. He's also easy enough to reach,

taking just over an hour to walk to along a well-worn track. But if you want to avoid the crowds, it's best to start early. The Old Man figures large in several local legends. One tells of an old man and his wife and what happened when they encountered a group of giants roaming the hills. Fleeing in terror, they made the fatal mistake of looking back at their pursuers and were turned to stone by the terrifying sight they beheld. I'm not sure where his old lady is, but the Old Man must have been something of a giant himself. He's over 50 metres tall. Locally, he's known as Am Bodach, which is also Gaelic for the male member – and it doesn't take much imagination to see why!

After walking for a couple of hours along the high-level path of the Trotternish Ridge, I descended to the beautiful waterfall of the Lealt river, which is famous for being the shortest salmon river in Europe. The fishing beat is actually just a few hundred metres long, from the sea to first waterfall. Here I met angling guide Ian Stewart to learn about the mystic art of fly-fishing. 'It's not about strength. It's about timing,' said Ian, as he demonstrated how to execute the overhand cast.

'So, it's about rhythm; like playing an instrument – a single stringed instrument!' I suggested. 'But do you think the salmon will be fooled by my antics?'

'You have to remember that when the salmon returns from the sea, it stops feeding,' explained Ian.

'But if it's not hungry, why are we trying to entice it to bite on a fly?'

'We're trying to trigger an instinctive reaction. The salmon might not be hungry, but it can get angry, and when it's annoyed it lashes out – hopefully at our fly so we can hook it.'

Unfortunately, my casting skills showed no

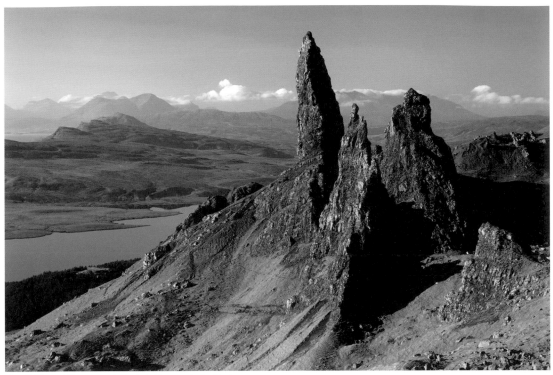

The Old Man of Storr, one of Skye's striking geological features.

signs of improving. After a couple of hours, I hadn't had a single bite. Ian then decided to change tactics and swapped my feather fly for a bright metal spinner. With my very first cast, I snagged it on a grassy ledge high on the waterfall cliff. At that point, even Ian thought it was time to give up.

For generations of islanders, salmon fishing was in their blood – not just as a sport, but as a means of making a living. All along the coast there were commercial fishing stations where salmon were caught in a complicated system of nets. Leaving the Lealt, I headed up the road to Staffin, where I dropped in on Lachie Gillies, who is one of the last men to use the traditional bag net technique to land salmon in commercial quantities. Now

retired, Lachie was a fisherman all his working life. He proudly showed me a detailed model of his last boat. 'The *Osprey* was the best boat I ever owned,' he said. Before he was a skipper/owner, Lachie spent many years going after salmon. 'That's when they were plentiful,' he said. 'But no longer.' To help me understand the bag net technique, he produced his photograph album. Inside was a snapshot of a smiling 20-year-old Lachie, standing with his four mates outside the single-storey bothy on Staffin Island, where they stayed during the week. 'The bag net was really a double cage made of netting, kept afloat by barrels, and tied with stakes to the shore,' Lachie explained. 'We rowed it into position and from there to the anchor was

Salmon fisherman Lachie Gillies, with a model of his boat, the *Osprey*.

probably 100 metres, so it was a big old net. And after every catch, we had to dry the net onshore. It was a lot of work, I can tell you. The salmon were then packed in ice, which had been collected during the winter and stored in an ice house. After that the fish went by steamer and train to restaurants in Glasgow and London.'

'How many salmon would you be catching?'

'Well I've seen us catching a hundred a day. The day you caught a hundred fish or more, the boss in Portree would always send down a bottle of whisky so you could make a hundred the following day!'

'That's a good incentive!'

'Not for me – I don't drink!'

At 86, Lachie was still as sharp as a tack. He and his wife Peggy spoke to each other in Gaelic, jogging each other's memories as they reminisced. She came from Scalpay in the Outer Hebrides, and still felt like an incomer. The pair had met when Peggy was a teenager, working in a local hotel.

'You must have seen a lot of changes, Lachie.'

'Och yes, and not just the decline in fishing. There's no salmon any more, and we are surrounded by English people now,' he said wistfully, before teaching me to say *mar sin leibh*, which is Gaelic for 'goodbye'.

Before I left Staffin, I headed down to the shore, where at low tide I'd been assured it's possible to get in touch, quite literally, with some giants of the fossil age. In a smirr of chilly rain, I met local fossil expert Dugald Ross. Together we paced the seaweed-covered rocks looking for footprints. In front of us was a series of shallow water-filled depressions in the exposed sandstone. These, Dugald insisted, had been made by living, breathing dinosaurs, as they wandered across an area of tidal mudflats some 170 million years ago, long before the great Cuillin volcano spewed billions of tons of lava across the landscape. It is only now, as the layer of basalt lava is eroded, that the much older rocks have been revealed – along with their extraordinary fossilised footprints. When the prints were discovered a few years ago, they caused a sensation. They enabled scientists to increase our understanding of the long-extinct creatures that made them. 'They were sauropods,' Dugald said, 'and walked on four legs. They weighed about fifteen tonnes.'

No one should leave Trotternish without visiting the mysterious and wonderfully named Quiraing, a word which supposedly comes from the Old Norse *kvi rand*, which means a 'round fold', or 'animal pen'. To get to the Quiraing is relatively straightforward. A path leads across the hills from the pass on the road between Staffin and Uig. The wild jumble of rocks that makes up the landscape is the result of an ancient landslip that happened on a truly gigantic scale some 60 million years

ago, when Skye's giant Cuillin volcano was active, pumping out unimaginable quantities of molten rock. This lava cooled and became the basalt that makes up the Trotternish Ridge. The layer of basalt is about 300 metres thick and sits on top of much older, softer rock, which eventually collapsed under the colossal weight. The land split and slid away to the east of the summit ridge. Apparently it's still moving a few centimetres each year – a kind of slow-motion natural disaster which has created the landmarks that tourists have flocked to see for generations. A favourite with the Victorians was the Needle – a 40-metre-high pinnacle that's not unlike the Old Man of Storr, which makes me think that perhaps this is his missing wife! At the heart of the Quiraing is the Table – an extraordinary elevated level platform which is probably the original *kvi rand*, the Viking's animal fold. It's not difficult to imagine cattle or sheep grazing on its green, hidden pastures. This is also where Skye men of old enjoyed a midsummer shinty match.

On the way across the island from Trotternish lies Skeabost. This little island in the River Snizort was the site of the Norse bishopric of the Isles, and to this day the tumbled-down remains of the

At the Quiraing, Skye. The extraordinary landscape here was caused by an enormous landslide which occurred 60 million years ago.

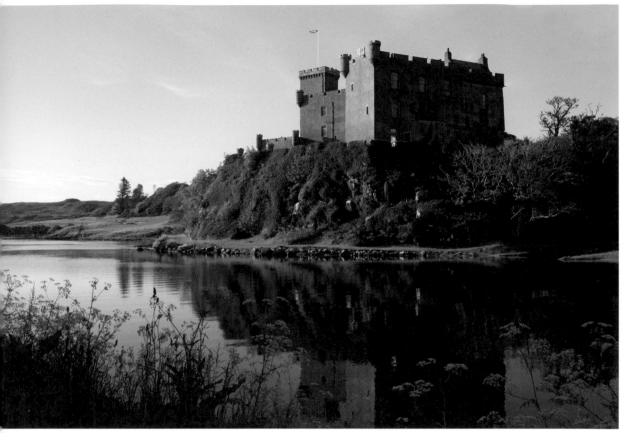

Dunvegan Castle, Skye, seat of the Clan MacLeod.

church and tombs have a peculiarly haunting effect.

Skye's historical jewel in the crown has to be Dunvegan Castle, the ancient seat of Clan MacLeod, home to the current chief and the oldest permanently occupied castle in all Scotland. The MacLeods are said to be descended from the son of the Viking King Olaf the Black, who died in 1237. He ruled over the Isle of Man and the Northern Isles and had two sons: Tormod, from whom the MacLeods of Harris and Dunvegan are descended, and Torquil, the progenitor of the MacLeods of Lewis. The present castle dates back to 1266 and stands on the foundations of an even earlier Viking fortress. The most notable relic from those far-off days is the famous Fairy Flag: a fragile piece of silken cloth that hangs in a glass case in the castle. According to one of the many legends associated with the flag, the MacLeod chiefs are part fairy folk as well as part Viking. The story goes that a MacLeod chief had a child with a fairy princess. When the princess returned to fairyland, she came back to Dunvegan to comfort her baby when it cried. The shawl in which the fairy princess wrapped the infant became imbued with magical powers and is now

the fairy flag. It's claimed that when carried into battle by the MacLeods, the fairy flag will ensure victory. However, other stories say that the flag can only be deployed three times. Two of these lives have already been used. During the Second World War, the MacLeod chief offered to unfurl the flag for a third and final time at Dover, to protect the nation from the Nazi threat across the channel. Fortunately for all concerned, the services of fairyland were not required in the fight against fascism.

Further to the west another sort of battle took place. Glendale – just beyond which is situated one of Scotland's most spectacular mainland lighthouses – saw the final struggles of the crofters in the run-up to the great crofting reforms of the late 19th century. Here Britain came close to insurrection when local crofters took up arms in protest against a system which removed all security of tenure from families whose ties to the land had lasted many centuries.

Inspired by thoughts of fairy folk and their hidden, parallel world, I set off to explore one of Skye's most enchanting locations, the Fairy Glen. It's a curiously miniature landscape of grassy knolls and tiny weathered trees. Seeing it for the first time, it actually reminded me a little of TV's Tellytubbyland. But Skye's fairies are not the sort to entertain young children. These supernatural beings are not sweet, cherubic creatures with faces like little angels. They are strong-willed, warlike spirit-beings, with magical powers, capable of doing great harm. Stories abound of children taken from their homes to be replaced with changelings, or of people who disappear into the fairy realm for what seems a few moments, only to discover when they return that several days or even years have passed.

EILEAN BÀN

The name is Gaelic and means the 'White Island'. Technically speaking, Eilean Bàn is an island no longer. When the Skye Bridge was built in 1995, this tiny island of 2.5 hectares became a stepping stone for the final span and is now permanently linked to both Skye and the mainland. Indeed, for travellers speeding to Skye by car, it passes by in a flash, and the busy road carrying the traffic seems to leave little space for anything else. Eilean Bàn lies in the middle of the Kyle of Lochalsh, at the narrowest point of the strait that separates Skye from the mainland. In the old days car ferries shuttled back and forth between Kyleakin on Skye and the mainland village of Kyle of Lochalsh, carrying locals and tourists. As the ferry could only take a few cars at a time, the wait to cross could take hours. The solution was to build a bridge, which opened in October 1995. Now people *drive* over the sea to Skye – up to 20,000 cars and their passengers on a busy day. Interestingly, the bridge doesn't cross the Kyle in a single leap. It hops across, and the place where it rests its legs for a while is Eilean Bàn.

This little island has played a strategic role in the history of the Skye crossing for centuries. In Viking times, a Norwegian princess known locally as Saucy Mary married the chief of Clan MacKinnon and together they set about extorting money from any ship passing through the Kyle. According to legend, they ordered a chain to be strung across the water from Skye to Eilean Bàn and from Eilean Bàn to the mainland. To sail beyond this barrier, ships had to pay a toll to Saucy Mary, who grew rich and fat on the fares, though history is silent on the exact nature of her sauciness!

Inside the home on Eilean Bàn of Gavin Maxwell, bestselling author of *Ring of Bright Water*.

For many years Eilean Bàn was inhabited by lighthouse keepers who were stationed on the island until the 1960s. After that time, it became the final home to Gavin Maxwell, the author and naturalist who rose to fame with his book *Ring of Bright Water*. Maxwell bought the island after his previous home on the mainland near Glenelg burned to the ground. On Eilean Bàn he converted the keepers' two cottages into one residence and created what is known as the Long Room, which looks a little incongruous. It's modelled on the Long Room of an aristocratic castle – but then Maxwell was a blue-blood, being the grandson of the Duke of Northumberland. Today, the keepers' cottages on Eilean Bàn are the only museum to the life of Gavin Maxwell anywhere in the country.

Maxwell was always an outsider. During the war, he was a member of the secret and deadly organisation of spies and saboteurs called the Special Operations Executive. Later, he squandered his inheritance on a doomed shark-fishing enterprise in the Hebrides. Bankrupt, he tried various unlikely schemes to survive. For a brief time, he was a racing driver, then a society portrait artist, seeking commissions from wealthy aristocrats. He later became an explorer and finally a writer, finding fame and fortune with the story of a pet otter. Maxwell was only able to enjoy Eilean Bàn for a short time. A few months after he moved in, he developed an aggressive form of cancer and died. Today, Eilean Bàn is a memorial to an extraordinary life.

SOAY

The name is from the Old Norse *so-øy*, meaning 'Sheep Island'. Soay is a figure-of-eight-shaped island measuring about 5 kilometres long by 3 kilometres wide, nestling close to the Skye shore and dwarfed by the imposing Cuillin mountains which rise above it to the north. There is no regular scheduled ferry service to the island, which had a population of four when I visited in 2014.

The day I went to Soay, I took the boat *Heather Grace* from Elgol, skippered by Oliver Davis, who at the time was one of the full-time residents on Soay. Ollie told me that he had lived on the island for over 40 years. He was born in Botswana, but his parents, who were opposed to the influence of apartheid white South Africa on the affairs of the African kingdom, decided to leave when he was seven years old. Ollie's father, who had seen an advertisement in the *Times* newspaper for property for sale on Soay, bought a house on the island without seeing it first. 'The contrast with life in Africa was a bit of a shock to the system,' Ollie said. 'We tried to work the croft, but it was a steep learning curve. When we sought advice from the laird of Muck, Lawrence MacEwan, he fell in love with my sister and married her.'

Ollie's father wasn't the only person to buy a property on Soay on a whim. One of the other remaining residents, Anne Cholawo, fell in love with the island whilst on holiday on Skye almost 30 years ago and gave up the ratrace in London to make a new life there. She too had a very steep learning curve but in the end overcame the immense challenges and even wrote a book about it.

Although Soay is almost deserted now, there were 25 working crofts on the island up until 1953, when most of the population was voluntarily evacuated to new accommodation that had been provided for them near Craignure on Mull. Before then, Soay had achieved a degree of fame as the working base for Gavin Maxwell's ill-fated shark-fishing business, a venture which cost him a fortune and lasted for just three seasons. From Soay harbour, Maxwell's shark boat sailed the seas of the Hebrides looking for basking sharks, harpooning those they found and returning with them to Soay, where they were butchered for the oil extracted from the livers. When Maxwell went bankrupt, his harpooner Tex Geddes took over the operation and moved to Soay with his wife and son. Tex was a colourful character. He'd met Maxwell in the army during the war, when they had worked together training members of the Special Operations Executive for dangerous missions behind enemy lines. From his island base, Tex continued to hunt basking sharks until their numbers declined, probably due to overfishing. However, after hanging up his harpoon, Tex stayed on, becoming the fisherman 'laird' of Soay. Ollie remembered Tex with great affection. The Davis family were neighbours for many years, and Ollie even worked on Tex's fishing boat. 'He was one of the real characters of the islands – and there are very few of them left. When there were a few drams going of an evening, he'd keep the whole company spellbound with his stories of shark fishing and his exploits during the war. He had an amazing life – that's if you were to believe everything he said.'

Landing beside the ruins of a 19th-century fishing station at Soay harbour, Ollie and I explored the remains of Maxwell's original factory, where sharks measuring up to 10 metres long were hauled ashore and butchered. Corroded artefacts

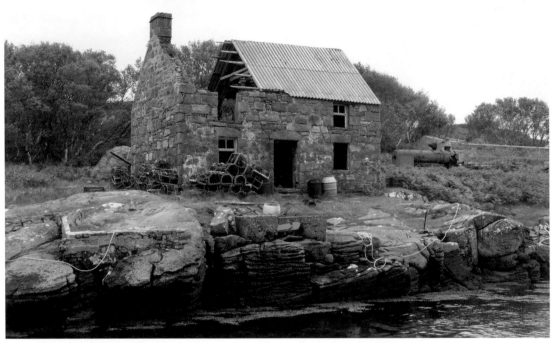

Soay harbour, where Gavin Maxwell and Tex Geddes set up a shark factory after the Second World War.

from this grisly business were scattered around, becoming part of the industrial archaeology of the Hebrides: old rails, bogie wheels, vats for boiling up shark livers and, dominating the scene, the bizarre spectacle of an old steam locomotive, which had formerly provided power to the whole operation. As Ollie skippered the *Heather Grace* out of Soay harbour, we had an unexpected and truly magical encounter with a pod of bottlenose dolphins. Four or five of these beautiful creatures sped alongside our boat like torpedoes, turning to look up at me as I crouched on the foredeck in awe and then leaping out of the water with barely a splash. To be so close to these truly wild, curious and intelligent animals was an exhilarating experience.

RAASAY

Another Viking-named Hebridean island, probably from the Old Norse *Raas Øy*, meaning 'Roe Deer Island'. Known in legend as the island of the big men, Raasay lies between Skye and the mainland, running 23 kilometres north to south and, at its widest, about 4.5 kilometres east to west. It has a population of about 150 people who mostly live in the south and east of the island. The main settlement is Inverarish, where the ferry arrives and departs. Traditionally, Raasay was MacLeod territory, famous for the musical prowess of its pipers and its support for the Jacobite cause. One hundred men and twenty-six pipers from Raasay fought at Culloden in 1746. After the Jacobites'

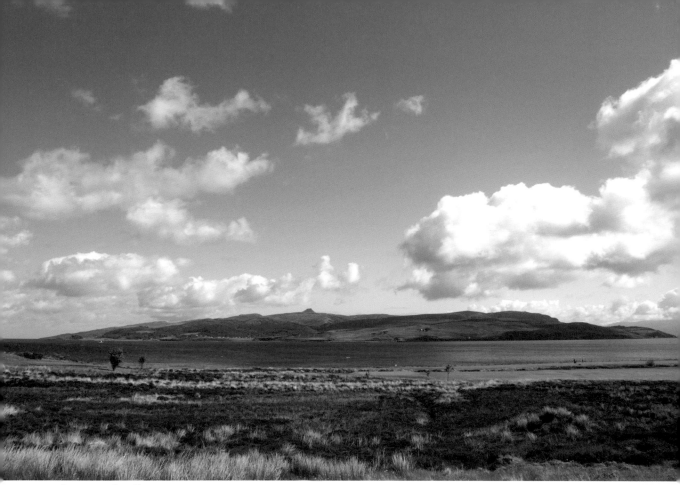
Raasay, seen from Skye.

crushing defeat, islanders hid the fugitive Bonnie Prince Charlie on Raasay. But they later paid the price for their devotion to the Stuart cause. In reprisal, government troops burned down the laird's house and nearly every island home.

A generation after this destruction the literary travellers to the Hebrides, Johnson and Boswell, visited the new Raasay laird. He had restored MacLeod fortunes and built a grand mansion where he regaled his southern visitors with Highland hospitality. Unfortunately, Sarah Murray, who came to Raasay three decades later, was not so well received by the laird's son. In the wet August of 1802, bad weather trapped Sarah on the island and she was forced to throw herself on the mercy of the new laird of Raasay House. To her

distress, Sarah found that she had overstayed her welcome: 'I have to lament that the hospitality of Dr Johnson's Raasay did not descend in full force to his son. His countrymen will not envy his being a sole exception to the universal hospitality towards strangers that prevails throughout North Britain.'

Unlike Sarah Murray, my experience of island generosity couldn't have been happier. At the time I was on the trail of Raasay's great Gaelic poet Sorley MacLean. Having just explored the remains of the old iron ore mine which had been worked by German prisoners of war during the First World War, I dropped in on Sorley MacLean's brother-in-law. He and his wife entertained me with a mind-blowing Hebridean measure of whisky and

told me about life growing up on Raasay in the 1930s, when geologists came to study the island's rare rocks and when the poet Hugh MacDiarmid paid a visit to discuss politics and literature with Sorley MacLean and his family. Before I left to climb Raasay's highest hill, Dun Caan, a flat-topped volcanic peak that's the island's most distinctive feature, I was offered another massive dram. Unable to refuse this noble gesture of hospitality, I downed it quickly and then floated to the summit cairn some 443 metres above sea level, where I had glorious views of the mountains of Kintail and the Red Cuillin. The same panorama was enjoyed by Boswell in 1773 when he climbed the hill. He was so impressed that he apparently danced a jig. I wouldn't be surprised if his ascent had also been aided by a dram or two.

The main settlement of Inverarish, which, with its rows of single-storey houses, has the look of a mining village. This is precisely what it once was. Just before the First World War, rich deposits of iron ore were discovered nearby. The William Baird mining company bought the whole island to exploit these reserves. The value of these deposits increased with the outbreak of hostilities in 1914. As the war dragged on and Germany's U-boat campaign strangled Britain's supply of ore from overseas, the Raasay mine acquired a new strategic importance. But to extract the raw material required increased manpower, difficult when so many Raasay men were already fighting at the front. The solution was to use German prisoners of war. Up to 280 men were housed in a camp at Inverarish between 1916 and 1918, spending their days labouring underground. The fact that enemy combatants were exploited in this way, with at least two losing their lives, was in contravention of the Hague Conventions. It was an illegal and

shameful act which the British government tried to cover up. To the north of the village, at the road-side, stands one of the most enigmatic products of the Picts: a symbol stone which is peculiarly atmospheric in its woodland setting.

Brochel Castle, which stands towards the north-east of Raasay, is an extraordinary 15th-century ruin, with walls that rise precariously and precipitously from a 15-metre rock pinnacle. Reputedly built by Raasay's first MacLeod chief, Calum (MacGilleChaluim), Brochel was used as a base by MacLeod pirates to control their territory, which extended to the nearby islands of the Inner Sound, and to the mainland on the opposite shore. Despite its ruinous condition, Brochel Castle inspires all kinds of fantastical, romantic associations and seems to belong to the mythical realm of Celtic heroes.

The road north of Brochel is the work of a modern hero – another Calum MacLeod. Unlike his pirate namesake, this Calum was determined to save the community he loved, and his story is the stuff of legend. Calum came from the little township of Arnish, one of several crofting communities at the far north end of Raasay. Together they had a combined population of about a hundred. But the people began to leave – not because they were the victims of an oppressive landlord hell-bent on eviction, but because there was no road to the south of the island and the ferry to Skye. Despite several appeals for help, the council wouldn't build a road and the communities remained cut off. Then in the 1960s crofter Calum MacLeod decided to take things into his own hands. Working for nearly ten years with a barrow, a pickaxe and a shovel, he built the road from Arnish himself. He was already in his late 50s when he started the project, and the Herculean

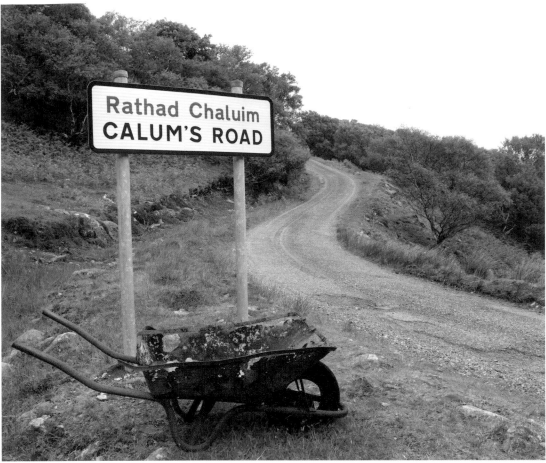

The start of Calum's Road, Raasay, the extraordinary achievement of Calum MacLeod, who died after finishing it.

task would dominate the last 20 years of his life. Ironically, by the time he had finished his road, there were only two people still living at the north end of Raasay: Calum and his wife. But he was proving a point about the spirit of crofters: they wouldn't just lie down and accept their fate.

After a two-mile hike from Brochel Castle, I reached the road's end at Arnish and the house where Calum and his family had lived. It's where Calum died at the age of 76. His wife found him outside, collapsed in his wheelbarrow after a heart attack. Previously, whenever people from the north of Raasay died, their bodies were taken by boat to the burial ground in the south. The terrible irony now was that Calum's road made it possible for the first time to make that journey by motor vehicle. The hearse was able to drive right up to his front door; and so Calum MacLeod became the first man to be taken out of Arnish by coffin, along the road that he had built with his own bare hands.

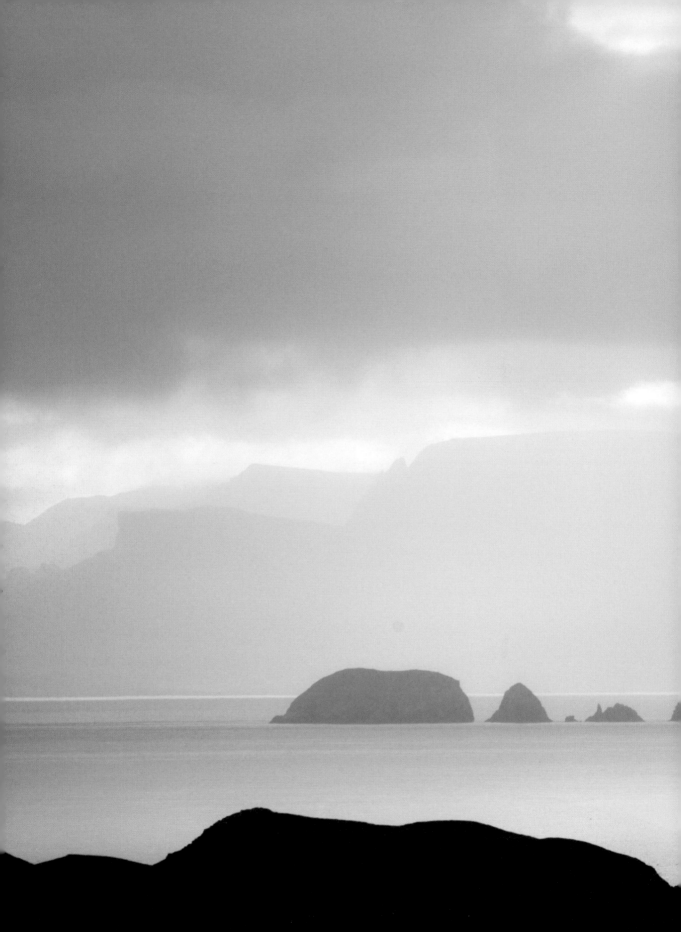

CHAPTER FIVE THE SHIANTS TO HANDA

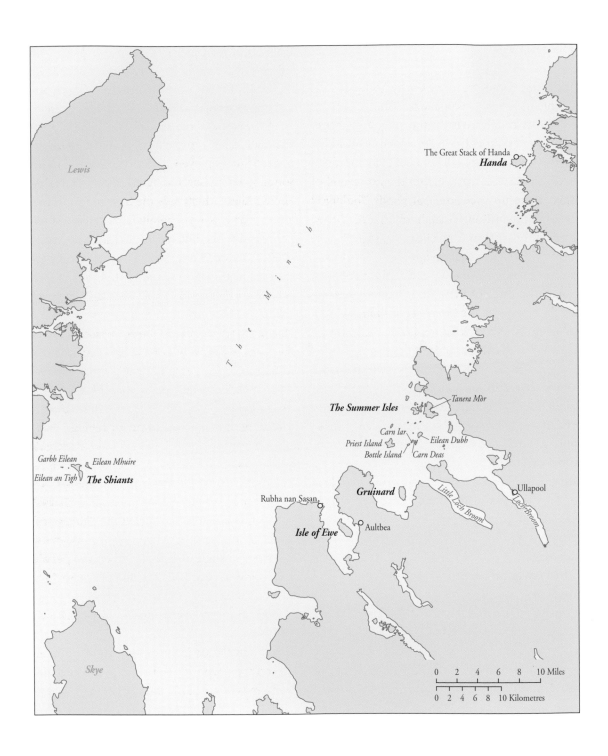

Lewis

The Great Stack of Handa ○
Handa

The Minch

The Summer Isles *Tanera Mòr*

Carn Iar
Priest Island *Eilean Dubh*
Bottle Island *Carn Deas*

Garbh Eilean *Eilean Mhuire*
Eilean an Tigh **The Shiants**

Rubha nan Sasan **Gruinard** *Little Loch Broom* ○ Ullapool

Isle of Ewe ○ Aultbea

Skye

| 0 | 2 | 4 | 6 | 8 | 10 Miles |

| 0 | 2 | 4 | 6 | 8 | 10 Kilometres |

THE SHIANTS

The name comes from the Gaelic Na h-Eileanan Seunta meaning 'Enchanted Islands'.

This privately owned group of about 12 rocky islands and skerries lies in the Minch, some 8 kilometres east of Lewis, 35 kilometres from the mainland, and 20 kilometres from the north end of Skye. There are three principal islands. The largest is Garbh Eilean (Rough Island), which is connected by a shingle isthmus to Eilean an Tigh (House Island). The separate Eilean Mhuire (Mary's Island) lies a few hundred metres east across the Bay of Shiant. All three of these islands cover no more than 143 hectares and have been uninhabited for many years, although the bothy on Eilean an Tigh is used by the owners and visiting naturalists.

I crossed to the Shiants in a fast inflatable from Harris. My skipper Seamus had made the trip many times, but delighted in telling me the story of the Blue Men (Na Fir Ghorma in Gaelic). These blue-skinned mythological creatures take human form and inhabit the waters of the Minch, raising storms and wrecking ships. Sometimes the chief of the Blue Men will challenge the skipper of a passing boat to a rhyming competition. If the skipper fails to finish a couplet, he and his ship are doomed.

As we approached the biggest island, I was struck by the scale of the cliffs on Garbh Eilean. Consisting of columnar basalt pillars, they are similar to the rocks of Staffa, but are much higher, rising sheer out of the sea to over 120 metres. When geologist and traveller John MacCulloch visited the Shiants in 1819 he was also mightily impressed: 'They exceed them [the cliffs of Staffa] in simplicity, in grandeur, in depth of shadow, and in that repose which is essential to the great style in land-scape.' And just like Staffa, there are fabulous sea caves and arches in the cliffs. As MacCulloch pointed out: 'The lover of picturesque beauty will . . . be gratified with a display of maritime scenery.'

As I stared at the great cliff, watching a pair of sea eagles soar into the dizzying void above my head, Seamus played a traditional tune on his sound system: a Gaelic song 'Ailein Duinn' or 'Dark-Haired Alan', which tells the doleful tale of two lovers. Alan was a sea captain from Lewis and was betrothed to the love of his life, the young and beautiful Annie Campbell. In the spring of 1788, Alan set sail from Stornoway to the island of Scalpay, where the happy couple were to be married. Tragically, Alan never reached his destination. A violent storm caught his ship and dashed it onto the rocks with the loss of all hands. Alan's body drifted in the tide until it reached the Shiants. When his bride-to-be heard news of his drowning, she wrote the lament for her lover: 'Ailein Duinn'. Knowing that she would never feel his arms around her again, Annie pined away. But that's not the end of the story. The boat that later took Annie's coffin to the burial ground was also struck by a storm and her coffin fell into the sea. Carried by swirling currents, it reached the Shiants and landed at the exact same spot where Alan's body had been washed ashore. There on the pebble beach between Garbh Eilean and Eilean an Tigh, the two lovers were reunited in death.

Seamus steered us through a natural rock arch and then anchored in the bay, letting me use a dinghy to make my own way ashore. The cliffs all around were teeming with noisy, raucous life. Thousands of sea fowl crowded on the ledges or

Chapter opening: The Galtachan stacks, The Shiant Islands.

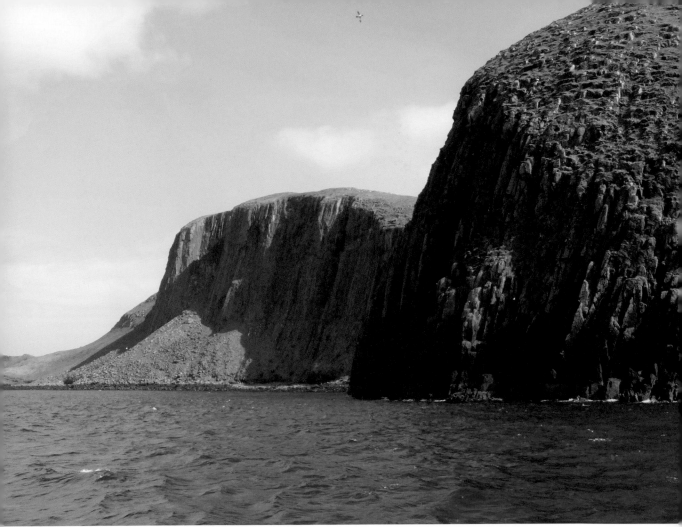

The enormous basalt pillars on the cliff face of Garbh Eilean.

floated on the guano-splashed water where feathers drifted in the tide. Overhead, the sky pulsated with dark, swirling flocks of shrieking seabirds: puffins, razorbills, guillemots, kittiwakes and innumerable gulls of different varieties. The Shiants are home to one of the biggest and most important breeding colonies of seabirds anywhere in Europe. It's a veritable seabird city, where every spring an estimated half-a-million birds arrive to nest, hatch their eggs and rear their young.

Sadly, the numbers that throng the cliffs have been steadily declining over the years. Various theories have been put forward to explain why, from global warming to pollution, but there is one explanation that seems as undeniable as it's unpalatable: rats – an estimated 3,000 of them. The rats are *Rattus rattus* – the black plague rats that originated long ago in South East Asia. No one knows when the rats arrived on the Shiants but it's likely that their ancestors escaped from one of the many ships that were wrecked on the islands over the centuries. Perversely, because black rats are actually very rare in Britain and certainly rarer than the seabirds they kill, they are considered to be a protected species. Until recently, a natural balance existed between the numbers of rats and seabirds. Although rats attack and eat nesting birds, the bird colony was never destroyed

The bothy restored as a writer's retreat by Compton Mackenzie, author of *Whisky Galore*.

because in winter, after the birds have left, the rats have no food supply and many die of starvation. However, because the birds have suffered severe food shortages in recent years, their numbers have declined dramatically. This is why, controversially, there is now a campaign to eradicate the rats completely.

Although the rats might have flourished on the Shiants, the permanent population of humans left long ago, ending a history of habitation that's generations deep. The original Iron Age settlers tilled the land and lived off fish and seabirds. The Vikings knew the islands well, stopping off on their way up and down the Minch. Celtic monks built a place of worship 1,400 years ago on Eilean Mhuire.

By the beginning of the 20th century, the Shiants were only sporadically inhabited by seasonal shepherds and passing fishermen, but in 1925 the novelist Compton Mackenzie bought the islands and restored the old shepherd's bothy as a writer's retreat. Best known today for his books *Whisky Galore* and *Monarch of the Glen*, Edward Montague Compton Mackenzie was a colourful, extrovert character, born in England to a theatrical family. During the First World War he was recruited by British intelligence and operated as a spy in the eastern Mediterranean. Although he

was born English and spoke with the cut-glass tones of the English aristocracy, Compton Mackenzie had a Scottish soul. He immersed himself in Scottish culture and became a founder member of the SNP.

Mackenzie loved islands almost as much as he loved Scotland. In fact, he collected them. After living on various islands in the Mediterranean and the English Channel, he bought the Shiants in order to get closer to his Scottish roots; and it was in the bothy on Eilean an Tigh that he was inspired to write a two-volume novel called *The North Wind of Love*. Set on an island, it tells the story of an author, uncannily similar to Compton Mackenzie, who builds a house, and dreams about an independent Scotland. Sadly, a decade later, and with his dream still unrealised, financial worries forced Mackenzie to sell up and move on – eventually settling on another island further to the west: Barra. However, the Shiants' literary connections didn't end there. The islands were purchased by the publisher Nigel Nicolson – son of the controversial and flamboyant author Vita Sackville-West, whose lesbian love affairs had scandalised society in the 1920s and '30s. The Shiants are still in the care of the Nicolson family, and the author and broadcaster Adam Nicolson has written extensively about the islands, which he loves with a passion.

ISLE OF EWE

The derivation of the name is obscure. Some scholars believe it comes from the old Celtic word for the yew tree. The Isle of Ewe, which measures just 2 kilometres long by a kilometre wide, lies in Loch Ewe, very close to the mainland, and opposite the village of Aultbea. Because Isle of Ewe sounds, when you say it out loud, like 'I love you', it has been known for various love-struck men and women to beat a path to its shores to 'pop the question'.

There's no public ferry service to the island, so to get across I hitched a lift with Jane Grant, who skippers her own tugboat made, she explained, by welders from Whitby. Originally from Somerset, Jane went to a posh school in Devon and then trained as an engineer, becoming only the second-ever female engineer in the merchant navy. She then made a career for herself sailing the world's oceans on bulk carriers and container ships. Her romantic connection with the Isle of Ewe began when she met her seafaring husband Willie Grant on board a ship in Karachi. After they married, they left the merchant navy and returned to Willie's home on the Isle of Ewe, where his family have been farming since the middle of the 19th century. As we walked up the pier, Jane outlined the setup: 'There are four houses on the island – all occupied by members of the Grant family. Brother-in-law Roddy does prawns; hubby Willie has cattle and we all graze sheep. Our son hopes to build a house of his own soon.'

Shortly after Jane moved to the island, she took up scallop diving to help with the family finances. But over the years the wild scallop stocks, along with the whole biomass of the west coast, have been seriously depleted. 'Twenty years ago, if you wanted to do scallop farming, you'd put spat bags out, which are basically like onion bags, and tiny little wild scallops would settle on them. But now, if I put spat bags out, I don't get any scallops, because overfishing has taken too many of the spawning adults,' Jane explained. After a lot of twists and turns, Jane is still in the scallop business,

The Isle of Ewe.

With scallop diver Jane Grant.

running what she hopes will become Scotland's first scallop ranch. 'We are looking at hatchery technology. Here in Scotland we have the best scallop growing waters in the world. What we do is to breed native scallops and return them to the wild where we ranch them. In other words, we let them roam around on the sea bed. When they mature after five years, we simply dive down and lift what we need by hand.'

'How many do you hope to produce annually?'

'Well, if we get the right investment in the project, up to ten million.'

'That's a hell of a lot of scallops. I hope you like them,' I said.

'I never tire of them!'

Jane took me in her tugboat back to Aultbea. It was good to know that the peaceful waters of Loch Ewe were being put to peaceful and productive use as a scallop ranch – a very different situation to 70 years ago, when this part of the north-west coast was a no-go area to the public: part of a huge restricted militarised zone. During the Second World War, Arctic convoys assembled in the sheltered waters of Loch Ewe, from where they sailed north with weapons and munitions to keep Russian forces supplied in the fight against Hitler. Nearly 500 merchant ships and over 100 naval escort vessels left Loch Ewe for Russia during those dark times. Many of their crews never returned. On the headland of Rubha nan Sasan, overlooking the enfolding arms of the loch and close to the crumbling concrete remains of what was once a gun battery, I came across a simple stone memorial dedicated to all those who lost their lives in the cold waters of the north Atlantic. Reading the inscription, I found it impossible to imagine the naval activity that once filled the loch below. This coast today seems very remote and a long, long way from the violent reality of war.

GRUINARD

The derivation and meaning are obscure, possibly from the Old Norse *grønn*, meaning 'green', and *fjord,* 'fjord' or 'firth'. Gruinard is a small island lying a kilometre-and-a-half from the coastal road to Little Loch Broom. It is 2.5 kilometres long from north to south, by a kilometre wide and rises gently to the low summit of An Eillid at 106 metres. This is an inconspicuous, remote and unremarkable place – precisely the qualities that made Gruinard a suitable testing ground for Britain's biological warfare experiment.

It seems incredible now that such a potentially dangerous experiment took place so close to the Scottish mainland. But during the dark days of the Second World War, the stakes were high. The British had good reason to believe that the Nazis were developing biological weapons. To counter this threat, the Ministry for War wanted Britain to have a similar deadly capability. In 1942, scientists clad in white biological warfare suits released anthrax spores into the environment, deliberately infecting dozens of tethered sheep and contaminating the entire island. The results were closely monitored. All the sheep died, and autopsies were undertaken on the corpses, which were then incinerated en masse. I've since seen a formerly classified film showing the experiment. It's a chilling and surreal reminder of the how desperate the situation was back in 1942. Then Britain faced the very real possibility of defeat. Anything that might prevent that catastrophe was justified – even poisoning an island.

About 20 years ago, the government undertook an extensive clean-up operation on Gruinard. The ground was saturated with seawater and a solution of formaldehyde to kill the persistent anthrax spores still contaminating the topsoil. It's safe now – apparently. Though to be on the safe side, I declined the kind offer to be taken across by boat.

THE SUMMER ISLES

The origin of the name for this group of islands is disputed. Some say that they are collectively so called because of the summer grazing and fishing that were once an important part of their economic life. However, in Gaelic, they are known as Na h-Eileanan Samhraidh. The word *Samhraidh* is the Gaelicised version of the Old Norse word for 'summer', indicating that at one time these islands were part of the Viking world.

The Summer Isles are a group of small islands that cluster together in the mouth of Loch Broom. They are often visited by passing yachts and pleasure boats from Ullapool. When I arrived, I opted to explore by sea kayak, paddling from Priest Island, along the coast of Bottle Island to the green sward of Carn Iar and Carn Deas, passing Eilean Dubh and landing finally on the biggest island in the archipelago, Tanera Mòr. Over the centuries, many of the islands in the archipelago have been settled or put to productive use. On Priest Island (Eilean a' Chleirich in Gaelic) stone circles are evidence of the island's religious significance to our early ancestors, while the name itself suggests that the island had a spiritual role during the early Christian era when it was perhaps settled by an anchorite or prayerful monk seeking an isolated life. Eilean a' Chleirich was later worked as a croft

by the descendants of an outlaw who was banished there in the 18th century. My kayak guide Julie-Anne told me that there used to be a bothy on Eilean Dubh which was used as accommodation by the men who lived there during the herring fishing season. Because the microclimate of the islands is milder than that of the mainland coast, they provided good summer grazing for livestock. Sheep and cattle used to be swum out or brought by boat in the spring. The ruins of shielings or shepherds' huts can still be seen in the grass and heather on some of the islands.

Geology is partly what makes the Summer Isles such a great place to explore in a kayak. They are made of sandstone, which erodes easily, leaving an intricate coastline of sea arches and caves, which also create a great wildlife habitat. To prove the point, a grey seal popped its head out of the water and watched as we glided past the dark mouth of a large sea cave. 'I've seen porpoises and dolphins out here,' Julie-Anne said enthusiastically.

With my guide Julie-Anne in a kayak in the sea off Eilean a' Chleirich.

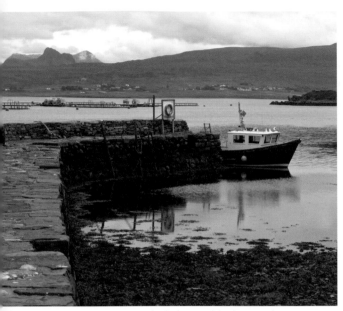

The pier at Tanera Mòr, the largest of the Summer Isles.

She is a great believer in kayaking as a way to get close to nature. Paddling almost silently and in synch with the rise and fall of the Atlantic swell beneath the hull, she explained that in a kayak, you are no longer just a spectator. 'You enter the animal world in a direct and physical way. Out here on the water, there's peace and freedom – a oneness with nature that is really special.'

I parted company with Julie-Anne on Tanera Mòr, where a handful of houses are strung out around a pretty bay, which is also the location for several large salmon cages. Just up from the shore and overlooking the 18th-century pier is the ruin of a once substantial house. Two centuries ago, this was the heart of a very prosperous herring fishing station. Every year, up to 200 boats anchored in the bay. Some landed fresh herring. Others loaded barrels of salted fish for export to the slave plantations of the West Indies. But all this activity was short-lived. After a couple of

decades the fishing bonanza was over. By 1820, the herring had been fished to commercial extinction and the enterprise bankrupted. The fortunes of the island fluctuated wildly after that. High rents brought poverty and eviction, then, for a brief spell, some enterprising islanders enjoyed the rewards of illicit whisky distilling. But it was not enough to stop the seemingly inevitable decline.

The story of Tanera Mòr is typical of a lot of the smaller islands around our coast: a once thriving community brought to the edge of collapse because of economic disaster, poor communications and neglect. By the 1930s it was deserted. The old homes were in ruins and the pier falling into the sea. But this was exactly the sort of place that a pioneering conservationist was looking for to prove that it was possible to live a sustainable life in harmony with nature. The man who had these radical ideas was Frank Fraser Darling. In his lifetime he became known as one of the founders of the modern environmental movement. A man of great energy and conviction, he fought his way from rural poverty in Derbyshire to become an intellectual pioneer and one of the first Green activists. In his academic work, Fraser Darling described how the landscape of the Scottish Highlands and Islands, much vaunted for its picturesque and dramatic appeal, was in fact a man-made desert. Over the centuries, forests had been felled and people cleared to make way for great deer forests and sheep farming on a massive scale. The land which lay fallow had become sour and infertile. But it didn't have to be that way.

Fraser Darling moved into an abandoned croft on Tanera Mòr with his wife and young son in 1938. He wanted to prove that crofting could be more than just subsistence farming and that, with

At the post office on Tanera Mòr.

the right husbandry, the wet desert of the West Highlands could bloom again. He and his wife Bobbie laboured for four years, nourishing the impoverished soil with seaweed and sand. They rebuilt drystone dykes, cleared rubble and raised cattle, sheep and hens. Against the odds, they succeeded, breathing life back into the moribund island. Fraser Darling wrote about his experiences in his book *Island Farm*.

He argued that, in order to bring nature back to bountiful health, people needed to work with the environment, instead of against it. A landscape full of working crofts and people nourishing the soil was his solution for a better future. Sadly, his experiment was short-lived. After he and his family left Tanera Mòr, the island was uninhabited for a generation.

Although there are presently no permanent residents, Tanera Mòr is still a busy place in the summer. Most of the old croft houses have been converted into holiday lets and there's a constant flow of day-trippers from the mainland arriving by boat to visit the tearoom and the post office, which sells rare and collectable Tanera Mòr postage stamps. But as I discovered when I bought one celebrating the life of Frank Fraser Darling, the island-issue stamps only cover the cost of carriage to the mainland; so I also had to purchase a Royal Mail stamp before I could post the card I'd bought extolling the glories of Tanera Mòr.

HANDA

According to the experts, Handa is derived from the Old Norse *Hund-øy*, meaning 'Dog Island', though why this would be is far from clear to me. Handa is a spectacular, cliff-girt island, hugging the coast of Sutherland. It's roughly 2.5 kilometres east to west, by 2 kilometres from north to south. Composed mostly of Torridonian sandstone, it rises to over 100 metres in the north, dropping away to the sea in spectacular cliffs, which provide a sanctuary for thousands of breeding seabirds.

Handa has been uninhabited since the middle of the 19th century, but there is a regular ferry service in the summer months. Although the island is owned by Scourie Estate, it's run by the Scottish Wildlife Trust as a bird sanctuary, and the small ferry that makes the short crossing from the mainland carries birdwatchers, walkers and wildlife enthusiasts to enjoy its charms. Among the many different species of bird I saw nesting on the dramatic sandstone cliffs were over 56,000 guillemots and 5,000 razorbills, as well as great numbers of kittiwakes, fulmars and puffins. Not that I counted all these birds myself. I got the figures from the Handa Ranger Kate Thompson, who took me for a boat trip around the coastline. But I was concerned to learn that this huge breeding colony has been suffering in recent years and numbers are down. Twenty years ago, there were twice as many seabirds. Sadly, this is a common story all along the coast. The reason is complicated: global warming, overfishing and changing patterns in the food chain, but the bottom line is that the once bountiful seas around Handa and elsewhere can no longer sustain birds in the great numbers that they did previously. Breeding colonies depend on sand eels for food but, over successive summers,

they have failed to appear, with the result that many young birds starve before they fledge.

Walking inland from the beach where the ferry lands, or more accurately 'runs ashore', I came across the ruined village that was once home for Handa folk. In the 18th century, the population never counted more than about 60 souls, but the community was very tight knit and had its own peculiar customs and practices. Like faraway St Kilda, the islanders had their own parliament, presided over by the island queen. She was always the oldest widow in the village – age and sex conferring on her the wisdom to adjudicate over important decisions. The islanders grew a variety of crops, but became very dependent on the potato. The lazy beds where they grew their crops can still be seen in the long tangled grass below the village. But this over-reliance made the population vulnerable and, when the potato famine arrived from Ireland in the 1840s, the people began to starve. In desperation, they elected to leave the island of their ancestors and emigrate to America. But why, I wondered, did the islanders face famine when the potato crop failed? After all, they lived on an island full of seabirds. I suspect that, when the cliffs were empty of their raucous tenants in the winter, the islanders would have had little else to rely on other than the potatoes they'd grown in the summer. And if these had failed because of blight, the human population would indeed have been pushed to the edge of starvation.

Crossing the island from south to north, I came to Handa's most famous landmark – a 100-metre pillar of rock that rises out of the sea in a deep-cut recess in the mighty cliffs. This awe-inspiring rock tower is known, rather uninspiringly, as the Great Stack of Handa and looks like a guano-splattered skyscraper in a seabird city – or an

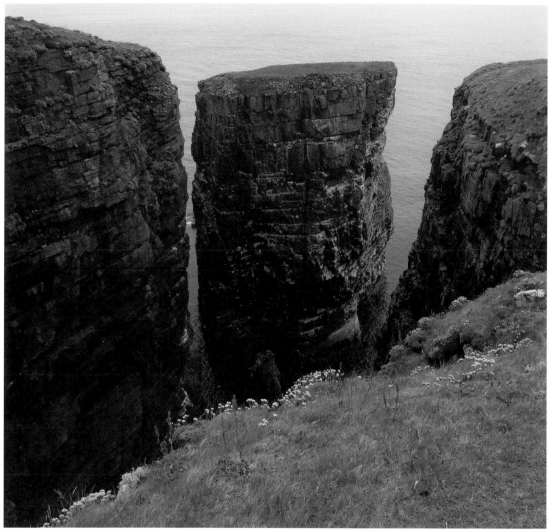

The 100-metre tall Great Stack, Handa, home to tens of thousands of seabirds.

impregnable fortress perhaps. But in 1870, three intrepid crofters from Lewis breached the defences of the Great Stack and became the first men to stand on its summit. The party of men came from Ness on the Isle of Lewis and rowed 43 kilometres across the Minch to get to Handa – a tiring-enough feat in itself. After they made their landfall they stretched a rope from one side of the recess in the cliffs to the other, allowing the middle of the rope to just touch the top of the Great Stack. Climbing hand over hand and defying the terror of a 100-metre drop into the sea, they crossed the rope to conquer the summit. Standing on the cliff today, watching the swirling water below, it was definitely not a journey that I would have fancied making.

ERISKAY

BARRA

VATERSAY

SANDRAY

PABBAY

MINGULAY

BERNERAY OR BARRA HEAD

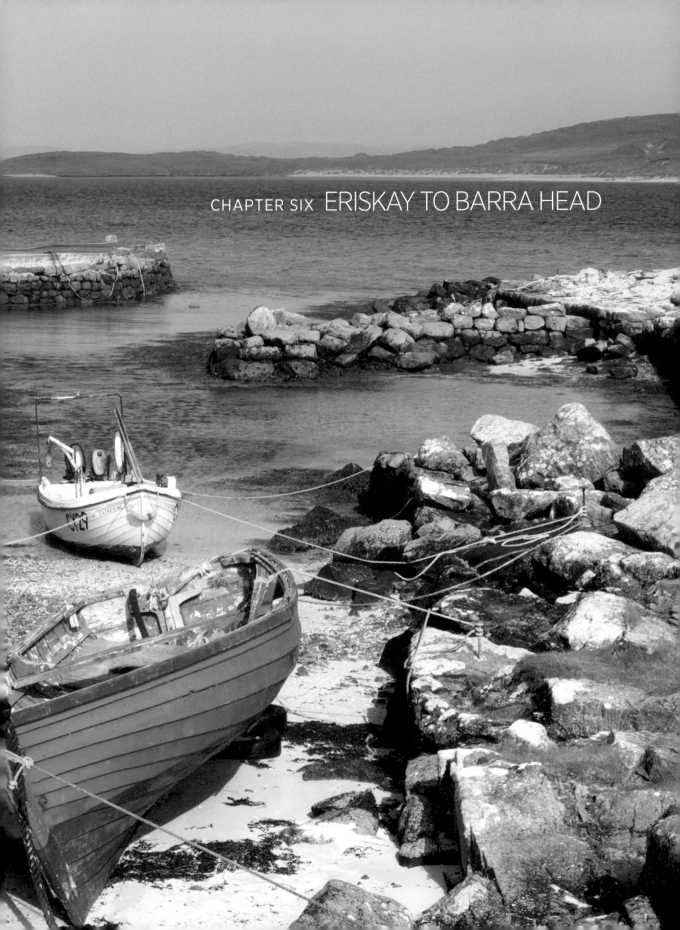

CHAPTER SIX ERISKAY TO BARRA HEAD

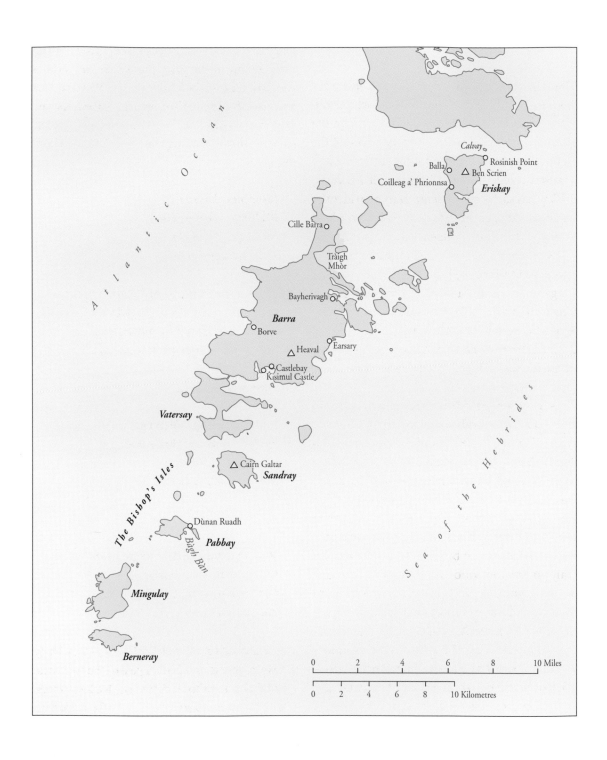

Atlantic Ocean

Calvay
Rosinish Point
Balla
Ben Scrien
Coilleag a' Phrionnsa
Eriskay

Cille Barra

Tràigh
Mhòr

Bayherivagh

Barra

Borve

Heaval
Earsary

Castlebay
Kisimul Castle

Vatersay

The Bishop's Isles

Cairn Galtar
Sandray

Dùnan Ruadh
Pabbay
Bàgh Bàn

Mingulay

Berneray

Sea of the Hebrides

| 0 | 2 | 4 | 6 | 8 | 10 Miles |

| 0 | 2 | 4 | 6 | 8 | 10 Kilometres |

ERISKAY

The name could come from the Old Norse for 'Eric's Isle', or from a combined Norse-Gaelic derivation: *ùruisg*, the Gaelic for a 'goblin', and *øy*, the Norse for 'isle'. Eriskay is one of the jewels of the Hebrides, but lost its island status in 2001 when a causeway link to South Uist was built. However, Eriskay has such a strong sense of its own identity that it would be churlish to deny its unique island heritage. It is home today to about 150 people, many of whom still work their crofts and fish the seas around the coast, just as their ancestors did for generations. It's a small island: 5 kilometres long by just over 2 kilometres wide, rising to Ben Scrien at 185 metres in the north. It lies towards the northern end of the Sound of Barra, in shallow turquoise seas, fringed by beautiful white, shell-sand beaches.

A few years ago, before the causeway was built and when the Sabbath was more strictly observed than it is now, I tried to cross the sound from South Uist to Barra. It was a beautiful day. There wasn't a breath of wind, the sea sparkled, and it was so quiet you could have heard a pin drop. Nothing was moving. There were no ferries or even the prospect of one, but after a tip-off, I used the old red telephone box beside the pier to call a man on Eriskay, who came to my rescue in a power boat. As we hydroplaned over the glassy sound in brilliant sunshine, with dolphins leaping alongside, I felt a million miles away. This wasn't the north-west coast of Scotland. This was somewhere tropical! The boatman noted my appreciation of his homeland and nodded approvingly.

Eriskay is famous for the unique Eriskay pony, of which there are only about 400 in the world. This ancient breed is so rare, in fact, you'll be more likely to see one in a paddock in England than on Eriskay; but in the past, these pale-grey ponies were used extensively all over the Western Isles and were the original horsepower of the Hebrides. Eriskay is also famous for its eponymous 'Love Lilt' – a hauntingly beautiful and wistful song about lost love:

Bheir me o, horo van o
Bheir me o, horo van ee
Bheir me o, o horo ho
Sad am I, without thee.

Thou'rt the music of my heart;
Harp of joy, *o cruit mo chruidh*;
Moon of guidance by night;
Strength and light thou'rt to me.

Bheir me o, horo van o . . .

In the morning, when I go
To the white and shining sea,
In the calling of the seals
Thy soft calling to me.

Bheir me o, horo van o . . .

When I'm lonely, dear white heart,
Black the night and wild the sea,
By love's light, my foot finds
The old pathway to me.

The stunning scenery of Eriskay is just as likely to inspire music as it is to appeal to the romantic sensibilities. For those with a taste for lost causes, it was here that Bonnie Prince Charlie turned up

Chapter opening: Boats at Eoligarry, Barra.

An Eriskay pony, one of the most ancient breeds and one of the rarest too.

he came with just seven men and no money. The local laird Alexander MacDonald of Boisdale was unimpressed. When he met the prince he advised the royal personage to 'go home!' to which the prince famously replied, 'I am come home,' and insisted that his cause was blessed by heaven. He was on a mission from God to march on London and claim the throne for the Stuart dynasty – whatever the cost. And the cost was huge. A year later, after his disastrous defeat at the Battle of Culloden, the prince fled the country and returned to France. Thousands of his loyal supporters had been killed in the campaign, leaving a vengeful British state to persecute Highland society to the point of extinction. Walking the empty sands of Coilleag a' Phrionnsa there is nothing to commemorate that initial historic moment; but then the prince's presence was a fleeting one, and the tide soon swept his footprints from the sand.

After leaving the Prince's Strand, I got a lift with the local postman, Iain Ruaraidh MacInnes, who took me on a quick tour of the island while he delivered the mail. Iain Ruaraidh was born to Eriskay parents in Glasgow but, like many Hebridean children, spent every summer holiday with his grandparents, helping with the peat cutting and the haymaking. He told me about the fresh water wells on the island where every day he was sent to collect water for the house. Iain Ruaraidh said that the knowledge of these fresh water springs is dying out. Everyone has water plumbed into their homes now, and soon they will enjoy the benefits of fibre-optic broadband. Changed days since his youth, when there were almost 500 people living on Eriskay, all of them Gaelic-speaking, all of them subsisting from crofting and fishing. Their traditional way of life attracted the attention of the German anthropo-

in 1745 to begin his ill-fated military campaign to restore the Stuart dynasty to the British throne. After a dangerous voyage from France, Prince Charles Edward Stuart set foot on Scottish soil for the first time on a beautiful beach on the west coast of the island. It has been named after him ever since: Coilleag a' Phrionnsa or the Prince's Strand. This lonely stretch of white shell-sand is the unlikely starting point for a campaign that came close to overthrowing the British state. But this Jacobite uprising got off to a shaky start. Among the Highland clans, there was considerable support for the Stuart cause and the Prince's allies fully expected him to arrive with an army. Instead

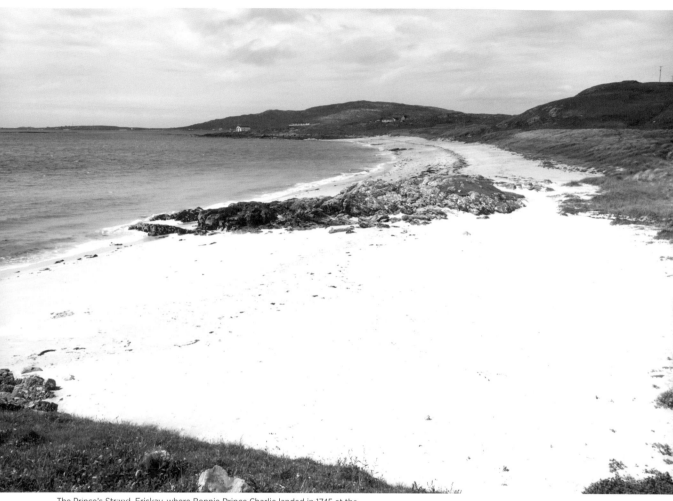

The Prince's Strand, Eriskay, where Bonnie Prince Charlie landed in 1745 at the start of his ill-fated bid to reclaim the British throne for the Stuarts.

logical filmmaker Werner Kissling, who made a beautiful film here in the 1930s. Called *Eriskay – A Poem of Remote Lives* it is one of the most intimate and evocative films ever made of a now almost forgotten way of life. Iain Ruaraidh explained that Kissling was fascinated by the traditional Gaelic culture that had survived on Eriskay and wanted to record what he found on film before it was lost.

'I'm sure he would have thought it pretty prim-itive out here,' said Iain Ruaraidh. 'A lot of the houses were still old blackhouses: thatched, with no running water, no electricity, Tilley lamps provid-ing the light. There were no cars of course. And nearly all the work on the croft was done by hand.' Kissling filmed the everyday details of island life: men and women, girls and boys, fishing, shearing, gathering peats, collecting lichen for dying the wool, spinning, carding and waulking the tweed.

'It must have seemed almost medieval,' Iain Ruaraidh said as we pulled up beside a post box.

'And yet it was not that long ago.'

'That's right. Several of my relatives appear in the film. You can see five of my aunts waulking the tweed!'

Back at the post office in the main settlement of Balla, Iain Ruaraidh told me that the island school had recently been forced to close. There are eight children of primary school age on the island, he explained, but they now have to take a bus across the causeway to a bigger school in South Uist.

Opposite Rosinish Point at the north-west corner of Eriskay is the tiny isle of Calvay, which traditionally forms the object of a toast still drunk by locals when they raise a glass 'to the man who couldn't see Calvay'. The reason has become the stuff of legend. In February 1941 the ship ss *Politician* was on her way to America with more than a quarter of a million cases of whisky when she ran aground on Calvay. Invoking the ancient rights of salvage, the islanders of Eriskay 'liberated' about 24,000 bottles, inspiring Compton Mackenzie to write his novel *Whisky Galore* – a ripping yarn that was later made into the Ealing film comedy of the same name, starring Basil Radford and Joan Greenwood. Seeking shelter from rain and low cloud that had unexpectedly descended, I entered the island pub, the aptly named *Am Politician*, where I was amazed to see bottles of whisky that had been taken from the wreck, including one that seemed almost full of the fabled *uisge beatha*. Behind the bar stood the landlady, Morag Mackinnon, who in a previous life had been a WPC in Govan. While she poured me a pint, Morag explained that while the book and the film highlighted the booze, there was actually much more

in the holds of the *Politician* when she ran aground. 'The cargo contained a lot of other daily essentials which were very useful to the islanders: linens, bicycles, shoes, food, even machetes for the sugar plantations in Jamaica where she was heading. Some of the men who went aboard also discovered newly printed bank notes for the Caribbean colony. But they said it would have been stealing to take cash, whereas the other stuff counted as legitimate salvage. It was a bonanza all right, but they didn't lose their moral compass!'

However, that was not how the wartime authorities regarded the actions of the Eriskay men. Although the book and the film portray the game of cat-and-mouse between customs officials and islanders as a humorous romp, in reality the matter was taken extremely seriously. Homes were raided and crofts were turned upside down. Bottles were hidden or sometimes drunk in order to get rid of the evidence. The police and customs men seemed determined to make an example of the people. Morag showed me a police charge sheet made out against her husband's uncle, James Campbell, who was the first man aboard the *Politician*. Listed among the items he was accused of taking were: a shovel, a bunch of keys, a shaving stick, a paintbrush, door fittings – all very low-value items. Intriguingly though, there was no mention made of him taking any whisky. 'Did he not take any whisky then?' I asked naively.

'They all took whisky! The island was awash with it. Men were lying drunk at the side of the road. But curiously no one on the island was ever charged with its theft. Other men went to prison, but they too were charged with stealing other goods. They all got about four weeks in jail'

Perhaps the reason no one went to prison for stealing whisky is because the islanders were so

Some of the bottles recovered from the ss *Politician* when it ran aground on the rocks off Calvay in 1941.

good at both hiding it and drinking it. They stashed it under floorboards, in byres, down rabbit holes, anywhere they could think of. In total they disposed of 24,000 bottles. That's a lot of whisky. With so much of the stuff cached across the island, it's not surprising that bottles occasionally reappear. The most valuable are those with the contents intact, like the one that takes pride of place behind the bar. It was found a few years ago in a peat bog. Although unfit for human consumption, bottles like it can fetch upwards of £12,000. Unfortunately, since it was removed from the peat the lead seal has corroded and its precious contents are evaporating. Perhaps the Eriskay angels are taking more than their fair share! In the film *Whisky Galore!* the stricken ship eventually

sinks, but in reality things came to a more dramatic conclusion. To ensure that there would be no more temptation, the authorities decided to blow up the ss *Politician*, which still contained about 1,000 cases of whisky. Shocked and dismayed, one islander famously commented: 'Dynamiting whisky. You wouldn't think there'd be men in the world so crazy as that!'

BARRA

The island is named after the Celtic saint St Barr, who was sent in the 6th century to replace an earlier missionary who is said to have been eaten by the island's early inhabitants. The name Barra

actually comes from the Old Norse, *Barr-øy*, 'Barr's Island'. Barra is the largest inhabited island in the chain of islands, rocks and skerries that lie south of the Uists. It covers about 50 square kilometres of moor and machair. The highest hill, Heaval, rises to 383 metres above sea level. Barra is home to over a thousand islanders, many Gaelic-speaking, who mostly live in the settlements of Castlebay, Borve, Earsary and Bayherivagh. Archaeological evidence demonstrates that Barra has been inhabited since the Stone Age. There are Neolithic sites, standing stones, Bronze Age remains and Iron Age structures. A thousand years ago, Barra became the heartland of Clan MacNeil, who claim descent from Niall of the Nine Hostages, the 4th-century High King of Ireland. For centuries, the MacNeils occupied Kisimul Castle just offshore from Castlebay, where they earned a reputation as Gaeldom's pirates. My first view of Kisimul Castle was from the CalMac ferry as it slowly negotiated the entrance to Castlebay harbour. It was an impressive sight. There's nothing quite like it anywhere else in Scotland – built on a rocky island in the most sheltered natural harbour in the Hebrides, it's the archetypal picture-postcard Hebridean castle.

In the 15th and 16th centuries Kisimul provided

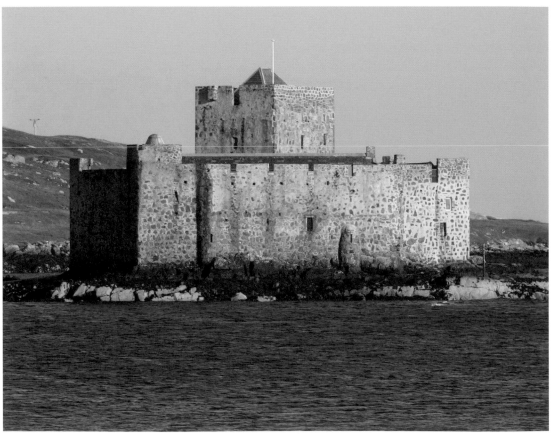

Kisimul Castle, Barra, the base from which the MacNeils set off on their pirate raids.

the chief of Clan MacNeil with the perfect base from which to launch his notorious pirate raids on merchant shipping, which plied the major sea lanes that run close to Barra. Roderick MacNeil, known as Roderick the Turbulent, was the most feared of all the MacNeil pirate chiefs. He also had a reputation for boasting. From the top of Kisimul Castle, his trumpeter is said to have cried: 'Hear ye all ye people and listen all ye nations, the great MacNeil of Barra having finished his meal, the princes of the earth may dine.' Another story about the over-mighty MacNeil chief claims that, during the Great Biblical Flood, Noah invited MacNeil and his wife to join him aboard the ark. MacNeil is said to have declined Noah's offer, saying: 'Thank you, but the MacNeil has a boat of his own.' To maintain himself in the style that matched his boastful claims, MacNeil had to look beyond the shores of his barren island empire to fill his table and stock his cellars. Ships and the open sea were key both to survival and to maintaining the loyalty of his clan. In making raids on vulnerable merchant ships, he was following his Viking prede-cessors, the Norse raiders and settlers who had such an important and enduring impact on the history of the Hebrides. The fast attack-ship MacNeil used was the birlinn, or Highland galley, a direct descendent of the longships of the Vikings.

Taking the little ferry from the village jetty, I crossed the waters of Castle Bay to Kisimul, where I met Rory MacNeil, the 47th chief of the clan. To be honest Rory wasn't exactly what I expected from a descendant of Roderick the Turbulent, being a quietly-spoken American who divides his time between Barra and Edinburgh. Rory's father was an American law lecturer who once taught former US president Barack Obama. He gave most of his Barra estates to the Scottish nation and the

castle to the keeping of Historic Scotland for an annual rent of £1.00 and, more significantly, a bottle of whisky. Rory told me that his grandfather, the American architect Robert Lister MacNeil, had managed to buy back the old MacNeil lands in 1937 after they had been lost to the clan for more than a century. He then set about restoring Kisimul, which for decades had languished as a ruin, making it habitable for the first time in two centuries. Rory took me into the great hall – a place designed to impress guests and members of the clan with the chief's lordly status. But that was just for show. Significantly, all the important deci-sions of politics and power were made in the castle tower, where the chief's private life was played out behind closed doors.

Stepping into an anteroom, the present clan chief recalled the time when he'd been asked to provide hospitality to a female visitor from the Royal Yacht *Britannia*, Diana, Princess of Wales. 'This was the first-ever visit to Kisimul by such a close member of the royal household,' Rory recalled: 'And I was pretty darn nervous too.'

The MacNeils' relationship with royalty has always been rather complicated. During the reign of James VI, clan chief Roderick MacNeil earned the displeasure of the king by attacking ships of the Elizabethan Royal Navy. King James, who hoped to accede to the English crown, was over-anxious to keep on the right side of the English Queen Elizabeth. James had the chief arrested and brought in chains to Edinburgh. Faced with the death sentence, Roderick MacNeil was interro-gated by no less a figure than King James himself, who asked the chief to explain his acts of piracy. He said that he thought the king would be pleased that he had attacked ships belonging to the woman who had had his mother, Mary, Queen of Scots,

The cockle sands of Traigh Mhor on Barra.

executed. King James was so baffled by MacNeil's reply that he let the wily chief go on a promise of good conduct in the future.

But old habits die hard. The MacNeils had been pirates ever since they had been at Kisimul. It was the tradition they had inherited from the Vikings, whose blood had long ago mingled with theirs. At first, the Norse raiders were pagan but, after they settled in the Hebrides, they gradually converted to Christianity. At the ancient ruined church of Cille Barra, I found a unique stone cross that displays the fusion of cultures and faiths that was beginning to take place on Barra over 1,000 years ago. The cross is a fine specimen of the stone-mason's art, but what makes it so unusual and fascinating isn't so much the intricate Celtic carving on the front, but what's on the other side, where strange marks have been cut into the stone. They are Norse runes – the written language of the Vikings. The inscription reads: 'This cross has been raised in memory of Thorgeth, daughter of Steinar'. We don't know who Steinar or his daughter were, but the inscription says a lot about the integration of cultures: the Vikings had become Christian, and their Christianity was infused with the Celtic version of the faith.

The MacNeil domination of Barra came to an end in the 19th century when the bankrupt clan chief was forced to sell up. The new owner, Colonel Gordon Cluny, was an avaricious tyrant who forced many of his tenants from their homes to make way for sheep. With the help of the police and press gangs, Cluny transported hundreds of Barra folk to Canada. The remaining islanders were crowded onto the poorest land where they fought off starvation by whatever means they could. For the people who lived at the north end of Barra, the great stretches of tidal sand at Traigh

Mhor provided an unexpected form of nutrition: cockles. During the dark days of the Clearances, the sands were dotted with the silhouettes of hundreds of people – whole families – raking through the wet sand to find something to eat. In later years, Traigh Mhor provided a steady if meagre living for cockle pickers who sold their catch to fish merchants. The cockles were pickled in vinegar and sold in fish and chip shops up and down the country. Nowadays, the sands of Traigh Mhor, which were once the best in the country for cockles, no longer produce bountiful harvests, perhaps because of over-exploitation in the past. Today, the business of 'cockling' has become more of a relaxing hobby than a way of keeping body and soul together – a pastime that's even been recommended in official tourist literature. Surprisingly, the tourist literature also warns would-be cockle pickers to beware low-flying aircraft.

Although the prospect of being hit by a plane in the middle of the huge expanse of Traigh Mhor might seem highly unlikely, the hazard is a real one. A line of posts in the sand marks the boundaries of where it's safe to walk. Stray beyond them and you'll find yourself on the main runway of Barra airport, which is the only airport in the world where planes land on the beach. The runway is quite literally washed away by the tide twice a day. My first-ever trip to Barra was by a tiny Twin Otter plane, and a wild and stormy flight it was. By the time we landed on the beach, my legs felt like jelly, and I was glad to seek the comfort of the hotel bar at Castlebay to restore my equilibrium.

The following morning, the weather was still wild, so I decided to blow away the proverbial cobwebs with a walk on the beach. Up at the north end of the island is a gigantic submerged reef that I was keen to see. It was a dramatic and terrifying

The airport, Barra: the only one in the world with a runway washed by the tide twice a day.

sight as huge waves exploded over it. For a boat to be caught near the reef in bad weather like this could mean almost certain death. Tragically, this is exactly what happened one night in January 1723 to the *Adelaar*, a ship of the Dutch East India Company. Laden with a rich cargo of gold, silver and jewels, the *Adelaar* was struck by hurricane-force winds and driven onto the reef. Within minutes, her back was broken and the 350 passengers and crew were thrown into the wild water. There were no survivors. Many of the bodies were washed ashore on the big beach to the west of the island. But what was a human tragedy for the men and women whose lives had been lost at sea quickly became an opportunity for the people of Barra. The bodies were systematically looted and the shoreline combed for the goods that were

washed ashore. When the MacNeil chief heard of the disaster, he sealed off the island, desperate to grab as much of the treasure as he could for himself. He spent a fortune employing divers, who brought to the surface 30 tons of gold and silver bars. At today's prices, this would be worth $170 million. But MacNeil never made a penny from it. Neighbouring Clan Ranald, acting on behalf of their feudal superior MacKenzie, invaded Barra and secured the wreck site. The resulting legal action saw MacNeil lose everything he'd taken from the *Adelaar*.

Barra is one of the few islands in the Hebrides to be predominantly Catholic, having defied the currents of history which saw the bulk of Scotland become Protestant during the Reformation of the 16th century. On the upper slopes of Heaval is a

The Madonna and Child at Heaval.

rather lovely white marble statue of the Madonna and Child, called locally Our Lady the Star of the Sea, which overlooks distant Castlebay. Its weather-worn appearance suggests that it must have been there for centuries, but in fact the statue was erected in 1954, which was a Marian year, declared by the Pope to be dedicated to the Virgin Mary. To get to Our Lady makes for a delightful two-hour hill walk from Castlebay, following the road north out of the village and then taking a path over rough ground to the statue, before continuing to the summit trig point where, I was told, the views are absolutely stunning. Unfortunately, on the day I made the walk I could see very little. The clouds were so low I had difficulty finding the statue and saw nothing at all from the top. However, when I returned, the clouds lifted a little and the rain eased,

affording me a very atmospheric view of the statue and Castlebay, which appeared mysteriously through the mist.

VATERSAY

The name's derivation is disputed, although there is a consensus that it is of Norse origin. Vatersay is one of those Hebridean islands that have a causeway connection. In 1990, the road link to Barra over the narrow Sound of Vatersay was completed. Until that time, cattle had to be swum 170 metres across the sea to get them to market. But in 1986 Bernie, a prize bull, drowned in the attempt. The publicity that resulted from his tragic demise helped persuade the authorities to build a permanent link.

The Isle of Vatersay.

Vatersay is home today to about 40 people – but in the 19th century an absentee landlord forced the entire native population of several hundred to leave. He wanted to realise the profitable potential of the land and run the island as a single efficient farming unit. He achieved this by getting rid of the traditional subsistent farmers on his island. For 50 years the landlords of Vatersay refused to allow anyone to re-settle the island, despite the fact that the Vatersay clearances had caused severe overcrowding on the neighbouring islands of Barra and Mingulay. But then, in an unprecedented move, the dispossessed people began to come back – led by ten men known to history as 'The Vatersay Raiders'. They and the people they represented were in a desperate state. To survive, they needed land – and the empty island of Vatersay was their target. Using an ancient Gaelic tradition which gave land rights to any man who could build a shelter and light a fire in a day and a night, the landless Vatersay Raiders staked their claim in the summer of 1906. They believed they were reclaiming what was rightfully theirs – the right to make a living in the islands of their ancestors – but, in the eyes of the law, the men were criminals and they were arrested and jailed. However, public sympathy in urban Scotland unexpectedly swung behind them. The landless, desperate men were seen as heroic victims of injustice. The case of the Vatersay Raiders caused such a furore across Scotland that in 1909 the government bought the island for the people and divided the land into 58 crofts. Today, the raiders are hailed as heroes and many of their descendants still live on Vatersay.

The flip side of the land and crofting is the sea and fishing, which have an equal importance to the people who live an island life. Down at the jetty, I met two local creel fishermen who took me in their small wooden boat to the big lumpy seas west of Vatersay. It was a beautiful, bright morning, but the motion of the boat was enough to make me fear I might lose my full Scottish break-

fast, so I concentrated on the passing scene as big Atlantic rollers burst on the rocky shoreline and washed over dangerous reefs. Puffing on a cigarette, skipper Neil Simpson skilfully navigated towards a line of distant orange buoys, which marked the spot where he had previously set his creels. Neil is a Vatersay man, born and bred. His grandfather was one of the original Vatersay Raiders. Neil's shipmate Paul opted to become a fisherman after graduating from university with a degree in geography. Originally from landlocked Cumbernauld, he fell in love with the islands when his parents took him to Barra on holiday. As we bobbed and lurched in the swell, the men began to haul in the catch. Creel after creel had something in it: edible crabs, lobsters and even a ferocious-looking conger eel. As Paul tied the claws of a lobster together with a rubber band, to stop it attacking the others he'd already caught and packed alive in the fish box, I asked what was the biggest lobster they'd ever caught. 'Eight kilos,'

Creel fisherman Paul McGuire at work on a lobster.

said Neil. 'It was huge, like a small dog! But lobsters that size are very rare these days.'

'It's overfishing,' said Paul, 'not by us on Vatersay, but by the big continental boats that come in with thousands of creels. They pull up a huge tonnage of lobsters every year. We are just the wee guys trying to make a living from this tiny wee boat. Our impact by itself is sustainable. But it's just anarchy when the big industrial fishing vessels are working close to the coast.'

By this time we were quite some distance out to sea, at least 3 kilometres. Paul and Neil quite often work much further out, up to 16 kilometres off the west coast of Vatersay and around Barra Head. 'It's the most dangerous job you can do,' said Neil as he winched another creel aboard. 'It can be really exposed out here. There are very strong tides, big waves and it's usually blowing a hooley. I was taught by my dad. The older men keep you right.'

The islands to the east and south of where we were fishing are known as the Bishop's Isles or Eileanan an Easbaig: Sandray, Pabbay, Mingulay and Bernaray.

THE BISHOP'S ISLES

SANDRAY

The name comes from the Old Norse *Sandr-øy*, meaning 'Sand Island', and the reason is pretty obvious. When the island is seen from the east, a huge 55-metre sand dune dominates the shore. Sandray is an uninhabited island lying a kilometre south of Vatersay. It covers an area of about 3.5 hectares, rising to the summit of Cairn Galtar at 207 metres. In the early 19th century there were nine families living on Sandray, working the croft lands and fishing its waters. The population was cleared for sheep grazing in 1835. A couple of shepherds occupied the island up until the 1930s, but it has been deserted since then.

PABBAY

The name comes from the Old Norse language of the Vikings and suggests that a religious community was present before the Vikings arrived. *Pabba øy* means 'Priest's Island'. Pabbay is a beautiful island that measures approximately 3 kilometres from east to west, and a kilometre-and-a-half from north to south. As its name suggests, it has had religious associations since the days of the early Celtic Church. On a hill slope towards the east of the island is an ancient symbol stone and cross slabs. Beside a burn above the white shell-sands of Bàgh Bàn, the remains of an ancient chapel have been found. There is also clear evidence of much earlier human occupation, with a ruined galleried Iron Age broch at Dùnan Ruadh.

Like Sandray, Pabbay was once populated, and the ruins of the township where the people lived can be seen nestling in a sheltered crook of land above Bàgh Bàn. At its peak, the population of the island was just under 30 people – but then disaster struck. In 1897, two open fishing boats, one from Pabbay and the other from the neighbouring island of Mingulay, were six miles out in the Atlantic when a terrible storm sprang up. The Mingulay boat managed to reach safety, but the Pabbay boat was overwhelmed by the waves. All on board drowned. The loss of every island man of working age was a terrible blow from which the community never recovered and, within a few years, Pabbay was uninhabited and has remained so ever since.

The awe-inspiring cliffs of Mingulay.

MINGULAY

Another Viking name, this comes from the Old Norse *Mikil-øy* – meaning 'Muckle Island' or 'Big Island'. Mingulay is a beautiful and dramatic island, and the largest of the Bishop's Isles. It was often described by visitors as the *nearer* St Kilda, because the life of its people – like the life of the St Kildans – was uniquely dominated by the sea. On the western side of the island, stacks and vertiginous sea cliffs rise 215 metres out of the Atlantic. They are among the highest and most awe-inspiring cliffs in the whole of the British Isles and, during the summer, are home to thousands of nesting seabirds, which the islanders risked life and limb to catch for their meat and feathers. To the east

of the island, where the land slopes gently towards the sea, is the village, which looks across the stunning white sands of Mingulay Bay. No one lives on Mingulay today. It was evacuated in 1912, ending almost 5,000 years of human occupation.

I first landed on Mingulay in the company of two academics from Northern Ireland who had crossed to Barra in their inflatable from Ballycastle in County Antrim. The trip had turned out to be more of an ordeal than they had expected and they were both a little shaken by the experience. After a night in Castlebay they were sufficiently restored to continue, and in the morning we left Barra with our 'expedition guide', local fisherman Calum MacNeil. A few miles from our destination, we had a slightly embarrassing nautical mishap

A ruined house on Mingulay. The island was evacuated in 1915; at its peak 150 people lived there.

when the propeller fouled on a rope we'd been trailing. Calum watched quietly as the academics and I struggled to get us going again. As we drifted towards the rocks, he eventually came to our rescue and then helped navigate the boat towards our landing place on Mingulay, where the academics were somewhat alarmed to discover that there was no pier, jetty or slipway. Boats in the past were forced to improvise and come alongshore at a suitable section of the rocky coast. Calum, who was in his sixties, stood on the bow and leapt ashore with the mooring ropes.

The old schoolhouse was the first and most prominent building that we came to. Calum told me that he used to stay here when he was a teenager, working as a shepherd during the lambing and shearing seasons. For some reason, he was left one night entirely alone on the island. In the wee small hours, strange noises disturbed his sleep. Going outside, he got the fright of his life when an old ram rushed at him out the darkness. 'I thought it was the devil himself,' he said.

'Or a ghost?' I suggested. 'There must be plenty of them about.'

Calum looked across at the tumbled walls of the ruined village and at the forlorn headstones in the overgrown burial ground. 'I don't know about ghosts but there'll be plenty of memories

attached to the place, right enough.'

In the 1880s the population of Mingulay reached its peak at over 150. Numbers had been swollen by recent island clearances. With nowhere else to settle, desperate families migrated from Barra and Vatersay hoping to eke out a living. A new priest's house was built by the church to administer to their needs. Until then, the folk on Mingulay had to row every Sunday, weather permitting, to Pabbay to go to church or to get married. 'That's how romance used to flourish,' Calum said. 'A young man might catch the eye of a lassie in church on Pabbay, and one thing would lead to another.'

Calum showed me some old photographs taken in the summer of 1896, by a young Aberdonian photographer called Robert Adam. Looking at them where they had been taken over a century ago gave the images a haunting quality: they were a vivid reminder of a way of life that has gone forever. 'It became more and more difficult to live out here. As you saw yourself, there is no proper landing place, the doctor couldn't get here from Barra in bad weather. The school closed, and the priest felt the people would be better off elsewhere, so in 1912, the last inhabitants left for good,' said Calum.

The people may have gone, but Mingulay is home now to settlers of another kind. Before we left, I walked across the great crescent of the beach where I inadvertently disturbed a seal pup. Alarmed, it struggled to escape to the safety of the open sea. A couple of years later, on a return trip to Mingulay, I was utterly amazed to find that the same stretch of sand was now occupied by thousands of breeding seals. As I approached, they lumbered into the sea, churning the water in their unseemly haste to get out of my way.

BERNERAY OR BARRA HEAD

Berneray comes from the Old Norse *Bjarnar-øy*, 'Bear Island' or, more probably, 'Bjorn's Island'. Uninhabited Berneray is the most southerly of the Bishop's Isles and the very last link in the chain of the Outer Hebrides. Wedge-shaped and cliff-girt, it covers an area of about 2 hectares. The landing here is apparently regarded by the men who maintain the lighthouse as one of the most dangerous in Scotland. The imposing western cliffs rise sheer out of the ocean to a height of 190 metres and take the full force of Atlantic storms. Because there is nothing between Berneray and the coast of Labrador 5,000 kilometres away, the seas around the island are treacherous. Even on a calm day they are foam-flecked with the ceaseless Atlantic swell, or with the white streaks of tidal currents, and the dark eddies of hidden undertows. It's perhaps only to be expected that this coast has been the setting for many tragic shipwrecks.

The worst recorded disaster occurred in 1853, when the three-masted *Annie Jane* – a crowded emigrant ship with 450 men, women and children packed on board – was driven ashore in a storm. The 'Dreadful Shipwreck' was reported in the London *Times* on Saturday, 8 October 1853: 'We regret to announce one of the most terrible catastrophes that has come under our notice for some time – the total loss of the ship *Annie Jane*, belonging to Liverpool, which was driven ashore on the iron-bound coast of Barra.' According to *The Times*, the *Annie Jane* had made some progress west of the islands, but was driven back by the ferocity of the storm, passing close to Barra Head on the island of Berneray: 'There is a lighthouse on the head, which is the highest in the United Kingdom, being 680 feet above the level of the sea. Such is

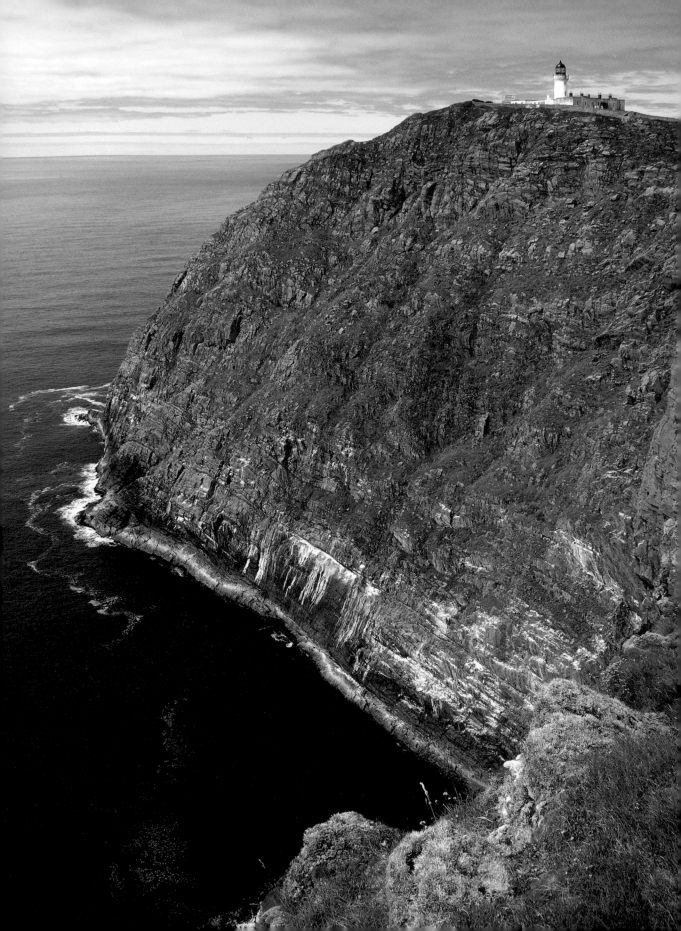

the terrible character of the coast, however, that there is little chance of a vessel being rescued when once it is entangled among the reefs.' The terrified and helpless passengers on board the *Annie Jane* would have seen the warning beams of the lighthouse on that fateful night and must have known that disaster was imminent. The lighthouse keepers and the crofters who lived on the island were quite powerless to help as the *Annie Jane* was carried north towards the rocks and destruction. Three hundred and forty-eight bodies were later washed ashore on Vatersay, where they were buried in a mass grave. Miraculously there were 130 survivors, including a four-month-old baby.

My landing on Berneray was relatively straightforward. My boat nudged towards the old concrete jetty that was formerly used by the keepers of the lighthouse. There was not much swell, enabling me to time my hop ashore with considerably greater ease than a remarkable Victorian lady traveller who visited in 1863. She was forced to make what she described as a death-defying leap onto the rocks. Arriving stirred, but not shaken by her ordeal, Isabella Bird made her way inland towards the village, where she was impressed by the people she met, describing them as 'well-dressed, clean and healthy looking'. At that time the population of Berneray numbered about 30 souls in addition

to the men who manned Barra Head lighthouse. Somehow the islanders managed to eke out an existence by crofting, fishing and fowling – catching seabirds and eating their eggs. Despite their isolation, Isabella Bird considered these people to be model citizens who were more sophisticated than other Hebrideans she had met on her grand tour: 'Far out into the Atlantic, exposed to its fullest fury, and generally inaccessible ... these very interesting people thirst for education, and would make considerable sacrifices to obtain it.'

In 1922 the descendants of the hardy, self-reliant islanders who'd impressed Isabella Bird were evacuated from the island. With the last of the population gone, only the lighthouse keepers remained. It was not an easy posting, and they were often cut off for months at a time because of bad weather. The wind speeds they recorded during the many Atlantic storms that battered the island were frequently hurricane force, and on one occasion were strong enough to move a 40-ton boulder several feet. Eventually, even the keepers left. Since the 1970s, the lighthouse has been automatic and the island uninhabited.

The wilderness has taken over now, which is appropriate I suppose for an island that is literally at the ends of the earth.

Opposite. The dramatic setting of the lighthouse at Barra Head.

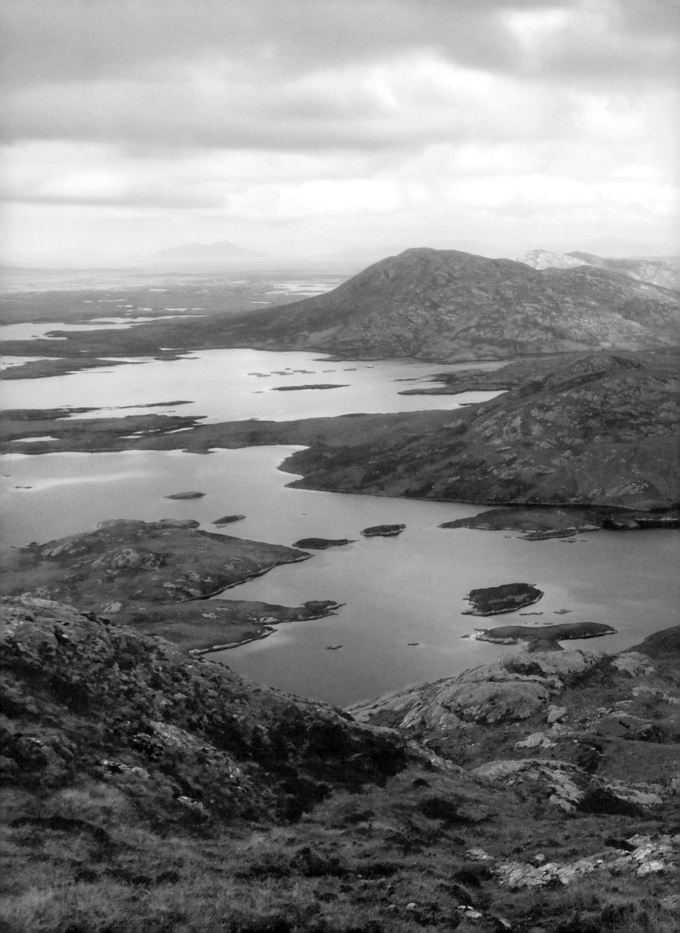

CHAPTER SEVEN SOUTH UIST TO THE MONACH ISLANDS

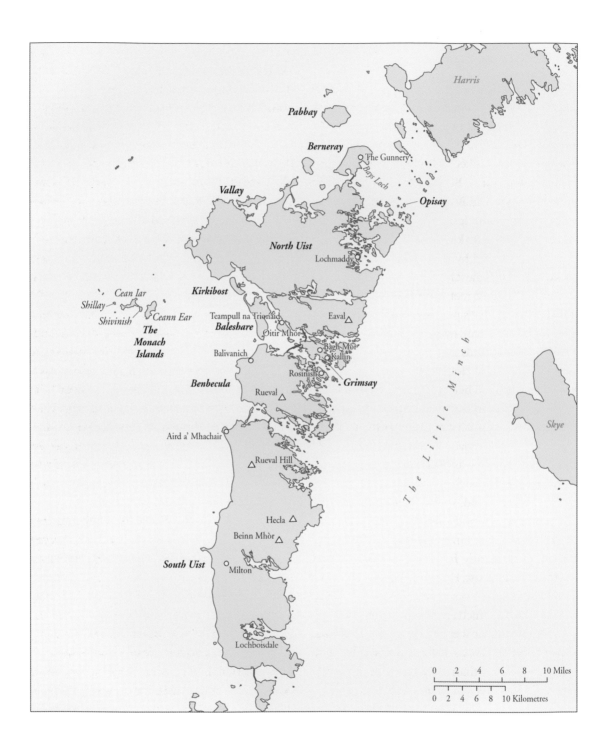

Harris

Pabbay

Berneray
The Gunnery

Bays Loch

Valley

Opisay

North Uist

Lochmaddy

Kirkibost

Shillay
Cean Iar

Shivinish
Ceann Ear

Teampull na Trionaid
Eaval △

The Monach Islands

Baleshare
Oitir Mhòr

Balivanich

Bagh Mòr
Kallin

Rosinish
Grimsay

Benbecula

Rueval △

Aird a' Mhachair

Rueval Hill △

The Little Minch

Skye

Hecla △

Beinn Mhòr △

South Uist
Milton

Lochboisdale

| 0 | 2 | 4 | 6 | 8 | 10 Miles |

| 0 2 4 6 8 10 Kilometres |

SOUTH UIST

The Gaelic spelling of the name is Uibhist and it apparently derives from the Old Norse word *vest*, which means 'west' in English. South Uist is the second largest of the Western Isles. Once a separate island, it is now linked by causeways to its neighbours in the north: Benbecula, Grimsay, North Uist, Baleshare and Berneray, making it possible to drive the entire length of the island chain, a distance of about 80 kilometres. The east of South Uist is dominated by a range of rugged, steep-sided hills, the highest being the prominent peaks of Beinn Mhòr (620 metres) and Hecla (606 metres). Most of South Uist's population of 5,000 live on the western seaboard of the island where the flat, fertile machair lands are covered by a profusion of beautiful wild flowers in spring and early summer. The land between the machair and the mountains is peaty and waterlogged – punctured by thousands of small freshwater lochs and pools. When seen from above, the whole landscape looks riddled with holes – as if a giant had drilled them to let in the sea, which at any moment threatens to engulf the island. In fact, South Uist is on a frontier between land and water: a battleground, which is felt very dramatically during the winter months when truly ferocious and destructive storms lash the coast. Hurricane-force winds have been known to hurl seaweed far inland – even into the lochs, which are becoming increasingly salty as the Atlantic seeps in. According to climate experts, the rate of coastal erosion and sea-level rise here is faster than anywhere else in the UK. Best enjoy it while you can!

Lochboisdale, towards the south, is the largest village on the island and is where I arrived early one May having had a rather uncomfortable ferry crossing from Oban. Monsoon rains had set in as we'd made our way up the Sound of Mull. All along the coast, swollen rivers had become torrents and poured in spectacular cataracts from the heights of the Morvern cliffs. When hit by squalls, these waterfalls were blown upwards by the force of the wind and didn't seem to reach the ground at all. Instead, they dissolved in a cloud of white spume into the mist and rain. When the clouds lifted a little, I watched a school of harbour porpoises leaping out of the water, as they made their way down the sound. The ship's PA system crackled. The young woman in the restaurant addressed the passengers: 'We are open for the duration of the four-hour crossing, but anyone who's hungry should make their way to the restaurant. It's very rough out there and, if you want to hold onto your plate, or keep your food down, eat now before we hit the big waves ahead.' Her prediction must have been born from experience and was soon confirmed. As we sailed past Ardna-murchan lighthouse and headed west across the Minch, the wind and the seas picked up alarmingly. As predicted, it wasn't long before some poor souls were throwing up.

After my first night on South Uist, the weather hadn't improved much. Leaving the hotel, I headed north. The sky looked ugly. Eventually, the threatening black clouds gave up their burden, deluging the island and soaking me to the skin. Lightning flashed, thunder rolled, sheets of rain swept the moors and hailstones bounced off the road, making it almost impossible to see the way ahead. Despite the biblical weather, I chuckled to myself because it reminded me of how my old Victorian guidebook, *Black's Picturesque Tourist of Scotland*,

Chapter opening: North Uist from Eaval.

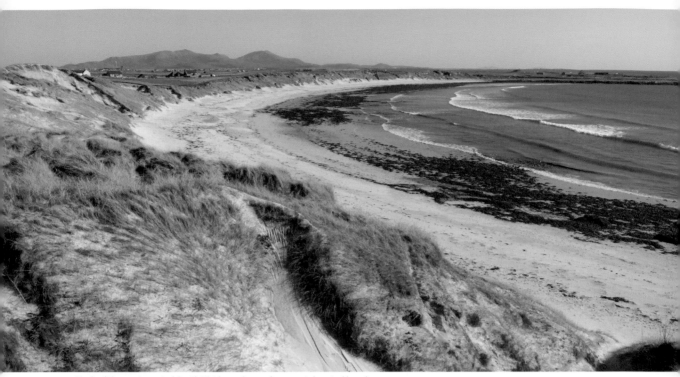

Much of the west coast of South Uist is made up of one vast deserted beach.

described South Uist. The author hadn't been impressed, obviously, declaring the island to be nothing but 'brown, windswept and saturated with water. Few people except sportsmen penetrate the Outer Isles for pleasure – and only the sturdy lover of nature can appreciate their charms.' Admittedly, you had to be fairly stoical to endure a downpour such as the one I was struggling through; but it soon passed and then the sun came out, revealing the machair, the sand dunes and the sparkling sea in all their colourful glory.

Most of the west coast of South Uist is one vast, beautiful, deserted beach: a haven for wildlife and wading seabirds, but it wasn't always so empty of people. A hundred and sixty years ago, the population of the islands was four times what it is today.

A combination of famine and eviction by ruthless landlords brought South Uist to its knees. In the 1850s over a thousand destitute local people were packed into a sailing ship called the *Admiral* and sent to America. The poverty was still so great 40 years later that even my old guidebook mentioned it, quoting from a worthy visitor who was compelled to write: 'The very existence of South Uist is itself a tragedy which shames our civilisation.' Strong stuff indeed! Emptied of so many of its people and battered by misfortune (as much as by the weather), it's hardly surprising that the Uists weren't considered to offer the ideal holiday destination. But as my guidebook points out, the islands were perfect for enthusiastic sporting gentlemen. 'It is in fact a fishing and shooting place, pure and

Fishing for sea trout with Rory MacGillivray.

simple – and no one would go there with any other object than sport.'

One bright but bitterly cold evening, I met up with gamekeeper Rory MacGillivray near the mouth of a river. The tide was on the ebb, leaving large pools of seawater to act as natural fish traps. This is where we hoped to catch wild sea trout; but Rory was keen that I should have an authentic fishing experience so, before we could make a cast, we first had to find our bait – the traditional way. Rory probed the sand using an old iron sickle. He was looking for small sand eels, which hide just below the surface when the tide goes out. I was impressed by how easily he howked them out, and it wasn't long before we had enough to start fishing, casting the line and then reeling it

back in again, hoping to hook a trout with a sand eel. 'I was taught this technique by old Donald Alan,' Rory told me. 'A wonderful man who was totally in tune with his environment. He used to have a pet golden eagle – until animal welfare officers said he couldn't keep it. They took it off him and gave it to a wealthy landowner – the actor James Robertson Justice. What did he know about nature? His only qualification was money!'

Rory loves South Uist, its landscape, wildlife – and even the weather. He was born on the island and has been fishing for as long as he can remember. It was something the whole community did. But, as he admitted, fishing in the rivers and along the coast wasn't entirely legal – and still isn't without a permit. The fish have always been jealously

guarded and belong to the owner of the land the river runs through – usually the laird of a big estate – and to take fish without permission is theft. 'It was difficult,' Rory explained. 'There were water bailiffs, gamekeepers and river watchers waiting to catch you.'

'So you admit that you were poaching?'

Rory hesitated and then grinned. 'No, not poaching! That was a different thing altogether. No! We were taking something just for the pot. Nothing more.'

In many ways Rory is the classic poacher turned gamekeeper. Perhaps ironically, he is now employed to protect the rivers on the community-owned estate that he once fished without a permit. He admits that the skills he learned as a wee boy have come in handy, both to police the river and to help his paying clients fish the pools he has known since childhood. After two hours of constant casting, I was down to my last sand eel – and still I hadn't caught anything. Not even a bite. But then I felt a tug on the line and a sea trout – an absolute whopper – surfaced in a frenzy of splashing. I shouted to Rory in excitement. He rushed to my side and began to offer advice on how to land this monster. But then disaster and disappointment: the line broke and it got away. At least that's my version of events. Rory saw it differently. 'No, Paul. It didn't get away. You lost it!'

Near the village of Milton, I made a pilgrimage to the birthplace of Flora MacDonald, the woman celebrated as the saviour of the Young Pretender, Charles Edward Stuart. As a result of helping the fugitive prince, she became one of the most famous women in Scottish history. Sadly, there's not much to see of the house where she was born and raised. A simple mound of stones now marks

Flora MacDonald's birthplace, 'a name that will be mentioned in history,' declared Dr Johnson, 'and if courage and fidelity be virtues, mentioned with honour'. After her Jacobite excitement and anti-government plotting, Flora married and emigrated to North Carolina. Perversely, during the American War of Independence, she sided with the Hanoverian government – the same regime that had persecuted her people and defeated the prince.

In spring and early summer, the rasping call of the corncrake is ubiquitous on the islands. The call of this little bird is loud enough to wake you at dawn and will probably be the last thing you hear at night as you drift off to sleep in the extended twilight. Yet, despite being so noisy and so common in the Hebrides, the corncrake is very difficult to spot and is rare enough to be regarded as an endangered species. Similar to the partridge and related to moorhens, coots and rails, the corncrake is a summer visitor from North Africa. A secretive bird, it seeks out long grass in which to breed and rear its young. For this reason, hayfields are very attractive to them but, since the introduction of mechanised farming techniques, earlier hay harvests and the move to silage crops, the corncrake has lost much of its former habitat. In Britain, the Western Isles are its last stronghold. The first time I saw one was back in the 1980s. I was in South Uist with a friend who was involved at the time in trying to encourage crofters to adopt corncrake-friendly harvesting schedules. We had come to visit a crofter and his family in the south of the island. They were interesting to my friend because they used traditional techniques to cut and gather hay on their croft. On a beautiful, cloudless day I watched the family at work. It was a timeless scene. The father and grandfather swung their long scythes in a slow, methodical rhythm,

The birthplace of Flora MacDonald at Milton, South Uist.

while the mother and her two children turned over the cut grass to dry in the sun. The family's happy Gaelic chatter was punctuated by the rasping call of 'crex crex': a corncrake suddenly broke into the open and made a dash for the long grass in a neighbouring field. But as the bird ran, it caught its leg in the wire mesh of a fence. I hurried over and gently untangled the bird and then held it for a moment, feeling its heart fluttering in my hands, before releasing it into the grass.

After the Second World War, the modern world seemed to encroach on traditional life in South Uist ever more rapidly. In the 1940s hundreds of servicemen arrived to build an airfield on neighbouring Benbecula and a causeway link with South Uist, making it possible to drive between the two islands for the first time. In the 1950s the military significance of the whole area continued. The government deemed the Outer Hebrides to be the perfect remote location to test the latest deadly

weapons and plans were drawn up for a rocket range in the islands. The headquarters and personnel were based on neighbouring Benbecula, the missiles fired from South Uist and then tracked by a radar station located 65 kilometres to the west on the island of St Kilda. The space age had arrived in earnest, and South Uist found itself on a new frontier: the great ideological divide between Western democracy and Soviet communism that marked the frontline of the Cold War.

Local teacher Mary McInnes was a young girl at the time. I met her on the beach near Aird a' Mhachair, not far from the rocket range, to learn first-hand what impact all this military activity had on the lives of the islanders. Mary told me that the plans for the rocket range initially divided the community. Some people were in favour of modernity, but many more feared for the future of their traditional crofting way of life. The protestors were led by the parish priest, Father John Morrison, who

became known as Father Rocket because of his campaign to get the best deal possible for the islanders. 'He was the only rocket to become a canon,' said Mary, explaining Fr Morrison's later clerical promotion. With the eyes of the world on him, Father Rocket took up the fight to stop crofters being forced off their land. But despite prayers for divine intervention, the Ministry of Defence went ahead. However, Father Rocket managed to wring many concessions from the government, and the plans to take over the whole of the north of the island were significantly scaled down. Having ensured that local people benefitted from the project as much as possible, Father Rocket was still concerned for their spiritual welfare. He feared that the coming of the space age would have a damaging effect. To counter the threat to their souls, he managed to persuade the army to help him erect a huge 30-foot statue of the Madonna and Child on the Hill of Rueval, the 'Hill of Miracles'. Created by the sculptor Hew Lorimer, Our Lady of the Isles overlooks both the missile firing range and the wider community.

Under the watchful gaze of Our Lady, missile firing began. But what must it have been like for the islanders? Mary told me that a red flag would be raised prior to a launch to keep people away from various parts of the island. 'We were very anxious and frightened at first. There would be a tremendous amount of noise and then a big boom. As the rocket flew over the house, you could clearly see the little spearhead of fire and smoke, before it safely drowned itself in the Atlantic. At peak times they would fire two or three times a day, so we got used to it eventually.'

It didn't take long for the 400 or so military

Our Lady of the Isles, the hill of Rueval, South Uist.

One of South Uist's many roadside shrines.

personnel to succumb to the charms of the island – and its locals. Most of the soldiers working at the range were single young men, a long way from home and looking for fun, which is a recipe for a party. And party they did.

'Many of them have stayed and become part of our community,' Mary told me. 'And who can blame them. They were just taken by the beauty of the island, the hospitality of the people and the beauty of the young women!'

Our Lady of the Isles might be the biggest, but she's not the only statue to the Holy Mother on South Uist. In fact, there are several of them, staring through protective glass-fronted shrines at crossroads or watching over passing traffic from

a discreet distance, their existence a very obvious sign that South Uist remains firmly Catholic, despite the Protestant reformation of the 16th century. Under the watchful gaze of the Madonna and Child and with one eye on the skies, I turned my attention north to my next destination: Benbecula, crossing the causeway that was first built by the army during the war. It's not far – just 400 metres separates the island from South Uist. But the road link made all the difference in the world to islanders when it opened. Until then, three options were available to the intrepid traveller hoping to cross to Benbecula. The first was to take a rowing boat at high tide – dangerous when it was blowing a hooley – or secondly risk

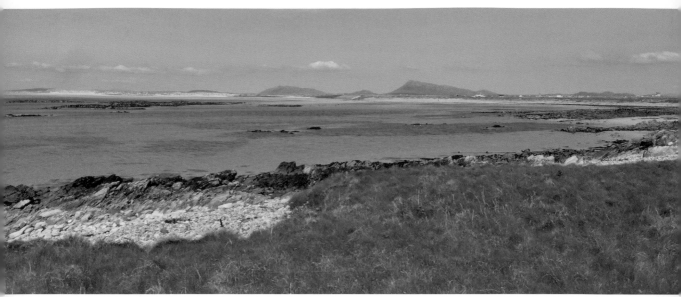

The island of Benbecula.

getting your feet wet by walking over the wet sands at low tide. Or, for those who want to travel in style and keep their feet dry, a pony and trap provided a convenient and exciting way to cross.

BENBECULA

This Gaelic name has obscure origins, possibly from *beinn bheag a'bh-faodhla,* or 'the Little Hill of the Fords' which, given its position between the two Uists, seems entirely appropriate. Compared with many Hebridean islands, Benbecula is quite densely populated, being home to over 1,300 people. The main village at Balivanich, near the airport, has an almost urban feel, with a lot of activity around the numerous flights that connect this link in the Hebridean chain to the mainland and beyond. Balivanich was developed during the war, initially as an RAF base to provide air cover

for Atlantic convoys. In the 1950s, the army moved in and the base became the operational centre for the missile firing range on South Uist. Balivanich in Gaelic is Baile a' Mhanaich, which means 'Town of the Monks'. In the 6th century there was a monastery here and the ruins of Columba's Church lie just south of the village.

Benbecula measures roughly 9.5 kilometres from north to south, by 12 kilometres from east to west, and is very low-lying. Beautiful sweeping white shell-sand beaches and dunes fringe the west coast, while the east is more rugged and hilly. It's a small island and is often referred to as the stepping stone between its two larger neighbours. This is perhaps unfair as there is a lot more to the island than that. Nevertheless, it is a transitional place. Here the religious mix is different from South Uist, with more Protestants and no shrines. Across in North Uist the dominant religion is Protestantism. The highest point on the island is

the hill called Rueval (Rhabhal), which rises to the not-so-dizzy height of 124 metres, from where there are magnificent views of the whole island, and of the Uists to the north and south.

As I set off to make the short ascent (a round trip of about 3.5 kilometres), I passed through a landscape that had once been familiar to Bonnie Prince Charlie – the Jacobite prince who landed in the Hebrides in 1745 with the aim of winning back the British crown for his exiled father and the Stuart dynasty. The Jacobite rising ended horribly, of course. Defeated at the Battle of Culloden, the prince was forced to flee. On the run, he spent many miserable weeks hiding in the wilds, first on the mainland and then among the islands of the Hebrides. Arriving on Benbecula, he landed on the rocky east coast at a place called Rosinish. The armed might of the British state was actively

pursuing him – hunting him down like a dangerous animal on the loose. To make matters even worse, he had a price on his head of £30,000 – the equivalent of £50 million in today's money. It was a king's ransom – well, a prince's ransom – and very tempting. Things looked bleak indeed for the prince until a saviour appeared. She was young and pretty and her name was Flora MacDonald from South Uist. A writer later described her as a woman with 'soft features, gentle manners, a kind soul and elegant presence'. She was just 24 when she met the prince and had an audacious plan to spirit him to safety. Incredibly, it involved the old pantomime trick of cross-dressing, with the prince playing the dame. Slipping into a frock, the Bonnie Prince became the bonnie Miss Betty Burke, Flora's devoted maidservant. Together they escaped by boat from Rosinish 'over the sea to

The view from Rueval, Benbecula.

Skye' – an event ever after immortalised on millions of shortbread tins. Eventually, the prince managed to slip away to France where he died a bitter old man. Flora MacDonald became a legend.

The view when I reached the summit trig point didn't disappoint. I could see all the way south to Barra and Vatersay, north to the hills of Harris and east to Skye and the Cuillin. Taking in this magnificent panorama, I was joined by a cheerful group of three middle-aged Glaswegian men who were touring the Uists by walking, taking buses and enjoying a dram or two in the evenings. They had started at Lochboisdale on South Uist, had climbed Beinn Mhór and Hecla, and were now looking forward to walking the hills of North Uist.

GRIMSAY

Griomasaigh is the Gaelic spelling for this island, named after a Viking called Grim: *Grims-øy*, or 'Grim's Island'. For drivers heading north across the causeway that connects South Uist to North Uist, it's easy to miss Grimsay, which lies midway across the tidal sands of the Oitir Mhòr ('Great Sandbank' in English). Before the crossing was opened in 1960, travellers heading northwards had to negotiate the North Ford, where the route at low tide was marked with cairns. However, this route often changed with the shifting sands, which for much of the day were either too wet to cross by vehicle or foot or too shallow for a boat. Today, the road link actually crosses the western end of Grimsay for a few hundred metres, before continuing over the next section of the causeway link; however, the rest of the island lies to the east, where the population is scattered among small crofting communities. The village of Kallin clusters around the busy harbour at Bàgh Mòr (Baymore), which was developed in the 1980s for the island's growing fishing fleet. The scallops, crabs and lobsters landed here are exported to gourmet restaurants across the UK and Europe. Kallin is also home to the Boatshed. For generations, Grimsay was famous for

North Uist.

the wooden fishing boats that were made here. The Boatshed is a charitable organisation that seeks to preserve and continue the traditional skills of Grimsay boatbuilding for future generations.

NORTH UIST

The derivation is the same as for South Uist – Uist being a Gaelicisation of the Old Norse word for 'west'. North Uist is slightly smaller than its southern twin and has a much smaller population of around 1,200. Like South Uist, crofting is still an important feature of island life, especially on the fertile machair land to the west; but, if the geography of South Uist is a product of being on the frontier between the land and sea, then North Uist is a dynamic battleground between the elements. The whole island is extremely low-lying and so pockmarked by pools and lochans that more than half its total area is covered by water

of varying degrees of brackishness. Rising above this semi-submerged landscape is the elegant dorsal-fin peak of Eaval, North Uist's highest hill, at 347 metres.

The main town on North Uist is Lochmaddy. With a population of around 1,200, it's more of a village really, but this is where the CalMac ferry arrives. There is a large Victorian hotel catering for tourists and anglers, a vibrant arts centre and a few shops selling island essentials. The name Lochmaddy comes from the Gaelic Loch nam Madadh, meaning the 'Loch of the Dog', of which, by tradition, there are three: Madadh Mòr ('Big Dog'), Madadh Beag ('Little Dog') and Madadh Gruamach ('Grumpy Dog'). These legendary canines are dog-shaped rocks that guard the entrance to the harbour.

One of the features of living on a storm-swept island like North Uist is the bounty of the sea that is continually washed ashore: timber for building houses often arrived this way, along with all kinds of other useful flotsam and jetsam that islanders

Eaval, North Uist's highest hill.

A traditional blackhouse on North Uist.

put to good use. However, the biggest beachcombing prize would be less obvious to the untrained eye: seaweed, or kelp, to be precise; and it was the basis of an important Hebridean industry. Kelp grows in dense underwater forests just offshore and is often washed up on beaches after storms, lying in piles on the sand where it rots away. But, unlikely as it might seem, islanders in the past learned how to burn this sodden, slimy material in stone-lined kilns along the shore. The ash and residue that was collected were rich in soda and potash – alginates that are important chemical compounds used in a diverse range of manufacturing processes, from soap making to glass manufacture. By 1800, the Hebrides were producing around 20,000 tons of alginate every year, and island landowners grew rich on the labours of their tenants, who did the back-breaking work of harvesting the seaweed, often standing waist deep in cold seawater at low tide for hours at a time. When supplies of continental soda were cut off during the Napoleonic Wars, the price of island-produced alginate increased dramatically. At the height of the kelp boom, almost 70 per cent of the population of North Uist was dependent on kelp to make a living. When the European wars ended, the price of the home-grown product crashed, leaving whole communities destitute. The *Inverness Courier* reported on their miserable conditions: 'Their best food consists of shell-fish, and a kind of broth made of sea-weed, nettles, and other wild plants, into which is infused a small sprinkling of oatmeal.' These were desperate times, and many families were forced to emigrate.

Despite this history of decline, alginate production from seaweed has continued on an intermittent basis over the decades. Up at the north end of the island, Raghnall Maclain makes a seaweed product that finds its way to the Gulf States, where it is fed to racing camels. Apparently, it improves the glossy appearance of their coats. Raghnall said that the tricky thing is to get hold of the seaweed in the first place. Because he needs a continuity of supply to feed his alginate factory with the raw material it needs, he can't wait for a storm to wash seaweed ashore. Instead, thousands of tonnes of it are cut at low tide every year from where it grows on rocks. As I was about to discover for myself, the harvesting process is laborious, wet and uncomfortable. Down on the rocky shore, Raghnall handed me the only tool he uses for the job – a very sharp handsickle. Climbing over slippery wet rocks and standing in water that came up to the knees of my waders, I attempted to cut the stems of bladderwrack seaweed floating in the tide. 'This is a low-carbon operation,' said Raghnal cheerfully. 'A good worker can bring in eight tonnes a day.' It must be back-breaking and dangerous work, I thought, as the rain poured from leaden skies and trickled down my neck.

Crossing the causeway from Benbecula, I made my way along the west coast of North Uist, stopping off to explore the ruins of Teampull na Trionaid, which in Gaelic means the 'Temple of the Trinity'. It was built about 1200 on the site of an earlier Celtic chapel and given a makeover in the 14th century by the daughter of King Robert the Second, who had married the first MacDonald Lord of the Isles. The temple apparently had a great reputation as a centre of learning and is said to have been attended by Duns Scotus, Scotland's first great metaphysical philosopher, who later taught at the universities of Oxford, Paris and Cologne. Duns Scotus, who lived in the 13th century, had a formidable reputation as a thinker and theologian whose ideas had a significant influence

The ruins of Teampull na Trionaid, North Uist, reputedly a great centre of learning attended by the eminent medieval philosopher Duns Scotus.

on Catholic and secular thought. His nuanced arguments for the existence of God earned him the academic soubriquet 'The Subtle Doctor'. But later philosophers were less reverential and attacked Duns Scotus's ideas – along with his followers, who were referred to as 'dunces': individuals incapable of scholarship.

Immediately to the west of the temple is the Oitir Mhòr, or 'Great Sandbank', which, at low tide, creates a huge area of almost totally exposed sand between the tidal island of Baleshare and North Uist.

BALESHARE

In Gaelic Am Baile Sear means 'the eastern township'. It has a population of around 50, and has been connected by a 350-metre causeway since 1962. It is an extremely low-lying island, rising no higher than 12 metres above sea level, and looks like an extension of the tidal sandbanks, from which it seems to only just emerge. Given the global rise in sea levels, thoughts that the sea could at any moment overwhelm the island could well be justified, and there are several stories of settlements that have been washed away in the past. Where for example is 'the western township' of which Baleshare is a twin? Answer – under the waves. Legend has it that, until the 16th century, it was possible to walk from Baleshare at low tide all the way to the distant Monach Islands, which lie 15 kilometres further out to sea. A great storm apparently destroyed this tidal land bridge and separated the Monachs from the Uists for good. Lying to the north of Baleshare is uninhabited Kirkibost Island, separated by another narrow channel, which once again almost completely dries out at low tide.

KIRKIBOST

Called Eilean Chirceboist in Gaelic, the name comes from Old Norse, meaning a 'church farm'. My one and only visit to uninhabited Kirkibost

was made on a beautiful summer's afternoon in the company of Neil Nicholson, who is a traditional thatcher by trade. Neil needed raw material for a croft he was thatching so, at low tide, we took his old flat-bottomed, aluminium, former army assault boat across the extremely shallow waters between Kirkibost and North Uist. Once we'd landed, I climbed aboard the trailer of Neil's quad bike and we then bumped our way cautiously among the sand dunes, keeping a careful look-out for ground-nesting seabirds which breed on the island. Pulling up at a long stretch of marram grass, Neil introduced me to his mower: a fearsome-looking machine with deadly blades for cutting the marram grass he uses for thatching. Under a blazing sun, we spent a delightful couple of hours of hard but productive work. Neil cut while I gathered the grass, making sheaves and piling them up to be loaded onto the trailer. Neil said that it takes about two football pitches worth of cut grass to cover an average Hebridean roof, so there was much to do. We returned with our load of marram grass as the sun was beginning to sink low in the sky, silhouetting the distant lighthouse on the Monach Islands on the horizon. Retracing our outward route, Neil made a diversion to show me the ruins of a once substantial farmhouse. Until the beginning of the 20th century, Kirkibost was run as a dairy farm. Cattle are still grazed on the island but less so nowadays than in the past. Apparently they keep escaping from the island at low tide!

Arriving on Kirkibost.

Thatcher Neil Nicholson stands in front of a roof he's been working on.

VALLAY

Bhalaigh in Gaelic: the name apparently derives from the Old Norse *Fjall-øy*, meaning 'Mountain Island'. Given that the highest point is a mere 38 metres above sea level, I think this is unlikely. Vallay is a beautiful tidal island on the north-west coast of North Uist. It measures about 3.7 kilometres from east to west and is around half a kilometre wide. At low tide it is possible to walk all the way across the sand from the coast of North Uist near Solas, a distance of just over 2 kilometres – but keep an eye on the time. It's very easy to get cut off by the tide and spend longer on Vallay than you intended! Although Vallay is uninhabited today, the island has a history of human occupation that goes back at least 8,000 years. It's littered with ancient monuments – chambered cairns, standing stones and the evidence of cultures lost to history.

I met up with local guide Jim McLetchie to walk over to Vallay from North Uist. It was a morning of exceptional beauty. The wet sand shimmered and sparkled in the brilliant spring sunlight as we picked our way towards Vallay. Jim, who is Hebridean through and through, has been making this crossing since he was in short trousers, and is full of stories about the place. I wondered if many people had been caught out here when the tide turned. 'When it's as clear as it is today, there isn't really any danger. But in bad weather or mist, it can be deadly,' he said, before going on to relate a tragic tale of a woman who did get lost in the 19th century. She was trying to make her away across to Vallay when the mists descended. She apparently wandered round and round in circles, unable to make her way to either shore, getting more and more lost and disorientated, until the tides crept back and she was drowned.

Astonishingly, plans were once drawn up that would have radically transformed this beautiful landscape. In 1969 a Dutch flower-producing company secured government backing to develop 1,500 acres of the tidal sands for large-scale commercial bulb growing. The Dutch had been drawn to the island because of the disease-free nature of the machair soil. The aim was to reclaim Vallay Strand like a Dutch-style *polder* and fill it with tulip bulbs. Fortunately, after some field trials, the company folded and Vallay's wonderful sands survived exploitation.

Ahead of us I could see a prominent, gaunt ruin: all that's left of Vallay House, built in 1902 by the Dunfermline industrialist and linen manufacturer Erskine Beveridge. Construction took three years and cost £8,000 – a mighty sum in

The abandoned Vallay House, built by industrialist Erskine Beveridge in 1902.

those days. Jim described how the house must have looked in its heyday. 'It was a magnificent, opulent mansion. It had over 365 window panes, an avenue of fuchsia trees leading up to the main entrance, a walled garden with fruit trees. They had their own dairy and a lot of staff to attend to their every need. It was like another world.' Beveridge originally intended Vallay House to be the lodge for his sporting estate, and where he could bring guests for the summer. But his real passion lay elsewhere, and he fell in love with his tiny island on the edge of the Atlantic, not because of its sporting potential, but for its extraordinary antiquities. 'He discovered an amazing concentration of archaeology here,' Jim explained. 'This island is only a mile square, but it has so much human history crammed into a tiny area. Here, we go right back to the Stone Age. We've got Neolithic settlements. We go back to the early Iron Age, the Bronze Age. It's incredible that people have been living here for so long.' In 1911, Beveridge presented the results of his archaeological excavations in a book called *North Uist: Its Archaeology and Topography*. Today, he is regarded as one of the first and most significant archaeological excavators of the Hebrides.

Beveridge died in 1920. Sadly, Vallay House later fell on hard times. Badly neglected and roofless, it is now too dangerous to enter – a bitter irony for a man who spent his life studying the ruins of the past that his former home should itself have become a complete ruin.

BERNERAY AND OPISAY

The name probably derives from the Old Norse *Bjørn Øy*, meaning 'Bear Island', or from a Viking whose name was Bjorn. Berneray covers an area of about 10 square kilometres, rises to a height of just over 300 metres and has a population of about 130. Technically, Berneray is no longer an island. Since 1999 it has been connected to North Uist by a causeway straddling the shallows. But, oddly, Berneray is still considered to be part of the territory of Harris far away across the sea to the north. But whatever its territorial allegiances, Berneray is an astonishingly beautiful island – and the great sweep of sand that makes up the west bay is the jewel in its crown.

At the north-east of the island near Bays Loch, not far from a group of traditional thatched houses that now serve as a popular hostel, is a humble ruin that gives a clue to Berneray's surprising loyalty to British monarchs. Known as the

Gunnery, it doesn't look much, but is in fact the oldest and most important house on Berneray. Built in the 16th century, the Gunnery is the birthplace of Sir Norman Macleod – a highly influential Highland nobleman who fought for King Charles II at the Battle of Worcester against Oliver Cromwell and his New Model Army. The battle in September 1651 was a disaster for the Royalist forces, which were effectively a Scottish army, with 3,000 men killed and 8,000 taken prisoner and sent as slaves to sugar plantations in the Americas. Sir Norman Macleod escaped the battlefield and returned to Berneray, where he spent much of the rest of his life. He lived to be over 100 years old and gained a reputation as a scholar and patron of Gaelic culture. Above the front door of the Gunnery is an inscription – ironically in Latin and not Gaelic – commemorating the illustrious warrior, scholar and friend of King Charles II: *Hic natus est ille Normannus Macleod de Berneray, eques auratus*, which means 'Here was born the illustri-

The Gunnery, Berneray, birthplace of Sir Norman Macleod, veteran of the Battle of Worcester, 1651.

ous Norman Macleod of Berneray, a distinguished cavalier.'

Three hundred years later, Berneray renewed its support for royalty in a more peaceful way – and with another Charles: the Prince of Wales. In 1987 the heir to the throne spent several weeks living secretly on the island, learning Gaelic and experiencing crofting life first-hand. During his stay he lifted potatoes, cut peat, helped dip sheep and planted trees. When news of his Hebridean adventure broke, Berneray was thrust into the spotlight of international press attention. But of all places in the realm, why had the future king of Britain shown so much interest in such an insignificant little island? Perhaps because Prince Charles had a deep, if somewhat romantic, view of crofting life. For him it was a tradition that commanded respect: a way of life that was distinctive and inherently valuable and inspirational. He used much of what he learned on Berneray to form his own philosophy on organic farming.

Early one spring morning I met the brothers Donald and Neil MacAskill outside Berneray community hall. Neil was leaning on his shepherd's stick looking at a flock of sheep which had been rounded up and put into a holding pen. A collie at his feet was eyeing them with anticipation. Donald told me they had been crofting on Berneray for over 70 years. At that moment a 4x4 pulled up and a wiry, energetic man leapt out wearing dark blue overalls. 'I'm "Young Donald",' he told me. 'I'm the gofer, the youngster here. But I'm nearly 70. Between us we have almost three hundred years of crofting experience!' Young Donald gave me a stick and together we herded the sheep along the single-track road for about a mile until we reached the harbour, where we coaxed, cajoled and threatened the flock on board the MacAskills' boat. The deck was soon packed with bleating sheep, which squeezed into every corner. I was literally wedged into position by the woolly mass. 'That's right. Standing room only!' shouted Young

With Donald and Neil MacAskill's sheep on the way to the summer grazing.

Sea pinks on Opisay.

Donald above the sound of the engine as we left the harbour.

For as long as anyone can remember the shepherds of Berneray have moved their flocks every summer to graze on one of the tiny uninhabited islands that lie across the Sound of Harris. Under clear blue skies, but with a stiff northerly wind blowing, Old Donald steered us towards the distant island of Opisay, about four miles to the south east. All seemed to be going well. I tried to stay upright on the swaying deck, supported by the crush of sheep around my legs. Young Donald chatted about his days on the CalMac ferry, which at that time was approaching us from the direction of Harris. But then we became aware of loud Gaelic voices coming from the wheelhouse. Fighting our

way over the backs of several sheep, we went inside to see what had caused the commotion. Neil and Old Donald were looking with concern at the engine thermostat. Donald said something in Gaelic and then shut down the engine. We were adrift. From the Gaelic exchanges I gathered that the engine had overheated because the cooling pump had failed. What to do? The wind and waves had already carried us a good distance, and there were some rather dangerous-looking rocks and skerries not far off. It was an anxious time. Then suddenly the engine sprang back to life. A cloud of diesel smoke briefly hung in the air above us and then caught the rising wind before dispersing as the boat got under way again. Young Donald held up a handful of seaweed. 'It was blocking the

coolant intake. That's why we overheated. It happens all the time.' But our drama on the high seas wasn't finished. A moment later one of the lambs suddenly decided to make a break for freedom and jumped overboard into the sea. Once again the dynamic Young Donald came to the rescue. He grabbed a boat hook and, within seconds, had caught the errant lamb and hauled it back aboard. 'He's a lucky one,' said Donald. 'They sink fast because of their wool. Given a few more moments and this one would have gone for good.'

We eventually reached our destination of Opisay. In the absence of a pier or jetty, Old Donald was forced to bring the boat alongside the rocky shore, where we laid boards across the gap to make a temporary gangplank for the sheep. When they realised that land was near, they hurled themselves ashore. One lamb misjudged the distance and fell between the boat and the rocks. I thought it would almost certainly be crushed – but Donald caught it before it went under and threw it ashore. 'I bet it's the same bloody one!' he shouted, grinning.

Having seen Young Donald and the MacAskill brothers manhandle their sheep with such consummate ease, I wasn't surprised to learn that there's a long tradition of Berneray strongmen bearing the MacAskill name. Just across the machair at the south end of the island is a memorial to the greatest of them – the famous 'giant' Angus MacAskill.

Angus was one of ten children. When he was born in 1825, he was considered to be the runt of the pack because he was so small. His worried parents thought he might not survive into adulthood – but to their relief and surprise he grew and grew. In fact, he grew so much that as an adult he measured 7 feet 9 inches in his stockinged feet – the height of the cairn that marks his birthplace – becoming the tallest-ever Scotsman. However,

by the time Angus was fully grown, he was living in Canada. He and the rest of the family had been cleared from their home on Berneray and forced to emigrate to the New World, where Angus was recruited to take part in PT Barnum's travelling circus, performing as the 'Cape Breton Giant' alongside the famous 'Colonel Tom Thumb' – the world's smallest man. Angus became renowned for feats of strength such as lifting a ship's anchor chest-high.

THE MONACH ISLANDS

The name is from the English and Gaelic for Monk Islands, known locally as Eilean Heisgeir, a name which itself derives from Old Norse *hellu-sker*, meaning a 'flat skerry'. The uninhabited Monachs are a group of small islands strung out in a chain over 6 kilometres long, lying over 9 kilometres west of the nearest point of North Uist. A shield of reefs and skerries guards the main islands of Shillay, Ceann Iar, Shivinish and Ceann Ear, which makes approaching any of them a matter of skill and delicate judgement. In fact, the seas around Heisgeir are so dangerous and cluttered with half-submerged rocks that not one but two lighthouses have been built on the small western island of Shillay. The islands of the Heisgeir have sandy, fertile soils and are extremely low-lying, the highest point being a mere 19 metres above sea level. In spring and early summer, the grasslands of the machair behind the sand dunes are full of wild flowers. These remote, beautiful, but windswept islands were inhabited for centuries. Among the earliest recorded residents was a community of nuns who had connections with the religious centre on the island of Iona. Later, in the 10th

One of the two lighthouses on the isle of Shillay.

century, a group of monks established a community on the tiny western island of Shillay – where the Stevenson lighthouse now stands – and their presence gave the islands their name.

After the religious communities fell into ruin, families from the Uists settled and turned the land to agriculture, producing sufficient food to sustain a population of 100 people. Their traditional way of life continued for generations until the islands were finally abandoned in the 20th century. There have been no permanent inhabitants since the 1950s, the keepers of the lighthouse on Shillay being the last to leave. The ruins of the old village are prominent on the main island of Ceann Ear and, empty now of people, the Monachs have become home to thousands of grey seals, which come ashore every year to breed, their eerie cries filling the air.

The remoteness and isolation of the Monachs not only make the islands an excellent choice for a religious retreat, but also the perfect location for a prison – or a place where someone could 'disappear'. In 1734, this is exactly what happened to an Edinburgh society lady when she arrived on Ceann Ear. Unlike the nuns who had lived there earlier, her retirement from the world wasn't voluntary. She was a prisoner and the victim of a kidnap. Her name was Lady Grange and the man behind her abduction was none other than her husband: Lord Grange. A devout churchgoer and top Edinburgh lawyer, he was also a Jacobite conspirator with a soft spot for the ladies.

Lady Grange was born Rachel Chiesley and came from a notorious family. When she was ten years old, her father was hanged for murdering an Edinburgh judge. In her late 20s, Rachel, who was considered a 'wild beauty', married James Erskine (Lord Grange), the younger brother of the Earl of Mar, who later became a leading Jacobite in the rising of 1715. Together Rachel and James had nine children. But later in their marriage, Lord Grange took a lover. It seems that his wife was unable to bear the pain and indignity of her husband's infidelity and began a campaign against him, threatening to expose him and his circle of Jacobite plotters. His wife having become a dangerous liability, Lord Grange decided to act. With the help of Highland Jacobite friends, he arranged the

kidnap of his wife from her Edinburgh home. To cover up his crime, he staged her funeral to account for her sudden disappearance. Lady Grange was taken to the west coast and then to Heisgeir, where she spent two miserable years living with an elderly couple before she was moved to the even more remote St Kilda. Despite a failed rescue attempt, Lady Grange never regained her liberty. In total, she spent 13 years in illegal captivity, before death finally released her in 1745.

When Lady Grange was held captive on Heisgeir, she was forced to experience first-hand the poverty of 18th-century island life. Although the islands were considered to be relatively fertile, the fragile sandy soils were vulnerable to the frequent storms that blow for most months of the year. Eventually, the power of the wind triggered an exodus from Heisgeir. A terrible storm in the early 19th century blew large areas of topsoil and pasture into the sea. With nowhere to plant crops or to graze animals, the islanders had no choice but to leave. However, after a decade or so, people returned. By 1886, the population was 75 souls, who were described by an early visitor as 'tall, healthy and intelligent'. The naturalist and travel writer Seton Gordon visited Heisgeir in the 1920s and wrote affectionately about the island and its people in his beautiful book *The Immortal Isles*, illustrating it with photographs that he and his wife took on their travels.

Seton Gordon noted several differences about life on Heisgeir that made the islands distinctive. The boat he sailed over from North Uist on was of a class of its own, having two masts instead of one. Apparently, islanders believed this made for easier handling in bad weather. The houses too were different. Seaton Gordon thought them superior to other Hebridean dwellings. They had a grain-drying kiln at one end of the house, similar to those found in Orkney. He also pointed out that every stone for building had been brought from North Uist by boat, a tribute, he said, 'to the energy of the islesmen'. Of the people themselves, he was very complimentary: 'The people seemed strong and healthy, and one was impressed by their prosperous appearance. They were well dressed and most had an excellent knowledge of English. The children were unusually attractive and handsome.'

Angus Moy MacDonald is the last person alive to have been born on Heisgeir. I was lucky enough to join him and his children, who came from as far afield as Fort William and Toronto, on a pilgrimage to the island of his birth.

It was a day of spectacular beauty when we left the harbour on Grimsay. Huge cumulus clouds soared menacingly on the eastern skyline as we turned west towards the open sea and unbroken blue skies. After navigating a maze of narrow channels through exposed sandbanks and 'ducking' under a causeway bridge, our boat reached the open Atlantic and headed in the direction of a dark line on the horizon: our destination, Heisgeir. Accompanying the MacDonald family group was a young musician called Padruig Morrison from North Uist. Padruig was making the trip in honour of his father's family, who were the last people to live permanently on Heisgeir. The boat rolled heavily in a lumpy sea. Padruig played a tune on his accordion appropriately entitled 'The Everlasting Swell', while Angus Moy reminisced about the Grimsay-built mail boat the *Morning Star*, which made the crossing when he was a boy. Everything they needed came with her – coal, livestock, equipment, letters and parcels, people – all making the precarious crossing to connect the islanders with the outside world.

Landfall on Ceann Ear.

We anchored in the shallow waters of the bay below the ruined village, surrounded by dozens of inquisitive grey seals. Angus Moy explained that there never had been much of a pier on Heisgeir. The crofters had built a slipway many years ago, but its stones have long since been scattered by winter storms. From the beach, we watched the rest of the family disembark. Angus Moy leant on his walking stick and took in the surrounding scene. His eyes brightened and a smile of deep contentment spread over his face. He was 14 when the family abandoned their croft in 1942, but the island still exerts its magic on him. 'There is something on the island. You can feel it, in the atmosphere. As soon as you set foot here, all your troubles leave you,' he said.

The old schoolhouse is maintained by the Heisgeir Trust, a charity that provides basic accommodation for fishermen, visitors and friends of the island. It is also where Angus Moy received his primary education. Classes were in English,

but Angus Moy and the rest of the children spoke only Gaelic. 'Learning was a slow process,' he said. 'I had no idea what was going on!'

Outside I caught up with Padruig Morrison, who was exploring the ruins where his family had lived. Padruig's grandfather came originally from the island of Grimsay and had survived the horrors of the Western Front during the First World War. The experience had a profound effect on him and when he returned home he searched for ways to make a better future in peacetime. He knew that the soil on Heisgeir was very fertile by comparison with the thin, rocky, peaty ground on his North Uist croft, so when Angus Moy's family left he decided to resettle the island with four other Grimsay families. 'He wanted to create a crofting co-operative where everyone shared everything and helped each other,' Padruig explained. 'It was idealistic I suppose, but he was someone who had a strong belief in the values of community living.' Unfortunately, when it

The old schoolhouse on Heisgeir.

came to put these theories to the test, only Padruig's grandfather's family made the journey from Grimsay to Heisgeir.

The Morrison family spent four years on Heisgeir. They took their livestock over in a boat and ploughed the machair. Their efforts were noticed by an aviator, who had overflown the abandoned island a couple of years earlier. Now he saw the newly ploughed land and growing crops and wrote to a newspaper saying: 'The natives are back!' Perhaps this alerted another unexpected visitor who arrived one summer a couple of years later: the broadcaster Richard Dimbleby. He came to report on the progress of the experiment to resettle Heisgeir. Padruig's grandfather regarded the arrival of the great BBC presenter as an opportunity to invite other like-minded crofters to join his social experiment. He got a response to his appeal, but not in the way he intended. Instead of other crofting families, who could have made the cooperative a reality, a group of Cambridge botanists took up residence, attracted by the unique and abundant flora that flourishes on the machair.

Botanists, however eager, were not the sort of incomers the island community needed to survive. After they left, life for the Morrison family became increasingly difficult. Eventually, after the children had grown up and had left the island to study, it became impossible to work the land and harvest the sea; and so reluctantly, after four successful years, Padruig's grandfather made the painful decision to return to Grimsay. Since then there have been no permanent residents on Heisgeir. As we walked together among the tumbled walls of the old village, which clusters around a small loch providing the only fresh water on the island, Padruig told me how much he loves coming to Heisgeir. He feels he has a strong bond with the past and the people who lived there – but he said the fact that Heisgeir has remained abandoned is a warning about the fragility of all island communities. Good connections are everything.

HARRIS

LEWIS

PABBAY

SCARP

SCALPAY

GREAT BERNERA

THE FLANNAN ISLES

SULA SGEIR

NORTH RONA

ST KILDA

CHAPTER EIGHT HARRIS TO ST KILDA

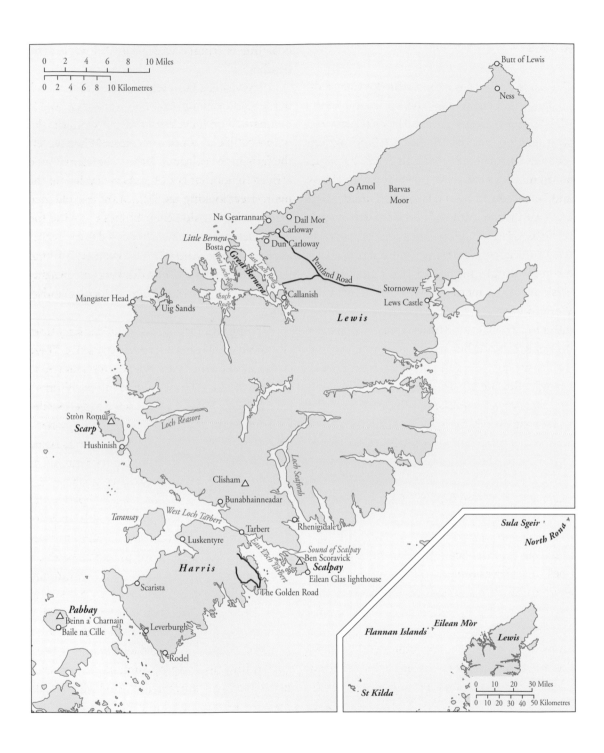

Map labels:

0 2 4 6 8 10 Miles
0 2 4 6 8 10 Kilometres

Butt of Lewis

Ness

Arnol Barvas
 Moor

Na Gearrannan Dail Mor
 Carloway
Little Bernera
Bosta Dun Carloway
Great Bernera East Loch Roag Pentland Road
West Loch Roag
Glen
Valtos
Road Stornoway
Mangaster Head Lews Castle
Uig Sands Callanish

 Lewis

Stròn Romul
Scarp
Hushinish
Loch Reasort
Loch Seaforth

Clisham
Bunabhainneadar
Taransay West Loch Tarbert
Tarbert Rhenigidale
Luskentyre
East Loch Tarbert
Sound of Scalpay
Ben Scoravick
Scalpay
Eilean Glas lighthouse
Harris
Scarista
The Golden Road

Pabbay
Beinn a' Charnain
Baile na Cille
Leverburgh
Rodel

Sula Sgeir
North Rona

Flannan Islands Eilean Mòr
St Kilda Lewis

0 10 20 30 Miles
0 10 20 30 40 50 Kilometres

HARRIS

The name derives from the Gaelic Na Hearraidh meaning 'the heights', probably on account of the island's mountainous nature. Harris is really the southern portion of the Long Island, which includes its northern neighbour Lewis. Its population numbers less than 2,000. Together Harris and Lewis constitute the largest offshore island of Great Britain. Although they share the same landmass, Harris and Lewis are remarkably different from each other. Harris is the significantly more mountainous of the two and includes Clisham, at 799 metres the highest peak in the Western Isles. The histories of Harris and Lewis differ too. For many centuries, the Clan MacLeod dominated both, but when they incurred the displeasure of James VI they lost their titles to Lewis, which were granted to their enemies on the mainland: Clan Mackenzie. The MacLeods still had control over Harris to the south and were able to raise an army to fight for Charles II at Worcester in 1651, where they lost over 1,000 men in battle. There are also linguistic differences in the way that Gaelic is spoken between Harris and Lewis. Lewis has an accent and vocabulary all of its own. Indeed, it has been thought by scholars of the language that the Scandinavian influence on Gaelic must have been particularly strong in Lewis, which was settled extensively by the Vikings. Harris covers the southern third of the Long Island, its borders being Loch Resort in the west and Loch Seaforth in the east. The mountains that lie along this line are the haunt of golden eagles and form a natural barrier to communication. Further south, Harris is almost cut in half by East and West Loch Tarbert. Beyond this the land becomes less mountainous. Indented by many lochs and bays the coastline is fringed with beautiful white sand beaches.

I first visited Harris when I was a student back in the 1980s. Having skived off classes for a week, I embarked on a cycle tour of the Western Isles with a couple of American chums. When we left the ferry in the village of Tarbert, we felt as if we'd arrived in another country. As we cycled up the main street looking for the nearest bar, old men were sitting outside their homes enjoying the warm October sunshine. They called to each other loudly in Gaelic. And when we eventually found the pub, it was packed with drinkers – all speaking Gaelic. We felt like foreigners – which of course, we were.

Arriving into Tarbert on the CalMac ferry from Uig on Skye today is a different experience. There is much less Gaelic heard on the streets and none at all in the bar when I popped in for old time's sake. Leaving Tarbert, which is the biggest settlement on Harris, I headed south along what's known as the Golden Road, which got its name because of the huge sums of money required to build it. Constructed in 1897, it connects all the communities along the coast that had previously been accessible only by boat. Today, this beautiful single-track route is little changed and continues to serve the crofting townships that lie between Tarbert and Rodel, where the road winds through a landscape that becomes increasingly barren and rocky. Here great boilerplates of hard crystalline gneiss protrude through the thin soil. Boulders of different sizes are scattered about, having been carried into position by ancient glaciers that melted long ago. Leaning into a cold wind I made my way south. The road dipped towards the

Chapter opening: The beach at Luskentyre, Harris.

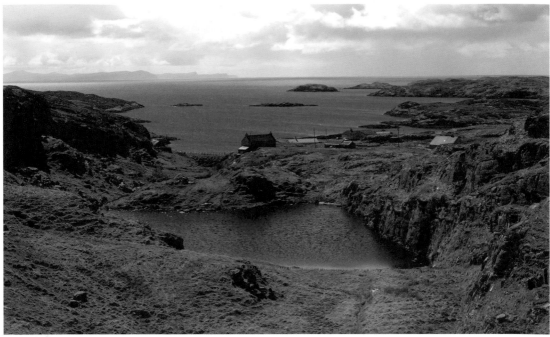

The view from the Golden Road, Harris, which leads south from Tarbert.

sparkling sea, giving me expansive views of the distant Cuillin mountains and the old MacLeod territories on Skye.

At Rodel I made straight for the beautiful 16th-century church of St Clements, which stands on a low hill guarding the road. St Clements has been described as the finest building in the whole of the Western Isles, and I'm inclined to agree. Its founder was the 15th-century MacLeod chief Alasdair Crotach, the most ferocious and bloodthirsty of all the mighty MacLeod chiefs. The Gaelic *crotach* means 'crippled', a nickname Alasdair acquired after a severe wound he received in battle gave him a hunched back for life. This crippled warrior was the same Alasdair Crotach who ordered the massacre of the MacDonalds on the Isle of Eigg. Seeing the approaching MacLeod warships, the entire population hid in a cave on

the island, but were discovered and then murdered when Alasdair Crotach's men lit a fire at the cave entrance, suffocating everyone inside. It seems that Alasdair Crotach later worried about the effect that this, and his other acts of violence, might have had upon his mortal soul. Seeking redemption before it was too late, he began investing heavily in the afterlife. To atone for his sins, he retired to the monastery at Rodel, built the church with sandstone imported from the Isle of Mull and became a monk, spending the rest of his days praying for salvation. Alasdair Crotach's magnificent tomb is inside the church, and what's particularly fascinating is the image that he chose to symbolise his earthly power and status. It's a birlinn or Highland galley, and looks exactly like a Viking longship – which is pretty much what it is. Like all MacLeod chiefs, Alasdair was descended

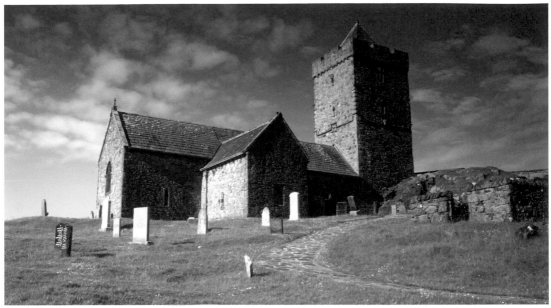
St Clement's Church, Rodel, perhaps the finest building in the Hebrides.

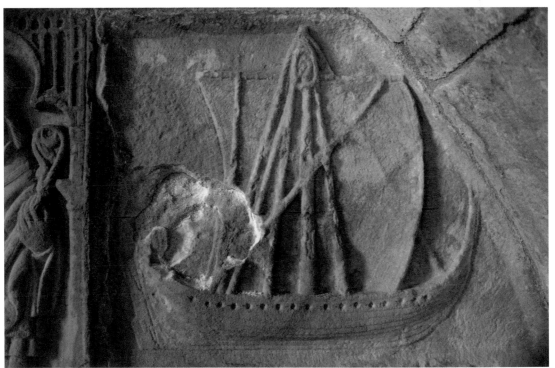
The tomb of Alasdair Crotach, founder of St Clement's.

from Norwegian Vikings, and the Highland galley depicted at Rodel is a development of the ships of his ancestors.

The galley remains a potent reminder of the importance of the sea to the history of the island. In the 19th century, Rodel was a fishing boom-town, the most important village on Harris – all thanks to the sea. The old, now empty harbour is a reminder of the boats and crews that once came from all over Britain to chase the migrating shoals of silver herring in the waters of the Minch.

Following the road around the coast, I came to Leverburgh, the second largest village on Harris. Once called An t-ob, which in Gaelic means 'the creek', the village changed its name in 1921 after multi-millionaire industrialist Lord Leverhulme, the founder of Unilever, bought the whole of Harris and Lewis, determined to transform the economic and social fabric of the islands. Lever-hulme had ambitious plans for An t-ob, which he wanted to develop as the hub of a commercial empire founded on fishing. He spent over £250,000 on the project and commissioned a fleet of fishing boats, created a fish-processing centre in the village, together with fish-smoking and refrigeration facilities, warehousing and accom-modation. To improve the chances of success, he planned to use aeroplanes to spot shoals of fish swimming past the coast. The fleet would be directed from on high to shoot their nets on target. Leverhulme hoped his heavily laden boats would then return to Leverburgh and discharge their catch. Most of it was destined to be sold through a UK chain of fish shops called Mac Fisheries. Sadly, Leverhulme died in 1925 before his dream could become a reality, and today there is very little to remind visitors of his grandiose plans for the village.

My first impressions of Leverburgh were also my first impressions of the Hebridean Sabbath. When I cycled into the village with my two Amer-ican student friends, we found the place deserted. Nothing moved. It was as if a neutron bomb had gone off, and we had wandered into a place where the dead lay behind closed doors. Then we saw a line of figures, all dressed in black, making their slow progress along a road leading to a church on a hill. They were walking with such solemnity, I thought at first they were going to a funeral. Then I realised it was Sunday, and they were the congre-gation, dressed for a Presbyterian service, Bibles held firmly in their hands. After they'd disappeared inside, our curiosity drew us closer and we heard the eerie sound of unaccompanied Gaelic psalm singing echoing from within. The voices of the congregation rose and fell like waves breaking on a distant shore, answering the melody lines of the solo precentor: a call and response that had a spine-tingling and haunting quality that I would never forget.

Heading from Leverburgh to Tarbert I passed along one of the most beautiful stretches of coastal road to be found anywhere in the Hebrides. For that reason it is also one of the most photographed. The views of the huge white shell-sand beaches of Scarista and Luskentyre, framed by the island of Taransay and the rugged mountains to the north, are world famous, adorning many calendars, post-cards and tourist brochures that extol the virtues of the Western Isles.

Not far from the road junction to Hushinish I came across a monument to the time when islanders believed that the ocean's bounty was unlimited. Overlooking the rocky shore at Bunabh-ainneadar is a brick factory chimney, which stands tall amid some low ruins and rusting machinery.

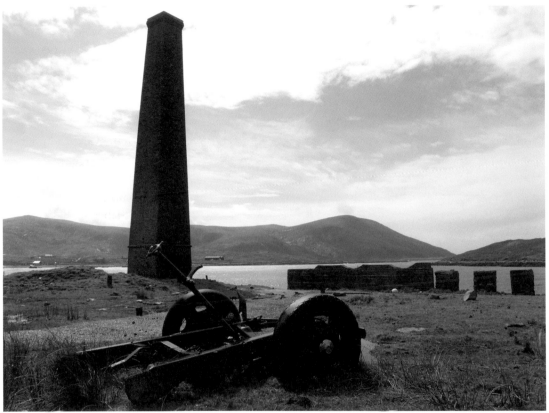

The remains of the whaling station at Bunabhainneadar, the only reminder of the once-thriving Hebridean whaling industry.

It is all that's left of the once thriving Hebridean whaling industry. Before Lord Leverhulme set his sights on Harris and Lewis, the Norwegian fishing company Salvesen had already arrived in the islands to trade and harvest the seas. In 1904 Karl and Peter Herlofsen from Norway began operations from the base they had built for a whaling fleet. The venture was initially very successful and produced the highest yield of whale oil from a single station anywhere outside of Iceland. At its peak, Bunabhainneadar employed over 158 local men and woman. In the years before the First World War, ships crewed by Norwegians and Harris men sailed from their Harris base into the north Atlantic seeking out the leviathans of the deep, catching mainly common rorqual whale, sperm whale and the blue whale – the biggest animal to have ever lived on planet Earth. Hundreds of these mighty creatures were harpooned west of St Kilda and further north around North Rona and in the waters between Scotland and the Faroe Islands. When the fleet returned to the processing factory at Bunabhainneadar, gangs of workers flensed the whales on a slipway. The blubber was refined for oil and the meat smoked and ground down for export. However, much of the whale meat never made it into the human food chain. Instead – and it sounds almost unbelievable today

– it was further processed and fed to cows, or used as fertiliser, which is an absolutely tragic end for such magnificent creatures. When the First World War finally came to an end, whaling resumed at Bunabhainneadar, but with less success than previously. The Norwegians decided to pull out in 1921.

After the Second World War, another Norwegian company took over Bunabhainneadar, employing up to 40 locals to butcher the whales and boil the blubber. This operation came to an end in 1950 and the site fell into the deserted and ruinous state that I found on my visit. Walking around the site I was buffeted by blustery squalls of hail and sleet. It was hard to visualise the industrial activity that had gone on here in former years – boats heading out to sea, whale carcasses being dragged ashore with chains and cables, blubber being stripped off and the chimney belching out black smoke. But it was clear that whaling must have been an unpleasant and smelly business. The filmmaker Margaret Fay Shaw encountered the process while on a cycling holiday in the 1930s. She later wrote about the impact it had on her senses: 'The stench was indescribable on that hot day and the aroma stayed with us for miles.'

Towering above Bunabhainneadar is An Cliseam, also known as Clisham, the highest mountain in the Western Isles. Although not a Munro it is still a significant little mountain. The first recorded ascent of Clisham was made in 1817 by an Aberdonian naturalist of Hebridean descent, the remarkable William MacGillivray, an extraordinary man who came from the humblest of beginnings. Illegitimate and abandoned at birth, he was brought up on Harris by an uncle and went on to study at Aberdeen University, becoming one of Scotland's first great naturalists, one whose work impressed and inspired Darwin. He was also

a great walker and mountaineer. As a student MacGillivray walked from Aberdeen to London, just to visit the British Museum – a round trip of over a thousand miles! In his quest for specimens, MacGillivray explored the Cairngorms and made the first recorded ascents of many peaks in the process. In 1817, while staying with his uncle on Harris, he decided to scale the mighty Clisham. 'In spite of hail and snow and the furious whirlwinds I made my way to the summit where I enjoyed a very sublime spectacle,' he wrote afterwards. Fortunately, I didn't have inclement weather to contend with on my ascent, and like MacGillivray before me, my efforts were rewarded with a similarly sublime spectacle – a view of the whole length of the Long Island, the Uists and all the way down to Barra in the south.

Descending from the glorious heights of Clisham, I made my way to the tiny village of Rhenigidale, which until 1990 was the last place in the Western Isles not to have a road connection. Until then, only a postman's path linked the now-lost communities along the east coast. The last of the postmen who made the thrice-weekly walk from Tarbert still lived in Rhenigidale when I visited. Kenny Mackay and his wife entertained me with tea and cake in their house below the youth hostel. Kenny is a remarkably fit 80-something. He'd met his wife in the 1970s when she came from Glasgow to teach in the tiny village school. Being an eligible bachelor, Kenny won her heart, and she has been in Rhenigidale ever since. 'When I first came here, the only way in or out was by boat, or by taking the postman's path – a long hike over the hills to Tarbert five miles away,' recalled Mrs Mackay as she handed me a huge slice of Victoria sponge.

Kenny has written a local history about the

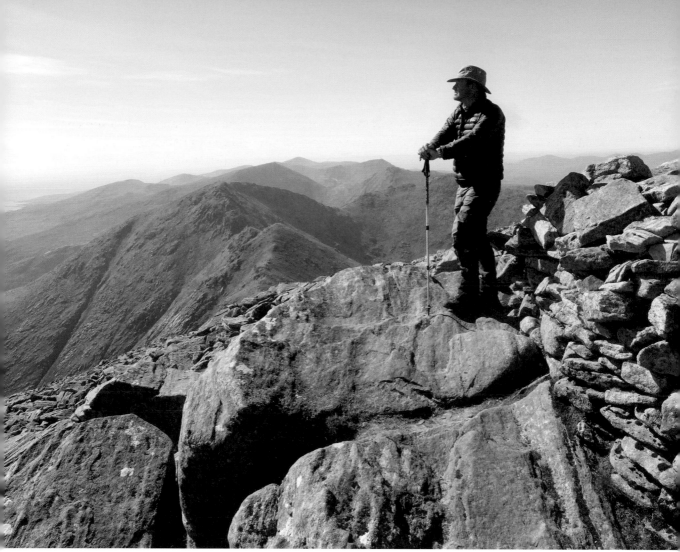

At the summit of An Cliseam (Clisham), the highest mountain in the Hebrides.

village of his birth and the surrounding area. The book is called *Rhenigidale – A Community's Fight for Survival*. As we left the house and headed along the old postman's path, Kenny was keen to tell me why life had been so difficult for his ancestors. There used to be several villages clustered along the rocky coast places like Moilingearnis and Gearraidh Lòtalgear – now reduced to a sad huddle of stones and half-remembered names on the map. But when Kenny first started walking the path, people still lived there. As we paused above the abandoned ruins of Gearraidh Lòtalgear, low clouds hung over the surrounding hills and the wind blew a smirr of rain off the leaden grey sea. It was a desolate scene. 'People never chose to live here,' Kenny began. 'They were dumped here with next to nothing by their landlords who had cleared the people from other parts of Harris. Men, women and children, the old and the sick were allocated the worst of the land and expected to survive with little more than their wits and the will to live. It was a brutal time.' The evidence of their desperate struggle was written in the landscape. Lazy beds were everywhere, demonstrating

189

how the villagers had tried to grow food wherever they could: between boulders, in hollows in the thin, sour, stony soil – even beside the postman's path. Wherever there was a chance that something might grow the people made a lazy bed.

Looking at the ruins, it was almost impossible to imagine that a community could ever have supported itself. 'There used to be a shop,' said Kenny. 'It sold everything from a gallon of paraffin to a pair of boots. But eventually, because there was no road, people gave up the struggle and left.' The same sad fate may well have befallen Kenny's home village of Rhenigidale. But in 1990, the new road arrived just in time to secure the future of this little township. As we wandered further along the path, Kenny told me it wasn't until he was in his 50s that he began delivering the mail, making the journey three times a week for 12 years until the new road made him redundant, by which time only Rhenigidale was still inhabited. A quick calculation gave a total distance of 30,000 kilometres that Kenny had travelled, walking backwards and forwards along the path. In all that time and over that huge distance, he had only ever missed one delivery. 'In an age before the telephone came to this part of the island, I carried the news and the gossip. I would always get a cup of tea and maybe a slice of cake from village to village. It was very nice, especially when the weather was bad – which it was quite often. After struggling over the high road it was always a relief to see the light on in the house at Moilingearnis. It meant that you weren't alone.'

After about 40 minutes, Kenny returned home, telling me to look out for a memorial along the way. Alone now, I felt as if I were walking along a road of ghosts, following in the footsteps of generations of Kenny's people, including the chil-dren who had used it regularly to get to secondary school in Tarbert. About an hour and a half into the walk, the path began to descend towards the west and the distant prospect of the main road. Near a viewpoint, I discovered the memorial Kenny had mentioned, and I was intrigued to see that the dedication mentioned two separate Duncan MacInneses. One was Kenny's uncle, the other his grandfather. Both men had died at the same spot, 74 years apart. Kenny had earlier told me that his uncle John MacInnes was his immediate predecessor. He had been delivering the mail when he died of a heart attack, leaving a vacancy which Kenny then filled when he became the postman. 'Weren't you anxious that you'd meet the same fate?' I'd asked before we parted.

'Not at all,' he'd said. 'They were both Mac-Inneses. I'm a Mackay!'

LEWIS

Eilean Leòdhais is the Gaelic for Lewis, a name which probably derives from the word *leogach*, meaning 'marshy' or 'boggy', on account of the dominant appearance of the northern part of the Long Island. Lewis is the bigger, northern portion of the Long Island of Harris and Lewis and covers an area of approximately 1,770 square kilometres lying north of the Loch Seaforth–Loch Resort boundary that separates the two island territories. The principal town of Stornoway, which is also the biggest town in the Western Isles, has a population of about 12,000 and is the principal administrative centre for the Comhairle nan Eilean Siar, the Western Isles Council. Stornoway is also the transport hub, with a regular ferry service from Ullapool as well as an airport. Much of central

Lewis is taken up by Barvas Moor, a vast desolate expanse of peat, broken up with innumerable lochans and peat workings. Lewis is an island of big skies, wide-open spaces, scattered crofting communities and some amazing ancient monuments that testify to the island's 8,000 years of human occupation.

For centuries, Lewis was controlled by clan MacLeod, who are directly descended from the Norse-Gaels who once ruled over the Hebrides. In the 16th century, James VI turned his attention to the clans of the west coast, determined to curb their power and independence. On Lewis, he attempted to do this by creating a Lowland Scots-speaking colony in the midst of Gaeldom. In 1598, the so-called Fife Adventurers, 12 wealthy gentleman landowners from Fife, arrived on Lewis with a mercenary army of 600 men. With royal sanction, their mission was to use the genocidal tactics of 'slauchter, mutilation and fyre-raising' to conquer the natives and to establish a prosperous civilised colony on the island. But the adventure became a nightmare. The land was not the fertile arcadia that had been promised, the weather was cruel and the natives proved much tougher to subdue than expected. Two MacLeod brothers, Neil and Murdo, attacked the Lowlanders' settlement at Stornoway with 200 'bluidie and wiket Heiland-men'. Armed with bows and arrows, two-handed swords and pistols, the MacLeod force killed at least 20 settlers and destroyed much of their property. Although the Fife Adventurers regrouped, they were constantly harried by the MacLeods, who conducted a guerrilla war against them. After nearly a decade of struggle, the Fife Adventurers eventually gave up and abandoned all hope of ever being able to secure a foothold on Lewis and bringing 'civilisation' to the Western Isles.

Stornoway's more recent history is tied up with the fishing boom of the late 19th century

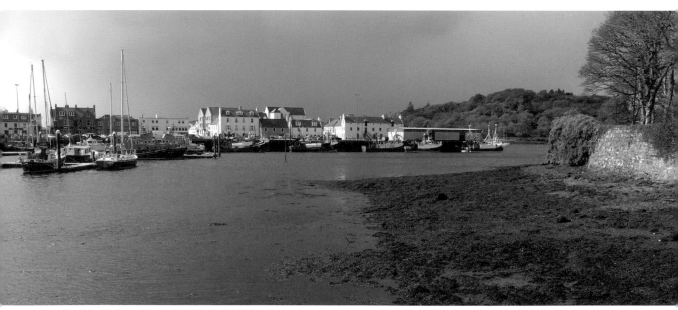

Stornoway harbour was a key port during the 19th-century herring boom; it is much quieter now.

Brandishing the world famous Stornoway black pudding.

when boats from all across the United Kingdom and from continental Europe chased great shoals of silver herring. On the quayside today a statue of a fisher lass commemorates the thousands of young women who followed the fishing fleets around the coast, from East Anglia to Shetland, gutting the fish and packing them in barrels of salt. Sadly for Stornoway, the fisher lassies and the marine environment, overfishing caused the near extinction of the herring. The frenetic activity that annually occurred along the quayside is today a fading memory. A few fishing boats remain, but they land only a fraction of the catch that was once exported all over Europe.

If herring once made Stornoway famous, another food is now a contender for the culinary crown. Just up from the harbour is the home of Stornoway's greatest modern food export: the world-beating and remarkable sausage known as the Stornoway Black Pudding. The family firm of Charles MacLeod has been making this rival 'chieftain o' the pudding race' for the last three generations. The shop is known locally as Charlie Barley's, and Ria Macdonald is the granddaughter of founder Charlie MacLeod. Although black pudding is about as Hebridean as you can get, Ria's family have an unusual Latin American connection. Like many young Hebrideans of his generation, Ria's grandfather Murdo MacLeod was forced by lack of work opportunities to emigrate

after the First World War. Following other Gaels before him, he sought his fortune as a sheep farmer in Patagonia, Argentina. 'Men from Lewis were much in demand because they were good shepherds and had really well-trained collie dogs to help them round up the sheep,' Ria explained, showing me in the family photograph album lots of shots of grandfather Murdo, smiling at the camera outside a big *estancia,* his faithful border collie sitting at his feet. Murdo was successful and well-liked by his employer Signor Menendez, who wanted him to stay on. But Murdo was in love with a girl back on Lewis and pining to return to the Hebrides. Before he left the *estancia* for good, his boss made him promise to name his first born son Menendez in memory of his life in Patagonia, which explains why Ria's father is called Charles Menendez MacLeod.

Overlooking the harbour is the magnificent and grandiose edifice of Lews Castle, built in 1847 by Sir James Matheson on the site of Seaforth Lodge, erected by the Mackenzies after they acquired Lewis from the MacLeods in the 17th century. The castle was later owned by Lord Leverhulme. When he left the island, he gave it to the people of Stornoway. Since then the castle has been used for a variety of different purposes. During the Second World War, it became a military hospital, then a residential technical school and college. The premises now have a mixed use and are home to a museum and archive, a shop and a cafe. Perhaps the most important exhibit in the museum is the collection of 12th-century carved ivory figures known as the Lewis Chessmen.

Dominating the skyline to the west of the town is a tall castellated stone tower, standing almost 30 metres high on the summit of a hill known locally as Cnoc nan Uan. This striking landmark

is the Lewis war memorial. On its walls are four bronze plaques listing the names of 1,151 servicemen from Lewis who lost their lives during the First World War. No other part of the UK lost such a high proportion of young men from the community as Lewis. The statistics make grim reading. Half the male population answered the call to arms; one in six never returned. If that sacrifice wasn't enough, tragedy struck the island at the end of the war when a troop ship, the HMY *Iolaire,* which was carrying nearly 300 returning servicemen, mostly Royal Navy ratings, ran aground just outside Stornoway harbour in the small hours of New Year's Day 1919. Earlier that night, at the town of Kyle of Lochalsh on the mainland, several troop trains had disgorged hundreds of boisterous, happy and expectant servicemen returning home after the horrors of war, all keen to see in the New Year with their families and loved ones. The *Iolaire*'s captain was reportedly concerned that his ship only carried 80 life jackets, hardly enough for all the men who were hoping to make the crossing. When no more men could be packed on board the overcrowded ship, the *Iolaire* left the quayside and headed out across the dark Minch towards Lewis. Halfway across, the weather deteriorated. In pitch darkness and in driving sleet, the captain, who had never before navigated his ship into Stornoway harbour at night, miscalculated and ran the *Iolaire* at full speed onto a vicious reef called Biastan Thuilm, the 'Beasts of Holm'. The ship capsized almost immediately. She was only 7 metres from land, but between the ship and the rocks was a boiling, raging sea. Fifty men jumped into the water and tried to swim to the shore, but drowned in tumultuous seas. The ship's two lifeboats were launched, but were overturned by desperate men trying to board them. At three

o'clock in the morning the *Iolaire* broke her back and sank. One man, John MacLeod, swam for his life, hauling a rope behind him. He reached shore and the rope was used to help 25 men to safety.

Within sight of the lights of home, 205 men drowned that New Year's night. Their bodies began to be washed up along the shore as news of the terrible tragedy spread across the island. People came with carts to carry away the dead. Newspaper reports from the time describe the scene of terrible grief on an island already reeling from the loss of a generation of young men killed in action. The effect of the *Iolaire* disaster was profoundly felt throughout the island. Somehow, hope itself had become a casualty. Throughout the following decades, there was an exodus of people from the island as the young sought fresh opportunities elsewhere. Even today, there are people who believe that the streak of fatalism, so often associated with Lewis folk, can be traced to the trauma of the First World War and the tragedy of the *Iolaire*.

Leaving Stornoway, I decided to take the less-frequented single-track road west across Barvas Moor. Known as the Pentland Road, it takes the more direct route to Carloway and was funded by an Act of Parliament in 1891. At about the same time, it was hoped that a railway line would one day follow the same route, connecting Carloway to Stornoway, thereby allowing for the easy transportation of fish caught on the west coast to the bigger port in the east. The railway never came, and today the main road for heavy traffic lies further south, which makes the Pentland Road a quieter alternative for travellers who want to avoid undue haste, allowing ample time to enjoy the expansive views across the lochan-studded moors to the high hills of Harris. At intervals along the road there is plenty of evidence of the tradition

of peat cutting, which is still continued by islanders who are happy to take advantage of free fuel for a week's hard graft on the open moor. Dotted on either side of the road are old shielings. Some are mere ruins, others ramshackle-looking huts that are near collapse. Still others are used as occasional summer houses, but all are examples of a lost Hebridean tradition when women and children would spend a few weeks up on the moor tending grazing sheep and cattle. For most islanders, the time spent in the shieling was the nearest they ever got to a summer holiday.

To the west and north of Barvas the road runs north to the little harbour of Ness, where men set sail every year for Sula Sgeir to hunt for the guga (see p. 218). The beautiful church of St Moluag at Eoropie and the stronghold of Dun Eistean on its vertiginous rock stack bear witness to its importance in years gone by.

The Pentland Road led me across the moor and down to the village of Carloway. Just south of the main settlement I made the short detour to Dun Charlabhaigh (Dun Carloway), a remarkably well-preserved and impressive broch or fortified tower, dating back to the Iron Age. Brochs are uniquely Scottish. There is nothing like them anywhere else on earth. Although there are over 500 of them listed along the fringes of the Atlantic coast and on the islands of the Hebrides and up to the Northern Isles, most are nothing more than piles of stones. But Dun Charlabhaigh is a magnificent exception. Its drystone walls look like a great broken tooth rising to nearly 10 metres on a hilltop above Loch an Duin. The exterior diameter of the broch is over 14 metres and the double walls are over 3 metres thick, accommodating a stone stairway within. Despite the fact that these iconic structures have been thoroughly investigated by

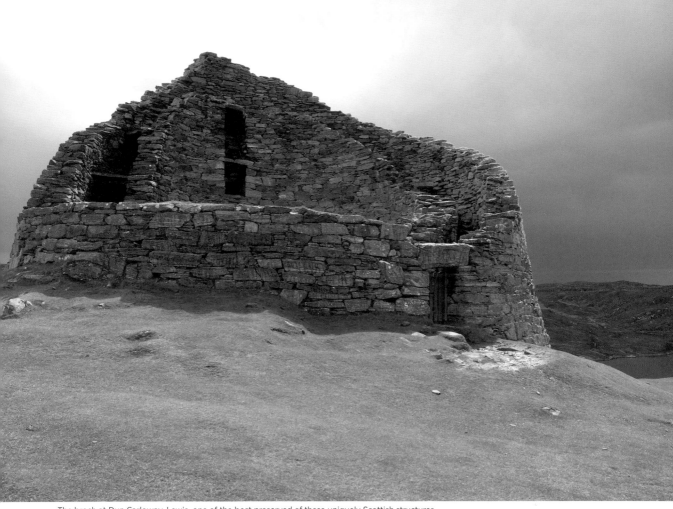

The broch at Dun Carloway, Lewis, one of the best preserved of these uniquely Scottish structures.

antiquarians since the middle of the 18th century, remarkably little is actually known about them or the culture they belong to. Archaeologists believe that they were built about 2,000 years ago but their purpose remains a mystery. Were they castles, status symbols perhaps for wealthy chiefs, or defensive refuges for the community? No one knows for sure. But one thing seems obvious.

Whoever occupied Carloway Broch must have been on the small side, given the narrowness of the stairway, and the incredibly low entrance. Perhaps this is why in the legends of the islands, there is such a strong belief in a race of little people with extraordinary powers.

The west coast of Lewis boasts some magnificent beaches. Dail Mor is perhaps the finest of

The blackhouse at Arnol. Blackhouses were the traditional dwellings of the islanders. This one was occupied until 1965.

these. Contained by two headlands and an impressive sea stack, its white sands are a great place to enjoy a picnic on a fine summer's day. Between Dail Mor and the neighbouring beach at Dail Beg is the village of Na Gearrannan where several traditional thatched houses have been restored, offering tourists self-catering accommodation, a cafe and a museum of island life. Further north at Arnol, there is a fascinating insight into domestic life on

Lewis which, until the 20th century, had changed little for hundreds of years. The blackhouse at Arnol is a living museum. The *taigh dubh*, as it's known in Gaelic, has a primitive appearance – indeed it looks almost prehistoric and can trace its architectural origins back to Viking long houses and earlier, perhaps all the way to the Neolithic dwellings of the islands. Built of double drystone walls packed with earth and covered with a rudi-

mentary thatch, the blackhouse has no windows or chimney. Smoke from a central peat fire rises into the rafters and escapes through the thatch. Originally, it provided shelter for both people and their livestock, which shared the roof space and the far end of the house. Despite its ancient appearance, the Arnol blackhouse was built as recently as 1880 and was occupied by a family until 1965, when they moved into accommodation with modern facilities. Hundreds of similar blackhouses once dotted the landscape of Lewis, right up until the middle of the last century. When they were eventually abandoned, they quickly fell into ruin.

No one should leave Lewis without a visit to the famous Callanish stone circle, which is ranked second only to Stonehenge in importance. Erected over 5,000 years ago, Callanish is considerably older than Stonehenge, but its significance only became apparent in the 19th century when Sir James Matheson had 1.5 metres of peat removed from the site, revealing the true extent and awesome nature of the henge, which until then had been substantially hidden below ground. At the heart of this ancient monument of 53 standing stones is a 4.8-metre monolith of grey Lewisian gneiss. Thirteen smaller standing stones of about 3 metres in height form a circle around it. Radiating from the circle are other stones arranged in a cruciform pattern, with an 83-metre-long avenue of monoliths leading from the north. Archaeologists are unable to say why the stones were erected and what purpose the site served, but excavations have demonstrated that it was used as a site for religious ceremonies for a period of approximately 2,000 years. The idea that the stones were aligned to facilitate astronomical observations has been frequently put forward, and it has further been

suggested that it may have been some kind of lunar observatory. Apparently, every 18.6 years, the moon appears low over the southern hills known in Gaelic as Cailleach na Mointeach, the 'Old Woman of the Moors', or in English as the 'Sleeping Beauty'.

Some years ago, I made a midsummer's night visit to the stones in the company of astro-archaeologist Margaret Curtis, who was a great enthusiast for the lunar interpretation of Callanish. She explained that the Old Woman of the Moors represents an earth-mother goddess. Margaret pointed to the distant southern hills, which included Clisham. 'The hills look like a reclining woman,' she explained. 'When the moon is at its extreme south, it rises from the hills as if the goddess is giving birth to it. Then passing low across the woman's body, the moon sets into Clisham and later dramatically reappears in the V-shape of Glen Langdale. A person standing in the stone circle would then be silhouetted by the moon – a miraculous vision that's as heart stopping today as it must have been five thousand years ago.'

Unfortunately, my visit didn't coincide with the important lunar cycle. Even if it had, I wouldn't have seen much of the moon anyway, because the skies were cloud covered, which made me wonder how it would have been possible for our early ancestors to have made the observations Margaret had described. 'It's always cloudy in the Hebrides, Margaret,' I pointed out. 'How could our ancestors have built Callanish around an event they would have had little chance of ever seeing?'

Margaret was unperturbed by my scepticism. 'Five thousand years ago, the climate was much warmer and drier here. The peat that previously covered the site, until it was excavated in Victorian times, only began forming when the climate

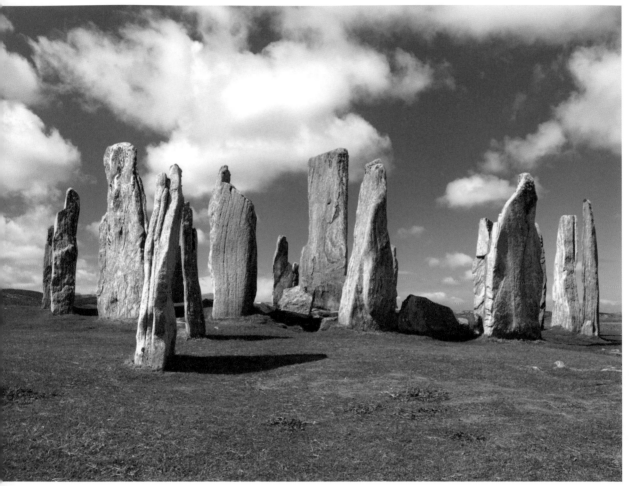

The stone circle at Callanish, one of the most atmospheric monuments in the Hebrides.

became wetter and colder – between 100 and 500 BC. So when Callanish was an active ceremonial centre, the weather was much more benign – and crucially, the skies were less cloud covered, making lunar observations much easier than they are today.'

Following the road south and west around the contorted indentations of Loch Roag, I arrived at the beautiful Uig Sands – one of the finest and most visually stunning locations in the Hebrides.

Uig is celebrated in mythology and folklore as the birthplace of the Brahan Seer who had mysterious powers and the ability to predict the future. Uig is also where the beautiful, intriguing and iconic Lewis Chessmen were discovered in the 19th century. Malcolm Maclean lives on a croft over-looking the sands. I joined him to walk across their glistening expanse as he related the story of how the chess pieces were found. Malcolm told me that the 93 pieces carved from walrus ivory were

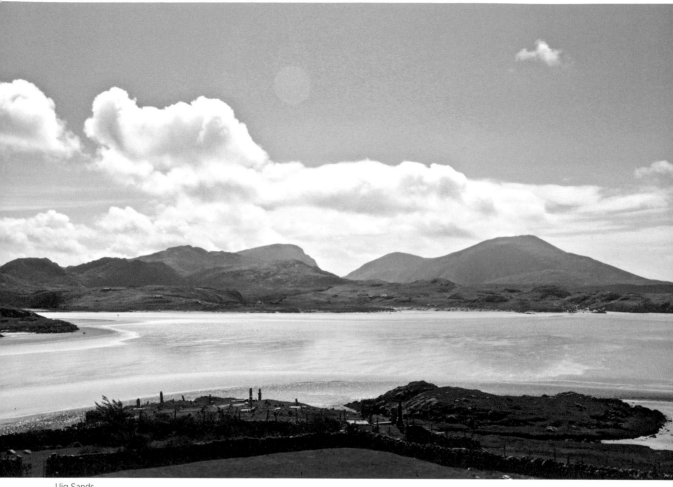

Uig Sands.

discovered by local man Calum MacLeod in 1831, after his cow had dug into a sand dune. When he first saw them, Calum didn't know what to do, but, realising that they must have some value, he decided to sell them to a local worthy for the princely sum of £30.00, which in those days was a lot of money.

I wanted to know how the chessmen found their way into a sand dune at Uig. 'No one knows for sure,' said Malcolm, but then he began to tell me a genuinely mysterious and gruesome legend that predates their discovery by Calum MacLeod.

This strange story tells of a local man – An Gillean Ruadh – who was working in the mountains when he saw a ship drop anchor and a man steal ashore in a rowing boat, carrying a bag. An Gillean Ruadh followed the stranger through the hills, thinking the bag contained treasure of some kind. 'There was murderous intent in the actions of An Gillean Ruadh, who stalked his quarry as if

he were hunting a deer. Seizing the moment, he attacked the stranger and smashed his skull with a stone. Then, taking the bag from the corpse, he returned to the beach, where he examined his haul. When he saw the chess figures, he thought they were *Sidhe* – the fairy folk of Celtic folklore. In a panic, he buried them in a sand dune and fled the scene. Many years later, he was arrested and condemned to death for the murder of another man. Prior to his hanging at gallows hill in Stornoway, he confessed to the Uig murder and to the bag he'd buried on the beach.'

'Is there any evidence to support this story?' I asked.

'Well, yes, to a degree there is,' Malcolm replied. 'As a young boy my uncle took me into the hills behind our croft and showed me a partially walled-up cave, formed by an overhanging rock where boulders had been placed to block the opening. My uncle pulled out one of the stones. Inside I could clearly see a human skeleton with a broken skull.'

'And who do you think it was that you saw?'

'I think it was the skeleton of the stranger who'd been murdered by An Gillean Ruadh.'

We'll probably never know the reality behind this legend, or where the murdered stranger may have come from. But whatever the truth, mystery still surrounds the beautiful ivory figures that bear the name of the island where they were found. For a long time, they were thought to have a purely Scandinavian origin. But a recent study suggests that they are closer to Lewis than previously supposed. Their intricate decoration is very similar to the loops and swirls of Celtic artwork, placing them historically in the world of the medieval Norse–Gaels, and men like Alasdair Crotach MacLeod at Rodel, who once ruled the Hebrides.

PABBAY

The name comes from the Old Norse: *Pap øy*, meaning 'Priests' Island'. Measuring roughly 3 kilometres by 4 kilometres and rising to 196 metres, Pabbay lies in the Sound of Harris 3 kilometres north of Berneray. It is uninhabited now, except periodically, when the owners are in residence during the holidays, or when the farm manager is present during the lambing and shearing seasons.

To get to Pabbay, I hitched a ride aboard a powerful launch, which picked me up from the island of Berneray. Raymond Campbell was at the wheel, accompanied by his teenage daughter Sarah and his father Kenny from Leverburgh on Harris. Speeding over an azure sea beneath a peerless blue sky, Kenny told me that his family used to own Pabbay. It was sold in the 1970s to an Englishman who runs a famous racing stable. Since passing on ownership, the Campbell family has continued to manage the crofting rights and the 700 sheep which graze on the island. The month being May, Kenny and his son and granddaughter had taken up residence on the island to take care of the lambing. As we approached Pabbay, I was struck by how gorgeous the island was on this day of truly stunning weather. Jumping ashore, we made our way across the close-cropped machair where flowers were beginning to bloom in the brilliant green grass. I turned to look at where we had come from: the white fringed beaches of Berneray were clearly visible across the turquoise sound. The beauty of the place was overwhelming. Sitting just inland from the sand dunes were the ruins of a village, Baile na Cille, the 'Township of the Church'. Pabbay has been uninhabited for more than 150 years, but it was clear that the island was once a thriving

Landing on Pabbay.

place. In fact, at its height, there were three villages, a castle, an ancient chapel and a population of nearly 300.

Leaving the Campbell family to tend their sheep, I set off to explore. In the Middle Ages, the powerful Clan MacLeod held sway over much of the Hebrides, and Pabbay was one of their principal strongholds. But it wasn't just Pabbay's strategic position in the Sound of Harris that made it important: the soil was extremely fertile and the harvests bountiful. Unfortunately for the MacLeods, their sworn enemies the MacDonalds wanted Pabbay for themselves. One fateful day, the MacDonalds

decided to attack. A terrible clan battle ensued on the banks of a small burn running beside the ruins of another abandoned village, Baile Lingay – 'Heather Town' in Gaelic. The MacDonald invasion force was slaughtered to a man and the burn ran red with their blood

Back at Baile na Cille, I met up with Kenny Campbell again. Standing beside the ancient ruined chapel in an equally ancient graveyard, where crumbling headstones leant at crazy angles, Kenny told me about the eventual fate of the people who once called Pabbay home. It wasn't clan warfare that finally saw the last of Pabbay's

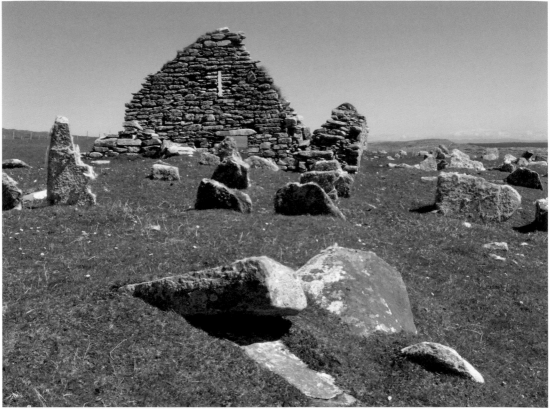

The ruined church at Baile na Cille, Pabbay.

residents leave in 1846. In fact, they were thriving, because Pabbay was one of the richest agricultural islands in the Western Isles, famous for producing grain. There was such a surplus of barley that Pabbay was able to produce illicit whisky – lots of it. 'This bootleg whisky wasn't looked upon too kindly by the Excisemen, who were on the go chasing people and looking for whisky stills,' said Kenny. 'But the boatman, whose job it was to bring the Excisemen over, had a secret warning sign – a special coloured sail that he'd always set if he had Excisemen on board. This warned the Pabbay people to hide the whisky.' The system worked perfectly for a long time until the boatman

unexpectedly fell ill and was replaced by another, unschooled in the use of the warning sail. The islanders were rumbled and caught red-handed. This had dire consequences for the whole community. The factor from Harris had been looking for an excuse to clear the island and he used criminal activity as a pretext to evict the entire population of more than 300 people.

Of course, clearance and eviction are an all-too-familiar story. As I left Kenny and the ruins of Baile Cille I considered the irony of how the painful history of the Hebrides is so often set against the wildly beautiful backdrop of a place like Pabbay, which was doing its best to imper-

sonate paradise as I climbed to the summit of the island's highest hill, Beinn a' Charnain. There I drank in an unparalleled vista. St Kilda and Boreray were visible on the blue, western horizon. Rum and the snow-capped peaks of Skye were to the east, Barra to the south and the mighty Clisham rose across the Sound of Harris to the north. I felt as if I were in heaven. To celebrate my celestial elevation and to toast the view I took a good dram from my hipflask, just to remind me of what once made Pabbay famous. *Slainte!*

SCARP

The name probably comes from the Old Norse *skarpoe,* meaning 'sharp'. Scarp measures roughly 3.5 kilometres by 4 kilometres and lies very close to the western coast of Harris near the mouth of Loch Resort. It is a rugged island, rising to Sròn Romul at 308 metres. For the most part, the land is rocky and infertile, with cliffs dropping away to the north down to the beautiful sequestered white sand beach. Scarp has been uninhabited since 1971, but before that time it was home to a vibrant and populous community. Getting to Scarp has never been easy. Despite being so close to Harris, the lack of a proper ferry service meant that the population was cut off from the outside world. This isolation became a principal reason people began to leave.

Making my own way over on a hired inflatable boat, I travelled from the pier at Hushinish on Harris with two Scarp veterans (*Scarpachs* as they call themselves): Donald John MacInnes and Hugh Dan MacLennan. Both men have intimate links with the island. Donald John was born on Scarp in 1947 and his family were the last family to leave the island in 1971. Back in the 1950s when Donald John was growing up, Scarp was a wholly Gaelic-speaking community. At that time, there were 19 families living in the village, which had a population of about 70 souls. Hugh Dan MacLennan is proud of his Scarp connections. His mother was born on the island over 90 years ago. 'She's the oldest living person who was born on Scarp,' he told me. Although Hugh Dan wasn't born a *Scarpach,* many of his earliest memories were formed on the island because his family spent eight weeks every summer with his grandparents and uncles working the croft. 'A lot of people assume I am a *Scarpach* because my memories of the community there are so strong. The truth is I've had a remote connection with the island. But as I've grown older, my connection with Scarp has actually become stronger and means much more to me now probably than it ever did.'

As we tied up alongside the old slipway below the village, the sun burst through the leaden skies and the clouds began to disperse. The island shimmered in clear Hebridean light. The rugged hills and bare rocks of Harris opposite looked close enough to touch. Donald John led us through the ruins of the village to the house where he was born. We stood in the roofless shell. At one end was a fireplace, at the other, a rusting kitchen range. 'My grandfather built this house,' said Donald John. 'He was known hereabouts as *an Rìgh,* which is Gaelic for 'the king'.

'Does that make you a prince of Scarp?' I asked.

'Not at all. An Rìgh was a nickname. My grandfather had a shop here in this house, the only one for miles around, selling just about anything you could imagine in those days. He had a boat that made deliveries to other communities along the coast.' Standing in the ruins of what had obviously

203

Hugh Dan MacLennan occupying his grandfather's seat in the Scarp parliament.

once been a very fine house, I asked Donald John if he didn't feel sad about the fate of the place that had meant so much to his family. He was surprisingly stoical. 'A lot of people ask me why I don't sell it or do it up. But I'm not interested in it becoming a holiday home for strangers. I'd rather it just went back to nature.'

As we walked on, Donald John and Hugh Dan reminisced about the past and about the people they both knew who had once lived in the now ruined and abandoned homes. It was a conversation that filled the island with ghosts of the departed. As we approached a red corrugated-iron house, now a holiday home for an absent German family, Hugh Dan explained that this had been his uncle and aunt's home when they got married. 'It's where we stayed in the summer months during the holidays,' said Hugh Dan. 'And as kids, we'd come down here early in the morning and rattle a stick along the corrugated metal walls and make a racket so that John MacDonald would come out and demand to know what was going on,' said Donald John with a boyish grin.

'That must have been very annoying.'

'I suppose it must – especially as they were newlyweds and he was perhaps trying to enjoy a liaison with his young bride!'

Down in what was formerly the village street, we stood beside a low mound at the end of one of the ruined houses. This is where the Scarp 'parliament' used to meet to take significant decisions that affected the whole community. 'They would decide what they were going to do for the rest of the day, for the rest of the week. They would

decide that on the basis of what time of year it was, what needed to be done, the priorities of life, just to get the work done. It was an equal society in one sense, but a leader would always emerge,' said Hugh Dan. He showed me a picture taken just after the First World War of a group of men gathered around the reclining figure of an elderly gentleman. 'That's Donald Yock, my grandfather. And he was the elder statesman of the parliament, if you like.'

I looked at the photograph. Significantly there wasn't a woman to be seen. 'Was this an all-male parliament?' I asked.

'Yes, it was. The women had other things to do.'

'Like what?'

'Well, there was the milking, collecting eggs, cleaning and cooking to be done. Looking after the children.'

'So really, they were too busy to take part in the decision making of the parliament?'

'In a way they were. But it was just how things were done back then.'

Despite Hugh Dan's protestations, it seemed clear to me that the men of Scarp spent their morning making decisions, while the women did all the work. In recognition of the good old days of patriarchy, I took a picture of Hugh Dan occupying his grandfather's seat in parliament. Moving on, we passed through the ancient graveyard where generations of *Scarpachs* lie at peace. Many of the graves have no inscriptions, just ancient weathered stone markers like broken teeth in rows facing east. Even today, the sons and daughters of Scarp come home to find a final resting place among their ancestors.

Scarp might have been a remote community, but it was endowed with many of the institutions

Donald John MacInnes in the abandoned school on Scarp, which he attended in the 1950s.

that make up civil society – a parliament, a church and of course a school, which today is a roofless ruin. Donald John took me to visit the classroom where he received his first education. 'In the old days, every child would bring a peat for the fire and a slate to write on.'

'What was your teacher like?' I asked.

'We had several but they were all tremendously encouraging and outward-looking; so the education we got wasn't parochial – it was first-rate. Everyone in my class did exceptionally well. It was as if the teachers were urging us to get on and get out into the wider world. I suppose that was the paradox. The kids who were born and brought up here were encouraged to use education as a ticket to leave – which is what we all did. We were invited to do things all over the world, but not on the island where we were born.' Donald John's story

is a case in point. He left Scarp and went on to university and ended up working for the Scottish government at the EU in Brussels, promoting economic development. The irony of coming from an underdeveloped island like Scarp isn't lost on him. During his student days more families left, and by the time he graduated the island had been abandoned. 'Leaving felt more than just the end of an era, it felt like the end of a way of life – a way of living on a small island, in a communal way. Although the end was inexorable, it wasn't inevitable. If we'd had a proper ferry or a causeway, the community would have survived.'

Ironically, it was precisely because Scarp was so isolated that it was propelled unexpectedly into the space age with the arrival of the Rocket Post, championed by a self-styled German entrepreneur and inventor, Gerhard Zucker. It's a story that starts with the birth of twins. On 14 January 1934, Donald John's aunt was in labour. She had given birth to one child, but she needed urgent medical help to deliver the other. Raising the alarm, a neighbour rowed to Harris and then hiked for 12 miles to the nearest telephone to call a doctor. The aunt was transported on a makeshift stretcher across rough seas to Harris and then taken by bus to Stornoway hospital, where she gave birth to a daughter. The twins became internationally famous for being born on different days, on different islands and in different counties. When the story reached the ears of a young Gerhard Zucker, he thought he could capitalise on the circumstances of the twins' birth by demonstrating the advantages of his latest invention: the Rocket Post.

Zucker arrived on Scarp on 12 July 1934 to show how sending mail across the sea using a rocket could help remote communities communicate swiftly and effectively. He'd already presold the idea, having issued 1,200 special-edition and very profitable postal covers to stamp collectors and enthusiasts who wanted to be the first to have letters delivered by his new Rocket Post. The payload of letters even included one addressed to King George. But the demonstration was an embarrassing failure. On 31 July 1934, watched by Post Office officials and government agents, Zucker's rocket shot skywards. Seconds later, it exploded, scattering its payload of letters over the beach. The officials were less than impressed. Even worse, his actions were considered to be a 'threat to the income of the post office and the security of the country'. Zucker was deported to Germany, where Nazi authorities immediately arrested him on suspicion of spying and collaborating with Britain.

SCALPAY

Scalpaigh in Gaelic, the name is of Old Norse origin, from *Skalpr øy* ('Scallop Island'). Scalpay is a low-lying rocky island covering 650 hectares. Its coastline and shape are complex. Towards the south-west, a cluster of small islands and skerries guard the seaward approaches. Prominent on the east coast is the red-and-white-painted Eilean Glas lighthouse, built in 1824 by Robert Stevenson to replace an earlier light tower, which was one of the first to be constructed by the Commissioners of the Northern Lights, in 1789.

Strictly speaking, Scalpay is an island no longer. In 1997 a fine bridge was opened, spanning the narrow Sound of Scalpay which separates the island from Harris to the north. Before the bridge was built, a short ferry crossing was the way most people crossed over to the island.

The Stevenson lighthouse at Eilean Glas, Scalpay.

For an island of just 5 square kilometres, Scalpay is fairly built up, with a population today of around 300. During the years of the great herring-fishing boom in the early 20th century, dozens of boats filled the harbour, and hundreds of young women worked on the quayside gutting the catch. At that time Scalpay was a busy cosmopolitan place with boats, crews and fisher girls coming from all over the UK – and beyond – to an island that was rich in Gaelic folklore, where music and song played an important part in daily life.

Morag MacLeod is a native of Scalpay. For many years she worked at the School of Scottish Studies in Edinburgh and is an expert on the traditions and songs of the island. She had kindly gathered together some Scalpay ladies – both young and

The harbour, Scalpay.

not so young – to give me a demonstration of how music and the human voice were woven into the fabric of everyday life in days gone by. The ladies sat on either side of a long table with 'the leader' at the head. In front of them was a large, heavy roll of Harris tweed which Morag said they were going to 'waulk' – a process of manipulating the fibres of the cloth to shrink it from 32 inches in width to 28. Traditionally, the cloth was first soaked in urine. Thankfully, the ladies had chosen a less authentic demonstration and had merely dampened the cloth with water – at least that's what

they told me. 'It's very rhythmic work,' explained Morag. 'The cloth is lifted and rolled on the board. The slack is then taken up and passed to the woman next to you in a clockwise manner. Because it is so rhythmical, waulking lends itself to music.' With that, she nodded to Crissy at the head of the table who got to work by singing a line of Gaelic verse in a beautiful clear voice. The other ladies joined in, answering with a chorus line and beating the table with the cloth. The rhythm having been established, they passed the tweed one to the other, so that it resembled a long fabric snake slowly making its way from hand to hand. The effect of the voices and the rhythmic pulse of physical work was magical and almost hypnotic. After a couple of verses, Morag interrupted to explain that waulking used to be an important social event and a tradition that has an ancient history.

'Women always looked forward to it and would be terribly disappointed if they weren't asked because it gave them precious time to themselves.' Waulking allowed the women of the community to meet, catch up, gossip, sing, tell stories and jokes – all without the bothersome interference of their menfolk: a communal activity that produced a fabric that has become world famous.

Before I left Scalpay, I made the short climb under a bright sun to the top of the island's highest hill, Ben Scoravick (104 metres). As I reached the summit cairn, fingers of sea mist began to drift in from the cold waters of the Minch, breaking like a slow vaporous wave around the Stevenson lighthouse of Eilean Glas below me. To the north-west I could make out the bridge to Harris and the distant town of Tarbert, where a ferry was just leaving, heading down the loch and south-east to Skye, whose great mountains looked close enough to touch.

GREAT BERNERA

Beàrnaraigh Mòr in Gaelic, the name comes from the Old Norse *Bjarnar Øy*, meaning 'Bear Island' or, more probably, 'Bjørn's Island'. Great Bernera, usually just called Bernera, lies close to the west coast of Lewis in a great inlet formed by two sea lochs: West Loch Roag and East Loch Roag. The island covers 22 square kilometres of mostly rough, infertile, rocky land, which rises to just 87 metres at its highest point. Crofting and fishing are the traditional mainstays of employment on the island, which has a population of 250 people, many of whom have Gaelic as their first language. In 1962, the island was bought by an eccentric and flamboyant man with aristocratic pretentions: Robin Ian Evelyn Milne Stuart de la Lanne-Mirrlees. Born in Cairo and educated at Oxford, Mirrlees was a colourful figure, a bon viveur, Ruritanian fantasist and collector of titles. He claimed to be a count, a prince, a baron, a knight of St John – and Laird of Bernera. He had property in wealthy Holland Park in London, a chateau in France, a castle in Austria, as well as flats in Paris and Switzerland. But this multi-titled friend of the rich lost much of his wealth in the Lloyds crash of the 1990s and he ended his days living in a modest house on Bernera. When he died in 2012, he offered the island he loved to the people of Bernera, who hope to buy it for the community.

In 2015, the local community painted the Great Bernera bridge to celebrate its 62nd anniversary. Before it was opened, the island was pretty much cut off from the modern world. Life was becoming increasingly difficult for the islanders, who understood that without a bridge their community was doomed. The people continually petitioned the local authorities to help them, but their requests

The beach at Bosta, Bernera, one of the jewels of the Hebrides.

for a link were ignored – until they decided to take things into their own hands. If the council wouldn't help, they'd build a road link themselves. It was a bold plan and one that would have involved dynamiting a hillside for rock to fill in the shallow waters of the kyle. Provoked and shamed into action, the council finally submitted to pressure and stepped in, and a bridge was built. When it opened in 1953, over 4,000 people turned out for the occasion – a demonstration of how important island links are to the wider community.

I think it's fair to say that a certain independence of mind characterises a lot of islanders I've met on my travels. On Bernera, that individual spirit has a long and distinguished pedigree.

On a high point overlooking the island is a monument to an earlier generation who understood the value of direct action. Made of stones from every croft on the island, the memorial cairn is dedicated to the 19th-century Great Bernera Riot which broke out when islanders were forced to defend their rights to work the land and keep a roof over their heads. In 1874, at the height of the Clearances, a group of young men threw stones at three bailiffs who'd come to serve eviction notices to 57 homes. One of the bailiffs said that, if he had a gun, he'd have shot them all. It was a

rash statement and only served to stoke more anger. A scuffle broke out and the bailiff's jacket was torn. A few days later, one of the young men involved was in Stornoway where he was recognised. When the police were called to arrest him, a large crowd gathered and things began to get out of hand. The police read the Riot Act, and the young man was carted off to jail. When news of his arrest reached Bernera, the community reacted angrily and decided to mobilise. A crusade of islanders from across Bernera and Lewis descended on Stornoway demanding justice. It was a bold act of defiance, which resulted in a famous victory for the crofters and helped pave the way to land reform and to securing crofters' rights. The islanders' victory meant that, instead of leaving, people stayed, allowing the community to flourish. The victory was also a sign that independent thinking paid dividends, so it's perhaps not surprising that Great Bernera became celebrated for its proud educational record. It's claimed that the island has produced more professionally qualified people than any other Scottish island of similar size.

At the north end of the island I followed a coastal route that led me along the cliffs opposite the uninhabited island of Little Bernera. After an hour or so, I came to a high point overlooking an extraordinarily beautiful beach: Bosta, one of the

Elizabeth Macleod at the Bosta Iron Age House.

Peter Love. Together they harried and robbed passing ships. Eventually Neil MacLeod betrayed his partner in crime, hoping to obtain a royal pardon by handing Peter Love over to the king's men. But King James wasn't impressed, and ordered the Mackenzies to arrest Neil MacLeod. The Mackenzies besieged Bearsay and captured as many local MacLeod women and children as they could find. Abandoning them on a nearby tidal reef, they threatened to let them drown in the incoming sea unless Neil MacLeod surrendered. The MacLeod men on Bearsay could clearly see the plight of their loved ones. Unwilling to let them become innocent sacrifices, Neil Macleod surrendered and was taken in chains to Edinburgh, where he was executed. All his lands were handed over to his Mackenzie enemies.

Walking the pristine sands of Bosta beach I could easily understand why Clan Mackenzie was so keen to possess the MacLeod lands. It is a truly glorious place and was inhabited long before the bloody clan struggle that ended with the death of Neil MacLeod. Layers of history are hidden in the sand, testifying to human settlement that goes back thousands of years. In 1993 a storm uncovered a rare Iron Age site in the sands of Bosta. Archaeologists excavated five houses, which were probably part of a larger village that once extended across the now-eroded machair. Because the site was vulnerable to the elements, a reconstruction of one of the houses was built further up the beach. Known today as the Bosta Iron Age House, it's a living museum and provides a unique insight into what Hebridean life might have been like 2,000 years ago during the late Iron Age. Inside the dark interior, the only light came from a faintly glowing peat fire. No sound seemed to penetrate from the outside world, although there had been

jewels of the Hebrides. Yet, despite its beauty, Bosta has a dark history. Lying just to the north are three rocky islands. The middle one is Bearsay, the once-impregnable fortress of clan chief Neil MacLeod who fought a guerrilla war against the Fife Adventurers in the 16th century. Although MacLeod was successful in defeating the Lowland colonists, he lost the subsequent war with Clan Mackenzie, which was backed by James VI in his campaign to exert royal control over Lewis. After a bloody battle with Mackenzies, Neil MacLeod retreated to his fortress on Bearsay, where he joined forces with the notorious English pirate

a strong wind blowing when I arrived. The effect was like being underground. Elizabeth Macleod, who has been the guide for 17 years, explained that the house would have been home to an extended family of up to 15 members. There was a platform in the main room just above head height. 'That's where the children would be put at night to go to sleep. I can imagine them peeping over the edge and looking down at the adults, gathered around the fire, talking and telling old stories,' she said.

Because the Iron Age house is a living museum, Elizabeth not only acts as a tour guide but also spends her time exploring Iron Age domestic life. She has cooked over the peat fire and has learned contemporary pottery skills. I was intrigued to see examples of her work.

'Clay would have come from river banks,' she said. 'The pots were fashioned from long coils of worked clay, smoothed and fired in a peat kiln, with a milk-based glaze. Each pot was dunked into milk. The fat would soak into the clay. When it heated in the fire, the fat in the milk formed a waterproof glaze.' I held one of Elizabeth's roughly made pots, and examined it closely. 'Could you use the pots for cooking?'

'Oh, yes. They are also quite fireproof and I've often cooked on them over the peat fire here.'

Archaeologists have recently found evidence of a later Viking long house close to the Iron Age site, demonstrating the influence of Norse settlement on the island. In fact, the name Bosta comes from an Old Norse word for 'farm'. The agricultural potential of the area continued to be exploited for centuries afterwards. Further up the little glen are the remains of later blackhouses, which made up a settlement that was finally abandoned in the 1870s when supplies of peat became exhausted.

THE FLANNAN ISLES

These islands are apparently named after the Celtic St Flann or Flannan, a relative of St Ronan. The Flannan Isles lie 30 kilometres west of Mangaster Head on the Isle of Lewis and comprise three separate clusters of small uninhabited islands and skerries, which are often referred to as the Seven Hunters or sometimes the Seven Holy Isles. A tiny medieval oratory on Eilean Mor, the largest of the Flannans, is reputedly dedicated to St Flannan. People from Uig on Lewis used to make an annual pilgrimage to worship there; but it must have been something of a tight squeeze because the chapel only measures 2.5 metres by 1.5 metres. Accounts from the 17th century describe a tradition of rituals that visitors had to observe. Hats had to be removed and a clockwise turn made by the visitor, who was expected to give thanks to God at the same time, before removing his clothes and placing them on a stone as he approached the alter. Other prescriptions and prohibitions included: not urinating near the landing site, not killing any birds with a stone and not eating secretly. After Eilean Mor ceased to be home to holy men, the islands were uninhabited until the lighthouse was built in 1899. When three keepers mysteriously disappeared a year later, the Flannan Isles became notorious throughout the world.

Before I sailed to explore the islands for myself, I made a trip to the cliffs of Mangaster Head from where I could just make out my distant destination. In 1900 it was from the same rocky vantage point that a local shepherd was paid to keep an eye on the recently opened lighthouse on Eilean Mor. But, in the stormy December of that year, it was what the shepherd *didn't* see that became part of the mythology of the Hebrides. Throughout

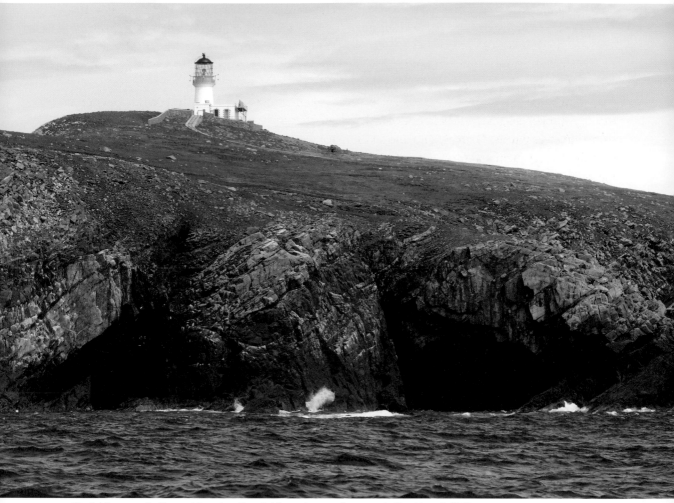

The lighthouse on the Flannan Isles, where three lighthouse keepers disappeared without trace in 1900.

December 1900 wild weather had shrouded both the lighthouse and its light, making it impossible for the shepherd on Mangaster to watch out for the safety of the keepers on their remote rocky island. For several days in succession, he climbed to the viewpoint and peered expectantly through driving rain but could see nothing but low clouds and angry seas. He had no inkling of the terrible tragedy that had befallen the three men stationed on the Flannan Isles. I took an inflatable boat from Lewis to reach the Flannans, hoping to gain a better understanding of what might have happened over a century ago. Significantly, the shepherd on Mangaster Head hadn't been the only one unable to see the lighthouse. On the stormy night of 15 December a cargo ship from the United States had approached the Scottish coast, fully expecting to see the new light of the Flannan Isles,

but the captain saw no warning beam – only the unlit tower, which stood like a gaunt sentinel above the dark, wave-lashed islands.

A few days later, the Northern Lighthouse relief ship arrived on Eilean Mor with a replacement keeper on board and supplies for the keepers. As the ship approached, the crew became aware that something was wrong. There was no one on the slipway to meet them and no flag flew from the masthead. The ship's captain blew the siren to notify the lighthouse keepers of his approach, but still no one appeared. The relief keeper was sent ashore to find out what had happened. What he discovered haunted him for the rest of his life. All three lighthouse keepers had vanished without trace. This is what he later wrote to the enquiry that was set up to investigate the tragedy:

> I went up, and on coming to the entrance gate I found it closed. I made for the entrance door leading to the kitchen and store room, found it also closed and the door inside that, but the kitchen door itself was open. On entering the kitchen, I looked at the fireplace and saw that the fire was not lighted for some days. I then entered the rooms in succession, found the beds empty just as they left them in the early morning. I did not take time to search further, for I only too well knew something serious had occurred.

The story quickly became the stuff of legend and was immortalised in a famous poem by Wilfred Wilson Gibson, which was based on the relief keeper's testimony accounts – with a bit of poetic licence. Despite an enquiry and years of speculation and investigation, no one to this day can be certain about the fate of the three keepers. The most likely explanation seems to be that they were washed into the sea and drowned by a freak wave while they were working outside the lighthouse near the jetty. But no one knows for sure.

Unfortunately for me, the boat's skipper told me that the sea conditions were too dangerous for us to make a landing on Eilean Mor. Instead, we sailed around the islands, watched over by the now-automated lighthouse. Gazing at the sea-damaged and neglected landing stage where the keepers may have been working before they met their mysterious fate, I couldn't help wondering what on earth happened to them.

SULA SGEIR AND NORTH RONA

It's thought that the island of North Rona could be named after the 7th-century Celtic St Ronan. Alternatively, the name may derive from a combination of the Gaelic *ròn*, meaning 'seal', and the Old Norse *øy*, meaning 'island', no doubt because the island is an important breeding colony for Atlantic seals. North Rona is a truly remote island, lying some 72 kilometres north-east of the Butt of Lewis. When it was inhabited, up until the early 19th century, the population was regarded as the most remote island community in the whole of Europe. Not only is it a long way from any significant land mass, it's also very small. A mere speck in the enormity of the surging North Atlantic, it covers an area of 109 hectares, and rises from the waves to a height of 108 metres.

North Rona was an island destination that had eluded me for several years. Poor weather, even in summer, had prevented me from making the long sea journey to the cliff-girt island where there

On the way to North Rona with George Geddes.

is no landing stage or safe anchorage. Eventually however, my chance came. In early dawn light on a morning of breathless calm, I climbed aboard the 440-horsepower boat *Lochlann* at Miavaig harbour, on the shores of Loch Roag, Lewis. Neil the skipper was hopeful that the journey shouldn't take much more than five hours. Roddy the mate grinned. 'If the wind picks up, it could take a wee bit more.'

'Or not at all,' chimed in the ship's 'boy', a sprightly 78-year-old Englishman called John. Last to climb aboard was George Geddes, an Edinburgh-based archaeologist who works for the Royal Commission on the Ancient and Historical Monu-

ments of Scotland. 'Of all the islands I've ever visited, North Rona is my favourite by a long shot,' he said. 'You'll understand why when we get there. It is a truly remarkable place!'

The *Lochlann*'s engines roared into life and we were soon skimming across the glassy waters of Loch Roag, heading out to sea. Passing Bearsay, I could make out Bosta beach on Great Bernera, bathed in the light of the rising sun. But, as soon as we emerged into the open ocean, the Atlantic swell began to build. Within an hour of our departure, the swell was running at a good two metres from a northerly direction. The rising wind caught the wave tops, turning them into white breaking

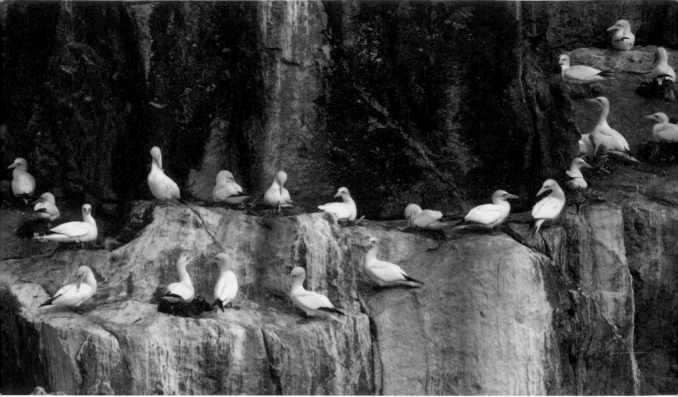

Gannets on Sula Sgeir.

crests, impeding the *Lochlann*'s progress. The boat rose to meet some waves, but smashed through others, showering the aft deck with spray. Millions of tiny droplets refracted the sunlight, creating a permanent rainbow which arched over our route towards invisible North Rona. I was hoping a landfall on the island would be our gold at rainbow's end. But how did early people first know that North Rona even existed? It's way below the horizon and must have been invisible from anywhere on Scotland. 'For most of the time bad weather definitely makes it impossible to see,' agreed George. 'But on a day of rare clarity, it can just be made out from the highest hills on Lewis, or from

the tops of the mountains of Sutherland. And if you imagine boats sailing north around the Butt of Lewis, early sailors might have seen signs of it on the horizon and thought, "Let's go and have a closer look."' Those first explorers must have arrived a long time ago. Archaeologists believe that North Rona was first inhabited over 1,700 years ago and, as we continued to batter towards the still-invisible island, it was difficult to imagine what kind of boats the early settlers had used to cross the perilous seas to reach their new home.

After weathering some pretty rough seas for over four hours, a lonely sentinel hove into view: the rocky mass of Sula Sgeir (Gaelic for 'Solan' or

North Rona rises from the sea.

'Gannet Rock') rising sheer out of the Atlantic and looking as if it were snow-covered – the effect of thousands of breeding gannets on the cliffs and rock ledges. Every August, men from Ness in Lewis make the traditional long sail north and clamber up the steep rocks of Sula Sgeir, where they are still licensed to hunt guga or unfledged gannets. Landing their supplies, the men make use of a centuries-old stone bothy where they stay for up to three weeks while they catch the young gannets with long poles. The birds are skinned and smoked over a peat fire, before being carefully packaged for the folks at home, where the guga is considered to be an epicurean delight and enjoyed on tables throughout Lewis to this day. The bothy on Sula Sgeir is called Taigh Beannaichte, which in Gaelic means the 'Blessed House', and suggests that a hermit or holy man of the Celtic Church might once have occupied Sula Sgeir. In fact, there is a Lewis legend that speaks of a female anchorite, Brenhilda, the sister of St Ronan who gave his name to North Rona. She spent time in the Blessed House, but was later found dead inside, with a cormorant nesting in her ribcage.

Leaving Sula Sgeir in our wake, we continued north-east for a further 18 kilometres towards North Rona, which was visible now through the haze. George was growing more excited with every nautical mile. 'See how green it looks!' he said. 'It's such an unexpected and improbable sight in this vast ocean. It's like an oasis!' After a total journey time of over six hours, we finally reached our goal. However, the swell had remained significant, washing the rocks and bursting at the base of the cliffs where Neil proposed to drop us off. Landing was impossible there and the *Lochlann* moved on. After searching along the steep and rocky south coast, Neil and George identified another possible landing place which afforded a little more shelter from the wind and waves. The rubber dinghy was launched and we clambered aboard. Roddy the mate steered us to the base of a low cliff. Timing the rise and fall of the swell, George and I leapt ashore: we had achieved the near impossible. We had landed on North Rona! The first thing that struck me, as we scrambled to the top of the cliff and saw the island stretching before us, was just how green North Rona appeared.

'It was always known for its good grass and excellent grazing for cattle and sheep,' said George. 'It was actually famous for its cheese, which was exported to Lewis.' I was amazed to learn that the livestock – sheep and even cattle – were transported from Lewis in open boats and then carried up the cliffs to the pasture above by men who risked death.

Before the last permanent residents left in the 1830s other early travellers had also commented on the island inhabitants they met on North Rona. In the 17th century Martin Martin said that the people took their names from the colour of the sky, the rainbow and the clouds and that they were wonderfully hospitable, showering visitors with gifts of grain and sheepskins and blessing them by turning in circles, following the direction of the sun. But how on earth did they make a living on this wild and lonely island? As we walked further inland, George pointed out the long furrows of lazy beds in the grass. This is where the islanders worked the land, and today they make a vivid monument to the labours of generations of people. 'Think of the lazy beds as a centuries-long, slow landslide. Hundreds of tons of good soil were carried from one end of the island to the other on the backs of men and women so that the community could grow crops to survive,' George said, and then he told me that the most common crop grown was grain. 'If we'd been standing here three hundred years ago when about thirty people lived on North Rona, we could well have been standing in the middle of a crop of ripening barley,' said George. 'Incredible when you think of how windy it can get out here!' As we continued towards the village, our progress was slowed somewhat by a pair of bonxies – or Great Skuas – who'd decided that our presence

on the island was an unwelcome intrusion. They continually swooped and dived at our heads until we left their territory.

Close to the ruined village, which seemed almost invisible except for some scattered stones and a few mounds in the ground, we came to the first clearly recognisable building: the tiny chapel dedicated to St Ronan. Walking through the ancient graveyard, I was struck by the realisation that lying beneath the weathered grave markers were the bodies of generations of islanders. They had been born on North Rona, had lived their entire lives there and then died without seeing anything of the world beyond the sea-constrained territory of their island home. Having picked my way among the island's dead, I found that the chapel engaged my speculative imagination almost as much as the graves had done. St Ronan's place of worship was exceedingly small: a rectangular stone structure with a corbelled roof measuring 3.4 by 2.2 metres – and, judging by the size of the door, Ronan himself must have been a very small saint indeed! The only way inside was to go on all fours. I wondered if this was a deliberate way of ensuring that visitors adopted the correct devotional posture when entering a place where God dwelt. George said that it may have been partly the intention, but reminded me that the doorway had also been partially in-filled over the centuries. Even so, it was not easy to get inside, especially because an irate nesting fulmar vomited defensively as we crawled into the gloomy interior, where I could just make out the corbelled roof above my head. George told me that the chapel – or oratory – is one of the oldest Christian buildings in the whole of Scotland. It may even be the oldest and perhaps dates from the 7th century.

Legend has it that St Ronan originally came to

The ruined village, North Rona.

Lewis as a missionary of the Celtic Church. He established a place of prayer and contemplation there but, unfortunately, the local people disregarded his teachings. Even worse, he was annoyed by gossiping local women. In a vision, God spoke to him and commanded the saint to go down to the shore. There Ronan found a great sea creature, who carried him over the waves to the island now named after him. Huddled close to the chapel is the village – once home to a community of 30 people. The few visitors who made the trip to North Rona when it was inhabited often remarked on how the houses were invisible because they were built almost underground to protect the inhabitants from the elements. Climbing a low bank, I discovered the ruin of one of these semi-subterranean dwellings on the other side. According to George, this was the last occupied house

on North Rona and would have been a very foreign environment to modern sensibilities. 'If we were in here when people lived in the house, it would be quite smoky,' said George. 'It would be really dark and very smelly. There would be cattle here, seabirds and fish hanging from the rafters. A real assault to the senses for those unaccustomed to the smells of remote island life.'

It must have been an utterly grim existence, I thought. George went on to describe how on at least two occasions the entire community was wiped out through starvation, disease and natural disaster. But every time this happened, the landlord, traditionally the chief of Clan MacLeod, recolonised the island with new people from Lewis. I doubt there were many volunteers because the principal driver behind occupying the island was payment of rent to the chief. Effectively this meant that the people of North Rona were rent slaves in a feudal society and utterly dependent on their laird. And, perhaps to prevent their escape, MacLeod ensured that they didn't have a boat of their own. However, he thoughtfully sent one every year to collect the rent – and sometimes to keep them supplied with life's essentials. George explained that occasionally a Rona man might need a wife. He'd ask for one to be sent out with the next boat the following year and waited with baited breath to see what she'd be like. Similarly, if the island was short of labour, a man would be sent out to live and work on the island. 'The most important thing to understand about remote Scottish islands like North Rona is that they don't work unless they are connected,' said George. 'So, if a community like the one that existed out here really was isolated, it wouldn't survive for long. North Rona was caught up in a bigger world. The people here were never just living an isolated life.'

In the 1840s, the last family left North Rona for good. Significantly, the new laird Sir James Matheson, who had recently bought the Isle of Lewis, offered North Rona to the British government, hoping to develop it as a penal colony – a sort of Hebridean Alcatraz. Unsurprisingly the offer was turned down and the island was left uninhabited until a family from England decided to make it their home. In 1938 the remarkable pioneering ecologist Frank Fraser Darling brought his wife and their eight-year-old son to North Rona for a year. Fraser Darling's purpose was to study the huge colony of grey seals that breed every winter on the island. The family lived in a wooden hut lashed down to prevent it blowing away during winter storms. Despite the desperate weather conditions and the hardships of life on North Rona, Fraser Darling loved the island and said it was where he felt completely fulfilled. Three days before Christmas 1938, the family had their first glimpse of the mainland. From the highest hill on North Rona they could see the snow-capped mountains of Sutherland glistening in the winter sunshine over 70 kilometres to the south-east.

North Rona is the loneliest Scottish island I have ever visited. Never before have I been to a place where I've felt isolation so acutely, in an almost physical way. And I'm not alone in reacting like this. Other visitors had a similar reaction. When the geologist John MacCulloch came here in the early 1800s he was impressed by both the people and the extreme isolation. At first he thought that life on the island must be similar to living on board a ship. Then on reflection he realised that nothing could compare with the loneliness of North Rona. A ship, he said, sets sail with the expectation of arrival. But North Rona is going nowhere, anchored forever in the restless Atlantic.

ST KILDA

St Kilda is an exceptionally rugged group of islands lying some 66 kilometres west of North Uist. The archipelago, which no longer has a permanent population, is a World Heritage Site and consists of: the main island Hirta; the small island called Dun, which acts as a breakwater to Village Bay; and the cliff-girt island of Soay. Neighbouring Boreray, with its amazing rock stacks, lies 6 kilometres to the north. The origin of the island group's name is uncertain; the names of the islands and some of the high summits, which rise to over 430 metres, are mostly from Old Norse. It seems that the Vikings had little other impact – perhaps naming the features as they sailed by in their longships – although there have been a few archaeo-logical finds (brooches and stone bowls called steatite vessels) to suggest their presence on the islands.

Many books have been written about St Kilda, its fascinating history and geology, and there would be little point in adding to the thousands of words already produced, except that it would seem perverse in the extreme not to mention this extraordinary place in a guide to the Hebrides.

I have been lucky enough to visit St Kilda a couple of times. The most memorable occasion was when I was stranded for a week at the mercy of the army. I had arrived with a film crew to make a documentary. Earlier I had sought permission from both the National Trust for Scotland, which owns the islands, and the Ministry of Defence, which runs a radar station on Hirta, tracking

The awe-inspiring cliffs of St Kilda.

rockets that are fired from the range on North Uist. My filming request to St Kilda was eventually granted on condition that we didn't stay on Hirta. To comply, we hired a large motorboat from Harris, which we planned to use as a base for daily shore excursions. Unfortunately, the boat broke down as soon as we arrived. The skipper then presented me with a choice: either return to Harris with him and his malfunctioning craft and abandon the filming expedition or throw myself on the good will of the army. I chose that latter course of action. The skipper limped home, and I was forced to explain our predicament to a grumpy young captain, who allowed us to sleep on the floor of the windowless gym hall – and to occasionally find rest and recreational diversions in the club called the Puff Inn.

This wasn't an auspicious start to our St Kildan adventure. Despite its being a World Heritage Site, my first impressions were coloured by the unsightly military base. It dominated the old settlement of Village Bay with grey prefab buildings, Nissen huts and graffiti. Strikingly incongruous was a red hammer and sickle symbol with the letters KGB daubed on the side of various buildings. It turned out that this had nothing to do with support for Soviet Intelligence but was the work of an unorthodox army club and stood for Kill the Generator Board. To become a member of St Kilda's KGB involved all sorts of strange initiation rituals, some of which took place at the Puff Inn – and all of which seemed to involve alcohol. One was a form of crowdsurfing based on group trust. An applicant to the KGB had to throw himself from the bar into the arms of KGB members. On one occasion, this ended in a casualty being airlifted from the island. Apparently his trust was misplaced and he had a heavy landing. Perhaps

the lonely situation of the St Kilda base led to this eccentric behaviour. The most curious example of this was the sight of a grown man in army uniform taking his imaginary dog for a walk. Dogs were banned, of course. Instead, this soldier had a collar attached to a wire leash, with which he exercised his fantasy canine friend.

We didn't have to move very far from the military base to forget its presence. A few hundred metres away was the street of abandoned cottages where St Kildans lived before they were evacuated from their island home in 1930, ending a history of continuous habitation dating back at least 2,000 years. Archaeologists have also found much earlier evidence of human activity, perhaps as long ago as 5,000 years. However, whether these people were occasional visitors or were permanent island dwellers is not yet certain. But, whatever the truth, the very fact that early people could cross the dangerous and tempestuous stretch of water from the Western Isles is astounding, and it makes one wonder what boat technology they had. These were colonists, not single individuals drifting to St Kilda on a log or in a dugout canoe. Their boats had to be seaworthy and big enough to carry men, women, children, livestock and all the equipment necessary to begin a new life on their island home.

It seems that later inhabitants must have found the thought of an early seaborne migration impossible. They had legends to explain how the first people arrived. According to the old stories, St Kilda was once connected by a land bridge to Harris. This was the favoured hunting ground for a female warrior, who loved setting her hounds to chase the deer that roamed the land between Hirta and Harris. This Amazon is said to have lived in a stone-built house in Gleann Mor overlooking Glen Bay in the north of Hirta, where today there are the

remains of several dwellings dating from the Iron Age and perhaps from as early as the Stone Age.

The early traveller Martin Martin visited Hirta in 1697. He described a race of people that even to him, a Hebridean from Skye, were utterly foreign in their appearance and customs. When he landed on the island he was greeted by smooth-faced men dressed in sheepskins, wearing knee-length stockings stitched together with feathers. They spoke a form of Gaelic that to him seemed almost unintelligible. These men were brave and accomplished climbers on the great cliffs of St Kilda, which reach a height of 426 metres, making them Britain's highest. Using homemade ropes they fearlessly harvested the colonies of nesting seabirds on the dizzying heights. The whole economy of the island depended on their skill and success. They collected eggs, caught puffins, fulmars and other sea fowl, which provided, meat, oil, and great quantities of feathers. This produce not only nourished the islanders, it also formed the bulk of the rent they paid to their laird, MacLeod of Dunvegan on Skye. Despite this feudal existence, Martin Martin wrote that the people he met were 'happier than the generality of mankind, as being almost the only people in the world who feel the sweetness of true liberty'. The people who greeted Martin Martin were mostly killed by an outbreak of smallpox in 1726. This came about after a man from St Kilda visited Harris, where he contracted smallpox and died. Unfortunately, his contaminated belongings were packed up and returned to St Kilda. When his relatives opened the kist containing his clothes, they unknowingly released smallpox into the community, killing nearly everyone on the island. The tragedy went unnoticed for months until MacLeod's factor set sail from Harris to collect the rent. As he drew closer to St Kilda, his boat passed the 172-metre-high rock pinnacle of Stac Lee near Boreray. He was amazed to see the tiny figures of ragged, starving men waving for help from the rock ledges. After he'd picked them up, they explained that they had been stranded on the stack for nine months. They had been dropped off by boat from the main island of Hirta for the annual gannet hunt in August. But the boat never returned. It was now May. All eighteen men and boys had survived somehow, enduring the harsh winter huddled in a drystone shelter high on the stack. But their ordeal wasn't over. When they arrived in Village Bay, they discovered that the population of 200 souls had been wiped out, with the exception of themselves and a young mother and her baby, who had miraculously survived the epidemic. MacLeod of Dunvegan, who owned the island, was reluctant to lose his rental income. He later had the island repopulated with families from his lands on Skye and Harris.

Scattered around the houses in Village Bay are dozens of small stone buildings roofed with a stone slab, and capped with turf. These are St Kilda's famous *cleits*, which are unique to the archipelago. Despite there being over 1,200 of them, their origins are mysterious. Its known that in historical times *cleitean* were used for storage, where the islanders kept a range of perishable products including salted seabird carcasses, eggs stored in ash, salted fish, grain, peat for fuel and sundry agricultural and fishing implements. In 1734 the unfortunate Lady Grange, who had been kidnapped in Edinburgh by her Jacobite husband to keep her quiet about his political allegiances, was brought to St Kilda from the Monach Islands, where she had been exiled for two years. According to tradition, she was kept on Hirta in a large *cleit*,

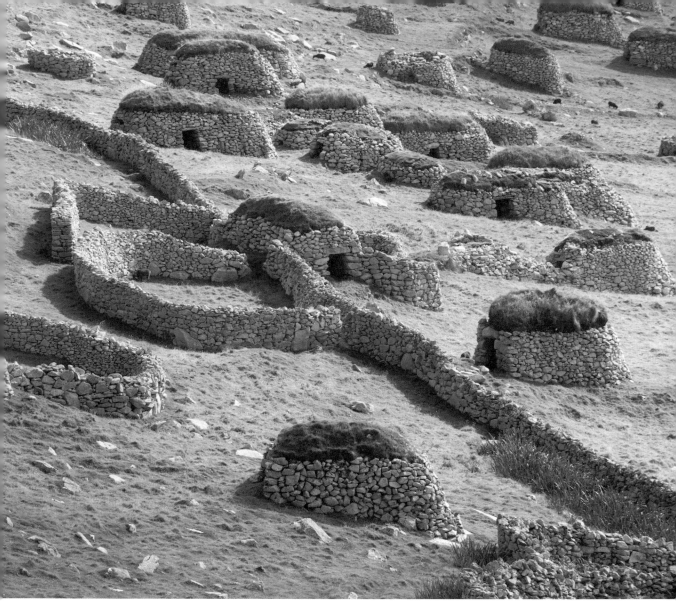

There are over a thousand *cleits* on St Kilda, which the islanders used for storage.

known as Lady Grange's House, which stands slightly apart from the others in the meadow below the village street.

Throughout the 19th century life for the St Kildans grew more and more difficult – perhaps perversely because communications were improving, making it easier to leave the island and easier to import goods. This made the community increasingly reliant on the outside world. In 1852, 36 people, almost half the population of the island

at the time, emigrated to Australia. Half of them died on the journey, but a few of the survivors settled in Melbourne, where there is a coastal suburb called St Kilda, named in memory of their island home.

On the shore overlooking Village Bay is an unusual and unexpected sight: a rusty artillery piece dating from the First World War. It was belatedly installed to deter German attacks after a U-boat shelled a radio transmitter that had been

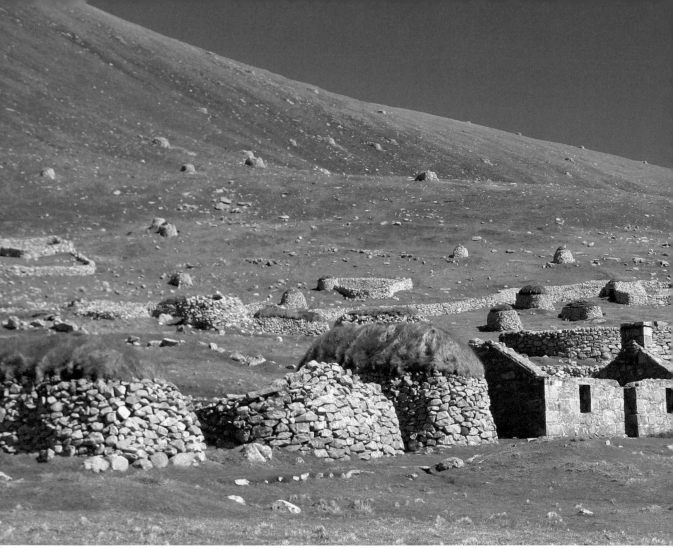

The remains of the Village, Hirta, which was evacuated in 1930.

set up near the island jetty by the Royal Navy. The enemy vessel fired a total of 72 shells. The wireless station was destroyed, and some other buildings were lightly damaged. According to one eye witness, 'It wasn't what you would call a bad submarine because it could have blowed every house down. He only wanted Admiralty property. One lamb was killed … all the cattle ran from one side of the island to the other when they heard the shots.' After the First World War, emigration continued. Young men and women left to find a more materially rewarding life overseas. This led to an increasingly elderly and vulnerable popula-

tion, which no longer had the capacity to endure life on St Kilda. In August 1930 the remaining 36 St Kildans reluctantly agreed to be evacuated, many settling in Lochaline across the Sound of Mull in the district of Morvern. The men were given work planting trees in the new forest plantations, an odd choice of employment since they had come from a treeless island.

My own farewell to St Kilda couldn't have been more memorable. Our cramped confinement in the army gym hall finally came to an end when our boat returned from Harris, its engines running sweetly again. Under cobalt-blue skies, we headed

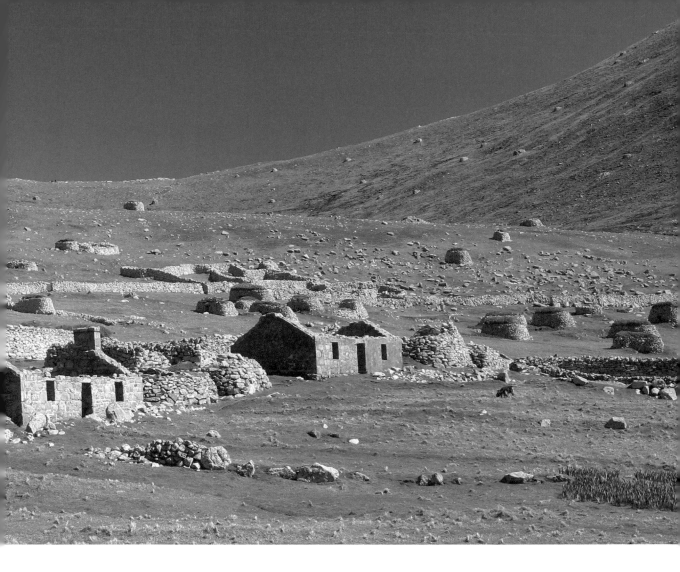

across a remarkably calm sea towards Boreray. We cruised for a while around the base of Stac an Armin and Stac Lee. Above us thousands of gannets were wheeling and diving, filling the air with their pulsating, throbbing cries. The noise seemed to reverberate inside my head, which I kept covered to protect myself from large quantities of guano being dropped from a great height. Because the weather was so balmy and benign, we were able to make a landing at the base of the great cliffs of Boreray. We roped up and climbed the rocks to where the grass swept up at an alarmingly steep angle, all the way to the summit at 384 metres

above the sparkling sea. I was surprised to see a flock of sheep grazing the precarious slopes. They had been abandoned by the St Kildans after the evacuation – although how they got them there in the first place was a mystery. As the summer sun dipped low to the north-west, puffins began to fly home to their nest burrows. The air was thick with them. But their landing skills left a lot to be desired. They seemed to prefer crash landings to anything more elegant. Some even collided with me as I gingerly made my descent in the light of the setting sun.

FURTHER READING

General books

Atkinson, R., *Island Going* (Birlinn Ltd, 2008)

Boswell, J. and Johnson, S. (ed. R. Black), *To the Hebrides* (Birlinn Ltd, 2011)

Bunting, M., *Love of Country: A Hebridean Journey* (Granta Books, 2016)

Geddes, T., *Hebridean Sharker* (Birlinn Ltd, 2012)

Gunn, N., *Off in a Boat* (House of Lochar, 1998)

Haswell-Smith, H., *The Scottish Islands* (Canongate, 2015)

Macdonald, A. and P., *The Hebrides: An Aerial View of a Cultural Landscape* (Birlinn Ltd, 2010)

Martin, M., *A Description of the Western Islands of Scotland, c. 1695* (Birlinn Ltd, 1999)

Maxwell, G., *Harpoon at a Venture* (Birlinn Ltd, 2013)

Moffat, A., *The Sea Kingdoms: The History of Celtic Britain and Ireland* (Birlinn Ltd, 2008)

Arran

Campbell, T., *Arran: A History* (Birlinn Ltd, 2013)

McKirdy, A., *Arran: Landscapes in Stone* (Birlinn Ltd, 2016)

Barra and South Uist

Buxton, B., *Mingulay: An Island and Its People* (Birlinn Ltd, 2016)

Buxton, B., *The Vatersay Raiders* (Birlinn Ltd, 2008)

Campbell, J. L. (ed.), *The Book of Barra: Being Accounts of the Island of Barra in the Outer Hebrides Written by Various Authors at Various Times, Together with Unpublished Letters and Other Matter Relating the Island* (Acair Ltd, 1998)

Macpherson, J., *Tales from Barra* (Birlinn Ltd, 1992)

Canna

Campbell, J. L., *Canna: The Story of a Hebridean Island* (Birlinn Ltd, 2014)

Perman, R., *The Man Who Gave Away His Island: The Life of John Lorne Campbell* (Birlinn Ltd, 2010)

Shaw, M. F., *From the Alleghenies to the Hebrides: An Autobiography* (Birlinn Ltd, 2008)

Colonsay

Alexander, D., *The Potters Tale: A Colonsay Life* (Birlinn Ltd, 2017)

Byrne, K., *Lonely Colonsay: Island at the Edge* (House of Lochar, 2010)

McPhee, J., *The Crofter and the Laird: Life on a Hebridean Island* (House of Lochar, 1998)

Eigg

Dressler, C., *Eigg: The Story of an Island* (Birlinn Ltd, 2017)

Gigha

Czerkawska, C., *The Way it Was: A History of Gigha* (Birlinn Ltd, 2016)

Iona

Adomnan of Iona, *Life of St Columba* (Penguin, 1995)

Clarkson, T., *Columba* (John Donald, 2012)

Crawford, R., *The Book of Iona: An Anthology* (Polygon, 2016)

MacArthur, E. M., *Iona: The Living Memory of a Crofting Community* (Edinburgh University Press, 2002)

Islay, Jura and Colonsay

Caldwell, D., *Islay, Jura and Colonsay: A Historical Guide* (Birlinn Ltd, 2011)

Caldwell, D., *Islay: The Land of the Lordship* (Birlinn Ltd, 2017)

Kerrera

MacDougall, H., *Kerrera: Mirror of History* (House of Lochar, 2004)

Lewis and Harris

Ferguson, C., *Children of the Black House* (Birlinn Ltd, 2003)

Harris, R., *The Soap Man: Lewis, Harris and Lord Leverhulme* (Birlinn Ltd, 2003)

Lawson, B., *Lewis in History and Legend: The East Coast* (Birlinn Ltd, 2011)

Lawson, B., *Lewis in History and Legend: The West Coast* (Birlinn Ltd, 2008)

MacDonald, D., *Tales and Traditions of the Lews* (Birlinn Ltd, 2004)

MacLeod, J., *When I Heard the Bell: The Loss of the Iolaire* (Birlinn Ltd, 2010)

MacLeod, J., *None Dare Oppose: The Laird, the Beast and the People of Lewis* (Birlinn Ltd, 2015)

McIntosh, A., *Poacher's Pilgrimage* (Birlinn Ltd, 2016)

Murray, D. S., *The Guga Hunters* (Birlinn Ltd, 2015)

Lismore

Hay, R., *How an Island Lost its People: Improvement, Clearance and Resettlement on Lismore, 1830–1914* (Island Book Trust, 2013)

Hay, R., *Lismore: The Great Garden* (Birlinn Ltd, 2015)

Mull

Currie, J., *Mull: The Island and its People* (John Donald, 2010)

Jones, R., *Tea with Chrissie: The Story of Burg and Ardmeanach on the Isle of Mull* (Craigmore Publications, 2007)

Mackenzie, D. W., *As It Was: An Ulva Boyhood* (Birlinn Ltd, 2011)

McKirdy, A., *Mull, Iona and Ardnamurchan: Landscapes in Stone* (Birlinn Ltd, 2017)

North Uist

Lawson, B., *North Uist: In History and Legend* (Birlinn Ltd, 2011)

Rum

Cameron, A., *Bare Feet and Tackety Boots: A Boyhood on the Island of Rum* (Luath, 1988)

Love, J. A., Rum: *A Landscape Without Figures* (Birlinn Ltd, 2002)

Sabbagh, K., *A Rum Affair: A True Story of Botanical Fraud* (Birlinn Ltd, 2016)

Scott, A., *Eccentric Wealth: The Bulloughs of Rum* (Birlinn Ltd, 2011)

St Kilda

Gannon, A. and G. Geddes, *St Kilda: The Last and Outmost Isle* (Historic Environment Scotland, 2015)

Gillies, D., *The Truth about St Kilda: An Islander's Memoir* (Birlinn Ltd, 2014)

Hutchinson, R., *St Kilda: A People's History* Birlinn Ltd, 2016)

Macaulay, M., *The Prisoner of St Kilda: The True Story of the Unfortunate Lady Grange* (Luath, 2010)

Maclean, C., *Island on the Edge of the World: The Story of St Kilda* (Canongate, 2009)

Steel, T., *Life and Death of St Kilda* (Harper Collins, 2011)

The Small Isles (Rum, Eigg, Muck)

Hunter, J., *The Small Isles* (Historic Environment Scotland, 2016)

Pullar, P., *A Drop in the Ocean: Lawrence MacEwen and the Isle of Muck* (Birlinn Ltd, 2015)

Rixson, D., *The Small Isles: Canna, Rum, Eigg and Muck* (Birlinn Ltd, 2001)

The Shiants

Nicolson, A., *Sea Room* (Harper Collins, 2002)

Skye, Raasay and Soay

Cholawo, A., *Island on the Edge: A Life on Soay* (Birlinn Ltd, 2016)

Hutchinson, R., *Calum's Road* (Birlinn Ltd, 2008)

Hutchinson, R., *Martyrs: Glendale and the Revolution in Skye* (Birlinn Ltd, 2015)

Mackenzie, W., *Old Skye Tales: Traditions, Reflections and Memories* (Birlinn Ltd, 2002)

McKirdy, A., *Skye: Landscapes in Stone* (Birlinn Ltd, 2016)

Swire, O., *Skye: The Island and its Legends* (Birlinn Ltd, 2006)

South Uist and Eriskay

Hutchinson, R., *Father Allan: The Life and Legacy of a Hebridean Priest* (Birlinn Ltd, 2017)

Hutchinson, R., *Polly: The True Story Behind Whisky Galore* (Mainstream, 1990)

MacInnes, A. E., *Eriskay: Where I Was Born* (Birlinn Ltd, 2017)

MacLellan, A., *Stories from South Uist* (Birlinn Ltd, 2005)

MacLellan, A., *The Furrow Behind Me: The Autobiography of a Hebridean Crofter* (Birlinn Ltd, 1997)

Rea, F., *A School in South Uist: Reminiscences of a Hebridean Schoolmaster, 1890–1913* (Birlinn Ltd, 2007)

Russell, M., *A Different Country: The Photographs of Werner Kissling* (Birlinn Ltd, 2002)

Strand, P., *Tir a'Mhurain: The Outer Hebrides of Scotland* (Birlinn Ltd, 2017)

Tanera Mòr (The Summer Isles)

Darling, F. F., *Island Years, Island Farm* (Little Toller, 2011)

Tiree

Meek, D. E., J. Holliday and R. Black, *The Secret Island: Towards a History of Tiree* (Islands Book Trust, 2014)

INDEX